Art on the Block

Art on the Block

TRACKING THE NEW YORK ART WORLD FROM SOHO TO THE BOWERY, BUSHWICK AND BEYOND

ANN FENSTERSTOCK

palgrave
macmillan

ART ON THE BLOCK
Copyright © Ann Fensterstock, 2013.
All rights reserved.

First published in 2013 by PALGRAVE MACMILLAN® in the United
States—a division of St. Martin's Press LLC, 175 Fifth Avenue, New
York, NY 10010.

Where this book is distributed in the UK, Europe and the rest of the
world, this is by Palgrave Macmillan, a division of Macmillan Publishers
Limited, registered in England, company number 785998, of Houndmills,
Basingstoke, Hampshire RG21 6XS.

Palgrave Macmillan is the global academic imprint of the above
companies and has companies and representatives throughout the world.

Palgrave® and Macmillan® are registered trademarks in the United
States, the United Kingdom, Europe and other countries.

Maps of Manhattan and Brooklyn designed by Rick Orlosky. Used with
permission.

ISBN 978-1-137-27849-4

Library of Congress Cataloging-in-Publication Data is available from the
Library of Congress.

A catalogue record of the book is available from the British Library.

Design by Letra Libre, Inc.

First edition: September 2013

10 9 8 7 6 5 4 3 2 1

Printed in the United States of America.

Contents

Preface

"We are polyglot and polychrome . . . a collection of villages—virtually self reliant hamlets, each exquisitely textured by its particular ethnicities, history and politics."

—Joseph Berger, *The World in a City: Traveling the Globe Through the Neighborhoods of the New New York,* 2007

New York City has always had a tribal attitude toward its neighborhoods. Fierce loyalty to one's own, dismissal, disdain or downright suspicion of anyone else's—every New Yorker intuitively knows where a particular neighborhood begins and where it ends. To live, work, shop, eat, be social or be cultivated in New York—namely to *be* a New Yorker—is to constantly explain and defend the choice of one circumscribed section of the city over another. An offhand reference to the Upper West Side, the Lower East Side or the West Village will be met with "But *where* exactly?" New Yorkers demand specific east/west cross streets and north/south avenues in order to home in on a precise block.

The mother ship in the ubiquitous "*my* neighborhood" of New Yorker parlance is defined not by zip code but by the dry cleaner, pizza delivery, sushi bar and local subway stop to which residents are slavishly attached. Choosing a neighborhood to live in, getting to know it like a native and agonizing over the prospect of a move elsewhere are all part of a local ritual that newcomers find to be wondrous.

Curiouser and curiouser, New Yorkers also seem to be magically imbued with an innate understanding of neighborhoods beyond their own—the city's many geographies of professional, commercial, social, cultural, ethnic, political and even sexual preference. Some of

these overlap, many are worlds apart. Other American cities have their "areas"—good and bad. There are South Sides, North Ends, French Quarters and Downtowns, but nowhere else insists with such block-by-block specificity, with such xenophobic intransigence, on the micro-distinctions between its neighborhoods. It's a New York thing.

I first came to New York City in the summer of 1974, a nineteen-year-old raised in England, with just one year of university life away from home. I had landed a summer job as a mother's helper in the Five Towns of Long Island and, blissfully unaware that New York City was mired in one of the worst economic, social and political crises of its history, I mapped out every minute of my thirty-six hours a week of free time, came into "The City"—as it was dubiously referred to in the outer boroughs—and blithely went everywhere.

From Harlem to Hell's Kitchen, from the dazzle of Fifth Avenue to the shadiness of the mob-run South Street Seaport, I naïvely criss-crossed the city. I strolled around crime-ridden Central Park, wandering through museums on a student pass and arriving early enough on the Jewish Lower East Side for the rumored first-customer-of-the-day bargain. I lunched on "a slice" in un-air-conditioned pizza parlors, squinted through the clouds gushing from manhole steam pipes at the gigantic cigarette billboards above Times Square and shuddered over the homeless bodies collapsed along the Bowery's skid row.

There were bustling jewelry merchants on Forty-Seventh Street, burly fur dealers unloading trucks in the West Thirties, garment racks, apparently escaped from any human handler, careening across the sidewalks of Seventh Avenue. The flower vendors on Twenty-Eighth Street, the money makers of Wall Street, the culturati milling around the West Side's Lincoln Center, they all seemed like worlds unto themselves, separate and idiosyncratic, self-absorbed, self-governed and often brashly self-important.

All these years later, I am still fascinated by that quirky, shape-shifting New York City entity—the neighborhood. Moving to New York permanently in 1981, I have lived on the Upper West Side, the Upper East Side, Brooklyn Heights, Cobble Hill and NoHo. With each move, friends and neighbors expressed shock and awe at my treachery in leaving. Teaching contemporary art in and around New York's galleries and

museums, I have worked uptown and downtown, in Greenwich Village and on Fifty-Seventh Street, in SoHo, the East Village and West Chelsea, in the Meatpacking District around Gansevoort Street and across the river in Brooklyn's Williamsburg. Also down under the Manhattan Bridge Overpass familiarly known as Dumbo and in Bushwick. Namely—in the art neighborhoods.

Walking in the East Village one day in early 2007, I was mentally preparing an itinerary for my students' first foray into the newly evolving enclave of galleries, exhibition spaces and art venues spawning around New York's latest new museum. Opening later that year on the Bowery at Prince Street, art world buzz had it that the New Museum of Contemporary Art was to make this once hardscrabble working-class neighborhood the latest center of New York City's strangely peripatetic art world.

And why not? The art world had long ago flown its fledgling beginnings in Greenwich Village in the 1930s and 1940s. It was there that Gertrude Vanderbilt Whitney, a rebellious champion of the new Modernist painters of contemporary urban life—Joseph Stella, Reginald Marsh and Edward Hopper—set up her Whitney Studio on West Eighth Street. Edith Halpert's Downtown Gallery was on West Thirteenth Street and from there she also fought for the new and the yet-to-be recognized—in Arthur Dove's undulating natural forms or the jazz-inflected syncopation of a Stuart Davis streetscape. All of it was incontestably *American* art.

The art world then moved east in the 1950s and misspent much of its youth arguing in the cooperative galleries of East Tenth Street or drinking in the Cedar Tavern on University Place. By now Jackson Pollock, Willem de Kooning and Franz Kline were creating the big-gestured Action Paintings—all splatter, dribble and slash, fiercely laid down onto huge canvases in strident color or equally shocking modulations of only black and white.

In the 1960s the art world grew up and got stylish along Fifty-Seventh Street and these Action Painters, now accepted by the collecting public, were referred to as Abstract Expressionists and treated with reverence. But no sooner were they established than a brash new generation of Pop artists—Roy Lichtenstein, James Rosenquist and Andy Warhol—shocked the public anew with painted copies of comic book

characters, plates of spaghetti and soup cans, changing the rules of the game once more.

The Minimalists who followed in the later 1960s proposed virtually objectless canvases, simply a sea of barely marked white, red or black. And once Robert Rauschenberg dragged a stuffed goat in off the street or pinned his own sheet-rumpled bed to the wall and called it art, it seemed that the salons of Fifty-Seventh Street would no longer do.

As the 1970s bloomed and more and more non-painting forms such as Conceptualism, Fluxus and Performance Art began to take hold, it was clear that the unruly child must leave home for an alternative lifestyle. The loft spaces of SoHo were waiting to accommodate such new developments as the Happening—a free-fall mix of barely scripted artist action and (often confused) audience participation.

By the early 1980s, the younger and more vital parts of the SoHo scene mutated and migrated to the burned out and drug infested East Village. There, graffiti writers like Fab Five Freddy, Dondi and Lady Pink worked the subway trains and alley walls alongside Keith Haring and Jean-Michel Basquiat, opening up yet another new art neighborhood.

The late 1980s saw the new chic of Neo-Expressionism as Julian Schnabel's broken plate cacophonies and Francesco Clemente's big, moody, mega-priced canvases left no room on the well architected walls of Mary Boone's elegant gallery for newer work. Chelsea white cube cool had now arrived. Here, at street level and on the weight-bearing concrete floors of refitted taxi garages, yet more new art forms could emerge. Monumental sculpture, large-scale installation work and noisy space-demanding video were given room to breathe.

Meanwhile, the working artist and his studio, once spaciously ensconced in the lofts of SoHo, decamped across the East River to other abandoned buildings on Brooklyn's waterfront. There they went to work on the next wave of scrappy, DIY, anti-Chelsea art. By the early 2000s, those working artists from Williamsburg and Dumbo had moved along yet again—deeper into Brooklyn, to Bushwick and Ridgewood, Red Hook and Gowanus. For the new set of young galleries waiting to show the art coming out of those studios, it seemed that the Lower East Side was next.

Yet some forty years after my first visit, the flower district was still on Twenty-Eighth Street and looked little different; diamonds were still being sold on Forty-Seventh and fur along a handful of relatively unchanged blocks in the Thirties. The very name "Broadway" was still understood to be one and the same thing as the theater and, while its signage might now be flashier and its tickets pricier, it also had stayed put.

But in less than a half century there had already been six, perhaps seven different art districts, each one of them radically different from the last. Why, having moved in, settled down and, like a good New Yorker, made the neighborhood its own, does the art world then uproot and reinvent itself somewhere else? Why does it go where it goes, why does it move on and what exactly does it leave in its wake? What moves the art world, where and why?

Acknowledgments

*T*his book is based on five years of research, hundreds of scholarly texts, journal, magazine and newspaper articles, gallery press releases, websites, online newsletters, blogs and personal conversations. I would first like to thank all of the people who are not specifically mentioned in these pages but who gave me their time and attention in hours of interviews, e-mail and telephone exchanges or generous press and research materials. Space has not allowed for all of your stories, but the knowledge you shared and the perspectives you offered have informed and colored so much of what I feel privileged to have written. Space limits me to citing quotations, personal interviews, hard data and controversial items. To everyone else not footnoted, I am the grateful beneficiary of your research.

Miguel Abreu, Augusto Arbizo, George Adams, Brooke Alexander, Carolyn Alexander, Joe Amrhein, Susan Anthony, Massimo Audiello, Roland Augustine, Daniel Aycock, Mike Ballou, Nicelle Beauchene, Joel Beck, Jen Bekman, Barry Blinderman, Marianne Boesky, Mary Boone Gallery, Ted Bonin, Karin Bravin, Hal Bromm, Helen Brough, Susan Caldwell, Don Carroll, Tracy Causey-Jeffery, Carla Chammas, Dennis Christie, James Cohan, Lisa Cooley, Paula Cooper, Betty Cuningham, Jimi Dams, Kristen Dodge, Ronald Feldman, Zach Feuer, Andrew Freiser, James Fuentes, Gagosian Gallery, Lia Gangitano, Kathleen Gilrain, Barbara Gladstone Gallery, Larissa Goldston, Jay Gorney, Carol Greene, Lynn Gumpert, Nelson Hancock, Eric Heist, Lesley Heller, Nancy Hoffman, Peter Hopkins, Sean Horton, Susan Inglett, Michael Jenkins, Priska Juschka, Ivan Karp, Sean Kelly, Breda Kennedy, Liza Kirwin, Nicole Klagsbrun, Anna Kustera, John Lee, Rachel Lehmann, Lawrence Luhring, Candice Madey, Gracie Mansion, Matthew Marks Gallery, Zannah Mass, Deborah Masters, Valerie McKenzie, Sara Meltzer, Doug Milford, Loren Munk, Peter Nagy, Risa Needleman, David Nolan, Bill O'Connor, Tatyana Okshteyn, Wendy Olsoff, James Panero, Laura Parnes, Penny Pilkington, Simon

Preston, Max Protetch, Sara Jo Romero, Andrea Rosen, Mary Ryan, Mary Sabbatino, Magda Sawon, Lisa Schroeder, Sue Scott, Betsy Senior, Jack Shainman, Adam Sheffer, Ward Shelley, Jean Shin, Mark Shorliffe, Claude Simard, Adam Simon, Amy Smith-Stewart, Becky Smith, Dick Solomon, Ken Solomon, Lisa Spellman, Fabienne Stephan, Heather Stephens, Sur Rodney Sur, Eve Sussman, Marvin J. Taylor, Mary Temple, Lucien Terras, Jack Tilton Gallery, Richard Timperio, Benjamin Tischer, Leslie Tonkonow, Ken Tyburski, Diane Villani, Larry Walczak, Sarah Walko, Michael Waugh, Jill Weinberg, Angela Westwater, Joni Weyl, Alun Williams, Helene Winer, Edward Winkleman, Kristine Woodward, Jamie Wolff and the David Zwirner Gallery.

To the artists and estates who honored me with permission to use their work in my illustrations. To Bill Orcutt and Ilonka Van Der Putten for their photography. To Fanny Pereire for her guidance on image copyright.

I am enormously grateful to my agent, William Clark, who saw the potential in this book from the outset. To Paul de Angelis who took a set of term-papers-from-hell and showed me how to make them readable. To Luba Ostashevsky, my editor at Palgrave Macmillan, who shaped the book and saw me through the agony of edits and deletions with understanding and forbearance. To Hilary Adams, Fiona Donovan, Alison Fensterstock, Frances Kazan and Janice Oresman who read hopelessly early drafts but were kind, and to Riva Blumenfeld, Lacy Doyle, Jane Fine and Elisabeth Kley who did meticulously close readings at the end. To my incredibly smart intern Sunny Wang who hung in on weekends long after graduating to higher callings. Any remaining errors are entirely my own.

To friends, students and art world colleagues too numerous to mention who have encouraged me through six years of this project.

And to my family. To our beagle, Tess, who walked with me as I thought this book through. To my daughters, Kate and Jane, who always had faith that I could do it. To my husband, Lee, who has been generous, supportive and patient through the highs and many lows of this project. The book I am proud of, but you are my greatest loves and my life with you will always be my finest achievement.

MANHATTAN

Upper West Side

Upper East Side

59TH ST.

Hell's Kitchen

Midtown

FIFTH AVE.

Midtown East

Murray Hill

34TH ST.

BROADWAY

Chelsea

Gramercy

14TH ST.

Greenwich Village

West Village

East Village

HOUSTON ST.

SoHo

Little Italy

Lower East Side

CANAL ST.

TriBeCa

Chinatown

WILLIAMSBURG BRIDGE

MANHATTAN BRIDGE

BROOKLYN BRIDGE

Financial District

BROOKLYN

1

WHAT MOVES THE ART WORLD?

"Inspiration is for amateurs. The rest of us just show up for work."
—Chuck Close, *New York Times,* December 18, 2012

When the question "What moves the art world?" first occurred to me, I ran it by some of the artists, dealers, directors of nonprofit exhibition spaces, writers and critics who are a part of it. Reactions were myriad. Rents and real estate, space and light, compatible community and collector convenience were all suggested, often insistently. Many (in this essentially liberal cohort) suspected the manipulative hand of city government or civic politics. Shrewd property speculators, ruthless developers and rapacious landlords were regularly cited. The responses were impassioned but rarely consistent. And yet, as I considered the actual history of the art world's migration from neighborhood to neighborhood, each in its own way contained elements of the truth. They all had their merits.

IT'S ALL ABOUT THE REAL ESTATE

Artists and fledgling galleries move into a neighborhood that is unloved and unwanted because the big spaces they need to make and show their art are cheap. The arts community cleans up the neighborhood and gives it cachet but is then forced to move on and make way for the far more profitable fashion, food and fabulous people. Of the more than 150 art

world participants I interviewed for this book—gallery owners, directors of not-for-profits, creators of experimental exhibition spaces, artists, art and cultural historians—many firmly believed this to be the one and only explanation necessary for the art world's frequent moves. Some of them still hold to that view.

There is a good deal of truth to the credo, and it would be naïve to deny the crushing velocity of the gentrification juggernaut. Stories abound in this narrative of greedy landlords and bourgeois dilution of a neighborhood's artistic vibe by yuppie scene seekers and stampeding tourists who drive up the price of everything from apartments to a cup of coffee.

Yet examples abound of artists, galleries or other exhibition venues leaving a neighborhood for new climes even when they are not at the mercy of the real estate market. In 1996 pioneer dealer Paula Cooper moved her gallery to utterly desolate Chelsea despite the fact that she already owned her SoHo exhibition space. There is also ample evidence that loyalties to a neighborhood, or a sense of origins and identity, will persuade an artist or exhibitor to stay long after the audiences have thinned and the rest of the crowd moved on. Devotees of Williamsburg, Brooklyn, are a case in point. While gentrification is a big thing, therefore, it's not the only thing. It's but one strand in a richly textured amalgam of phenomena, many of them particular to the art world.

THEN IT MUST BE THE ECONOMY

A number of the players who weighed in on what moves their art world feared that it might all be bigger and even badder than just that: the economy at large was to blame. Indeed the Big Apple's compulsive propensity for producing and selling the best and the brightest, its cutthroat ambition to be the first out of the gate and its shameless embrace of conspicuous consumption make New York the market of all markets. Homes, fashion, food and culture—even health and education—are all quickly commodified here and are indiscriminately flogged to the highest bidder.

Since New York has been alternately fueled or drained dry by its Wall Street machine, it's no surprise that many see the art world simply as a function of economic cycles. Flourishing with the ups and floundering

with the downs very much in lockstep with the real estate market that does or doesn't put up the walls on which to hang the art—supply, demand, markets and money have often colored the picture. Art is after all still a luxury product. Surely, then, a strong market must nourish the art neighborhood and a weak market diminish it.

It's true that rising fortunes among collectors do often result in a spike in art shopping, and several of the gallery relocations I track here were financed by the years of plenty. Similarly, a market downturn, reduced sales for artists, gallery closings and funding cuts to not-for-profits can decimate a building full of studios, shutter an entire block of galleries or cause nonprofits to lose the roof over their heads. Yet art districts regularly prove an exception to this rule, and economic slumps often mean that advantageous deals are to be had by those looking to find a studio or expand a gallery in a now-depressed real estate environment.

Qualitatively, also, the art world is tricky. Some of the most depressingly fallow years in terms of great work, iconic dealers and visionary exhibition programs have occurred during the go-go sprees of an overheated economy. Some of the best art, the most game-changing galleries and the most counterintuitive arts initiatives have found fertile soil among the ravages of New York City's catastrophic cyclical crashes. Art neighborhood shifts have therefore often come about in opposition to the prevailing economic trend.

POLITICS PERHAPS?

New York City is famous for cultivating extremes in many things, not the least of which is its politics. The political movements spawned, the radical groups fostered, the larger-than-life politicians put into office and the national, even global, attention the city's policies and practices have garnered mean that a certain undercurrent of politics must run through any accounting of its history. Its art world history is no different.

The political convictions of artists regularly inform the art they produce, particularly in times of war such as the Vietnam era or during America's seemingly endless engagements in Afghanistan and Iraq. Polemics against sexism, racism, homophobia, government incursion of individual liberties, environmental disaster and the demands of the green

movement have also found a way into the imagery. These images have then demanded a sympathetic site in which to be to be seen.

The women's movement of the 1960s and '70s undoubtedly empowered such SoHo gallery pioneers as Paula Cooper, Holly Solomon and Angela Westwater. Similarly, the Stonewall Riots in the West Village in 1969 and the ensuing gay rights movement did much to pave the way for artists like Keith Haring, David Wojnarowicz and Martin Wong to find empathetic galleries in the East Village of the 1980s.

Just as periods of political progress have helped to stimulate fledgling art neighborhoods, political disorder such as the Tompkins Square Riots or acts of political terrorism like the attacks on the World Trade Center have impacted the art world's capacity to survive. Ironically, they have also provoked it into re-creating itself. The August 1988 riots in many ways marked the final demise of the East Village scene, but it picked itself up and went elsewhere. Similarly, the paralyzing state of self-doubt experienced by most artists, dealers, curators and arts writers in the days that followed September 11—stripped as they were of all faith that art making mattered—was ultimately overcome and is, needless to say, a strong undercurrent in this New York story.

At the same time, New York–size egos of every political stripe have wandered on and off the local art world stages throughout the years described in this history: power mongers such as the "Master Builder" Robert Moses, his nemesis the preservationist Jane Jacobs, Governor Nelson Rockefeller and Congressman John Lindsay must all be considered in terms of their impact on the civic landscape. Equally, New York City's mayors—Lindsay again, Ed Koch, David Dinkins, Rudolf Giuliani and Michael Bloomberg—have all governed its cultural geography and affected where the art world settled and how long it stayed.

FRIENDS IN NEED AND IN DEED

One of the strongest factors that surfaced during my five years of researching this topic is the notion of arts professionals colonizing in like-minded communities.[1] In my own interviews with present-day artists (struggling and no-longer-struggling), with directors of both underfunded nonprofit organizations and megamillion-dollar revenue dealers, the need for proximity, collegiality and mutual support was palpable.

Visual arts workers' stock-in-trade is essentially ephemeral, not concrete; it is psychic rather than physical. The worth of the "product" is measured in aesthetic, intellectual or otherwise intangible terms. For many artists working alone in their studios, the result is an interiority and isolation that proves unsettling at best and terrifying at worst. Fundamentally visual communicators, artists still need language (their own or that of a studio visitor), reaction (from collectors or critics visiting their exhibitions), debate (about the process, not just the product), support (when a work is floundering or a show bombs) and confirmation (when the reverse is happily the case.)

Most will still attest to the need for connection, association with a group, ideally one whose members are struggling with the same misgivings about the life to which they have been irresistibly called, and who face the same challenges (personal, social and financial) out there on the margins. Often having started out without much support (from anxious parents, dubious teachers or bourgeois skeptics of indolence), artists routinely live in fear of no recognition of their talent or, even worse, no talent after all. No money for studio rent and no dental plan add to the pressure and intensify the need to confirm that there are others like them doing this thing.

THE DESTINATION VENUE

In addition to artists producing work in their studio enclaves, the art dealers whose job it is to exhibit (and hopefully sell) the art from their galleries also spoke of the need to be together. Motives differed in many ways between artists and dealers, but there were also many overlaps. Even the most successful gallery directors (financially speaking) confirmed that a peculiar sense of passion, absolute faith in one's vision and an unshakable commitment to the worth of the art they represent are prerequisites of the trade. Equally, like the artists they show, they have misgivings and doubts; errors of judgment occur and problems with touchy artists and difficult collectors become wearing. A gallery situated close to others either exulting in the same joys or suffering like miseries was often mentioned during our discussions.

Proximity and ease of access one to the other also facilitates dealers' need to keep a grip on the critical discourse, to see what work their

competitors are showing, to hear what their colleagues think of their program. Like most of us, arts professionals need to keep abreast of developments in their field, but in this case not just by reading or talking but by actually looking and spending time with the work. Again and again, directors of exhibition spaces confirmed the importance of getting out and about to the neighboring shows, and they often bemoaned how rarely they found the time to do so.

Galleries—their objectives being fundamentally commercial—also see trade benefits in being co-located. They want to be on the map, on the itinerary of gallery-goers and part of the choreography of opening nights. More often than not, galleries colonize around a key venue— what is often called the "destination gallery." In 1970s SoHo the dealer magnets were Leo Castelli, Ileana Sonnabend, André Emmerich and John Weber at 420 West Broadway. In the East Village of the 1980s Patti Astor's Fun Gallery or Gracie Mansion were the neighborhood draws and in Williamsburg Pierogi and Momenta. The destination gallery is the one that achieves name recognition and raises all the other boats. If a neighborhood doesn't get one, it often bodes ill for the health of the other galleries and is perhaps the reason that otherwise likely-looking neighborhoods such as Harlem, Long Island City or Dumbo in Brooklyn never really took hold.

ARE WE THERE YET?

That said, even with the allure of a significant destination gallery, the gallery-goer does have to actually get there to see what's on show. If an artist's studio, a gallery or a not-for-profit exhibition program is situated in a hopelessly inaccessible location, very few in the art world audience will go there. I say "very few" because quite regularly in doing my rounds, artists or dealers would name a hard core who would track down the good art come hell or high water. That said, if no one gets to see the work in the far reaches of a Bushwick studio, it will not get picked up by a Chelsea gallery or be offered for sale at an art fair in Miami.

Close-by subway stops with trains that actually run do not necessarily concern the wealthy collector, but freelance critics and junior curators, even of the well-respected publications and the most revered

institutions, do not generally have a limousine idling out front. They rely on public transportation. Even the price of a cab does you no good if taxi drivers won't go there. The island-dwelling Manhattanite is also particularly squeamish about crossing bodies of water, and the Williamsburg or Brooklyn Bridges might as well be space ships in terms of many a collector's inclination to be on one. This, as will be seen, can impact where an art scene develops and how well it endures.

While the volume of foot traffic is important to exhibitors of contemporary art, the quality of that traffic is of equal importance. When a well-colonized neighborhood with one or more destination galleries draws the right kind of visitor, the neighborhood flourishes. When the quality of that traffic changes, and the area becomes invaded by tourists, opportunistic bargain seekers or "scenesters," the serious are quickly driven away.

Just how to attract "the right kind of people" is a devilish little conundrum that has either graced or eluded many a worthy New York City enterprise—be it art show, Broadway production, restaurant or yoga class. In the case of the art world, there are at least four vitally important components to its highly judgmental client base: the collector (without them no sales), the museum curator (crucial to having an artist's work enter museums and thus the canon of art history), the art critic (all important in the intellectual discourse that attaches itself to serious art), and the broader media (key to having word travel beyond the very limited ranks of the first three).

EVERYONE'S A CRITIC

If a sufficient density of venues develops around a destination gallery in a given neighborhood, the expedition becomes worthwhile, and bridges and tunnels get crossed. Build it and they will come. The initial wailing and gnashing of teeth among Upper East Side collectors and foot-fatigued critics when they were first required to trudge to early-days West Chelsea was eventually overcome once there was enough art there to make a day of it. The same can be said about Williamsburg, across the East River in Brooklyn, during its turn-of-the-millennium heyday.

But too much access and too many people being in the know has also been the ruin of many a good neighborhood. Along the course of

this history, the voices of both inside observers and outsider commentators are enormously powerful. The press, whether serious journal or sensationalizing tabloid, has an impact and it is a protagonist in this story. As such, I give as much weight to the popular coverage of the art world by general readership publications like the *New York Times* and the *Village Voice* as I do to the cerebral essayists at *Artforum*. On more than one occasion, too much hype from *New York Magazine* or gossip in the *New York Post* has been as influential in the meteoric rise or crashing downfall of an artist and his gallery as a review from a respected critic.

What artists and dealers perceive, rightly or wrongly, as the fickleness and ultimate perfidy of the arts writer is legend. Attracting critical support in the first place is often an uphill battle. Even Betty Parsons, the visionary dealer of the as yet unappreciated Jackson Pollock, could rely on only one critic in the 1950s—the *New York Sun*'s Henry McBride—to lend support to her artists in the early days. The conflicting interests of critics (those who are friends or lovers of artists they review, collectors or dealers of their work) have also been debated for as long as there has been an art press. Critics making a cluster of galleries their darlings and then dropping them like so much old news can also be devastating. Certain Williamsburg galleries felt themselves to be on the receiving end of just such a cooling of affection around 2005.

Neighborhoods have shifted for lack of critical and media attention and the neglect of their excellent programs, and they have also fled in horror of it. Dealers have nursed the broken hearts of many an artist whose terrific show was completely ignored, and directors of exhibition spaces have decamped to escape media-instigated swarms of tourists seeking restaurant recommendations or teenage night clubbers vomiting in their doorways. Both extremes are responsible for some roadkill.

THE ART'S THE THING

There is much in what I have offered so far as neighborhood-shifting variables that could equally apply to communities other than the art world. Car dealerships routinely cluster in one long strip on the outskirts of town and think nothing of it. Restaurants are as vulnerable to scathing reviews as are art openings. A health club in an easily accessed area

where young professionals live or work is more likely to attract members than one in the outer reaches of a staid residential neighborhood. The difference, though, is that once there, these entities tend to put down roots and, assuming they survive commercially, they generally stay put.

In the context of contemporary art, the "product" being created by artists, displayed by galleries and exhibition spaces and distributed to critics, collectors and curators is one that is inherently hardwired for change. Along the course of the fifty-year history I lay out in this book, we will encounter artworks that are variously described as Modernism, Abstract Expressionism, Pop, Minimalism, Conceptualism, Land Art, Performance Art, Film and Video, Pattern and Decoration, Neo-Expressionism, Neo Geo, Installation, art that exists in a virtual state only and even collaboratives where the identities of the unnamed participating artists change regularly.

As varied as these art products have been and as radically as the form, fabric, size, shape, duration and condition of them has changed, so have the sites for their creation, display and distribution. The easel-sized early Modernist work, revolutionary as its imagery was, still hung well on the upholstered walls of Fifty-Seventh Street salons. By the time the Abstract Expressionists were producing their huge paint-flung canvases, however, the low ceilings and tight elevators of many midtown or Madison Avenue galleries were problematic. As the work that came out of 1970s Pluralism took all kinds of strange non-painting forms, things started to get even more unruly, and by the time Happenings came along, the art, its creators and those who came to see it could no longer be accommodated.

Moving the show downtown to SoHo in the late 1960s was not exactly a quantum leap as far as most artists were concerned for, as we shall see, most of them lived and/or worked down there anyway. The wide-open, light-filled, freight elevator–serviced and cheap, albeit illegal, lofts that could be found in the abandoned factories and sweatshops of the South Houston Industrial District provided the perfect facility for producing huge canvases, staging performance art or developing massive sculpture. What couldn't be scavenged from the streets and rolled into a new work could be bought cheaply from the hardware outlets along Canal Street. The galleries then needed comparable premises to show the work.

Subsequent shifts in the centers of art have also been catalyzed by changes in the form, medium, size, or installation demands of the new, new art. Obtrusive columns that broke up the open floors of SoHo lofts, charming as they might have looked in the 1970s, became problematic as big installation pieces got even bigger. A wooden floor's weight-bearing capacity was sometimes at issue, a third-floor location impossible to reach and a loading dock crucial for oversized pieces. With the increasing prevalence of video work, acoustics started to matter as conflicting soundtracks fought for attention. The wide-open concrete boxes of Chelsea's taxi garages beckoned.

Consequently, the notion of continuously seeking out the new, the next, the future thing makes the world of contemporary art a particularly restless place. It also, by corollary, tends to attract restless people, whether they are artists, exhibitors, collectors or the journalists who write about them. As one style, an art form or an entire movement gives way to the next, the whole contemporary art system is ready and waiting to embrace it. And the next and the next.

Visits to artists' live/work spaces routinely reveal that "the work" claims the lion's share of the space and cramped, makeshift living conditions in the back are accepted without much complaint. Every two to three years, the whole kit and caboodle is then shipped out for a show and a cavernous vacuum remains. Few normal homeowners live that way. Roughly every five weeks, a gallery is perfectly prepared to repaint walls, even break them down and move them, redo its electrical systems, close up its windows, destroy its floors or commit any number of other atrocities that would make vendors of other types of goods turn white overnight. I know of collectors who will get rid of furniture in order to reinstall their art or accommodate a new acquisition. If their children's rooms look tempting, there is always boarding school.

THAT WAS THEN AND THIS IS NOW

With the crash of the art market in the first decade of the 2000s and the waning of high-gloss, expensively fabricated work, the small storefronts of the Lower East Side were the next spaces to start filling up with art. Not only were they so much more suited aesthetically to the DIY

concoctions, homespun assemblages and rough-hewn sculptural work then being produced by a younger and funkier generation, they also appeared, in the tougher economic times, far more seemly than the flashy art-mart spaces of Chelsea.

Opened by a new cohort of young dealers, Chelsea white box chic, expensive European suits and sharp haircuts gave way to retro eyeglasses, aggressively angular body wear and unforgiving shoes for both sexes. True, generational shift is a driving force in social or cultural progress of all types, but in the contemporary art world, the differences between one generation and the next are particularly pronounced. Older artists nurturing younger ones, senior directors tutoring junior associates, or gallery founders now in their fifties actively seeking out next-generation scouts for the express purpose of keeping themselves current and the program fresh appear time and again.

Many of the neighborhood changes documented here came about by virtue of visionary and generous dealers encouraging their younger staffers to find their own curatorial voice and go out on their own. Very rarely does an art gallery pass from one generation to the next in the traditional sense of a family business; the tendency is rather to push the next generation out of the nest and let it fly away to new pastures.[2]

Like most of the rest of us, art people grow up, get wiser and get tired more easily. The successful ones have by now made something and so have something to lose. A big part of the demise of the East Village as an art center at the end of the 1980s was the drug use and overdoses, the unsafe sex and the scourge of AIDS. People left because they couldn't take the pace or the tragedy anymore. Several of the Chelsea gallerists who had made their start in the wilds of downright dangerous Williamsburg groaned painfully when I suggested the still raw Lower East Side as a future venue. Enough already with the bushwhacking. Time to leave that to the kids.

THERE GOES THE NEIGHBORHOOD— ART FAIRS AND THE INTERNET

Many of the notions I propose here for what moves the art world might also be said to be true of fashion or popular music. The actual spatial

contexts in which new clothes or a new beat get experienced are, however, far less important than the spatial context in which art is experienced. Fashion houses might tweak their interior design, stadiums might get bigger and more technically sophisticated but there is no art substitute equivalent to the way in which an iPod on the subway can offer a *pretty* good stand-in for a live performance. Time and again in my discussions with artists, dealers, critics and curators, Walter Benjamin's sacrosanct "aura" of the actual art object was almost fanatically insisted upon.

Discussions became particularly emotional when I pressed on the now-ubiquitous, peripatetic global art fair and the everyman Internet. By 2009, attendance figures at the major art fairs were staggering; 52,000 at the Armory Show in New York, 42,000 at Art Basel Miami, 61,000 at Art Basel, Switzerland, 60,000 at Frieze in London and 200,000 at ARCO, Madrid.[3] With such capacity to set up shop in a booth, show the goods, make the trade and move on, was there really any future for the art district? Indeed, given the ease with which a dealer can now jpeg an image to a client anywhere in the world and the capacity of that collector to Google an artist, check out the installation and zoom in on specific works online, why even bother with a gallery?

Reactions to art fairs vary widely among both artists and dealers. Some see them as little more than houses of prostitution, where you might enjoy the thrill of the sex but are unlikely to find true love. The frenetic pace, the commercial vibe, the glaring and unmediated exposure of an artist's work to all comers and the dangerous isolation and juxtaposition of works by radically different artists—all of this was deplored.

But many also acknowledge that the fairs are an opportunity to get the work out to the regions, connect with new collectors and get coverage in a broader array of international publications. Recent iterations have healthily extended beyond just the showroom floor aspect to include artist, curator or critic talks, scholarly symposia and the opening up to the public of important private collections. And then, of course, there is still the money that they generate—a good deal of which plays a part in this story.

What art fairs cannot do, however, is provide a sanctuary where an individual connects aesthetically, intellectually—many would say

spiritually—with the art. Spending time, searching for the curatorial premise or at least considering the one offered in a gallery press release, asking questions of the staff and returning for a second or third look tends not to happen in Miami, Chicago or Basel. Seeing a whole body of an artist's work in depth is also crucial to its being understood, and while a solo installation can be done at an art fair, it's a big risk to both the artist and the dealer if it doesn't happen to hit the mark on the day.

Committing to giving an artist a show a year, two or three years out, was also emphasized as crucially motivating and what keeps artists at work and on track in developing their oeuvre. Affording them the security that only a long-term relationship offers for growth, change, even some risk taking, are considered absolutely crucial. A bricks and mortar gallery space and an interrelated, symbiotic art world consisting of artist, exhibitor, critic and collector must exist.

Almost without exception, both artists and exhibitors used extreme caution in discussing how art travels on the Internet. Artists, who often feel passionately about who their art goes to, prefer to be sure that the collector has seen the piece in the flesh and truly connects with it. While dealers acknowledge the usefulness of the Internet as a communications mode (quicker and cheaper than the old slide transparencies shipped in the mail), few of them were comfortable with it as a replacement for being there in the room with the art.

Most dealers told me that they might send a collector a jpeg for an initial look at a work of interest, but a personal visit to see the actual object was always encouraged. Often they found that a new collector had already done some useful research on the Internet before contacting the gallery, and occasionally the Internet helped in closing a deal. After a visit to the gallery, a collector might consult a spouse or need to take time deciding between one work and another. Outright sales via the web alone, however, were generally limited to multiples such as prints or photographs, which, existing as they do in editions of three, ten or even one hundred, were often already familiar to the collector. An online deal is also occasionally closed between an established collector of an artist's work and a gallery with whom they have a long-term relationship.

SO WHAT DOES MOVE THE NEW YORK ART
WORLD AND WHY DOES IT MATTER?

Real estate markets, economic cycles and the city's peculiar political zeitgeist; the idiosyncrasies of its protagonists given their creative spirits, artistic temperaments and strangely restless souls; the whims, vicissitudes and caprices of its consumers, whether collector, curator, critic or media reporter; and then of course there is the product itself—the art. Ephemeral, often nameless, increasingly without shape or form but always shape shifting, contemporary art, if it is to stay contemporary, must by definition change. It must move on.

The cycles of genesis, incubation, metamorphosis and demise are as present in the history of contemporary art as they are in any other time- and place-based story, namely any other history. The causes, catalysts, protagonists, rules and exceptions that drive the story forward are rarely cleanly separable, almost never in operation all at once or throughout, but usually ebb and flow, crisscrossing the warp and weft of a richly textured fabric. I offer no firmly proposed thesis here but simply a set of variables that I invite the readers of this history to carry with them as they follow the story.

I was inspired to tell the story because it is history, a cultural history, seen through a lens of New York City's urban geography. Although the period is recent, some of the players are already gone. Many of those who were protagonists themselves have only parts of the full picture or had forgotten much of what went on where, when and with whom. This book is an attempt to put it all together and put it all down, probably just in time for the art world to move again.

2

MODERNS IN MIDTOWN

The End of an Era

"It was 1951, and everything was breaking wide open. The whole art world was right there between Madison and Fifth on Fifty-seventh Street. One could see every exhibition of importance at Sidney Janis, Betty Parsons and Charlie Egan . . ."

—Joan Washburn in *The Art Dealers: The Powers Behind the Scene Tell How the Art World Really Works*, 1984

As the veteran dealer Joan Washburn considered the New York art world of the mid-twentieth century, the tightly clustered midtown enclave that she so fondly remembered had already seen a full three decades of radical as well as frequent change.[1] While "exhibitions of importance" could still be seen in the upper-floor showrooms of Fifty-Seventh Street, this midtown axis in among the tony stores of Tiffany and Bergdorf Goodman was no longer the hub of what was groundbreaking on the modern art scene.[2] The very term "modern" was, in fact, beginning to wane as it gave way to the new "contemporary" in art world parlance. The cutting edge of new art production was still very much centered in New York City but, for the most part, those looking for it no longer looked only in midtown.

THE ECLIPSE OF THE ELITE

By the end of the 1960s, New York—along with most of the rest of the world—was well on its way down the tumultuous road to a whole

new cultural era. On Fifty-Seventh Street the rule of an elite core of what were then quaintly (but accurately) known as "picture dealers" was coming to an end and their practice of operating out of hushed and plushed salons on labyrinthine upper floors was about to change. A generation of indisputably great dealers was aging out, and with them the art and the artists they represented. Even the most visionary of them, who so bravely embraced and religiously supported the new distinctly American art were now seeing the ground shift.

In addition to the galleries on Washburn's list, Samuel Kootz, Eleanor Ward, Martha Jackson, Grace Borgenicht and John Myers at Tibor de Nagy were also important on Fifty-Seventh Street. Kootz opened his gallery in 1945 but had been championing new art in published writings such as *Modern American Painting* and *New Frontiers in American Painting* throughout the 1930s and 1940s. So impressive was his grasp of the new work being produced by artists such as Mark Rothko, Arshile Gorky, Adolf Gottlieb and Milton Avery that the Museum of Modern Art (a newborn itself in 1929) had invited him onto its advisory board. Once he opened a space of his own at 15 East Fifty-Seventh Street, he showed the abstract painters Robert Motherwell and William Baziotes as well as the African American collagist Romare Bearden.

Directly across the hall from Kootz, and a tenant of the same landlord, was the soon-to-be legendary Betty Parsons. Like Kootz, Parsons had the eye to recognize the power of the big, muscular, abstract work being produced by Jackson Pollock, Clyfford Still, Franz Kline and Barnett Newman as well as the European émigré Willem de Kooning. She opened just after her neighbor and, like him, had the courage early on to exhibit the peculiar new material—no matter that it met with complete indifference both critically and commercially.

Charles Egan, who opened in 1945, the same year as Kootz, gave de Kooning his first one-man show. The strange, angular, mostly black-and-white compositions were priced only in the hundreds of dollars, but they still found no more buyers than Pollock's drips and splatters or Still's vertical daubs of muddy browns. Egan also responded with vision and commitment to the early-career Surrealist figuration of Philip Guston, Aaron Siskind's abstract photographic studies and the obsessively packed curio boxes of Joseph Cornell, each one a bizarre little cornucopia of a world within a world.

Eleanor Ward opened her Stable Gallery in 1953 (actually on the still odiferous site of a former Fifty-Eighth Street stable). She gave Warhol his first exhibition and showed the early work of Cy Twombly well before his chalklike scribbles and scrawls were understood as art. Martha Jackson showed Louise Nevelson, whose monumental walls of black or white painted table legs, chair parts and other sundry wooden detritus confounded all earlier understandings of sculpture. Grace Borgenicht showed both Milton Avery and Ralston Crawford whose work, while more tangibly representational than Pollock's dribbled skeins or de Kooning's savage swaths, nevertheless abstracted the object in unfamiliar and disturbing ways. Tibor de Nagy offered the wild man Larry Rivers, whose utterly unorthodox figure paintings were often deeply shocking. By the middle of the 1960s, every one of these dealers had been courageously in the vanguard for a long time, some for almost a full two decades.

But by then several of the iconic names of twentieth-century Modernist painting were already dead. Arshile Gorky had taken his own life in 1948; Jackson Pollock, drunk behind the wheel out on Long Island, had driven himself into a tree in 1956; Franz Kline died in 1962; Milton Avery in 1965 and Hans Hoffman in 1966. Of those still alive and working, most had been born in the first decade of the new century, Adolph Gottlieb in 1903, de Kooning and Still in 1904 and Barnett Newman in 1905. Robert Motherwell, born in 1915, was the youngster of the group.

By midcentury, however, and thanks to both their dealers' efforts and the powerful endorsements of the reigning critic-gurus Clement Greenberg and Harold Rosenberg, the names of these artists had been lionized in the history of art. Their pictures were well placed in major collections, both private and public, and the work was recognized and expensive. But it was no longer new.

What was new—and startlingly so—was the bizarre output of a couple of young renegades called Jasper Johns and Robert Rauschenberg. Johns was creating oddly colored pictures of banal objects like targets and flags or covering a canvas with what seemed to be nothing more than literally rendered numerals. A crudely sculpted household flashlight or a domestic light bulb was offered, crafted not in classic marble or heroic bronze but in flimsy papier-mâché. Rauschenberg was making paintings that seemed to depict absolutely nothing at all, but were simply multiple

panels placed edge-to-edge, uniformly covered with plain white paint. Occasionally a piece of newspaper might find its way onto an otherwise tar-black surface. Despite a total lack of grandeur in the then-accepted sense of the term, the artist had the audacity to make these things more than six feet high.

Even more unfathomable were the so-called Pop artists who, in the wake of so much tortured introspection and angst-ridden mysticism from the AbEx painters, seemed to rejoice willfully in the vernacular. Unknowns like Roy Lichtenstein, Andy Warhol and James Rosenquist were using comic book characters, supermarket canned goods or crass advertising imagery and insisting that it was art.

But Pop Art was just the right thing at the right time, offering a lighthearted and irreverent aesthetic that was deliciously appealing to American youth. It was the first art movement that appeared not to need intermediating by pompous critics but—as Grace Glueck, the new girl on the *New York Times* press beat, was about to show—could be treated breezily, as a "scene." In March 1964 even CBS television did a segment on Pop.

As the New York School of Abstract Expressionists aged and their work, once so revolutionary, passed into the canon, their dealers struggled to find their footing with this new generation. When in 1951 a renegade downtown exhibition called the *Ninth Street Show* was proposed (so far outside the confines of the Fifty-Seventh Street corridor), Samuel Kootz refused to let his artists participate; only Motherwell dared to defy him. Parsons gave a one-man show of the white paintings to Rauschenberg in 1952 but when not a one of the seventeen sold, she refused him a second exhibition. She also took on—but again only briefly—Ellsworth Kelly, the painter of disarmingly simple but throbbing colored shapes, as well as Agnes Martin and her near-monochromatic squares and pencil-thin stripes. She did not succeed in holding on to them either. Egan also tried to come to grips with Rauschenberg and in 1954 put up his red paintings and some of the early assemblages of found objects that were to become known as *Combines*. He also failed to persuade the new talent into sticking with him for very long.

The difficulties for the older guard in dealing with the new breed did not stop at a struggle to fully understand their outlandish-looking

work. In reaction to the pride-in-poverty airs of the Abstract Expressionists came a cohort of artists who seemed entirely seduced by the material, the superficial and the downright commercial. The new arrivals needed different handlers for their youthful energies and unapologetic ambitions. The very nature of the artist-dealer relationship was changing, and the new cadre seemed to demand those unspeakable postwar vulgarities—promotion and marketing. Neither Parsons nor Egan had the temperament or the discipline to actively manage careers in that manner. Parsons confessed that she had absolutely no appetite for calling collectors on the phone to make a pitch; she found it distasteful. She was also known to have a tough eye for quality but a soft heart for mediocrity when it came to discriminating between the real deal and the limp output of friends and associates whose work she could not refuse.

Egan's drinking problem was every bit as bad as de Kooning's, and he was rumored to be having an affair with de Kooning's wife, Elaine, at the time of the first solo show. A slow payer, Egan also routinely got into unseemly disputes with his artists over what was due to them and when; he lost several, including Cornell and Guston, over money matters.[3]

There remained, however, one Fifty-Seventh Street dealer on the primo list who did a shrewder job of navigating the newly troubled waters. Sidney Janis, to whom the majority of these Kootz, Parsons and Egan defectors fled, came late in his day to the picture-dealing world. Janis was fifty-two years old in 1948 when he opened his own gallery, taking the space across the hall from Betty Parsons that Samuel Kootz had left empty when he moved around the corner to Madison Avenue.

Janis made his money through his M'Lord shirt company, a manufacturer of plain white garments whose only claim to notability was a second pocket at the breast. The shirt was a big seller with southern customers who, needing to work without a jacket in the days of pre-air conditioned heat, appreciated the extra pocket to stash their sundries. Janis was an astute businessman with an innate ability to market, a lot of experience with price points and a long track record in closing a deal. He was not, however, a philistine, but a man with a deep love of art, a connoisseur's eye, a curator's ability to select and present and a scholar's power to articulate. His 1944 publication *Abstract and Surrealist Art in*

America was an enormously important book in terms of its early recognition of these radical movements.

Once he decided to open his own space, Janis got to work quickly and in the first couple of seasons put together exhibitions that included Joseph Albers, Rothko, Gorky, Pollock and de Kooning as well as their wives, Lee Krasner and Elaine. By 1952 Pollock left Betty Parsons for Janis, who immediately hiked his prices. He gave the AbEx king a solo show every year thereafter until Pollock's death in 1956; even then he followed up with a posthumous exhibition. The Museum of Modern Art's founding director Alfred H. Barr Jr. described Janis as "the most brilliant new dealer, in terms of business acumen, to have appeared in New York since the war."[4]

Not everyone was as enamored of this "Janis effect" or was as charitable in terms of his impact on the world of art. Writing in his memoir *The Passionate Collector: Eighty Years in the World of Art,* the much respected patron Roy R. Neuberger cited Janis when he lamented that, "Promotion-minded gallery owners were bringing public attention to living artists . . . selling at what seemed to me highly inflated prices. I felt that contemporary American art had become subject to excessive speculation and market manipulation."[5] Neuberger had been collecting since the 1930s and had been buying from Sam Kootz since the war. He made his own fortune on Wall Street and was far from squeamish about money. Nevertheless, he, like many others on Fifty-Seventh Street, resisted this new way of things.

In 1953 Janis gave de Kooning a show of his totally radical *Women* series. Depicting gargantuan wenches with bulging eyes and vagina dentata orifices, some of these canvases stood as tall as the men they were staring down and certainly put the fear of God into many of them. Janis also successfully arranged to place de Kooning's masterful *Excavation* with the Art Institute of Chicago and he developed excellent relationships with several other important museums, including the Museum of Modern Art and Hilla Rebay's Museum of Non Objective Art (ultimately to become the Guggenheim). His carefully cultivated collector base included both Nelson and David Rockefeller, Burton and Emily Tremaine, Philip Johnson and the appallingly non-Fifty-Seventh-Street type, taxi-fleet owner Robert Scull.

In 1954 Rothko left Parsons for Janis and was followed across the hall by Guston, Kline and eventually Motherwell. As if this were not enough for poor Mrs. Parsons to bear, when she went to renew her lease of the half floor that she now shared with the ungentlemanly raider across the way, she discovered that Janis had gotten to the landlord first. He had not only renewed his half but had locked in hers as well.

Not surprisingly, Janis was just the ticket for the Pop artists. In 1962, in a show that he titled *The New Realists,* the work of Roy Lichtenstein, James Rosenquist and Andy Warhol was shown along with the equally quotidian-looking fabrications of Claes Oldenburg, who was working in inflatable plastic to create sagging toilet bowls. George Segal, who would go on to make his mark with his signature white plaster tableaux of grouped but strangely isolated figures, and Tom Wesselman with his brilliantly colored, buxom but usually faceless nudes, were also included. Shocked and insulted by the tawdry new product now insinuating itself into their gallery, the AbExes threatened Janis with an "us or them" ultimatum. Janis stood his ground, and Gorky, Guston, Gottlieb and Motherwell left him for the newly formed Marlborough Gallery across the street.

Of the 1950s A-list Samuel Kootz was the first to shut up shop shortly after the canonization of Pop in 1966. Parsons kept her gallery open until she passed away in 1982. Egan outlived her despite his hard-drinking ways, but he closed his gallery in 1971. Eleanor Ward closed just before him in 1970, the year after Martha Jackson died. Tibor de Nagy was the only other gallery on that original roster to remain open into the next century. Janis continued to be a powerful presence on Fifty-Seventh Street until he retired in 1986, and the gallery stayed open for another thirteen years under the control of his two sons. But, as we shall see, the second time Janis tried, twenty years after the advent of Pop, to legitimize another new movement, he was not only fifty years too old but also fifty city blocks too far uptown.

EVERYMAN EVERYWHERE

In the 1950s it was a given that the midtown galleries catered to an exclusive clientele. "Our clients on 57th Street," Joan Washburn observed,

"consist of people who already know what we offer and seek us out for specific reasons."[6] John Gruen, an art world habitué and a published commentator on New York culture at the time agreed. "In the fifties," he wrote, "the art world was exceedingly closed . . . and the public usually stayed away in droves."[7] On both counts he was right—but by the middle of the new decade what "the public" was—and what they did with their time—was about to change.

Beyond the narrow limits of the New York art world, social forces were already at work in the 1960s that would fundamentally alter the average American's perception of what even constituted the public. The Civil Rights Act of 1964 and the Voting Rights Act of the following year wrought radical changes for both blacks and women in terms of who would now have a voice in society. At the same time, opposition to the war in Vietnam was registering in the national consciousness and energizing the young in particular as a new force to be reckoned with. The year 1968 saw student unrest across the globe, including a demonstration at New York's own Columbia University on the Upper West Side. Also locally, in June 1969, the angry pushback by the once-too-often harassed homosexual patrons at the Stonewall Inn in Manhattan's West Village led to several days of rioting and demonstrations that fired up the beginnings of a gay activist movement.

In 1965 the three-term administration of New York's Mayor Robert F. Wagner, in office since 1953, came to an end, and the young and idealistic Congressman John V. Lindsay was voted into office. Lindsay's two terms, from 1965 to 1974, were controversial, and it was on his watch that all of these manifestations of social unrest and political frustration exploded; many still blame his free-spending ways for the disastrous economic downturn and near bankruptcy New York was to face after 1975. When he came to office in 1965, however, Lindsay had only the best intentions about changing how New York City worked—and for whom.

The new mayor set about breaking down boundaries and opening New York up to the people who lived there, not just politically but socially. He sought a different sense of public ownership of the fabric of the city itself and a greater popular usage of its geography. The Wagner administration had been responsible for the creation of the Landmarks Preservation Commission in 1965, but it was left to Lindsay's

people to start putting the law into practice. They chose carefully and well and, perhaps in response to the recent destruction of both the 1910 Pennsylvania Station and the original Metropolitan Opera house, they succeeded in rescuing both the 1902 United States Customs House on Bowling Green, and the magnificent Grand Central Terminal on Forty-Second Street. These early successes would be important symbolically as well as architecturally.

In January 1966 Lindsay replaced Wagner's parks commissioner, Robert Moses, with the wildly unconventional Thomas P. F. Hoving. By mid-decade, New Yorkers were growing weary of the 1950s demolish-and-rebuild strategies of Wagner's so-called "Master Builder." In power in various roles for close to forty years, Moses's undeniably herculean achievements in the rationalization and rejuvenation of New York's aging infrastructure had also taken a serious social toll on the communities it ravaged. His partiality to the automobile over the pedestrian brought the efficient and attractive parkways network to the peripheries of Manhattan, but it also spawned the proposal for a Lower Manhattan Expressway. The new ten-lane expressway would leverage the new outer-borough access roads by connecting the landmasses of New Jersey and Brooklyn. But it would do so by wiping out much of Greenwich Village and SoHo.

Even Moses's work within the city parks seemed, by the late 1960s, to be more about bullying control than freedom and recreation. Olmstead's pastoral landscape had effectively been converted into an exercise yard with rigid structure and organized regimens, an insistence on social decorum, dress codes and curfews. Meanwhile, half a million people were about to flock to the Woodstock Music Festival at Max Yasgur's farm upstate in Bethel and demonstrate that a new day was dawning.

While Hoving's reign was short—he soon went on to rattle cages as director of the Metropolitan Museum of Art—his whole response to the city's recreational spaces was iconoclastically different. He initiated the first of what would become open-ended adventure playgrounds, and he encouraged rock and roll concerts, mural painting, nighttime stargazing and the famous "be-ins" or Hoving's Happenings. He also worked with Mayor Lindsay to close both the East and West Drives of Central Park to cars and leave them traffic free for their users. By insisting that

the city's park be a place of liberty and exploration, of both individual pleasure and community involvement, Hoving set in motion a rethinking of the city's terrain and a fresh perception of New York as a place for recreation and enjoyment.

In 1967 Lindsay made further moves toward reassessing previously closed-off territories of the city. Under preceding administrations, New York City's zoning decisions had largely been about top-down control in terms of height and bulk, more a policing action of prevention and veto than a proactive force in the city's growth. Lindsay fundamentally recast the practice of zoning as creative purpose rather than simply limitation. His administration introduced what it called incentive zoning with bonuses to developers for desirable urban features such as open spaces and appealing public plazas. These new public plazas could perhaps hold new public art.

While not all of the projects that followed were a success, what these initiatives indicated was a growing impetus to expand the boundaries of city life to a wider constituency and an endorsing of the public's right to use and enjoy New York. The notion of attractive squares, lively streets and community participation in and around the city began to take hold. The pre-1950s perception of the city as a grim center for industry and purely economic payback was now giving way to its being seen as a site of social and cultural reward.

Not just in New York City but nationally, perceptions of the urban metropolis as a center of recreation and culture were steadily forming and with that came the notion that all comers could enjoy it. In 1965 the National Endowment for the Arts had been formed and right across the country the engine of arts production began to be fueled by a far greater degree of government support at both the federal and state level and for all types of culture.

Government grants and other forms of cultural funding were dramatically increased in the 1960s and 1970s in ways that had not been seen since the Works Progress Administration of the 1930s hired Depression-era art workers. The number of arts-related jobs available in government-supported educational and cultural institutions also multiplied, and the notion of specifically *contemporary* art being shown in newly liberated public spaces gained currency.

This government and institutional groundswell was also matched by many of the increasingly large corporate entities headquartered in America's urban centers. Recognizing the powerhouse status of well-placed art on their new downtown plazas and perhaps hoping to humanize their own enormous size, mega companies, banks and law firms began to develop corporate collections for the interior viewing pleasure of their myriad employees. Those employees, a new breed of better-educated, white-collar professionals, were happy to engage, if only to escape what sociologists of the era were labeling "the bureaucratization of the soul."[8]

While relations between Governor Nelson Rockefeller and Mayor Lindsay were often strained over issues of state funding for city deficits, in Nelson's brother David, New York had the seamless amalgam of both corporate and private patronage of the arts. Rockefeller the younger purchased close to 5,000 works by 1,500 artists for the Chase Manhattan Bank while also giving large sums of his personal fortune to the Museum of Modern Art.

Individual benevolence also went through some fundamental change in the late 1960s and early '70s. Philanthropic support of the arts was less and less regarded as the preserve of the patrician elite but began to be taken up by a broader base of supporters. As barriers fell and access to New York's previously cordoned-off cultural enclaves opened up, a certain class of more *nouvelle arriviste* philanthropist emerged. For many of the newly moneyed, support of contemporary art was less intimidating than trying to break into the ranks of the old guard uptown at the Metropolitan Museum or even the Whitney.

At the same time, the artist himself was undergoing a transformation in the way he (or, increasingly, she) was regarded in society. No longer perceived as a rebel outsider or a renegade bohemian, the artist could now be middle class or, conversely, the middle classes could respectably become artists. The newly opened art schools that proliferated across the United States in the 1960s meant that by the early 1970s more than a million adults in the United States were identifying their occupation as in some way connected to the arts. In New York City, census data reported an increase from fewer than 35,000 arts professionals at the beginning of the 1960s to more than 100,000 by the 1970s.[9]

And the art that these freshly minted artists were creating was like nothing before. As it turned out, Pop was to be the least of it in terms of rule-breaking new work that transgressed all previous norms of artistic practice or genre. Minimalism, Conceptualism, Earthworks, Performance Art, Fluxus and the Happening were all on the horizon. The new movements that were about to emerge were so diverse, so multifaceted, fluid and open ended that the best anyone seemed able to come up with by way of defining them was the term Pluralism. If all of this new energy was too much for Fifty-Seventh Street to handle, there were other parts of New York City ready and waiting to embrace it.

3

HELL'S HUNDRED ACRES

Early SoHo

"This urban frontier became an art town thanks, I repeat, to the initiative of thousands of independent individuals, seizing a unique opportunity."

—Richard Kostelanetz, *SoHo: The Rise and Fall of an Artists' Colony*, 2003

When Paula Cooper opened the first of SoHo's art galleries on a desolate stretch of Prince Street in 1968, she was bushwhacking her way into a New York City district that only a few years earlier had narrowly escaped the wrecking ball of urban renewal. In October 1962, a civic improvement group calling itself the City Club had published a report entitled "The Wastelands of New York City." It characterized the SoHo district as a vast, 600-building, 45-acre commercial slum and called for its complete razing.

Other organizations concerned with housing supply took up the report eagerly. One group actually retained an architect and drew up plans for the clearing of a 31-acre area and the development of 5,000 new apartments. The "slum" designation would facilitate the unlocking of federal funds available for clearance and make the eradication of SoHo's cast-iron district an attractively cost-effective prospect for city politicians. Meanwhile, highway enthusiasts clamored to resurrect the decades-old Robert Moses scheme for a Lower Manhattan Expressway

linking the shores of Brooklyn to the New Jersey waterfront. It looked as if the old South Houston Industrial District was about to be obliterated.

FROM PETTICOATS TO PAINT POTS

The classic cast-iron buildings that we associate with today's SoHo were built between 1840 and 1880.[1] Far cheaper to erect than stone or brick and more pliable and easily molded, the cast-iron frontages were prefabricated in the many foundries around New York City. They could be painted in shades of beige to simulate stone, or their ornate decorative features could be tinted to look like costly bronze. It was the stunning beauty of these essentially inauthentic facades on buildings along Broadway, Greene and Mercer, and up and down Broome and Spring Streets that saved them from demolition in the 1960s.

More important at the time they were built, however, were their commercial advantages. The superior compression strength of the new iron allowed for far greater ceiling heights, larger floors and more weight-bearing capacity than earlier building materials, and the huge floor-to-ceiling windows allowed the metal shops, glass manufacturers and tobacco processors who leased them to leave behind dim, gaslit interiors for more efficient light-filled spaces. These features—high ceilings, wide-open, industrial-strength floors and natural light would ultimately appeal to very different tenants.

Throughout the first half of the twentieth century the South Houston Industrial District cycled through a variety of commercial ups and downs. As methods of production and market demand for goods changed, manufacturing businesses relocated to cheaper and more efficient centers outside Manhattan. By midcentury only low-profit enterprises using outmoded methods to produce children's apparel, industrial uniforms or undergarments remained in SoHo. By the beginning of the 1960s the smaller loft spaces that these disappearing businesses had occupied began renting to even lower profit endeavors such as storage, used carton distribution or rag bailing. Many of the buildings that had fallen into tax delinquency and foreclosure had simply been abandoned.

Meanwhile, changes were occurring to SoHo's south. Since the early 1950s the Lower Manhattan financial district had been losing ground to

midtown where higher, broader buildings on wider streets offered light-filled, air-conditioned amenities that the older buildings on the narrow eighteenth-century downtown blocks couldn't match. In 1955 the David Rockefeller–led Chase Manhattan Bank announced plans to invest $120 million in the Wall Street area.

The Rockefeller family had huge holdings in downtown real estate and their personal fortunes would be at risk should the area decline; they were already losing face as their principal rival Citibank moved uptown to more state-of-the art premises. The 1960s plan for the redevelopment of the financial district included the building of the World Trade Center and, ultimately, Battery Park City. Smart new housing and recreation facilities for the young white-collar labor force that would work in the area would need to be developed, and SoHo, it seemed, would do nicely. The City Club's "Wastelands" report came, in part, as a response to that need.

The report found that in the South Houston Industrial District, more than 15 percent of the space was actually vacant, 50 percent of the buildings were renting for less than 75 cents per square foot and some were renting at the distress rate of 13 cents. The report was a shot in the arm not just for housing development advocates, but also for the still-lingering 1940s proposal for Robert Moses's Lower Manhattan Expressway, a project that would cut a savage swath through most of SoHo's cast-iron district to either side of Broome Street.

Happily for SoHo, 1962 also saw the publication of a New York City Planning Commission report by Chester Rapkin, a Columbia University economics professor and specialist in urban renewal. Rapkin and his team found that, despite the decline in manufacturing jobs in Manhattan, some 650 separate garment, rag and hat industry enterprises were still operating behind the grimy windows of the cast-iron buildings. Many of these lofts were in a deplorable state of disrepair, rife with fire and safety hazards and out of compliance with city codes, but Rapkin advised against their destruction.

By demonstrating that many of the employees working there were minority citizens or from the margins of New York society (40 percent of the workforce was Puerto Rican, 20 percent black and the remainder largely Jewish, Italian, Irish or Slav immigrants), he argued that jobs lost in SoHo were unlikely to be found elsewhere, given the demise of light

industry in Manhattan. These newly unemployed were more likely to join the expensively burdensome ranks of the city's poor.

By grafting socially based arguments for the protection of minority livelihoods onto the economic reasoning against further destruction of the area's remaining commercial infrastructure, Mayor Wagner (who owed a good deal of his political traction to organized labor) found a foothold against the demolition advocates. SoHo's once beautiful but now shabby, rag-strewn, near-deserted streets and its decrepit, empty loft buildings were spared for the moment.

The uses to which SoHo buildings could or could not be put in the 1960s were regulated, as in every other neighborhood in Manhattan, by the strictures of New York City's successive zoning laws, in place since 1916. Ever since prosperous residents on lower Fifth Avenue had objected to the incursion of their space by manufacturing operations to their south, the city has been variously segmented into usage zones. There are zones for residence, zones for commerce (retail and offices) and zones for both light and heavy manufacturing. The South Houston Industrial District had M1–5 zoning for light manufacturing. By 1970, however, the light industry and manufacturing enterprises had largely abandoned the area and the industrial loft spaces had been backfilled by a very different set of occupants.

About 2,000 artists had moved themselves into some 660 of the empty loft spaces across a twenty-six-block area in and around SoHo and were both working and living there. Their presence was, of course, illegal on two counts: they were not engaged in light manufacturing and they were living in spaces not zoned for residential use. This gradual influx had probably been going on clandestinely for a decade or more, and landlords, it appeared, were happy to have them.

How this new development came about and why these abandoned industrial spaces appealed to a population for which they were never intended had much to do with the straitened economic circumstances of the avant-garde artist before Betty Parsons et al. took notice of them. In the early 1950s the importance of the art that the Abstract Expressionists were creating was becoming known, and the increasing ascendancy of the United States as an art-producing nation recognized. But this didn't yet mean that the rising stars were well paid for their work. The growing

dominance of New York City as the newly crowned capital of art meant, however, that more and more artists were coming to the city despite the grim prospects of an income on which they could survive. At the same time, the new art schools opening around the country added daily to the ever-increasing density of young hopefuls arriving in Manhattan. They all needed an affordable place to live and work on their art.

Artists had been clustering in the downtown neighborhoods since the 1940s, and both Greenwich Village and the Lower East Side had been bohemian homes to the working artist. Jackson Pollock lived and worked, variously and erratically, on Horatio Street, Carmine Street, West Houston and East Eighth Street, and Philip Guston worked from a studio on West Tenth Street that had once been occupied by Winslow Homer. Robert Motherwell was a little south of there on Astor Place and Clyfford Still a block farther away on Cooper Square. All were within easy staggering distance of the Cedar Tavern on University Place or the Five Spot on Cooper Square. The photographers Bernice Abbott, Walker Evans, Margaret Bourke-White and Robert Frank all lived in the Village.

Both neighborhoods had served their purpose adequately enough until the rents got too expensive (in Greenwich Village) or the tenement spaces got too small (on the Lower East Side). The canvases required for the big, new gestural painting might be growing, but sales were not. The narrow, cramped tenements with tight stairways and tiny rooms became increasingly unworkable as the art grew taller and wider. Getting a huge stretched canvas or a muscular piece of sculpture out of a twenty-five-foot wide walk-up, much less being able to step back to take aesthetic stock of the work in progress, became a serious obstacle. But the pittance of an income that these artists were making on what was largely unsalable early work was rarely sufficient for a bigger, legitimately rented studio.

BELOW THE RADAR AND INTO THE
VACUUM—THE EARLY SIXTIES

In 1953 Robert Rauschenberg found an empty space on Fulton Street, south of SoHo near the fish market, in which to work on his increasingly large and heavy collage paintings. A 1954 work from that series

titled *Collection* measured 6 feet 8 inches by 8 feet 3 inches; *Charlene*, of that same year, was 7 feet 5 inches by 9 feet 4 inches. The landlord was only asking $15 a month, but Rauschenberg, determined that what little money he had go into materials to make these monsters, talked him down to $10. In 1960 James Rosenquist took space nearby on Coenties Slip for $50 a month, allowing him to create such billboard-size paintings as *Zone* (1960–1961), which was clocking in at just short of 8 feet square. The radical spaghetti-splattered *I Love You with My Ford* of that same early period measured 6 feet 10 inches by 7 feet 9 inches. Alison Knowles, who arrived at Broadway and Canal somewhere around 1957, may have been the first artist to move into a SoHo loft.

The Minimalist movement of the 1960s was every bit as space hungry, particularly as it related to the massive, industrial-weight work being created by sculptors like Carl Andre, Donald Judd or Richard Serra. The early Conceptualists fared little better in tight studio spaces since their materially ephemeral work still demanded room for its development, execution and staging. Artists from all of these movements took space in SoHo, as did the Earthworks pioneers Walter de Maria and Michael Heizer.

The next cycle of new art that began to develop made even greater demands for space. The Happening was first conceived in 1959 by Rutgers University teacher and artist Allan Kaprow. A spontaneous event that was part performer-inspired improvisation and part audience-induced free-fall, the Happening required wide-open space for its provocateurs and plenty of seating (if only on the floor) for its often-confused viewers. Uptown galleries had no interest in the new work, and downtown artists equally had no interest in staging their entirely ephemeral creations in commercial enterprises where the purchase and ownership of concrete objects was still paramount. Happening participants Claes Oldenburg, Robert Rauschenberg, Carolee Schneemann, Jim Dine, Lucas Samaras, Red Grooms and Robert Whitman all performed in downtown venues.

The so-called Performance Art that then followed on from the Happening also found a comfortable creative footing in, around and on top of the big, open spaces of this rundown industrial neighborhood. As one of its earliest advocates Roselee Goldberg describes it, "They performed on rooftops, in vacant parking lots, or in warehouses

turned-studio-cum-rudimentary-habitat. They hoisted pianos onto op-posing riverbanks and installed soundworks over water (Laurie Ander-son); led fellow artists and friends via public transportation to a nearby beach for one-of-a-kind-actions (Joan Jonas). They wound Super-8 cam-eras around their bodies as they turned in circles and filmed a partner doing the same (Dan Graham); gathered in semi-private meetings with other women and pulled from her vagina a scrolled manifesto on the politics of gender (Carolee Schneemann)."[2]

Even when performance works could be staged in contained set-tings, the SoHo loft space was preferred. In 1968 the Performing Garage opened, literally, in a 36-by-20-foot garage at 33 Wooster Street between Broome and Grand. One of its earliest productions, NYU drama profes-sor Richard Schechner's *Dionysus in '69,* was one part Euripides' *The Bacchae,* another part improvisation and the rest spontaneous audience participation. The scant costuming of the male performers ran to jock straps at the outset but gave way later to full nudity. Barely an eyebrow raiser today, in 1968 this outré stuff was not likely to be welcome on Fifty-Seventh Street.

Also in 1968, avant-garde dramatist Richard Foreman developed his impenetrably dense stage texts in his SoHo loft at 52 Wooster Street. Starting what he would ultimately name the Ontological-Hysteric The-ater, Foreman self-produced many of his early works and staged them at Jonas Mekas's Film-Makers Cinémathèque on the ground floor of Fluxus artist George Maciunas's first co-op building at 80 Wooster Street. In 1975 Foreman was able to move the theater into its own premises in a loft at 491 Broadway, just north of Broome Street. An audience of seventy could be snugly accommodated on steeply banked rows of bleachers.

The Fluxus movement that also flourished in the mid-1960s and mirrored and complemented the Happening in many ways *was* materi-ally based but, again, not in any sense understood by the fine-art picture dealers on Fifty-Seventh Street. A highly fluid movement incorporating image, text and sound, Fluxus produced art from found objects, DIY supplies and everyday detritus of no obvious aesthetic or commercial value. Although its mail art, event scores and Fluxkits were customarily small and did not call for a lot of loft space, the work did feed on the pa-per, twine and boxes abandoned in roadside dumpsters or the stationery

and other hardware supplies sold cheaply in the stores up and down Canal Street. Fluxus artists Nam June Paik and Jonas Mekas both had spaces in SoHo while Yoko Ono, also loosely associated with the group around that time, had a loft on the southern edge at 112 Chambers Street near City Hall.

INTO THE (LEGAL) LIGHT—THE MID SIXTIES

Artist refugees from Greenwich Village and the Lower East Side therefore eagerly sought out the open, unpartitioned working spaces of the abandoned factories and sweatshops of SoHo. Old, dilapidated and small by modern industry standards, they were huge in comparison to the tenement alternatives and, despite their lack of adequate heat, ventilation, plumbing or electrical systems, they were not that much less comfortable to live in. And the price was right. With their properties no longer in demand by the legitimate tenants they were zoned for, landlords of the empty spaces were in no position to drive a hard bargain with the only bidder on an essentially illegal deal. As a result, up until the mid-1960s, 2,500 square feet of unobstructed, light-filled space could often be had for as little as $90 a month.

Of course, the artists were also in a compromised position with no legal right to demand improvements on the often-deplorable conditions in which they lived. Payoffs of city inspectors to overlook code violations and the investment of hundreds of hours of "sweat equity" to bang the place into some kind of halfway habitable shape were silently tolerated by this generally peaceable population.

The lofts had been built and equipped as daytime work centers with commercial certificates of occupancy and were furnished with little more than a toilet and a cold-water sink. Heating was supplied according to the terms of a commercial lease and therefore limited to weekday business hours. Trucking garages in the neighborhood often started work with a 4:00 A.M. chorus of profanity-peppered engine revving. Access to and from the separate floors was by manually operated, often rope-hauled freight elevators that were only sporadically checked for mechanical safety. Ingeniously rigged hot water systems and terrifyingly hybrid electrical networks were cobbled together as cheaply and surreptitiously as possible.

There were no restaurants or other residential services in the area, and home cooking often had to be managed on a hot plate or two. Garbage disposal became a fine art of timing and feigned nonchalance as illegal loft dwellers carted refuse-stuffed shopping bags blocks from their homes in search of a discreetly placed dumpster. Outflanking a watchful police patrol was essential if detection was to be avoided. Windows were blacked out at night and resident artists even hid from each other: it was not unusual during these early years for one huddle of loft dwellers to know nothing of the existence of others three floors up, much less five blocks away. "Loft living back then," wrote film critic, author and downtown commentator Glenn O' Brien, "meant a raw space made habitable by any means necessary. The downsides included living with your own plumbing, iffy heat, funky freight elevators or heroic climbs, industrial neighbors and industrial-strength rodents, and spooky streets late at night. The upside: Lofts were big enough to produce museum-size paintings in natural light and to accommodate artists' penchant for wild dance parties and Ping-Pong."[3]

A series of deadly fires in the early 1960s in what the Fire Department now dubbed "Hell's Hundred Acres" set off a train of events that would eventually lead to the gradual regularization of these illegal enclaves. In 1960 a group calling itself the Artist Tenants Association pulled together 500 petition signatures to protest harassment and threats of eviction by the New York City Buildings Department. The Buildings Department was in fact responding to pressure of its own brought about by Fire Department complaints of code violations in the illegally occupied loft spaces. In the event of a fire, firefighters had no way of knowing the whereabouts of trapped residents, thus endangering illegal tenants and firefighters alike.

As he ran for re-election in the fall of 1961, Mayor Wagner was looking to supplement a diminished support base among the working class that had been substantially depleted by the fast-disappearing manufacturing trades. The political expediency of enlisting this new artist constituency was not lost on him; illegal artist loft dwellers at the time were thought to number somewhere between 5,000 and 7,000.[4]

Out of negotiations with the mayor the artists secured the "artist in residence" or A. I. R. waiver, allowing them to remain in their live-work

spaces in return for compliance with certain safety regulations and acceptance of a set of registration procedures that would record their existence with the authorities. An A. I. R. plaque was mounted on the building at street level, indicating to the Fire Department which floors had residents. A maximum of two artists per building was allowed; the plaques can still be seen all over SoHo today. In order to be accorded the protection of A. I. R. status, artists were required to submit to an Artist Certification Committee, a panel of their peers, to validate that they were indeed "regularly engaged in the visual fine arts" and that they both lived and worked in the loft.[5]

The compromise was far from perfect and was met with disappointment and complaint by many who either could not afford to bring their loft spaces up to building code standards or resented the peer vetting process required for registration. It was, nevertheless, a start. Over time, somewhere in the region of 3,500 artists received certification and protection under the system.[6] A further amendment in 1968 extended the definition of "artist" beyond that of academically trained painters and sculptors to include the performing arts, filmmaking and music composition.

Much of the progress that was made out of this furtive and anonymous existence must be attributed to the wildly charismatic artist, activist and social firebrand George Maciunas who, starting around 1966, embarked on a politically charged program of loft colonization. A front runner of the Fluxus movement of the early 1960s, Maciunas worked in the Dadaist tradition of radical politics and anarchic art making and was convinced of the power of the cooperative as a vehicle for emancipating the arts from what he saw as the controlling powers of bourgeois hegemony. His vision was not limited to cooperative ownership of housing and workspaces but extended to collective workshops in theater and other art forms as well as food cooperatives.

In 1966 Maciunas formed Fluxhouse Cooperatives Inc. and established himself as the go-to fixer for "forming cooperatives, purchasing buildings, obtaining mortgages, obtaining legal and architectural services, conducting work as a general contractor for all renovation and (handling the) future management if so desired by the members."[7] Having already identified the site for his first foray, Maciunas went into

action. He bought from the Miller Paper Company two attached six-story loft buildings at 80–82 Wooster Street for $12,000. He then set about taking deposits from buyers for individual floors or half-floors. By August 1967, 80 Wooster was fully subscribed and Maciunas had buyers lined up for a second building at 16–18 Greene Street. In September he advertised shares in three more buildings on Grand and Wooster at prices ranging from $2,500 to $5,000, a rate of $1 a square foot.

With the energy of a zealot, Maciunas worked his way through SoHo from block to block, identifying businesses that were failing and negotiating with their landlords to sell. He was aided in his price negotiations by the still ominous threat of Robert Moses's Lower Manhattan Expressway, which continued to loom as a SoHo-razing possibility until its ultimate defeat in July 1969 under the Lindsay administration. By June 1968 Fluxhouse Cooperatives had sponsored eleven different co-op units in seventeen buildings on Prince, Broome and West Broadway. Video and TV art pioneer Nam June Paik, experimental theater producer Richard Foreman and avant-garde filmmaker Jonas Mekas all lived in Fluxhouses.

By 1969, however, Maciunas's bizarrely complicated and often illegal financial structures for purchasing, renovating and running the buildings were beginning to come undone. The food cooperatives were the first to unravel (participants objected to nothing but black bread for days on end), and resistance was mounting to the extra assessment charges that were constantly needed to plug the holes in Maciunas's leaky building-maintenance budgets. Other problems also arose. Loans that had financed the original purchases came due, mortgage opportunities were not as forecast and foreclosures were threatened. Maciunas also rolled over deposit monies from one co-operative to another (an entirely illegal practice) and failed to register the co-ops with the attorney general.

At the same time, as cooperatives got themselves off the ground and organized, tenants demanded greater independence in the running of their affairs. Many were understandably unsettled by Maciunas's chaotic methods. While the original tenants—mainly painters, sculptors and composers—were not always well versed in, or temperamentally inclined to, matters of law or finance, many of the college art teachers,

writers and architects who arrived a little later were. The Fluxhouse frenzy was essentially over by late 1968 but for those still in the co-ops, a growing sense of activist solidarity in the face of their still largely illegal status was evolving.

Having exposed themselves to city officials through their cooperative initiatives, however, many loft tenants now found that they were even greater victims of the Buildings Department bribery system. Other illegal residents, who had come out from under cover through the Artists Against the Expressway effort, underway since March 1968, were also subject to ongoing harassment and extortion. As Maciunas's original Fluxhouse at 80 Wooster realized that its legal and financial problems were becoming insurmountable, the residents galvanized for battle. Recognizing that individual struggle must now be replaced with community action, they organized for an all-neighborhood solution, not just a building-by-building stopgap.

Joining forces with Community Board Two, which represented the Greenwich Village and SoHo areas, the activists worked doggedly throughout 1969 to compile survey data of artists living in the neighborhood. It seemed that indeed more than 2,000 people lived in a 26-block SoHo area, and those numbers rose to 5,000 to 6,000 if blocks north of Houston Street, south of Canal and east of Lafayette were included.

In April 1970 the artists won their first victory when they secured a moratorium on loft evictions. They then equipped themselves with employment, tourism and other commercial data and shrewdly laid claim to a veritable art industry, generating $100 million worth of business activity per year. By May they had developed a white paper defending the continued existence of SoHo as an economically viable center of art production and by the fall had city authorities engaged in a full-fledged debate over rezoning proposals across the full forty-three blocks of SoHo.

Much energetic debate followed on what size loft and which streets of SoHo should be covered by the zoning change, but on January 21, 1971, the City Planning Commission voted to legalize the residential use of lofts by artists right across SoHo. The arts community had made legal its de facto colonization of SoHo, and it was now able to bring its art out of the seclusion of the studio and into the public eye.

4

GETTING IT TOGETHER DOWNTOWN

1968 to 1975

"Here are artists, a scraggly, underpaid, highly individualistic group, mobilizing themselves as a community and claiming the right to living and working space in a space-hungry city."

—Sharon Zukin, *Loft Living: Culture and Capital in Urban Change*, 1989

SoHo's artists were producing plenty of art throughout the late 1950s and early 1960s, but it was still the uptown galleries that handled their exhibitions and sales. Robert Rauschenberg, Jasper Johns, John Chamberlain, Donald Judd, Sol LeWitt and Claes Oldenburg all lived or worked downtown, and their art was very much based in the downtown aesthetic, but Castelli and Bykert on the Upper East Side or Janis and later Pace on Fifty-Seventh Street were still the only galleries showing them. It was not, in fact, until the late 1960s that art created in the studios of SoHo started to be shown in venues in SoHo and that the art-viewing public began to recognize the area as a destination neighborhood for seeing the newest contemporary work.

STUDIOS, STREETS AND ALTERNATIVE SPACES

In the spring of 1968 the landmark *10 Downtown* exhibition got pulled together, marking the first time art being made downtown was officially

shown downtown, and it began a tradition that would be repeated in successive years. Rather than the works leaving the studio for viewing in a single exhibition venue in the traditional way, the viewing public moved *itself* around, visiting the artists in their lofts and looking at the work there. These first ten artists (none of them at that point represented by a commercial gallery) then recommended ten more for the following year, and the studio circuit was reenacted. Publicity and other administrative tasks were pooled cooperatively for maximum outreach.

The art stayed up in the studios for several weeks and over the course of the event several thousand visitors stopped in to see it. The *10 Downtown* show was one of the first art world affairs that SoHo could call its own, and it was important as such; the uptown galleries had been giving little mind to downtown art, but that was about to change.

Two years later the SoHo Artists Festival literally brought the work out of the studios and onto the streets. In the weekend-long event, more than one hundred artists' lofts were opened up for three days of exhibition and sales. The art and the energy behind it ultimately spilled out onto the sidewalks of SoHo, making it accessible to an ever-widening circle of spectators. Grace Glueck picked up the festival in the *New York Times* and was, in 1970, already describing "the dingy blocks of SoHo" as "the burgeoning artists' community in downtown Manhattan. Crowds came, music filled the air and there was dancing in the streets. The festival was held," she wrote, "to celebrate the emergence of SoHo as New York City's new center."[1]

Painting and sculpture, which tended to dominate at both *10 Downtown* and the Artists Festival, were not, however, the only creative forms taking shape in late-1960s SoHo. The end of the decade saw the opening of a variety of spaces for the newly evolving and regularly cross-disciplinary genres of performance, experimental theater, film and video arts and it was not unusual for any one work to include dance, live theater and musical performance, not to mention some entirely unscripted interventionist "event."

The Kitchen, so called after its original location in the kitchen of the Mercer Arts Center at 240 Mercer Street, was from the start an interdisciplinary entity that gave artists working across a variety of different artistic fields a chance to exhibit or perform. It was launched as

an artists' collective in 1971 by filmmakers Woody and Steina Vasulka, incorporated as a nonprofit in 1973 and was one of the earliest venues (along with Global Village at 454 Broome Street) to display the new video art. The Kitchen also embraced emerging or under-recognized artists and offered what it described as "a safe space for more established artists to take unusual creative risks."[2] Experimental music composition was also welcome and some of the earliest computer-generated and synthesizer work debuted there.

In 1974 four people were killed when the roof of the Mercer Arts Center building collapsed under the weight of too much water, and The Kitchen moved to 484 Broome Street between Wooster and West Broadway. Throughout the 1970s its creative energy and strong avant-garde allure attracted such luminary directors and curators as the experimental music composer Rhys Chatham, performance art curator Roselee Goldberg, and author, playwright and screen performer Eric Bogosian. In its radical programming it played a part in the early careers of painter, sculptor and printmaker Kiki Smith, performance artists Vito Acconci and Laurie Anderson, filmmaker Jack Goldstein, composers John Cage and Philip Glass, and choreographers Bill T. Jones and Meredith Monk.

When playwright, choreographer, stage director and all-around theater impresario Robert Wilson first came to New York City from Waco, Texas, in 1964, he took a loft at 147 Spring Street. After opening up his own living space for movement workshops, Wilson purchased the ground floor and basement space in 1971 and developed an innovative program of avant-garde theater, experimental movement and contemporary dance works. He also launched what would become the Byrd Hoffman Foundation, another key venue for the new performance art.

A cross-disciplinary enterprise from the start, Byrd Hoffman produced such important and enduring works as *Einstein on the Beach* (1976), a five-hour opera written by Wilson with music by Philip Glass and choreography by Andrew de Groat. Typical of the era's rule-bending oeuvres, Glass's composition radically and indelibly broadened what audiences might expect from music, theater or performance art, defying and redefining the rules of conventional opera. Non-narrative in form, the work used a series of powerful recurrent visual images and juxtaposed

them with abstract dance sequences in blended ways never before encountered by concert audiences, museum visitors or dance enthusiasts.

Three other important "alternative spaces" opened in SoHo in the very early 1970s. They were—and still are—112 Workshop/112 Greene, (since renamed White Columns), Artists Space and the Drawing Center. Three downtown artists—the Minimalist Jeffrey Lew, the sculptor Alan Saret and the unclassifiable Gordon Matta-Clark (his work consisted of cutting terrifying holes in vacant buildings)—founded 112 Greene Street as an artist-run organization in 1970. Within a few short years, however, the fledgling organization attracted a powerhouse board of (largely artist) directors, including Robert Rauschenberg, James Rosenquist, Lucinda Childs and Philip Glass. Exhibition opportunities were given to a roster of artists who went on to renown, including Dennis Oppenheim, Keith Sonnier and William Wegman, and also, notably for the time, the women artists Louise Bourgeois, Mary Heilmann, Joan Jonas, Susan Rothenberg and Carolee Schneemann.

Beyond its important role as a maverick supporter of individual artists, 112 Workshop/112 Greene also pushed the aesthetic boundaries of contemporary art in general, insistently exposing uncharted and entirely fresh forms of artistic expression to the art-viewing public. In their 1981 look back on the first ten years of the Workshop's activities, Robyn Brentano and Mark Savitt recall the still-novel use of cast-off materials from light industry that were so freely available in the SoHo neighborhood. "The results were often un-definable and un-saleable," they recall. "So when the clean, well lighted galleries uptown proved inadequate to the work, artists began to seek and create alternatives."[3] They often took those alternatives to 112 Greene Street.

Artists Space opened in the spring of 1973, three years after 112 Workshop/112 Greene, at 155 Wooster Street near Houston. Founded by NYU art history professor and arts advocate Irving Sandler, Artists Space is one of the longest enduring of New York's alternative spaces and has perhaps had the most far-reaching impact. In his 2003 memoir *A Sweeper-Up After Artists,* Sandler described the gaping need that gave birth to the organization in the early 1970s: "A distressing problem facing many excellent New York artists," he wrote, "was the lack of venues in which to exhibit their work. The existing galleries were not able or

willing to offer shows to the large number of artists who merited them. Moreover, there was a good deal of 'non-commercial' art, much of it 'anti-commercial'—that is, conceptual, anti-form, etc.—that private galleries did not show."

With a goal of three simultaneously mounted shows a year, one (usually) unknown, unrepresented artist was selected by an established, known name and given one, and only one, show. An exhibition at Artists Space quickly became an important first-step endorsement in a young artist's career—not surprising since the first year's selectors included Vito Acconci, Romare Bearden, Chuck Close, Donald Judd, Sol LeWitt and Richard Serra. The costs of shipping and installing and the administrative burdens of mounting the exhibitions were absorbed by Artists Space, but money from sales, should there per chance be one, went entirely to the artist. The established status of the artists who made the selections for these shows drew the art-viewing public's attention to otherwise unheard-of talent, and Artists Space quickly became a gallery-going "must" on the downtown itinerary.

In addition to its mounted exhibitions, the Wooster Street location of Artists Space (and its subsequent premises at 105 Hudson Street, 223 West Broadway, and 38 Greene Street) provided an after-hours venue two to three nights a week for performance pieces, poetry readings, experimental music, downtown bands, film screenings and arts advocacy meetings. Recognizing that, even with their new gallery, talent far outstripped available exhibition space and time, Sandler et al. went on to launch the historically important Artists File. This open file was available to any artist who took the time to send in slides. Four hundred had done so by the end of the first season and, over time, the work of several thousand artists, many of them from outside New York City, was made visible to the curators, critics, collectors and commercial gallery owners who regularly stopped by to take a look.

The catalogue essays, cultural critique and art world commentary stimulated by Artists Space over the years were also enormously important. Their bibliography includes writings by such scholar-intellectuals as Douglas Crimp, Bernard Tschumi and Thomas Lawson, critics Roberta Smith, Kay Larson, Lucy Lippard, Peter Schjeldahl and Herbert Muschamp and curators Michael Auping and Germano Celant. As we

shall see, Douglas Crimp's seminal essay contextualizing Artists Space 1977 *Pictures* show was in many ways as important to the eventual launching of the 1980s "Pictures" movement as the art work itself.

In 1975 the executive directorship of Artists Space was handed over to Helene Winer, a young California-trained curator who already had a well-respected track record identifying and exhibiting innovative work on the West Coast. Winer replaced the artist-selected, solo-show formula with thematically curated exhibitions. Emphasizing the experimental, risk-taking ethos of the program at the time, Winer later reflected, "It's hard to imagine, now, how inhospitable the art world was to young artists then. There were no young dealers with comfortable, un-intimidating galleries." At Artists Space, however, curators were not necessarily expected to do a *great* show, just an interesting one.[4] Winer left in 1980 to start a commercial gallery called Metro Pictures. There she would show the self-portraiture of the quirkily retro-dressed photographer who had temped at the front desk at Artist Space, a young woman called Cindy Sherman.

Sherman had her first show at 155 Wooster in November 1976; over the course of its history, Artists Space would premier, encourage, promote or otherwise help bring to public light the talent of, among thousands of others, '80s art stars Jeff Koons, Ashley Bickerton, Peter Halley and David Salle, the soon to be legend "Pictures Generation" of Robert Longo, Laurie Simmons, Richard Prince and Louise Lawler and the scribes of late-millennial irony Barbara Kruger and Jenny Holzer.

Felix Gonzalez-Torres, who created some of the most hauntingly ethereal installation work of the AIDS-wracked 1990s, showed early work at Artists Space as did Kiki Smith, whose searingly abject but strangely beautiful human forms also spoke volumes in the coming decade. Other Artist Space discoveries whose transgressive work would later become icons of fin-de-siècle angst included Tony Oursler, Lari Pittman, Zoe Leonard and Janine Antoni.

The Drawing Center opened in January 1977, initially at 137 Greene Street, and although it set itself a tighter programmatic focus than the all-media Artists Space, it has endured as long and held its own as a venerable downtown institution. The brainchild of former Museum of Modern Art staffer Martha Beck, the Drawing Center attracted more

than 125,000 visitors in its first year. Juxtaposing both historical and contemporary works and defining very broadly what constitutes the drawn line, the Center examined the act of drawing across multiple disciplines including theater, film, dance, architecture, literature, politics and science. The graphic work of painters Ellsworth Kelly and Leon Golub, sculptors Richard Serra, Louise Bourgeois and Richard Tuttle, even Earthworks pioneer Walter de Maria, were all explored there.

While not strictly speaking in SoHo (or, strictly speaking, anywhere *fixed* at first), no account of these early years of innovation is complete without mention of Alanna Heiss's Institute for Art and Urban Resources, founded in 1971. The institute was initially based in unused space in the Clocktower Building a little south of SoHo, but Heiss made it her business to scour the whole downtown terrain for empty, city-owned or landlord-sympathetic properties that could be temporarily used for the exhibition of art (in the case of larger floors) or for artist studios (where space was tighter.) While important projects were brought to life at borrowed spaces on Bleecker Street in NoHo and Reade Street in TriBeCa, her greatest coup came in 1976 when she persuaded New York City to lease her a defunct public school in Long Island City, across the river in Queens. Heiss turned PS1, which had been built in the 1890s but had been empty since 1963, into eight separate ground-floor exhibition rooms, created a performance space in the old assembly hall and rigged up several $50-a-month studio rentals in the old classrooms.

For her inaugural *Rooms* exhibition at PS1, Heiss showed sculptor Richard Serra, Earthworks artists Walter De Maria, Conceptualists Bruce Nauman, John Baldessari and Lawrence Weiner, and the multimedia works of both Alan Saret and Richard Nonas. At the same time, all of these artists were variously engaged with performance and process works or with the manipulation of highly mutable or otherwise unorthodox materials. Heiss symbolically and literally allowed them to break through the classroom walls and install their work wherever they pleased.

Throughout the late 1970s, PS1 was a crucial venue for the exhibition of avant-garde work in all media but particularly afforded space for longer-term installations or site-specific work. Richard Artschwager's light bulb piece *Exit—Don't Fight City Hall,* Lawrence Weiner's glass

stenciled *A Bit of Matter and a Little Bit More* and Alan Saret's *Brick Wall and Sun* were all empathetically received at PS1 at a time when they were unlikely to find homes anywhere else. As Richard Nonas later observed, "Alanna is probably the most important single figure in that effluence of another kind of art-making or art-doing in New York in the seventies—not only the art itself but the way the art existed in the city."[5]

THE COMING OF THE
COMMERCIAL GALLERIES

The first commercial gallery in SoHo was opened at 98–100 Prince Street in October 1968. Its young director Paula Cooper had arrived in New York City in 1959 at the age of twenty-one after spending her late teen years in Europe where she saw the work of Franz Kline, de Kooning and Pollock. Following some introductory experience among the staid dealers of Madison Avenue, she had opened a gallery of her own in 1964.[6] Resisting from the outset what she felt to be the moribund programs of the established dealers, she chose to exhibit the radical wood and foil sculptures of Walter de Maria in the days before he could afford to cast in metal. Cooper described this first endeavor as "not quite a *total* fiasco."[7]

Cooper then joined the visionary John Gibson in a ten-artist cooperative gallery at Park Place just north of Houston Street and forty blocks south of the established art world hub. She was excited by the sheer creative energy of the downtown environment and after two years was restless to go out on her own. Now certain that she wanted to distance herself even further from the traditions of the uptown picture dealers, she instinctively knew that a venue south of Fourteenth Street was the only possible option for her. "It didn't have anything to do with cheap space," Cooper insisted, "it had to do with being near the artists who were all living there. It was about being closer to the art."[8]

She opened on Prince Street with an exhibition to benefit the Student Mobilization Committee to End the War in Vietnam; that first show included early work by the Minimalists Carl Andre and Donald Judd as well as Dan Flavin's florescent tubing constructs. Robert Mangold, the painter of distorted ellipses on irregularly shaped canvas, and Robert

Ryman, who made mystifyingly simple colored solids or almost en-
tirely white-on-white canvases, were also included. The Paula Cooper
Gallery was also the site that year of Sol LeWitt's first wall drawing. In
1969 Cooper showed strangely new-looking paintings by Alan Shields,
concoctions that Grace Glueck would describe as "huge canvas wall
hangings . . . suffused with soaked-stained earth, rock and sky col-
ors . . . stitched and patched with totemic clan symbols, touched with
blobs of paint and adorned with tiny bead-strings that roam the field like
mini-snakes."[9]

Throughout the 1970s, Cooper continued to promote the muscu-
lar work of Park Place's Mark di Suvero as well as Joel Shapiro's and
Jonathan Borofsky's dynamically animated anthropomorphic sculp-
tures. Their weight was balanced by the ethereal lightness of Christopher
Wilmarth's glass structures. In the early part of the decade, Cooper also
showed the work of Lynda Benglis, who had first come to her attention
as a typist temping in the gallery to support her art making. Benglis was
working at the time in unorthodox sculptural mediums such as beeswax,
gold leaf and zinc, but was also developing the poured paint pieces that
would become her signature.

In 1974 Benglis went on to stage a photograph of herself, naked but
for sunglasses and a large rubber dildo grasped between her legs. She
ran the image as a full-page advertisement in *Artforum*, intending it as
a feminist stand against male domination of the art world; several mem-
bers of the editorial staff at *Artforum* objected and resigned in protest.
The debate divided the art world for years to come, but Benglis's gesture
was indicative of the kind of fearless feminist work being produced at
the time, and Cooper was not afraid to show it.

A locale for Performance Art (before anyone knew to call it that),
the Paula Cooper Gallery regularly hosted work that was still too un-
formed to be accepted anywhere else. Concerts, music symposia, dance
performances, poetry readings and book receptions were all held, cap-
turing the earliest multi- and cross-media excursions into 1970s Plural-
ism. A New Year's Eve all-night reading of Gertrude Stein's *The Making
of Americans* quickly became a SoHo tradition.

Cooper stayed in the Prince Street loft for five years, but in 1973 the
building was sold and the gallery was forced to move. Resolving never to

let that happen to her again, Cooper took over a lease from the Lieber-
mann China Company at 155 Wooster Street just below Houston in the
same building as Artists Space, making sure she had an option to buy.
With no money to speak of, a small baby and pregnant with her second
child, Cooper later reflected on the insanity of her venture, but insisted
"it did not occur to me for one minute not to press on."[10]

It was another full year before a second pioneer struck into the hin-
terlands of SoHo. In October 1969, Ivan Karp opened O.K. Harris in a
7,000-square-foot space at 465 West Broadway between Houston and
Prince.[11] A decade older than Cooper, Karp started out in the art world
of the 1950s writing criticism for the then fledgling *Village Voice* and
had already apprenticed at established uptown galleries including Mar-
tha Jackson on Madison Avenue. It was there, while enthusing about a
painting to a client, that Karp was overheard by another gallery visitor,
Michael Sonnabend. Sonnabend was friendly with the European couple
Ileana and Leo Castelli, and he suggested that Karp might be interested
in meeting Leo.

Castelli, an educated Jewish émigré who spoke five European lan-
guages, first arrived in America with his wife, Ileana, in 1941. He settled
permanently in 1946 after wartime service in the US Army, taking the
top floor of his father-in-law's townhouse at 4 East Seventy-Seventh
Street. Castelli had had some relatively part-time picture-dealing expe-
rience in Paris at the Galerie René Drouin, and he initially intended to
handle European Modernists at a branch of the gallery in New York.

In February 1957 Castelli opened very modestly with a show in his
own living room. The exhibit set up de Kooning, Pollock and David
Smith in opposition to the Europeans Jean Dubuffet, Fernand Léger,
Francis Picabia and Piet Mondrian as part of a mission to show that
the Americans could indeed hold their own. Though the venture was
respectably received, Castelli saw less future in the coming "second gen-
eration" of Abstract Expressionists and knew that he was waiting for a
truly new, new thing. He suspected that he had found it in the legendary
art historian and curator Meyer Schapiro's March 1957 show at the
Jewish Museum.

At that time the Jewish Museum served as an important venue for
cutting-edge contemporary art, and Schapiro included work by the

twentysomethings Jasper Johns and Robert Rauschenberg. Castelli had seen Rauschenberg's white paintings previously at the Betty Parsons Gallery and his red paintings at Charles Egan. Johns's green target painted in encaustic on newsprint, however, was like nothing he had ever seen and mesmerized him in a way even this gifted linguist couldn't articulate. Two days after seeing the museum show, Castelli and Ileana made a visit to Rauschenberg's studio downtown on Pearl Street. When they stopped in at Johns's studio one floor below to get ice for the drinks, Castelli was so bowled over by what he saw that, to Rauschenberg's wounded astonishment, he instantly offered the young neighbor a show.

Ivan Karp joined Castelli in 1959 and further boosted the stable of young iconoclasts. By the time Castelli opened on West Broadway in 1972, he was representing Frank Stella, Cy Twombly, Ellsworth Kelly, Roy Lichtenstein, Andy Warhol and James Rosenquist. He took on Ed Ruscha and his banal California parking lots and gas stations and Bruce Nauman, who was already producing his queasily disorienting corridor pieces. Keith Sonnier's bristling florescent light works hummed on the wall or pulsated on the gallery floor, power cables and all, along with John Chamberlain's mangled car parts and Richard Artschwager's slyly ironic faux wood objects.

In 1974 Castelli let Robert Morris hang his self-portrait—barechested and in sadomasochistic garb—the work that would provoke Lynda Benglis's notorious dildo-toting response. The Conceptual movement was represented in the bewilderingly non-material pieces of word artists Joseph Kosuth and Lawrence Weiner as well as in the densely cerebral, if aesthetically lean, work of the Europeans Hanne Darboven and Jan Dibbets. The intellectual capacity of Castelli's mind and the visual range of his eye were truly extraordinary.

Karp served as a young talent scout for Castelli for ten years. Always on the prowl around studios and ever open to looking at new things, Karp was the first to come across the peculiar new subject matter in Roy Lichtenstein's cartoon paintings and Andy Warhol's Campbell soup cans. When he then saw James Rosenquist's billboard-sized, similarly commercial imagery—and confirmed that none of these three had previously seen the work of the others—Karp was convinced that a new movement was afoot. It was Karp who cajoled a dubious Castelli into

the new Pop Art imagery, and the brash young Americans were ulti-
mately picked up by the suave European dealer, becoming a mainstay of
Castelli's enterprise throughout the rest of its history.

By 1968, however, Karp was becoming restless around a stable of
talent now in place for the best part of a decade, and he craved new
blood. When Castelli made moves to take on the Minimalist sculptor
Donald Judd and the fluorescent light artist Dan Flavin, Karp found
himself at aesthetic odds with his partner; he resigned for what he de-
scribed as "a new great adventure."[12]

Opening O.K. Harris Gallery in October 1969, Karp, like Paula
Cooper, was ready to develop something beyond the strictures of the
uptown art world, and he kicked off by concocting an entirely fictitious
name for the new gallery. "I felt O.K. Harris was a tough, American
name that sounded like that of a riverboat gambler," he said. "It would
look good in print, and one could blame everything on the mystery
character."[13]

Karp and his wife were already living downtown in the I. M. Pei
Silver Towers put up on La Guardia Place in 1966 in the one section
of SoHo's northern fringe that Robert Moses had succeeded in razing.
Operating on a $50,000 loan from a friend, Karp was perhaps more
sensitized than Cooper to the attractive economics of 7,000 square feet
for $350 a month, but he also wanted proximity to the artists and their
studios. Like Cooper, he believed that the discovery and development
of emerging talent and new art forms was what made the downtown
environment appealing, and he regularly took a risk on up-and-coming
but untested artists without necessarily committing to representing them
long term.

During his initial five years before moving to even larger quarters a
block or two south at 383 West Broadway, Karp promoted the New Re-
alist painters Robert Cottingham, Malcolm Morley and Robert Bechtle.
Very much in opposition to the cerebral and theory-informed Minimalist
and Conceptual movements that Karp had bridled against at Castelli,
the New Realism was based on exacting camera-lens verity and a hyper-
real accuracy. At the same time, however, he also gave early shows to the
abstract painter Jake Berthot, the assemblagist Al Souza and to Duane
Hanson, the sculptor of eerily real Everymen. Deborah Butterfield's

lyrically beautiful driftwood horses and work by the pioneering abstract filmmaker Jack Goldstein were also shown there.

Karp had purchased the 11,000-square-foot building with its 18-foot ceilings for around $1 per square foot. The space accommodated the big new work that was being produced, allowed him to run four to five shows concurrently and to change the shows as many as seven times a year. At the height of SoHo's heyday, O.K. Harris had as many as 5,000 visitors cross its threshold on a Saturday and several hundred more on weekdays. With so much exhibition space available Karp could leave his door wide open to aspiring artists and continued to see as many as twenty-five hopefuls per week. A handwritten note was courteously dispatched in response to every set of slides dropped off at the gallery.

When rents started to rise in the 1980s and pressure was put on leaseholders to vacate and make way for the newly arriving food and fashion tenants, Karp, like Paula Cooper, was insulated from it. Art, he felt, "should be shown under blunt, demographic circumstances, without the trappings of glamour, in a warehouse setting."[14] Despite the settling of all that glamour around him, his space remained much the same. He never found a more appealing place than SoHo.

Holly Solomon opened her commercial gallery (across the street from Ivan Karp) in 1975 but since 1969 she had been championing the new art—performance, poetry recitals, book readings and contemporary dance—in a space on Greene Street. Bringing her sense of theater to the program she called 98 Greene Street Loft, she produced an award-winning five-part anthology film called *98.5,* staged Happenings and gave early exposure to the performance pieces of Laurie Anderson. Her memory is immortalized in a number of portraits of her that she commissioned, including works by Andy Warhol, Roy Lichtenstein, Robert Rauschenberg, Richard Artschwager, Christo and Robert Mapplethorpe. She gave Mapplethorpe his first show.

The daughter of a Russian-born grocer and liquor merchant, Solomon had started out intent on a career as an actress. Doing the audition rounds in New York City, she would lift her spirits after a discouraging day by sitting in the Brancusi room at the Museum of Modern Art. She later immersed herself in Ad Reinhardt's bottomless monochromes, David Smith's muscular, but somehow weightless metal constructs and Dan

Flavin's luminescent tube-lighting work. She checked in on what was showing at Sidney Janis and at Eleanor Ward's Stable. It was after her marriage to the Yale-educated son of a wealthy bobby pin manufacturer that she was able to indulge her appetite for collecting, and she got herself involved in the avant-garde activities of Earthworks pioneer Walter de Maria, with Nam June Paik and his radical installations of defunct television sets and the equally hard to classify Gordon Matta-Clark.

Opening on the ground floor of 392 West Broadway between Spring and Broome in 1975, Solomon embraced the large floor-to-ceiling windows of the space as a democratizing way to get the art out in front of the public. In the later 1970s, while still promoting the Minimalist and Conceptual work that had initially attracted her, the Holly Solomon Gallery became the acknowledged progenitor of Pattern and Decoration, the dense, all-over, and often unapologetically lovely painting that was in many ways a reaction to the austerity of those earlier movements. P & D artists Robert Kushner, Kim MacConnel, Valerie Jaudon and Joyce Kozloff all showed with Solomon. Like her neighbor Ivan Karp, however, Solomon's eye was not limited to one movement. Throughout the 1970s she mounted shows of painter Mary Heilmann's blocky color abstractions, Thomas Lanigan-Schmidt's lush kitsch-inflected collages and William Wegman's camera-ready Weimaraners.

By 1972 the notion of SoHo as an art district began to really take hold. It was then that a 5-story, 10,000-square-feet-per-floor former paper warehouse at 420 West Broadway, purchased and stylishly remodeled at a cost of some $500,000, was taken over by Leo Castelli, Ileana Sonnabend, André Emmerich and John Weber.[15]

Although Leo and Ileana divorced in 1960 and Ileana married the Columbia University scholar and documentary filmmaker Michael Sonnabend, she remained on unusually good terms with Castelli. In 1962 she moved back to Paris with her new husband and opened her own gallery where she showed many of Castelli's Americans, introducing Johns, Warhol, Lichtenstein, Oldenburg and Rosenquist to puzzled European collectors. Returning to New York City eight years later, Sonnabend opened a gallery at 924 Madison Avenue, near Leo again on Manhattan's Upper East Side. She kept that space until 1974. In 1972, however, she also felt the draw of the downtown scene and took

the second floor of the West Broadway space directly above her former husband.

She opened with the English *Singing Sculpture* duo Gilbert & George who, with well-cut tweed suits worn over gold painted bodies, lip-synched the old British music-hall classic "Underneath the Arches" to the bemused audience. It was in her 420 Broadway space in 1972 that Vito Acconci performed his soon-to-be-infamous *Seedbed*. Hidden beneath a ramped gallery floor, Acconci masturbated throughout the course of the show, his amplified moans of ecstasy broadcast into the gallery.

The third gallery tenant was André Emmerich. Like the Castellis, Emmerich had fled the anti-Semitism of Nazi Germany, arriving in New York City in 1940. Emmerich had had a gallery dealing in classical antiquities on the Upper East Side since 1954 but shifted his focus to contemporary art during the 1960s. Operating principally out of the tony Fuller Building at 41 East Fifth-Seventh Street, he opened a second space in the 420 West Broadway building on the third floor above Sonnabend. An early proponent of Color Field painters Morris Louis, Kenneth Noland, Helen Frankenthaler and Jules Olitski, Emmerich also had a penchant for showing outdoor sculpture on land he owned upstate. Although he was an enormously respected dealer throughout his lifetime, Emmerich's stable was not especially informed by the SoHo art scene. Nevertheless, his polished demeanor, multilingual European heritage and long-established reputation brought cachet to the SoHo neighborhood.

The fourth new occupant of 420 West Broadway was John Weber, who described the new gallery building as an instant, literally overnight success. "The day we opened the galleries" he recalled, "twelve or thirteen thousand people came through like a swarm of locusts, stopping traffic all up the street."[16] Weber had apprenticed uptown under Martha Jackson in the 1960s and with the equally legendary Virginia Dwan in Los Angeles, where he was drawn to both Minimalism and the Earthworks artists Michael Heizer, Walter de Maria and Robert Smithson. His devotion to Smithson's geographically far-flung and highly ephemeral projects was unending. Smithson's seminal work, *Spiral Jetty* of 1970, was a 1,500-foot-long mud, crystal and basalt rock causeway that coiled out just above the surface of the Great Salt Lake in Utah. Only a

few years after its completion, rising lake water submerged it entirely; until climatic changes caused it to resurface again thirty years later, all that could be seen of the entirely unsalable work was a film documenting its existence.

Weber's stubborn commitment to both the Arte Povera and the Art and Language movements was equally fervent, despite the enormous difficulty he had selling their work; he was known to pay stipends to artists he believed in even in the face of his own struggling financial position. He also showed the chromatically and formally pared-down stripe works of Daniel Buren, the (almost) all-white paintings of Robert Ryman, the cerebral color geometries of Robert Mangold and the space-confounding yarn-and-wall works of Fred Sandback. He was particularly courageous in embracing the acerbic, establishment-baiting projects of Hans Haacke, an artist who, in works such as *MoMA Poll* of 1970, picked at the sore of wealth and power relationships binding such art world alumni as the Rockefeller family and the Museum of Modern Art.

MULTIPLICITY, MOMENTUM AND MAKING FRIENDS

By 1973, therefore, as both Paula Cooper and Ivan Karp looked toward their fifth anniversaries in SoHo, the neighborhood as an arts district was already developing an allure beyond the original rebels and risk takers. It was now a phenomenon with sure enough appeal to attract anointed veterans. Castelli, Sonnabend, Emmerich and Weber added gravitas as dealers of reputation and experience; their reach was international and their clients were sophisticated. At the same time, their different aesthetics and varied programs greatly enriched the diversity of art to be seen in SoHo. In the years immediately following their arrival, a number of other important additions to the neighborhood helped nudge SoHo out of its downtown isolation as a center of only radical and often unpurchasable art, to one also offering timely work of quality but also palatable collectability.

In November 1972 Betty Cuningham took 2,000 square feet right above Fanelli's Bar at 94 Prince Street and launched Cuningham Ward Gallery.[17] She was a Hunter College graduate with a specialty in

nineteenth-century American art and had started out on an altogether more traditional career trajectory with a registrar's position at uptown's Marlborough Gallery and executive positions with various art and historic preservation societies.

As the 1970s dawned, however, Cuningham found herself irresistibly drawn to living artists creating work in local SoHo studios where she could engage with them directly. It might still have been her nineteenth-century sensibility that drew her to the gorgeous allover floral paintings of Robert Rahway Zakanitch, but the work was startlingly innovative and fresh. Later, she represented the figure painter Philip Pearlstein, whose nonchalantly posed nudes and oddly stage-propped settings also looked like nothing before. Landscape painter Rackstraw Downes worked in a classic genre too, but his quirky, perspective-distorting fish-eye studies depicted the distinctly unlovely hinterlands of modern urban sprawl. Cuningham certainly showed fresh contemporary work, but her gallery also brought to the collector art that was domestically installable.

Nancy Hoffman launched her SoHo gallery in December 1972, a month after Betty Cuningham.[18] Another traditionally educated art historian, Hoffman had also apprenticed at long-established dealerships where she got a solid foundation in the fundamentals of making a business out of art. In addition to her canny eye for quality work, Hoffman brought to the growing SoHo community business professionalism, a clear head for profit and loss and an innate understanding of the crucial dynamic between the artist producer, the collector who purchases and the dealer who mediates for a commission. She also learned early on the importance of accurate cataloguing, meticulous condition reports, thoughtful installation and well-managed shipping and storage.

The Nancy Hoffman Gallery opened with the light- and color-filled flower paintings of Joseph Raffael, an artist introduced to Hoffman by the California Pop painter of bodacious babes, Mel Ramos. Hoffman's tastes did not trend toward Pop, nor, like those of Cuningham, to many of the other narrowly defined isms of the 1970s or 1980s. An aesthetic eclecticism across a range of media and genres drove her program, and she also searched regionally and internationally for art being produced beyond the limits of SoHo's studios. Radical and game-changing forms were certainly what got SoHo started, but as the arts enclave matured,

it also attracted the dealer of a quieter form—work that was intelligent but pleasing to the eye and meticulously executed to the highest levels of craftsman-like skill.

Several other early pioneers opened galleries in SoHo in the 1970s and thrived throughout the 1980s and 1990s, making important contributions to the increasingly energetic landscape and fueling the neighborhood's growing reputation as a national arts center. In 1974 Susan Caldwell opened upstairs from Ivan Karp at 383 West Broadway, carving out 4,000 of the 10,000 square feet of raw space for a gallery and creating a home for herself and her three children in the rest.[19] She paid $18,000 dollars for the floor. She kept her gallery open for eleven years, initially mounting a program of abstract painting and works on paper. Joanna Pousette-Dart, Sean Scully and David Reed all showed there to strong critical review. In the later 1970s Caldwell began to show figurative work, mounting the first Leon Golub show to be seen in New York since the 1960s. When artists in her stable produced work too large even for her enormous gallery space, Caldwell would capitalize on her proximity and walk prospective collectors directly over to their studios.

In 1975 both Phyllis Kind and Edward Thorp moved into available space at 139 Spring Street and established a New York foothold for their Chicago (Kind) and Santa Barbara (Thorp) programs—further testimony to the growing reputation of SoHo as a national art world hub. Jim Nutt and other members of the Chicago Hairy Who showed with Kind as did the Chicago Imagists Roger Brown and Ed Paschke. Thorp established a strong program in painting and sculpture showing Louisa Chase and Judy Pfaff in the 1970s. He was also instrumental in promoting the careers of several promising painters who would all go on to art world renown in the 1980s such as Eric Fischl, April Gornik and Richard Phillips.

Angela Westwater capitalized on her Turin, Rome and Düsseldorf gallery connections, setting up Sperone Westwater Fischer at 142 Greene Street in 1975 and Max Protetch moved to SoHo from Washington, DC, a year later.[20] They also, like Cuningham, Hoffman and Thorp, recognized SoHo's magnetic force early and developed vibrant programs that

thrived throughout the SoHo heydays and into the next century. Their stories continue.

At the end of the 1960s Paula Cooper and Ivan Karp had been virtually the only galleries in SoHo. By the time the 1970s drew to an end, they had been joined by close to one hundred other art-purveying entities. This new art world hub now had enough going on to merit two guidebooks detailing the downtown gallery scene. Helene Zucker Seeman and Alanna Siegfried's 1978 *SoHo: A Guide* put the number of galleries handling contemporary art at eighty-five. Twenty-one other arts venues, not strictly galleries but variously devoted to performance art, film, video, dance, experimental music and theater, were also included. Alexandra Anderson and Barbara Archer's 1979 *SoHo: The Essential Guide to Art and Life in Manhattan* described eighty-one "galleries" and "alternative art spaces." Within the next few years, of the 480-odd galleries listed in the widely used Art Now/New York guide, some 200 were south of Fourteenth Street.[21]

The fledgling arts community that had started out life a mere ten years earlier now had at least four of the essential characteristics of a healthy arts scene: mass, cohesion, energy and status. By the end of the 1970s the density of galleries was sufficient to make the destination worth the trip and a strong sense of community was developing. The system was also beginning to organize itself professionally with a cadre of formidable (often female) dealers, and even big uptown names (more often male) had decamped downtown to bring it cachet. SoHo was no longer home to just the extreme or the unpurchasable but was beginning to develop a broader-based allure.

The newcomers were also bonding as a group. "Rents were cheap and large raw spaces were plentiful," artist Sherrie Levine recalls. "There were lots of artists and writers around, but not so many that you couldn't know virtually everyone. Most of us lived in SoHo or Tribeca, and very few other people lived there. It was kind of a parish in that sense."[22] Betty Cuningham remembers that SoHo in those early days was "like a small town . . . every artist went to every other artist's opening and the sense of community was very important."[23] Likening the art world back then to the Cedar Tavern days of the 1950s, she recalls

that no one expected to sell and so artists depended even more heavily on mutual support and peer encouragement. By the close of the 1970s, however, sales were a reality, and not just dealers, but artists and collectors were beginning to recognize each other.

What had started out as a somewhat reckless gamble on the part of the early pioneers had by mid-decade grown into a going concern. The once embryonic mutation from the uptown body looked likely to survive. Savvy business minds like Ivan Karp and Nancy Hoffman understood that their intuitive love of the art object would not be enough without revenue. Holly Solomon saw it too. SoHo in the early '70s, she observed, was "like a little college town . . . with artists sitting in the Spring Street Bar and patting each other on the back. It was more damn fun than I can tell you. It was a little elite." She was, however, shrewd enough to add, "But the day comes when the artist must break through to his audience and deal with the real world, when he can no longer gain satisfaction just from his little clique. If no one can pay the rent for his loft, where does that lead?"[24]

Remarkably, given its ratty origins, the neighborhood was beginning to shape up. The settling of the brahmin Europeans at 420 West Broadway anchored the neighborhood, and by 1976 Castelli had moved all of his operations down to SoHo. Young but entrepreneurial dealers with one eye on the best new art and the other on the bottom line were opening galleries, and seriously respected dealers like Richard Bellamy, Hal Bromm, Heiner Friedrich and Barbara Toll had established "By Appointment" operations or had opened at addresses in TriBeCa or north of Houston, just beyond SoHo proper. SoHo was a newborn no more.

5

DILUTION AND DISCONTENT

The Later Seventies

"SoHo seemed to be dominated by boutiques, gourmet food stores, wine bars, and whimsical antique shops, while the galleries were occupied by the remnants of once powerful movements, like so many stragglers from dispirited tribes."

—Anthony Haden-Guest, *New York Magazine*, 1982

*I*t had taken at least two decades, perhaps even a quarter of a century, for the artists' colony in SoHo to grope its way tentatively into legal existence. From fragmented pockets of isolated and clandestine loft dwellers to a loosely patched together community of A. I. R. pioneers who were essentially tolerated on a variance basis, SoHo's artist residents had ultimately won not only legal status but also some degree of sanction as a viable professional and economic entity. Attitudinally they had evolved from a make-do acceptance of their uncertain and marginal status to a legitimized sense of their societal worth as generators of valuable product. And they had (some) legal and political endorsements to prove it. The civic activism, public campaigning and other attention-getting measures were crucial to coming out of the cultural shadow and into the societal light. When the loft laws were first amended in 1971, however, it was probably not fully anticipated just how brightly that light would soon glare.

FROM SURVIVOR MODE TO MODISH LIVING

Before the 1970s, the prospect of setting up home in a nineteenth-century factory, an abandoned warehouse or a former firetrap of a sweatshop would have been, quite literally, risible. Everything that had gone before in the history of urban America, cycling as it always has through immigration and basic economic survival to prosperity and social betterment, worked against this notion. With the opening up of mass transit and the development of residential neighborhoods in Queens and the Bronx in the 1920s and 1930s, the opportunity to put distance between work and home meant that moving up and out of the industrial center had become a middle-class mantra.

By the 1950s, a whole host of inner-city problems, both economic and social, were also beginning to fester, not only in New York but in metropolitan centers across the United States. Suddenly even New York's outer boroughs were too close for comfort. As people recoiled from the troubled urban cauldron, mass-market America beckoned the home-owning consumer with the perfect setting for a fully furnished suburban dream.

By the late 1960s, however, much about the suburban paradise was beginning to sour. Despite, or perhaps because of, the privacy of the well-trimmed yard on the quiet cul-de-sac, seclusion often turned to loneliness and even the communal promises of the open-plan ranch house could not compensate for feelings of isolation and despair. At the same time, a variety of broader sociopolitical movements and environmental trends were drawing the nation's attention back to the ecology of its struggling urban centers.

The mid-1960s flowering of a preservationist movement to protect the nation's endangered industrial architecture from destruction and the drawing of attention to the value of city neighborhoods and urban community by advocates such as Jane Jacobs were beginning to take hold. A new wave of nostalgia for the "original" and a quest for "authenticity" began to manifest themselves in the rejection of the shiny new high-rise in favor of the lovingly restored brownstone. As the culture writer Thomas Hine astutely observed of the 1970s, "When the future wasn't working as well as it used to, and perfection was starting to lose

its luster, people were attracted to things that had been buffeted by time and had survived."[1]

In 1968 Milton Glaser and Clay Felker launched *New York Magazine,* giving the new 1970s preoccupation with lifestyles an urban context, along with a neighborhood-by-neighborhood platform for showcasing what élan looked like in New York City. Columnist Barbara Goldsmith's interviews with contemporary art icons such as Marcel Breuer, I. M. Pei, even Pablo Picasso, forged perhaps the very first connections in the minds of the general public between contemporary art and stylish living. Between 1961 and 1973 there were more than 175 articles on various aspects of loft living, legalization and conversion in the pages of the *New York Post,* the *Village Voice* and the *New York Times,* and throughout the early 1970s a veritable campaign by the *Times* to hype the panache of downtown loft living fueled the acquisitive appetites of space-hungry uptowners.[2] In 1976 the newspaper debuted a new section entirely dedicated to the serious business of "Living" and bracketed consumerism, personal health and home furnishings with entertainment and the arts.

On August 14, 1973, the Landmarks Preservation Commission designated the twenty-six-block area of SoHo a landmark district. The Landmarks Preservation Commission had been in existence since 1965 and had been formed under the Wagner administration in reaction to the shocking destruction of a whole series of the nation's architecturally important structures; Philadelphia and St. Louis had already destroyed much of their nineteenth-century architectural heritage and a number of teardowns in New York were being regretted. Once given landmark designation, a building could not be demolished until the city had a chance to seek a new use or a new owner who would preserve its exterior.

Clearly, the artist community tended to have a natural aesthetic appreciation for the beauty of SoHo's ornate cast-iron facades and a sense of their place in the architectural history of New York. When they applauded the landmarking victory, therefore, they were genuinely celebrating the blocking of the bulldozers and the defeat of the high-rise developers. SoHo's noble structures would not be so easily reduced to rubble or be replaced with soulless commercial towers. At the same time, artist-owners were not naïve about the professional and economic protection that landmarking afforded them. The 1965 designation of

Brooklyn Heights just across the river, for example, had done much to establish the cachet of that neighborhood as well as raise its property values.

Though this preservationist shift in emphasis from "destroy and rebuild" to "refit and reuse" might also have been on the mind of the City Council in 1976 when it introduced the so-called J–51 tax abatement, here too money was the more likely motivator. New York (and indeed the nation as a whole) was in the midst of one of the worst economic downturns in its history, and its governors were ready to do anything possible to shore up its depressed real estate market and re-energize its record low levels of new development. The J–51 amendment gave favorable tax abatements to property owners who chose renovation rather than demolition.

Unfortunately for the artists, those typically lobbying for the J–51 were professional real estate developers, not individual owner-occupiers, and the revisions stood to favor not loft-by-loft upgrades of homes but entire gut conversions by building landlords. Artist owners could rarely afford to be a part of that kind of action given the stringent construction conditions attached to the granting of a legalizing certificate of occupation. Equally, artists could not afford to rent in the newly renovated buildings. As prices rose on space in the neighborhood, the best an artist might hope to do would be to cash in on their modest early investment while the market was hot.

As early as May 1970, when media attention first focused on the still-dilapidated but burgeoning arts neighborhood, price rises for both rentals and purchases were causing concern. Residents complained to the *New York Times* that buildings that had been purchased for $30,000 ten years before were now selling for $150,000, and rents had doubled and tripled.[3] In July another *New York Times* report bore the headline "Costs for SoHo Lofts Are Rising Drastically" and detailed the increasingly heavy "fixture fees" that loft dwellers claimed were being demanded for even the most rudimentary domestic services or appliances.

The original settlers also started voicing resentment over the neighborhood's being invaded by unwelcome outsiders—arrivistes' "galleries" that were little more than trendy emporiums of schlock artifacts, the suburban day trippers and foreign tourists who bought their wares, aggressive uptowners hoping to get in early on the latest art world trend,

real estate agents with the newly monikered Young Upwardly Mobile Professional in tow and various other forms of alien intruder. All of them, it seemed, needed to use a bathroom.

ART FOR ALL

The showcasing of this trendy new Artopolis by the media was not, however, the sole cause of its rise to must-see prominence in the minds of the SoHo-going public. There was also a good degree of very genuine interest in much of the new art being shown there. The new work was no longer about fusty eighteenth-century portraiture, bucolic but irrelevant nineteenth-century landscape or even the unfathomable twentieth-century abstraction. Artists (still living) were now amusingly painting the things of everyday life—Coca Cola bottles and Mickey Mouse cartoons delivered in popping magazine-copy colors or familiar American flags rendered in brazenly unconventional hues.

SoHo also meant that museums, long the keepers of the gate for the rich and art-history educated, were no longer the only game in town. Nor were the hushed salons of Fifty-Seventh Street that had to be ferreted out on the upper floors of intimidating midtown buildings. In 1970s SoHo most galleries were open to the passerby at street level or, if up the stairs, were welcoming—happy to see anyone who made the climb. The work being shown there was so new that no canon had yet been applied; an Everyman interpretation was perfectly valid and discussion was actively encouraged.

The renaissance of limited edition (but nevertheless multiple and affordable) print publishing by such printmaker revivalists as United Limited Art Editions, Tyler Graphics and Gemini G.E.L. also meant that a lithograph or screen print could now be purchased for hundreds as opposed to hundreds of thousands of dollars. A decent reprographic poster of an iconic piece of art was available for even less. As a result, consumption of the arts accelerated dramatically throughout the 1970s with sharp increases in art-purchasing activity and particularly high peaks in 1973 and 1979.[4]

A considerably more transparent market for the buying and selling of art also made collecting less of a mystery. The newer and less

exclusive galleries were happy to leave price lists at the reception desk, and the trading of the new art at auction meant that accurate numbers were available to the general public and could be understood by the ordinary enthusiast. In October 1974 a mayoral report put the size of the city's art market at $1 billion. The much-publicized sale of the collection of taxi fleet owners Robert and Ethel Scull at Sotheby Parke Bernet in October 1973 accounted for more than $2 million alone. Among that cache, Jasper John's *Double White Map,* purchased by the Sculls just eight years earlier for $10,200, had hammered down at $240,000. Robert Rauschenberg might as well have called Scull an outright shark when work purchased from the artist for $900 sold for $85,000. Instead, he settled for publicly shoving the profiteering Scull in the chest.

The market slumped in 1975 but rebounded again with the general economic recovery of 1976 to yield strong returns in the spring season. Castelli alone was rumored to be grossing over $2.5 million a year in sales. By 1979 soaring interest rates and double-digit inflation led to speculation on works of art as investable commodities. Record high prices were set at the principal auction houses, and a new house devoting itself solely to the sale of contemporary works opened on West Broadway.[5] The number of galleries in New York City by the end of the decade was purported to be somewhere between 300 and 500 and their volume of business upwards of $500 million a year.[6] Meanwhile, the number of college-educated Americans now intellectually able and financially equipped to absorb all of this new cultural product had never been higher. To so many of these newly arts-enfranchised consumers, SoHo looked like Nirvana reachable by subway.

The art itself was also ready for a change. The predominating movements of the 1960s and 1970s—Minimalism, Conceptualism, Earthworks—were beginning to be exhausted. Their ideas seemed depleted and the artists of that era were aging. Judd, Flavin and Andre were pushing sixty, and Robert Smithson was already dead. Even Johns, Rauschenberg and Warhol were in their fifties, and their museum-status work was now well beyond the reach of most collectors.

If the aesthetic direction of the New York art world was unclear as it entered the 1980s, the economic pump was certainly primed for a decade of plenty. SoHo had become stylish. Newly opened restaurants

and boutiques, well publicized by the lifestyle media, were drawing ever-greater numbers of consumers to the neighborhood, and such artists as could still afford to live there were newly chic. Both they and their product were marketable.

As demand in that market intensified, prices must, of course, rise and output be stepped up to meet the needs of the new and enthusiastic art-consuming public. More works or bigger ones with higher price tags were needed to meet quotas and ensure profit margins. These expectations were best made clear in signed contracts. Gradually but inexorably, the traditional lexicon of the art world was being replaced with the parlance of the marketplace. By 1978 the recession years of the mid-1970s were coming to an end, the real estate market had rebounded, another art market peak was on the horizon and the good times were once again about to roll. A new kind of gallery and a new breed of gallerist were about to emerge.

Needless to say, this surge in demand for the new contemporary art, the newly fashionable artist and the trendy new art neighborhood was beginning to take its toll. By March 1976, only eight years after her pioneering arrival in SoHo, Paula Cooper would complain to the *New York Times*' John Russell that "it's just a completely other world now" and "we seem to run a restaurant guidance service." Betty Cuningham described "a circus or Disneyland situation" and mourned the fact that most of the artists had moved out of SoHo because they could no longer afford it. [7]

The two SoHo visitor guides, both prepared as serious compendia for the art-going public, nevertheless included a Museum of Holography, a gallery dedicated to neon light and several poster shops. Vendors of artisanal jewelry, pottery, wooden furniture, enameled accessories and architectural bric-a-brac were also listed as were close to 30 food stores, 34 clothing outlets, 15 purveyors of "Crafts and Collectibles" and as many again of miscellaneous enterprises hawking everything from bicycles and kites to sex toys and naughty underwear. The profit-averse Food and the lowly Fanelli's had now been joined by close to 70 other restaurants and bars. By August 1980 Grace Glueck, who had for the longest time been almost the only media commentator interested in this newly bushwhacked terrain, would be noting its "minifactories,

bars, restaurants and boutiques," apparently reconciled to the fact that "the area offers irresistible pleasures for walkers, shoppers, eaters." She added almost as an afterthought, "and art-lookers."[8]

THE ROOTS OF RESTLESSNESS

Beyond booming SoHo, however, another kind of 1970s was unfolding. On the international stage, the still politically adolescent American nation was reeling not only from its first globally televised humiliation in Vietnam but also the cringingly public national disgrace of the Watergate scandal. Meanwhile, a generation of youth was emerging who had no appetite for either the anodyne palliatives of their parents' 1950s suburban cocoon or the "turn on, tune in, drop out" analgesics of the 1960s. Even the immediately preceding cultural credo of their older siblings seemed to be irrelevant, drifting as it did in a cloying glop of unfocused '70s Pluralism, running the gamut from saccharine Pop to pompous Conceptualism and prettified Pattern and Decoration. SoHo was most certainly hot, and stylish openings for wealthy collectors were being held in the increasingly exclusive galleries. But this was now an adult affair and, even if they had cared to be there, the kids were definitely not invited.

As the decade ground depressingly on, Richard Nixon resigned, Saigon fell, and Son of Sam seemed to remain forever on the loose. In July 1977 a citywide power blackout in New York led to looting and crime in the near-bankrupt metropolis. The Jonestown Massacre, the reinstatement of the Ayatollah Khomeini and the taking of sixty-six American hostages at the Tehran embassy suggested that the whole world had gone mad. The decade closed with the gunning down of John Lennon outside the fortress-like Dakota on the Upper West Side. It was no wonder that at least one historian of the era dubbed it the "Decade of Nightmares."[9] Many of the young people then inheriting the mess badly needed something to wake them up.

What might just do the job was Punk. Quickly expanding beyond its garage rock origins, Punk was an attitude, subculture and übercult—an anti-authoritarian backlash of nihilist aggression. It began to take hold in New York around 1973 and by the end of the decade had cultivated

not only its own abrasive sound, but also its own in-your-face visual aesthetics. Like the Hippies that came before them, the Punks, and their New Wave sidekicks, were ready to change the world, though less with peace and love than with a slap up the side of the head. To this new demographic cohort, SoHo was ten years old, looked soft in the middle— and they needed somewhere else to go. They found it on the wrong side of Broadway, in the seven by fourteen blocks beyond the Bowery known as the East Village.

Why was the gallery system failing this new generation and why had the art being shown there become irrelevant to the kids now coming of age? For one thing, money was starting to matter. The rising costs of space in SoHo meant that overheads must be covered with sure-fire saleable shows. As a result, galleries were growing cautious in the kinds of work they put up, not wanting to waste a valuable scheduling slot with untested work. Their receptivity to riskier fare diminished, and younger artists were giving up on the possibility of SoHo dealers even looking at their work, much less making space for it in their annual lineup.

Additionally, what was now being shown in SoHo no longer appealed to this younger generation of rule breakers, and they had little desire to be shown in galleries they no longer cared about. As they saw it, the dealers had shut their doors to new art, their rosters were impenetrable and, as a result, what was shown there was growing stale and tired. Just as once-radical SoHo had rolled its eyes at the uptown establishment, so the East Village began to disdain SoHo.

The new generation courted extremity and outrageousness, and they demanded forceful and immediate engagement, both aurally and visually. The optical paucity of an all-white canvas, the ephemerality of a Happening or the ethereal inertness of a quietly glowing florescent installation held little appeal for them. Earthworks seemed overly ponderous and intellectually removed, not to mention physically inaccessible, for these new urbanites, and early (black-and-white) video work was often mind-numbingly long and boring. At the same time, the pastiche of lukewarm mini isms that proliferated under the Pluralist banner (feminist art, body art, assemblage, collage, ceramic or fabric works) smacked of your mother's craft experiments, new age crystals, and ashrams. All this put the scene at a far remove from the life lived in the cheap tenement

walk-ups and the downtown clubs where the new kids crashed by day and hung out all night.

Even the alternative spaces, which had promised such experimental liberty in the early 1970s, seemed well on their way to becoming institutionalized showcases run by rich uptown boards of directors. Impatient of the stagnation, a new crop of artists coming of age to the sound of Punk rock and No Wave music, sought new outlets for their disgruntled energies, new spaces to throw together their scrappy, do-it-yourself shows and new avenues to their wide-open futures. They discovered that those avenues were, literally, between A and D in the East Village.

EAST OF EDEN

The social networks developing in the downtown clubs in the mid- to late 1970s were key to this history of the evolving East Village art scene, as were the incestuous interconnections and overlaps with music, performance, film and downtown publishing in the tightly knit neighborhood. With walk-up tenement apartments too small for throwing parties and since no one had a phone, dressing up, drinking and drug taking were done in a number of initially improvised and often illegal spaces that sprang up semi-spontaneously (or at least erratically and chaotically) around and about.

CBGB was one of the first to take root as a downtown hangout around 1974. It was also the longest to survive, only closing its doors in 2006, a year before the death of its seventy-five-year-old majordomo, Hilly Kristal. A squalid dive on the Bowery at East Second Street, CBGB-OMFUG was so called for its preferred music genres—Country, Bluegrass, Blues, and Other Music for Uplifting Gourmandizers. Kristal was willing, however, to try pretty much any band that might generate a decent door or increase the bar take. In March 1974 he booked Television, a group of juvenile crazies led by the erstwhile poets Tom Verlaine and Richard Hell. Blondie, the Ramones, Patti Smith Group and the Talking Heads were to follow and the Punk/New Wave scene was spawned.

Underground and subcultural music had had a place downtown since the late 1960s and early 1970s when Warhol's Velvet Underground and Iggy Pop and the Stooges played at Max's Kansas City on Park Avenue

and Seventeenth Street. Max's was also where the sexually ambivalent, musically challenged and technically deficient New York Dolls had first bridled against the mainstream commercialization of rock and roll.

Defiantly generating a sound that was aggressive, raw and dissonant—more noise than music—the Punk bands spat out accompanying lyrics that alternated between screams of rage, alienation and angst-ridden panic on the one hand, to boredom, estrangement and anomie on the other. Band names were as deliberately obnoxious as their members—Richard Hell's Voidoids, Lydia Lunch's Teenage Jesus and the Jerks, The Contortions, The Gynecologists, Blinding Headache, Tone Deaf—and their performance etiquette was a far cry from the alternate jazz being played around the corner at Studio Rivbea on Bond Street or the minimalist fare of Philip Glass and Steve Reich over at The Kitchen.

The audiences for this alarming performance phenomenon were visual artists and filmmakers, poets, writers, avant-garde dramatists and other habitués of the downtown demimonde occupying the rundown but cheap spaces close by. In fact, it was not unusual for a painter or performance artist, a cinematographer or poet audience member of any one night to be *in* the band that was playing the next. Jean-Michel Basquiat, Robert Longo and David Wojnarowicz all played in bands. Artist Keiko Bonk's East Village Orchestra included anyone who wanted to play (whether they could or not) and led to highly unorthodox arrangements of some thirty guitars, ten drum sets and the rest questionable vocalists. Super–8mm filmmakers documented performance artist theatrics and screened them in clubs between band sets, or showed their own fictive creations, works that operated way outside the censor in terms of language and sexuality and would have found a venue nowhere else. No Wave musicians provided the soundtracks.

CBGB was far from the only game in town, and games were pretty much what went on in the rented basement of the Holy Cross Polish National Church on St. Marks Place where underground actress Ann Magnuson's Club 57 sprang up around 1978. An unapologetically infantile extravaganza of ladies' night dress-up, B-movie screenings, slumber parties, vaudeville performances, baton twirling and glue-sniffing marathons, the subway chalk drawer Keith Haring and the cartoon king Kenny Scharf stuck artworks up on its grimy walls to the lyric

accompaniment of John Sex, with his one-foot-high hair and his twelve-foot-long pet snake. Opera diva Klaus Nomi perfected a persona that fell somewhere between Goth and extraterrestrial, and Joey Arias performed cabaret pieces worthy of the Weimar Republic. Amos Poe and James Nares screened their avant-garde films on its walls, and Nan Goldin worked out the slide sequences that would ultimately become *The Ballad of Sexual Dependency.* Costuming was covered by Manic Panic and Trash & Vaudeville, and downtown photographer Tseng Kwong Chi caught it all on camera.

Club 57 raged on until 1983 when a combination of bad to no management, costly fines for fire and noise violations and a hopelessly inadequate financial footing caused it to close. Michael Musto remembers it as "a cross between a thirties Berlin cabaret and a fifties sock hop."[10] Peter Frank and Michael McKenzie saw it more as "a sort of frat house gone wild, a playpen of fanciful make-believe."[11] The church went on to let the empty space to a mental health clinic.

By 1978 the Mudd Club had opened over at 77 White Street in a TriBeCa building owned by artist Ross Bleckner and was starting to draw the East Village clientele away from CBGB and Club 57. Funded with a $15,000 start-up by entrepreneur Steve Mass with a view to making an actual profit, it was from the start a slightly more organized affair than many of its counterparts. The Limbo Lounge, Tier 3, 8BC and the Pyramid Club were others up and down the East Village Avenues with Life Café on Tenth Street serving the coffee to sober up on.

The Mudd Club quickly caught on with all manner of creative types. Actress Patti Astor, performance artist Eric Bogosian, writer, filmmaker and crowned Queen of the Mudd Club Tina Lhotsky, and Tish and Snooky Bellomo, the sister act behind the St. Marks Place clothing store Manic Panic, were all there. Lhotsky described the crowd at the time as "one third CBGB, one third art scene, and one third uptown elite."[12] The latter included both the real uptown elite in Mick Jagger, David Bowie and members of both the Kinks and Roxy Music, but also the wannabes slumming it from north of Fourteenth Street who desperately hoped to posture enough attitude to meet the stringent door criteria.

The Mudd Club "art scene" component by this time included Kenny Scharf, Jean-Michel Basquiat and Keith Haring. Scharf was producing

garishly colored, loony-tunes spray paintings of Hanna-Barbera clones, nightmare renditions of Flintstonesesque characters and versions of the Jetson family your mother definitely wouldn't like. Basquiat, who usually showed up around 3:00 A.M. in the hope of finding a bed for what was left of the night, was in fact the incognito street artist SAMO, as in Same Old Shit. When he wasn't already too high on coke or heroin, he was working on his equally raucous but much darker and more iconoclastic, Afro-inflected street portraiture. Savagely daubed death-mask heads, often crowned, were partially obliterated by unfathomable words or phrases, themselves further obscured by jagged swaths of aggressive color. Haring's work appeared equally infantile in both its form and its content, based as it was on the rapidly scrawled compositions he was at the time scribbling, like a naughty child with a big crayon, onto the pre-prepped, ready-and-waiting blank black advertising spaces on subway platforms.

Mudd Club owner Steve Mass actually put Haring on the payroll in the hope that he would get more of his artist friends to come. Finding a third-floor space in the club empty, Haring set up an art gallery where he could show his work along with that of other downtown artists. In February 1981 he put up *The Lower Manhattan Drawing Show* in which over one hundred artists were exhibited, including everyone who had ever shown at Club 57 and a number of graffiti writers he met in Brooklyn and through the South Bronx–based Fashion Moda.

The second show featured photography by Tseng Kwong Chi, and the third was *Beyond Words,* a graffiti show co-curated by Fred Braithwaite and Lennie McGurr—aka Fab Five Freddy and Futura 2000. Train writers Lady Pink, Dondi, Phase II, Rammellzee, Zephyr, Daze, Crash and SAMO were also in it. Patti Astor, the self-styled downtown debutante and aspiring actress was at the opening party, where she met filmmaker Charlie Ahearn, who was about to put his graffiti story *Wild Style* into production. Mass fired Haring immediately after the show's opening owing to complaints across the neighborhood from property owners whose buildings had been tagged during the night. "I don't know what he thought would happen," complained Haring. "I mean there were like hundreds of the best writers in the city at the Mudd Club that night."[13] Graffiti art had come off the trains and into a gallery, albeit a woefully make-do one.

The work of a number of graffiti artists had actually been shown five years earlier when the SoHo-based Artists Space presented the street mural, metal security gate and subway car graphics of a group that called themselves the United Graffiti Artists. The exhibition received a degree of critical attention but in 1975 it was still too early for the new art form to be recognized as a movement.

The graffiti problem itself had been around since at least 1968 when Julio 204 and later TAKI 183 started working the trains, styling themselves with the numbers of the Manhattan streets from which they operated. They started with the subway car interiors, moved to the exteriors and then bombed entire lines with their incendiary graphics, working right in the train yards and directly under the noses of the incensed transit authorities. Once a train's exterior had been tagged, the writer's fame literally traveled across all five boroughs of New York City.

As the Koch administration poured $6.5 million taxpayer dollars into eradicating the vandalism, skill *and* speed became paramount. Danger and lawlessness were always a part of the draw as most writers knew they had only until the age of twenty-one to make their mark; after that they were sentenced as adult criminals rather than juvenile offenders. When Fab Five Freddy replicated Warhol's *Campbell's Soup Cans* on the side of the Lexington Avenue No. 5 train, the crossover from adolescent urban vandalism to art world notoriety was well underway.

By this time—early 1981—the art scene in the East Village was beginning to draw comments, not necessarily favorably, from art world cognoscenti, and a spate of aesthetically aggressive and wildly improvisational shows had recently caught the attention of those who eyed the cutting edge. In 1977 a politically active group calling itself Collaborative Projects (or Colab) had banded together, initially to pool their grant-seeking and fund-finding expertise. Colab went on during a number of membership changes and shape-shifting identities to initiate a variety of important East Village arts events including four hastily mounted and chaotically installed exhibitions in the last days of the '70s. These shows—*Income & Wealth, The Manifesto Show* and *The Real Estate Show,* all of 1979, and the *Times Square Show* of the following year, put the raw and raucous East Village art scene on the radar of those feeding both serious art world critical discourse and the popular press.

The *Times Square Show* was the most infamous of them all. Running through the month of June 1980 in a four-story tenement building on Seventh Avenue and Forty-First Street, it was organized by artists John Ahearn (who persuaded an unsuspecting landlord to lend them the space for free) and Tom Otterness. Stefan Eins and Joe Lewis of the South Bronx entity Fashion Moda were also involved. Installed in a former massage parlor in one of the least salubrious, pre-Giuliani parts of town, the show included more than a hundred artists working in every medium including Keith Haring, Kenny Scharf, Jenny Holzer, Kiki Smith and Jean-Michel Basquiat (still working as SAMO). Christy Rupp sculpted rats foraging through garbage, Jane Sherry mounted exposed breasts with the words "cunt" and "whore" daubed around them, Kathleen Thomas showed a spiked, rubber skinned dildo and Jane Dickson painted onto garbage bags. Air-conditioning units were big and featured in pieces by both Scharf and Dick Miller while Tom Otterness provided a punching bag backed by a chalkboard inviting public comment. Running the gamut from sex toy sculpture to wall graffiti and freewheeling scatter installations, Frank and McKenzie quipped "the Times Square show hit like a dose of free-based cocaine."[14]

Ironically, the person who did most to put the show on the art world map and break open the Pandora's box of East Village evils was neither an established critic nor an East Village commentator already au fait with the messy new aesthetic. It was Jeffrey Deitch, then an investment advisor working on Park Avenue for Citibank's Private Banking Group. Deitch, reviewing the *Times Square Show* for readers of *Art in America,* described in dazed astonishment "an aggressively unkempt exhibition at the epicenter of vice land."[15] The copious installation shots surely looked like nothing this seemly art world journal had ever shown before. As Phoebe Hoban put it, "The birth of the eighties art movement could not have found a more appropriate crèche for its unimmaculate conception."[16] Lucy Lippard, in October's issue of *Artforum,* sniffed and titled her review "Sex and Death and Shock and Schlock."

In February 1981 Mudd Club cofounder, curator, writer and all around art world intellect Diego Cortez drove the East Village nail home with an exhibition entitled *New York/New Wave*. Although he had originally planned the exhibition as a series of shows for various European

locations, Cortez ultimately succeeded in getting a portion of his concept mounted at Alanna Heiss's PS1 in Queens. Including the work of some twenty-five artists previously associated with Club 57, the show also had graffiti murals, pieces by the rock stars David Byrne and Brian Eno and documentary photographs of CBGB and the Mudd Club. Robert Mapplethorpe was included, and Basquiat had fifteen works in the show.

Drawing with what seemed like intuitive insight from the cacophony of forces that had all in their way been responsible for the spawning of the East Village aesthetic, Cortez brilliantly cajoled the scrappy, mismatched, multimedia hodgepodge into a cohesive phenomenon and spread it out before a flabbergasted art world. As Steven Hager rightly observed, the show was widely misunderstood and misinterpreted by the critics at the time and received far less praise than the *Times Square Show*. [17] But history proved Cortez's exhibition to be a prescient encapsulation of a phenomenon that had been a decade in the making but was still a freshly spawned monster.

By this point in mid-1981, the raw energy and raucous creativity that had led to the genesis of so much painting, sculpture, installation and other visual art product had found its way into clubs, improvised exhibition venues, alternative spaces and now the published art world press. There were, however, still no commercial galleries showing East Village art, not in SoHo, not on Fifty-Seventh Street, nor in the East Village itself. Alternative spaces were beginning to disappoint and, as Alan Jones observed, "The reduction in federal funding weaned the art world away from grantsmanship and touted supply-side entrepreneurship which the East Village took to heart." [18] The cacophony of objects and visual material now tumbling out of the walk-ups, basements and back rooms was ripe for more organized display, pricing and, who knew, perhaps even sales. Would this iconoclastic new art ultimately be adopted by the now well-primed SoHo gallery machine to the west, or would new outlets open up on native turf?

6

DECADE OF DECADENCE

SoHo 1980 to 1990

"Parties at fun-house discos, dinners at clubish restaurants, and, more tellingly, group exhibitions mounted on every imaginable pretext found broad-brush mythmongers shoulder to shoulder with deconstructors of late-capitalism, graffiti writers from S. V. A with hardcore minimalists from Yale."

—Robert Storr, *Devil on the Stairs: Looking Back on the Eighties*, 1991

*T*hat well-primed SoHo machine to the west of Broadway was itself about to get a fresh infusion of new blood. By 1980, Castelli was in his seventies, Sonnabend and Karp in their mid-sixties and even the radical new women dealers Holly Solomon and Paula Cooper were over forty. Their programs were still cutting edge, but they were also increasingly blue chip. As the shiny new decade dawned, several younger gallerists were ready to strike out on their own

The twenty- to thirtysomethings of this early 1980s art world were born in the early to mid-1950s. They were the first television generation, raised on cartoon characters and superheroes. They were the packaged goods generation, little consumers from the get-go, sure of their entitlement to a well-stocked life. And they were an image-conscious generation enthralled by magazine gloss and Hollywood pose. Generally too young for Vietnam, but college educated in the

liberal arts in the late 1960s and with few economic responsibilities during the mid-1970s malaise, a number of young staffers were ready to graduate.

BUILDING EMPIRES AND CROWNING KINGS

Mary Boone opened her downtown gallery in 1977 and is still generally regarded as the principal shifter of the SoHo paradigm from a '70s to an '80s ethos. Though hardly alone, it was she who pioneered the next wave of art movements, redefined the practices of the profession and altered the rules of the art-dealing game. She was the first to actively presell bodies of work before the exhibition opened to the public, and she replaced the discreet red wall dot next to a work that traditionally labeled it sold with the vainglorious name of the grateful purchaser. She shamelessly screened the pedigree of collectors before even granting them access to her art stars, and she created waiting lists for works that had yet to be produced by the now-pressured artist.

She forged lucrative links with a network of established international dealers including Switzerland's Bruno Bischofberger, London's Anthony d'Offay and the German Michael Werner, whom she married in 1986. In April 1982 *New York Magazine*'s Anthony Haden-Guest crowned her "The New Queen of the Art Scene." Even *Artforum*'s Thomas Lawson gave her awestruck credit for moving "beyond hyping her artists, beyond hyping herself, to hyping the idea of hype."[1] Thirty years on, in what was purportedly a revisionist take on the softer, kinder Boone, W magazine still characterized her as "the dealer who epitomized the hard charging excesses of the Eighties art market."[2]

Boone trained in studio art at the Rhode Island School of Design and then studied fifteenth-century Italian art history at New York's Hunter College. She intended to become an artist but soon sensed that she might have a greater flair for selling art than for making it. Recommended by a former teacher, the sculptor Lynda Benglis, she started out in 1973 working as an assistant to Klaus Kertess at Bykert Gallery. She left in 1975 to trade privately and made some nice commissions selling respected artists like Brice Marden and Chuck Close. What she was really waiting for, however, was something entirely new.

In 1975, Boone recognized the power of Ross Bleckner's work just from looking at his slides. Its departure from the austere forms of the still-prevailing Minimalism was striking. Textured and gestural without the canvas-flattening abstraction of the Action Painters, it was filled with hovering but tangible forms. Even if they did not always quite cohere into figurative or representational presences, psychological narratives were implied.

Through Bleckner, Boone met Julian Schnabel and was even more taken aback by his iconoclastic form and the near heretical content of the gargantuan, multicolored cacophonies. "Schnabel's painting was figurative and awkward, going against every current view of what was beautiful," Boone remembers. "The raw physical canvases were almost badly made; the stretchers didn't have the right corners, and the pictures themselves were ungainly and garish, to say the least. They were totally outlandish."[3]

At Artists Space that same year she saw the plane-shifting, over-laid figurative pastiches of David Salle for the first time and was again shocked by their unorthodoxy. Salle's thinly applied paint countered Schnabel's heavy Gaudiesque impasto, and his brashly contemporary physiques dissed Bleckner's moody mysticism.

Like the legendary Castelli before her, Boone intuitively understood that she had no appetite for arriving late to a movement. Her gift was for spotting fresh, young talent and having the guts to back it. Financing her operation with an unusual arrangement of syndicated partnerships, she took the tiny, but heavily foot-trafficked space on the ground floor of 420 West Broadway. Critics and collectors would practically trip over her on their way to her veteran neighbors upstairs. Their '50s Greenbergian Abstraction (Emmerich), '60s American Pop and European Arte Povera (Castelli and Sonnabend) and '70s Minimalism (Weber) were nicely rounded out with her newcomers of the 1980s.

Boone opened her gallery on West Broadway in late 1977. She had discovered her three young protégés two years before that, but she was initially unsure about what to make of the startling new work and took her time letting it settle on her eye and gestate in her mind. It was not until early 1979 that she began to show her new young painters. In February she showed Schnabel for the first time, selling out the show

before it even opened, and in June she put Bleckner into a group show. Once in motion, Boone moved at breakneck speed in promoting her discoveries.

In 1980 she included Schnabel in a September group show and then showed him solo in November. She followed in December with Bleckner and in April brought both Schnabel and Bleckner out again and added Salle to the lineup. Cautious at first, once she committed to an artist, Boone carried through with absolute conviction. In 1982 alone, she saw to it that Schnabel was included in twenty-two group and eight solo shows at venues including London's Tate Gallery and the Stedelijk in Amsterdam. In May 1983 the barely thirty-year-old artist's *Notre Dame* sold for $93,400 at Sotheby's, $40,000 above the auction estimate.[4]

At the same time, Boone was not about to put all her eggs into one programmatic basket and alongside these three new finds, she was also trying our other artists for size. In her closing show of the 1979–80 season she gave the up-and-coming Jeff Koons an exhibition and in the new decade put up both Matt Mullican and Troy Brauntuch, artists out of Helen Winer's program at Artists Space. Eric Fischl, the painter of taboo suburban eroticism, was exhibited in October 1984 and by the mid-1980s Boone was acknowledging the sea-changing importance of both Barbara Kruger's new feminist polemics and the appropriationist audacity of Sherrie Levine.

In 1985, at the urgings of the Swiss dealer Bruno Bischofburger, Boone also showed the East Village wild child Jean-Michel Basquiat, becoming what Phoebe Hoban would describe as "the next in Basquiat's revolving door of dealers."[5] The relationship between the inexhaustible and meticulously organized dealer and the volatile and self-destructive boy child ran a strained course for about three years.

By 1981 the limits of the ground-floor space in 420 West Broadway had already forced Boone to share a Julian Schnabel show with her more capaciously housed neighbor Castelli who had the space to hang the heroically scaled works her artist was now churning out. In September Boone expanded and moved to 417 West Broadway, a dramatically renovated former truck garage, directly across the street from 420 and still very much on the beaten art world path. Since Schnabel's prices alone had risen from $4,500 in 1979 to $15,000 just two years later, the

young dealer looked as if she would be good for the rent as well as the champagne tab at downtown's trendy Odeon restaurant.

Meanwhile, beyond the limits of SoHo's West Broadway galleries, the early years of this new decade saw the exhibition programs of a number of important European museums start to claim the attention of the New York art world. Perhaps they were jolted awake by the Guggenheim's 1979 exhibition of the art of the great German iconoclast Joseph Beuys and both the German pavilion at the 1980 Venice Biennale and the Italian painters showing in its Aperto section were noted by the art savvy. *A New Spirit in Painting,* the 1981 exhibition at the Royal Academy in London and Norman Rosenthal's Berlin-based *Zeitgeist* were also much talked about, as was Rudi Fuchs's *Documenta 7* in Kassel, Germany. Back in New York, the Guggenheim completed the cycle of Euromania with Diane Waldman's 1982 *Italian Art Now.* The names of the Italians Francesco Clemente, Enzo Cucchi and Sandro Chia (the so-called Three C's) as well as the German painters of postwar angst— Sigmar Polke, Anselm Kiefer and Gerhard Richter—soon became de rigueur around the New York art world. Their work was exhaustively covered, for and against, in a newly influential roster of scholarly art journals like *Artforum, Flash Art International* and Columbia University's *October.*

The Italian wing of this new Neo-Expressionist or Transavanguardia school—Clemente, Cucchi and Chia—had returned to figurative painting but not always in narrative or strictly representational ways. Heavily laden with enigma, mythmaking and the surreal, the work often hovered between the explicit and mere allusion, between motif and abstraction. Usually large in scale and often grandiose in subject, the cacophonies of heavily impastoed paint and Mediterranean color held enormous appeal for an art world suffering near starvation from the strict Minimalist diet of the last decade.

The heroically scaled canvases of the Germans Polke, Kiefer and Richter bore some formal similarities in their use of paint-laden surfaces and riots of barely cohering imagery. The themes they addressed, however, were vastly different, often having to do with the reconciliation of the current German Wirtschaftswunder, or economic miracle, with the trauma of its postwar guilt. The painterly techniques they used and the

palette they deployed to reach these ends conjured a German Sturm und Drang and posed a sobering counterpoint to the Italian euphoria.

The Sonnabend Gallery, by now in its second decade, had always been strong in representing the Europeans, and throughout the 1980s Ileana continued to exhibit the raw figurative imagery of the East German Neo-Expressionists A. R. Penck, Jörg Immendorff and Georg Baselitz. Penck was at that time creating his primitive pictograms and rough-hewn totemic sculpture, and Immendorf was making paintings that were heavy with symbols and infused with German history. Baselitz had already discovered his signature style of turning roughly rendered figurative imagery upside down. These new appetites were, of course, not lost on Mary Boone. By the 1982–83 season she was already onto Kiefer and Clemente while still maintaining her Americans Bleckner, Schnabel and Salle. Jörg Immendorff and Georg Baselitz joined their European counterparts at 417 West Broadway in the spring of 1984, and in the fall Boone added Enzo Cucchi and Sigmar Polke.

Three blocks away from West Broadway at 142 Greene Street, another forceful personality was doing her part to ensure that this Neo-Expressionist movement, so emblematic of the 1980s, was given its due. Opening in 1975, a year or two ahead of Mary Boone, Angela Westwater had been an advocate of the strong contemporary European art from the outset, no matter that it was then too rarely seen and too little appreciated in the United States. With her links to the European dealers Gian Enzo Sperone and Konrad Fischer, Westwater staged some of the earliest expositions of Italian and German artists not yet heard of in New York. Her 1977 *Aspects of Recent Art from Europe* featured Joseph Beuys and the Greek-born Italian Jannis Kounellis. It was Westwater who gave Gerhard Richter his first US solo exhibition in 1978, and in 1979 her Mario Merz exhibition introduced the late-'60s Arte Povera movement to the increasingly important 1980s New York market.

Westwater started out in the art world in the fall of 1971 by taking an entry-level position with John Weber at 420 West Broadway.[6] Running around the galleries across the city looking at what was new, she met John Coplans, then one of the West Coast editors of *Artforum*. After Coplans moved to New York in 1972, he offered Westwater an editorial role at the magazine. She worked there for three years, traveling to

Europe with artists like Carl Andre who had a show opening at London's Tate Gallery, stopping off in Düsseldorf to see work by Marcel Broodthaers and attending a champagne party given for Gilbert & George by Konrad Fischer. It was at *Documenta 5* in Kassel in 1972 that she first looked closely at Bruce Nauman's elliptical corridor pieces.

In 1975 Westwater took 4,700 square feet at 142 Greene Street and made Richter, Clemente, Cucchi and Chia core to the Sperone Westwater program. She was also responsible for introducing '80s SoHo and so, by definition, the American art world, to the strangely haunting wall text and pebble, twig and rock installations conceived by the British artist Richard Long during his marathon lone walks through the English countryside.

At the same time Westwater was also alert to groundbreaking American work despite, or perhaps because of, unorthodox new forms. As early as 1976 she began exhibiting Dan Graham's boundary-defying glass and mirrored pavilions, glistening investigations into inside/outside. Bruce Nauman's genre-busting work, incorporating film, photography, performance and sculpture, every one of them distress inducing, were also shown. The Expressionist painter Susan Rothenberg was also represented by Westwater; by the 1980s her staccato renderings of equine forms emerging frontally from ghostly backgrounds were starting to give way to an exploration of the human figure.

Metro Pictures was launched by Helene Winer and Janelle Reiring on Mercer Street in 1980. After two years in their first space, the gallery moved to larger premises at 150 Greene just below Houston. Winer, an art history major out of the University of Southern California, already had a well-respected history of groundbreaking curatorial programming as the former executive director of Artists Space. She had curated shows at Pomona College and the Los Angeles County Museum on the West Coast as well as at the Whitechapel Gallery in London. Janelle Reiring had a liberal arts education but learned her art history (and the art business) by apprenticing for five years with Leo Castelli. In all probability both women could have more than successfully maintained their existing career trajectories within the folds of these respected organizations. But the siren's call of an oddly new art phenomenon prompted them to open their own gallery.

In 1977, while she was director of Artists Space, Helene Winer had mounted a modest show of five out-of-town artists curated by the scholar and writer Douglas Crimp. The show was called quite simply *Pictures* and it included pieces by Troy Brauntuch, Jack Goldstein, Sherrie Levine, Robert Longo and Philip Smith. The work was wide ranging in terms of the form it took, but what held it together as an intriguing group show was imagery largely scavenged from readily available media visuals. Longo's writhing club hipsters were culled from the downtown glossies and Sherrie Levine's *After Walker Evans* photographs were just that—re-photographed photographs. Working from borrowed, copied or replicated imagery, the *Pictures* artists interrogated not just the image itself but the context in which it was being presented. As Jerry Saltz was later to quip, "They seized the means not of production but of reproduction."[7]

Although they were not included in the Artists Space exhibition, also intriguing to Winer and Reiring were the self-styled mock film stills of the retro dressing Cindy Sherman as well as the Marlborough Man cigarette imagery re-cycled and recast by the older but under-appreciated Richard Prince. This brazen appropriation of extant imagery challenged received notions of originality and authenticity in a way not seen since Duchamp had signed a factory-produced urinal and called it a Readymade. At the same time, the work posited wry critiques of the contemporary manipulation of social identity. It suggested to a generation of baby boomers that the media on which they had gorged since infancy was no longer merely a scribe recording the life lived, but rather an auteur, determining and dictating it. The media machine, once the image taker, had become the image maker.

These artists and several others working in the soon-to-be-labeled Appropriationist vein had been on Winer and Reiring's intellectual radar for some time. Several had arrived recently from Buffalo, New York, where a core had been involved in the Hallwalls alternative space initiative. By virtue of their West Coast connections, they had stayed apprised of the legendary California Institute of Arts sage John Baldessari and the graduates of his so-called Post Studio classes. By the 1970s CalArts, as it was familiarly known, had surpassed Yale and several other of the East Coast academic powerhouses in the estimation of many on the art

world's cutting edge. Its '70s novitiates included Brauntuch, Goldstein, Mike Kelley and James Welling as well as the painters Ross Bleckner, David Salle and Eric Fischl. Famed for pressing his students to move beyond the proliferation of even more studio-produced objects, yet impatient with the increasingly exhausted tenets of '70s Conceptualism, Baldessari called for art that stopped looking backward at its own history but rather scrutinized the here and now.

While the *Pictures* show was appreciated at the time by a certain inner circle of Artists Space, White Columns and PS1 cognoscenti, it went largely under the radar of the broader art world. Two years later, however, Crimp revisited the work in an updated and expanded version of his exhibition catalogue essay and published it in the theory-infused *October* magazine. Adding Cindy Sherman's photographs to his analysis, Crimp contextualized this audacious new work, launching a movement that ran directly counter to the prevailing mythology-laden, allegory-intense paintings of the Italian Transavantgardia or the German Neo-Expressionists.

By 1980, when Winer and Reiring opened their SoHo gallery to show these radical products, the pedagogical influence of a cohort of New York–based academics was already permeating the downtown art scene. Crimp was but one of an increasingly lauded coterie of critical thinkers currently teaching at the School of Visual Arts, CUNY's Center for Graduate Studies, Hunter College or Columbia University; the group included professors Rosalind Krauss, Benjamin Buchloh and Craig Owens. Under their tutelage, postgraduate interest in French critical theory surged, and figures such as Roland Barthes, Jacques Derrida, Michel Foucault, Julia Kristeva and Jacques Lacan became virtual cult figures.

The Whitney Museum's Independent Study Program, under the leadership of Ron Clark, rolled the new intellectualism into the museum world and the trend was aided and abetted at the more cerebral end of the art press spectrum when Ingrid Sischy took up the editorial reins at *Artforum* in 1980. In the decade's opening years, *Art in America* ran a whole series of articles on this "deconstruction" of meaning by writers such as Hal Foster and Craig Owens. Scholarly discourses on "Postmodernist Theory" appeared in all manner of arts journals throughout the early 1980s, and the Postmodernist model began to find its way into art

world parlance, taking over from the Pluralist paradigm of the previous decade.

By November 1981 Andy Grundberg was imposing Postmodernism on the general public in reviews for the *New York Times*. Although much ink was to be spilt throughout the rest of the decade debating exactly what the term "Postmodernism" meant—indeed, many of the artists themselves later confessed to not having understood a word of the theory babble—in retrospect, the essential elements of the newest ism were all there in the Metro Pictures opening show of November 1980.

The exhibition was made up of twelve of the *Pictures* artists, including Sherrie Levine, Laurie Simmons and Cindy Sherman. Each one of the twelve was then given at least one solo show over the next five years, as were Louise Lawler and Mike Kelley. It is perhaps ironic that, having culled their imagery from popular culture in the first place, Cindy Sherman's posed, psychodrama B movie *Film Stills* or Robert Longo's maybe-dancing or maybe-mugged *Men in the Cities,* ultimately passed back into the societal image bank and became emblems of the 1980s that even those well outside the art world began to recognize.

Metro Pictures went on later in the decade to mount important historical shows of mythical figures including sculptor Eva Hesse and bad-boy polymath Martin Kippenberger (both died tragically young). The gallery was also an early exhibiter of some of the conceptual artists coming out of the East Village like Peter Nagy, Alan Belcher and Gretchen Bender. The Metro Pictures program continued to evolve and flourish into a third decade of leading-edge art exhibition; throughout, Winer and Reiring have been anxious to resist the group packaging of their artists or too narrow a definition of their program. Like it or not, however, their first fame came in the 1980s for the launching of "The Pictures Generation."

Barbara Gladstone first opened on East Fifty-Seventh Street in 1979 after teaching art history at Hofstra University on Long Island and realizing that she was more drawn to the notion of talking to living artists than she was to lecturing on dead ones. When Gladstone's friend Diane Villani grew restless in her role at the Martha Jackson Gallery, the two went into partnership as Gladstone-Villani in a modest starter enterprise

dealing in works on paper. "The gallery was the size of a shoe box" Gladstone reminisced, "and the rent was $700 a month."[8]

Trading the work of a breadth of different artists left Gladstone feeling dissatisfied, however, and in 1980 she and Villani went their separate ways. Villani continued in works on paper, going on to become a highly respected publisher of limited edition prints, a status she retains today. Gladstone, with just a year of business experience behind her, set up in a slightly larger space across Fifth Avenue on West Fifty-Seventh Street. There she began to focus on the discovery and development of a smaller cadre of talent, identifying and encouraging the work that mattered and nurturing artists through transitional periods as they matured. With collectors, too, she took a long-term view, converting them one by one to the art she believed in.

In 1983 she made her move to SoHo and 152 Wooster Street, across from Paula Cooper, and expanded again two years later into bigger premises at 99 Greene Street. "Every time I could absorb a little more, I moved and the gallery would grow bigger," Gladstone remembers. "Each time I felt able to take on more, I just took it on as I could: it became a kind of organic growth."[9] By early 1988 Roberta Smith was reviewing Gladstone's program on a regular basis and labeling her "one of SoHo's hottest galleries."[10]

Gladstone had been representing rule-breaking Americans like Jenny Holzer and Richard Prince since her Fifty-Seventh Street days. Throughout the 1980s and into the '90s she again stepped up to both politically engaged art (Leon Golub and Nancy Spero) and socially provocative work (Vito Acconci, Robert Mapplethorpe, Hans Bellmer and Sarah Lucas). As early as 1991 she recognized the mesmerizing power of Matthew Barney's self-torturing, transsexualized personas and was key to the coming to fruition of Barney's epic, ten-hour, five-film, *Cremaster Cycle*.

As Gladstone's enterprise grew and she traveled internationally, she added a roster of European artists to her stable. Like Ileana Sonnabend and Angela Westwater, she recognized the power of the Italian Arte Povera movement as early as 1983 and lamented its inadequate exposure in the United States. Over the course of her years in SoHo, Gladstone also showed important work from Germany (Gerhard Richter, Imi Knoebel,

Stephan Balkenhol and Rosemarie Trockel) and England (Anish Kapoor, Gary Hume, Rachel Whiteread, Damien Hirst and Marc Quinn) as well as giving American debuts to a number of French, Swiss and Austrian artists.

Two other dealers crucial to the history of the era's art, Tony Shafrazi and Annina Nosei, also opened important spaces in SoHo at the turn of the decade. Shafrazi, an Iranian-born, English-educated and Royal College–trained art world dandy, thrived on the self-promoted legend of having met Warhol, Lichtenstein and Castelli all within twenty-four hours of getting off the plane from London in the swinging summer of 1965. He then gained notoriety in 1974 for spray painting Picasso's great anti-Spanish Civil War masterpiece *Guernica* with the words "KILL LIES ALL"—right under the (insufficiently) watchful eyes of the horrified guards at the Museum of Modern Art.

While he had spaces at both 163 Mercer and 119 Wooster Street, Shafrazi's real influence in the 1980s was based less in SoHo than it was in the East Village scene developing on the other side of the Bowery. There he was one of the first to discover the raw talents of Keith Haring, Kenny Scharf, Ronnie Cutrone and Jean-Michel Basquiat. It was the Tony Shafrazi Gallery in SoHo that exhibited Basquiat's collaborations with Warhol in September 1985; Jean-Michel's unruly scribbles overlaying Warhol's pristinely silk-screened symbols and logos, the whole extravaganza advertised in the now iconic poster of the two artists tricked out in Everlast boxing shorts and gloves. The show was excoriated by Eleanor Heartney in *Flash Art* and by Vivien Raynor in the *New York Times*.

Fairly or not, it is with Basquiat as well that Annina Nosei is most lastingly associated. Fairly in that she was one of the first to back the wildly color-daubed but heart-stoppingly vital graphics of the young street urchin; unfairly in that she represented and nurtured many other important artists besides. The Italian-born, PhD-educated Nosei started her career in the art world working for Ileana Sonnabend in her Paris gallery in the 1960s. She came to America on a Fulbright in 1964 and met John Cage and Robert Rauschenberg, who put her in touch with the 420 West Broadway dealer John Weber. Through Weber, whom she ultimately married, she was exposed to the Minimalists LeWitt, Flavin

and Andre but also to the Earthworks artists Robert Smithson, Michael Heizer and Walter de Maria.

She kept her connections with the European scene by staying abreast of what Sandro Chia, Francesco Clemente and Mimmo Paladino were doing in Italy. In 1979 in a semiprivate loft on West Broadway, and with some help from a West Coast transplant and newcomer to the SoHo art world called Larry Gagosian, she showed painter David Salle as well as the Pictures artists Troy Brauntuch and Richard Prince. She gave Barbara Kruger her first solo exhibition in 1982.

Nosei had first looked at Basquiat's work on the recommendation of Sandro Chia and had been drawn to it immediately. The landmark 1981 PS1 *New York/New Wave* show in Queens, however, convinced her of the artist's power and she decided to pursue this unruly talent. Offering the young vagabond funds for art supplies, a first-ever semipermanent home in a loft space at 101 Crosby Street and studio space in the basement of her gallery at 100 Prince, Nosei embarked upon what would be both a troubled and a troubling relationship with the infuriatingly complicated Basquiat.

Points of view varied widely (and still do) as to whether Nosei was in fact reaching out to a tragically self-destructive genius in the hope of saving him from himself or trying to wring works of art out of him at an uncontrolled rate by closeting Basquiat in her basement and fuelling him with cocaine and heroin. In any event, she was one of the first to buy his work and to place it with significant collectors, often insisting that a client add a $1,500 Basquiat painting to their $25,000 shopping cart of work by other artists. Soon all of the era's top collectors were coming to the gallery and going downstairs for a studio visit as Basquiat's prices rose to $5,000 and then $10,000 a painting.

In October 1981 Nosei included Basquiat in her *Public Address* exhibition alongside Jenny Holzer, Barbara Kruger and subway graffiti artist and fellow East Village scenester Keith Haring. In March 1982 she gave him his first one-person exhibition in the United States, to (largely) rave critical review, and mounted a second and then a third solo in 1983 and 1985. Although Basquiat also had a gallery relationship with Mary Boone at that time and had a show there in 1984, even Boone acknowledged that the best work was done during his time with Annina. Despite

a tumultuous and drama-ridden relationship with the mercurial youth, Basquiat's work was included in her group exhibition program on an almost annual schedule until 1985.

FEEDING FRENZY

By the end of Reagan's first term in 1984, the recession-crippled '70s had become just a bad economic dream, and other leading indicators—political, social and cultural—suggested the dawning of a new gilded age. An upwardly mobile postwar generation was entering its own belle époque with aspirations to collect, and they had the money to do so; by the end of the decade, the United States would have 1.5 million millionaires. Even if ready cash was not in hand, contemporary art was now an investible asset and, as such, collateralized loans could be secured for its purchase. Citibank had even created a special department to deal with the new market, appointing the Harvard MBA, downtown art world flâneur Jeffrey Deitch as its head. And for those recently arrived at the trough and unsure of the etiquette, a newly evolved professional, the art adviser, had emerged to mediate between the dealer, the auction house, the banker and the fledgling collector.

It was in the afterglow of Basquiat's meteoric rise that attention started to be focused on the fame, fortune and foolishness with which the downtown art world was now awash. As Phoebe Hoban observed, "It was a decade when the rags-to-riches routine—from Wall Street to SoHo—could virtually be accomplished in a nanosecond, a period that was saturated with success stories, from Ivan Boesky and Michael Milken to Julian Schnabel and David Salle."[11] On February 10, 1985, Basquiat, dreadlocked, barefoot and decked out in paint-splattered Armani attire, appeared on the cover of the *New York Times Magazine*. The accompanying article by Cathleen McGuigan, "New Art, New Money; The Marketing of an American Artist," named names, quoted numbers and placed Basquiat's dazzling rise at the epicenter of the decade's brave new art world. Diva dealers, in-the-know collectors, celebrity status artists and the haunts they frequented were all put on the downtown map. Mary Boone, Angela Westwater, Metro Pictures, Tony Shafrazi and Annina Nosei were all featured in the piece, as were Swiss

dealer Bruno Bischofberger and Nosei's Italian counterpart Emilio Mazzoli. McGuigan dropped such collector names as candy tycoon Peter Ludwig and publishing magnate S. I. Newhouse as well as film star Richard Gere and songwriter Paul Simon.

Schnabel, Salle and Longo were considered particularly hot as were the Three C's, Clemente, Cucchi and Chia. McGuigan noted the market relief at the demise of collector-hostile Minimalism, Conceptualism and Earthworks and an all-around celebration of the return of the purchasable object. She astutely called it when she noted, "For many new art patrons, connoisseurship of contemporary art is a necessary part of the urban life style. They look for paintings that are aesthetically aggressive, that physically assault space. The artworks offer proof of up-to-the-minute taste and have a perfect showcase in the reclaimed lofts or gentrified houses in which so many upper-middle class urbanites now live."

The decade opened in May 1980 with modern and contemporary sales grossing $55.8 million at the auction houses, beating all previous records. Cosmetics magnate Leonard Lauder and a consortium of Whitney Museum trustees paid $1 million for a single painting— Jasper Johns's 1958 *Three Flags*.[12] In 1983 Alfred Taubman (soon to be a convicted felon) purchased the British auction house Sotheby's while maintaining his seat on the Whitney board, with no apparent qualms as to conflict of interest. By then the art market in New York alone was estimated at $2 billion.[13] In 1987 Van Gogh's *Sunflowers* went to a Japanese corporate collection for $39.9 million, nearly three times its previous record, and the artist's *Irises* sold for a staggering $53.9 million, of which $27 million was borrowed from Sotheby's.[14]

By 1988, publisher S. I. Newhouse had to pay $17 million for a decent Johns (*False Start,* 1959) and Sotheby's was making 10 percent of its income from interest on loans, some of which were as much as 50 percent of the hammer price.[15] Potential purchasers, flush with the auction house's loan largesse, bid prices far higher than they might have without the funding, further increasing auction house commissions. In this red-hot market, sellers bypassed dealers and went straight to auction in the expectation of better profits. Some even suggest that artists' dealers bid against collectors to raise the numbers even higher and ensure an inflated hammer price on market-setting public record.

Even those who stood to gain from the feeding frenzy feared that the situation was getting out of hand. Dealer Richard Feigen had been around long enough to understand that "it didn't do anybody any good to have artists like Basquiat who had sold for ten to thirty thousand selling for six figures." In his view "Richard Bellamy or Leo Castelli would have demanded a substantial body of work before promoting him to such a star status."[16] Of Basquiat, Salle, Schnabel et al., Sotheby's Lucy Mitchell-Innes lamented that "much of the work should never have left the studio. It was unedited. The dealers were greedy and undisciplined about it, and the artists were just as greedy as the dealers for their sales."[17] Even the guilty parties were growing uncomfortable with their brigand status. Mary Boone herself cringed at the new breed of collector who was in it for all the wrong get-rich-quick reasons. "They buy art like lottery tickets," she said. "I used to have fifty collectors and suddenly it was five hundred . . . Second- and third-rate artists would sell. *Anything* would sell."[18]

When the art market crashed in the early 1990s, many condemned Boone for her part in inciting an overheated climate and accelerating rampant price rises. Her detractors accused her of overpromoting her artists and releasing inferior works onto the market in order to meet collector demand. However, Boone also stood by her artists during the sickeningly steep plunge in their prices, ensuring that they could afford to continue working.[19] Artists left other galleries to join her, but she did not actively raid talent nurtured by other dealers, and she had her own fair share of defections as artists she had championed left for better deals.

Whatever the perceived value of the art, the money-fueled artist himself had by now certainly become a veritable '80s deity. "In the 80s," said critic and curator Bob Nickas "you had the feeling that an artist could be as famous as a sports figure, a movie star, a rock star. They often ended up at the same parties."[20] "Julian would have these big movie-star parties," remembers artist Peter McGough, and his partner David McDermott added, "The collectors, they had to buy in order to go to those parties. Otherwise they didn't get into that scene. If they wanted to have a great social life, they had to buy art."[21] Clemente and Basquiat were now downtown aristocracy and passed with the greatest of ease

through hoi polloi–screening velvet ropes to see their own mural-sized work installed over the bar at trendy clubs like Palladium.

Palladium was the new offering on East Fourteenth Street from Steve Rubell and Ian Schrager of Studio 54 fame. They opened in 1985 after fulfilling, as Calvin Tomkins so gleefully put it, "an inconvenient obligation on their part to spend time in the slammer for tax evasion."[22] With uncanny prescience, they hired the highly innovative Arata Isozaki, an architect who was famous in Japan but, before his yet-to-be-built Los Angeles Museum of Contemporary Art, was relatively unknown in the United States. Equally shrewd was their unearthing of the near-derelict, sixty-year-old Academy of Music building. At various times an opera house, ballroom, burlesque theater, movie house and rock music space, it was one of the very few old, large public halls not to have been subdivided or torn down entirely.

With daring élan Isozaki left much of the dilapidation intact while inducing awe in even the venerable Tomkins with the creation of "a pristine, monumental grid of pilasters and a vast central arch, seven stories high; he used the old mezzanine for seating space, and brought in several tons of state-of-the-art lighting, video and audio equipment to blow the eye, the mind, and if anything went wrong, most of the electric circuits in Manhattan's lower quadrant."[23] Even architecture critic Paul Goldberger was seduced.

Recognizing that New York City night life was shifting from the singles bars of First Avenue to openings at the funky new art galleries on Avenue A, but knowing nothing about art themselves, Rubell and Schrager put curator, writer and all-around art worlder Henry Geldzahler on their payroll. Geldzahler, once the Metropolitan Museum's curator of twentieth century art as well as New York City commissioner for cultural affairs, was now clearly available for independent hire, and in short order he approached Clemente, Basquiat, Haring and Scharf to produce work for the new disco space.

Clemente painted a large fresco on the walls and ceiling at the top of the main staircase and Basquiat two large murals for the upstairs bar and lounge. Haring contributed a forty-foot-high canvas that hung from the ceiling at the back of the dance floor, and Scharf covered the basement restroom area with his sophomoric comic-strip characters and

Day-Glo splotches. The walls were treated with fake fur and the public telephones encrusted with plastic toys. Tomkins confessed that, to his eye, the work looked sensationally good and that the artists "had set a standard for disco art, a new form whose time has clearly come."[24] For those not quite hip enough to be admitted to these hallowed halls, Area on Hudson Street (1983–1987), Limelight (1983–1996) and Danceteria (1980–1986) were also venues of choice for the small hours. At Area, the art theme changed every six weeks and the disco succeeded in luring no less than Alex Katz, Larry Rivers and downtown daddy-of-them-all Andy Warhol into trying their hand at a scene or two.

A good lunch table the next day at Odeon in Tribeca and a fashionably late (but visible) dinner at Indochine on Lafayette Street in NoHo were further signs of admittance to the inner sanctum. Was it any wonder that expectations not just of a *career*, but a fast-track, lucrative and glamorous one at that, put dollar signs in the eyes of many of the 35,000 graduates now being disgorged annually by America's 1,500 art schools? Meanwhile, the increasing debauchery of the "downtown scene"—the clubs, the drugs and the sex in the bathrooms—was further disseminated to all and sundry in such best-selling novels as Jay McInerney's 1984 *Bright Lights, Big City.*

Ironically though, the commodity hungry 1980s were the optimal breeding ground for what would perhaps be one of the most important and enduring artistic movements of recent decades. As her powerhouse program continued to expand in the 1980s, Ileana Sonnabend had taken on Ashley Bickerton, Peter Halley, Meyer Vaisman, Haim Steinbach and Jeff Koons. The critical press made an attempt to forge yet another catchy art world ism by lumping together the audacious new work of these artists under such catch-all labels as Commodity, Consumerist or Simulationist art. Ultimately, however, the group gained recognition not for these forced categorizations but by virtue of their separate talents.

When Jeff Koons enshrined store-bought vacuum cleaners in high-art museum vitrines, set cheap inflatable toys up like religious statuary and riffed on Minimal and Conceptual pomposity with standard-purchase basketballs submerged in fluid, the art world was nearly speechless. In 1986 he named his meticulously replicated Jim Beam Bourbon decanters and slickly painted Bacardi liquor ads the *Luxury and Degradation*

series. He followed it in 1988 with the *Banality* works, using Michael Jackson, the Pink Panther and Buster Keaton as muses.

Ashley Bickerton created a pseudo-serious fabrication out of generic factory-produced merchandise, affixed consumer product labels and corporate logos and weightily entitled it *Formalist Painting in Red, Yellow and Blue*. Meyer Vaisman cynically tweaked Duchampian notions of replication and riffed on Warhol's limitless supply by photomechanically imprinting an image of canvas weave onto an actual canvas and stacking multiple impressions of the fakery against a wall. Haim Steinbach offered nothing more than elegantly retro-looking Formica-clad shelves pompously (but of course ironically) installed with entirely unmodified store-bought products.

By mid-decade the respected scholar and writer Brian Wallis had been able to find enough of this type of art product to curate a show called *Damaged Goods: Desire and the Economy of the Object* at the now SoHo-based New Museum. This work, darker and more ironic than the celebratory Pop of the 1960s, had been birthed in the fledgling galleries that had sprouted up over in the East Village. An October 1986 four-person show of Koons, Bickerton and Vaisman plus Peter Halley's so-called Neo-Geo—reductive but garishly hued cells and conduits that seemed to personify the soulless circuitry of the new art world machine—was one of the most well-attended and commercially successful exhibitions in Sonnabend's history. Iconoclastic and still controversial a quarter of a century later, this irreverent product of the brash, materialistic '80s would in many ways have the last laugh, outliving much else created in the hedonistic decade. Roberta Smith chose to review the show in one of her first pieces as a critic for the *New York Times* and called it "definitely one of the more hyped events of this hype-prone decade."[25]

In 1991, Koons would up the ante even further and the soft-spoken, grandmotherly Sonnabend, who was always resilient in the face of controversy, had cause to stand defiantly by her most recently minted bad boy, just as she had the masturbating Acconci back in '72. In a series wickedly called *Made in Heaven*, Koons included sexually explicit images of himself and his new wife Cicciolina (she held a seat in the Italian Parliament but was also a porn star), provoking a jaw-dropping scandal

in both the popular and the art world press. Ileana serenely stared them all down.

TEMPERANCE AND LONGEVITY

There were, of course, many abstemious exceptions to a far from universal 1980s rule of excess and dissipation, and many important spaces opened in SoHo in the 1980s with solid programs well distanced from the razzle-dazzle of the big guys. Jack Tilton, Paul Kasmin, Nicole Klagsbrun, and Lennon, Weinberg were all important galleries throughout the decade. They were key stops on the '80s downtown itinerary, but they operated at a lower temperature than the celebrated, overheated megadealers.

Held in equally high regard throughout the decade and on into the 1990s were the exhibitions mounted by such dealers as David Beitzel, Pamela Auchincloss and Curt Marcus. Although their galleries are now gone, their shows were influential at the time. Joe Fawbush, like the charismatic Colin de Land, died tragically young, but both were iconoclastic personas on the downtown landscape, breaking rules and changing paradigms. De Land—no one who knew him would ever call him temperate—is still cited as one of the great visionaries. His American Fine Arts shows of work by Cady Noland, Jessica Stockholder, Mark Dion and Andrea Fraser were considered some of the most important of the era. As early as 1996 he presciently backed a project called *So Long SoHo* that mined art world reaction to the demise of SoHo and the accelerating migration to Chelsea.

Also different in demeanor were a number of specialists who established works on paper galleries in SoHo in the 1980s. Experts in artists' prints or photography, these dealers took care of a more specialized collector base, often devotees of the medium and as such more deliberate in their research and measured in their collecting habits. Photographs and prints, available in an edition that could number anywhere from five to a hundred or more, also tended to trade at a less urgent pace than unique works, making them less vulnerable to the gyrations of the over-revved market.

In 1971, after interest in artists' prints had reawakened, Ronald Feldman launched his first gallery on East Seventy-Fourth Street on

premises previously occupied by Eleanor Ward.[26] Andy Warhol wandered in one day to see what his first dealer's old space now looked like and struck up a conversation with Feldman. A relationship began that flourished throughout the 1980s, and Ronald Feldman Fine Arts went on to publish the great Warhol screen prints of the era including the *Ten Portraits of Jews*, the *Myths* and *Moonwalk*. In 1980 Feldman secured a large ground-floor space at 31 Mercer with a relatively unusual forty-three-year leasehold at a purchase price of $250,000. There he developed an extraordinarily strong program of innovative, often socially or politically committed work, not just in print but in all media.

During the economic malaise of the mid-1970s, print publisher Brooke Alexander had capitalized on depressed demand for midtown real estate and for ten years ran a successful operation in the gallery building at 20 West Fifty-Seventh Street.[27] He expanded his floor space throughout the decade, but when his lease came due for renewal in 1985, he found that the revitalized New York City real estate pendulum was now swinging against him. In 1985 Alexander took the SoHo space formerly occupied by The Kitchen and, for what would have amounted to only five years' rent on Fifty-Seventh Street, was able to buy two floors of the SoHo building. Like Ronald Feldman, Alexander maintained an important program in all media but over the years he became recognized as the go-to dealer for editioned work by Jasper Johns, Donald Judd, Philip Guston, Ed Ruscha and others.

Although Feldman and Alexander were well insulated from the pressure of rising rents, they could, of course, have sold their premises for a considerable profit (like Paula Cooper and Helene Winer) and moved to Chelsea in the 1990s. Going against the prevailing tide, however, and despite diminishing foot traffic from both the gallery-going public and critics alike, they chose not to move. Specialist and respected enough to be destinations in and of themselves, both operations have resolutely stayed put in SoHo.

In the mid-1980s the Los Angeles–based Gemini G.E.L print publishing powerhouse opened shop in SoHo under the aegis of Joni Weyl, first in a loft on Crosby Street and then at 375 West Broadway where Weyl split a second floor with print dealer Betsy Senior.[28] When they were priced out of their lease in 2000 as SoHo gentrified, Weyl and

Senior resisted Chelsea. Betsy Senior broadened her program beyond prints and joined Larry Shopmaker in a works-on-paper enterprise on Madison Square Park at Twenty-Third Street. Weyl moved to the Fifty-Seventh Street neighborhood for a number of years but then wisely capitalized on the blue-chip reputation of her Johns, Rauschenberg, Serra, Kelly and Hockney print stable and took space on Madison Avenue closer to her Upper East Side clientele. Both ultimately succumbed to Chelsea's allure.

During the 1980s, Etheleen Staley and Taki Wise, Julie Saul and Janet Borden all opened photography galleries in 560 Broadway, a building that would later attract other important dealers like Yancey Richardson. Leica Gallery, another exhibition space respected for its photography shows, launched on Broadway just a few blocks north on the other side of Houston. Howard Greenberg was also close by at 120 Wooster Street and Laurence Miller at 138 Spring Street. This clustering of specialists on that stretch of Broadway made it very much a destination for photography enthusiasts, who, like all of the other steady-state collectors of quality work, certainly did not consider themselves a part of the decade's decadence.

The decorum and professionalism that prevailed in many galleries was also matched in the studios of plenty of steady-state artists. Just as few gallery owners could boast the acclaim of a Boone or Sonnabend, few working artists lived the life of a Basquiat or Clemente. Regular workdays and modest lifestyles were actually more the rule than the exception. The majority of artists still had to supplement earnings from sales with other employment, ranging from energy-sapping menial jobs as art handlers or truckers, to the time-consuming grind of teaching.

And so were the fun-house parties and dinners at clubbish restaurants described by Robert Storr but a part of the story? Certainly. But it was the story that usually made the front page and the one that, along with most other characterizations of '80s culture, both prevailed at that moment and endured long after. At the time, Storr was curator of painting and sculpture at midtown's Museum of Modern Art and one of the most respected cultural commentators in the city.

Twenty blocks uptown, another major museum was also weighing in on the state of play as the decade closed. "Today's art world is troubled,

yet resilient, something like the society it reflects," wrote the organizers of 1989's Whitney Biennial.[29] "Ours is a system adrift in mortgaged goods and obsessed with accumulation, where the spectacle of art consumption has been played out in a public forum geared to journalistic hyperbole." They went on to temper their doom-laden verdict, however, with faith in new healing energies despite the damage done. "Contemporary art," they wrote "as accomplished and eerie as the civilization we have created, continues to sustain us with its vital, regenerative power." Would it?

7

THE EAST VILLAGE SCENE

"New York's most dynamic avant-garde community, a melting pot of artists, ethnics, poets, junkies, barflies, radicals, mystics, street people, con men, flower children, losers, screwballs, professional eccentrics, and non-conformists."

—Alan Moore and Josh Gosciak, eds.,
*A Day in the Life: Tales from the Lower East Side:
An Anthology of Writings from the Lower
East Side, 1940–1980, 1990*

*I*n 1990 when the demonically tagged Evil Eye Press published their harrowing anthology, the demimonde that editors Alan Moore and Josh Gosciak were describing was in fact less Lower East Side proper, but rather a smaller geographic subset by this time variously known as Loisaida, Alphabet City or, most commonly, the East Village. An area bounded by Fourteenth Street to the north and Houston Street to the south, with a west-east axis running from Fourth Avenue and the Bowery to Avenue D, none of the three names used to describe the desolate area did much to improve its reputation. "Loisaida," a Spanglicized form of Lower East Side, was the name commonly used in the densely populated Puerto Rican enclaves far to the east of the neighborhood. Alphabet City referred to the (especially) drug-infested streets between Avenues A and D. The East Village might have sounded more bucolic but whatever you called it, in the 1980s all of it was dangerous.

The global escalation of oil prices and national economic downturn of the 1970s hit the East Village particularly hard as New York City's

finances plummeted, social welfare and public services were curtailed or eliminated and the nation's President Gerald Ford responded famously to the city's plea for federal help with the advice that it "Drop Dead."[1] Tax delinquency, property abandonment, insurance-related arson, a rising crime rate and escalating levels of hard drug use and addiction prevailed. As the Hippie era faded and the drug of choice shifted from LSD and marijuana to speed, attitudes of peace and love gave way to the harsh edginess of dependency and withdrawal. By the mid-1970s, what was left of the East Village was a blighted urban wasteland of "in rem" dereliction, terrifying to all. To all, that is, but a newly emerging generation of artists, needful, as always, of a cheap place to live and work, preferably in a community of like-minded bohemians, marginalized misfits, subversive counterculturalists or just plain weirdo creative types like themselves.

THE NEW, NEW BOHEMIA

By the beginning of the 1980s the East Village already had a fifty-year history as a locus of artistic counterculture. In the 1920s the Bohemians, who had begun their outré lifestyles in Greenwich Village to the west, found themselves increasingly gentrified out of the neighborhood by the uptown bourgeoisie as the cool vibe of their own supposedly anti-bourgeois existence was ironically sought out. Many chose to move east, where they indulged in a romanticized notion of the local residents as a radically unconventional and "authentic" alternative to the uptown society they despised. The same was also true of the Beats in the 1950s who were similarly squeezed out as tourists descended and prices rose. They often chose to move to the East Village in order to avoid the greater scrutiny of the city's law enforcers, who were cracking down on the use of narcotics in the jazz clubs and coffeehouses in the West Village and around Washington Square.

The art of the Bohemians and the Beats was more literary and musical than visual, but the early 1950s saw East Tenth Street around Fourth Avenue become a center of activity for the visual arts. In 1949 The Club, a chaotic amalgamation of friends and fellow travelers who for years had met informally in cafeterias and coffee shops around Greenwich Village,

groped its way into existence at 39 East Eighth Street. The original members, including Willem de Kooning, Franz Kline and Jack Tworkow, finally rented a loft space in an effort to give some structure to their constantly shape-shifting organization. Robert Motherwell, Adolf Gottlieb, William Baziotes and Barnett Newman also joined, though Jackson Pollock, Mark Rothko and Clyfford Still never would. Wednesday nights were members only, but Fridays were wildly social affairs with drinking, dancing, more drinking and then some fighting. Occasionally collectors, critics or dealers would show up including the Museum of Modern Art's Alfred Barr, critic Harold Rosenberg and the dealer Leo Castelli. Betty Parsons also made a foray into the scene once or twice, but the shenanigans that usually ensued were ultimately too wild for her taste.

It was by way of The Club that the *Ninth Street Show* of 1951 came to be organized in a store at 60 East Ninth Street. The exhibition was coaxed into being with some modest funding from Castelli, who, though still uptown, was game enough to undertake the nightmare task of trying to hang the show to the satisfaction of each of the sixty-one participating artists. With work by de Kooning, Guston, Hoffman, Kline and Motherwell as well as Helen Frankenthaler, Grace Hartigan, Joan Mitchell, Lee Krasner and Elaine de Kooning, the exhibition generated attendance levels well beyond what was expected. The organizers were sufficiently encouraged to make the show an annual event, and Eleanor Ward at uptown's Stable Gallery took up the challenge. The *Stable Annuals* ran until 1957 as a yearly homage to that first *Ninth Street Show*.

The Club lasted until 1962, moving from loft to loft and settling for a couple of years in the late 1950s on the corner of East Tenth Street and Fourth Avenue. In its later years it was frequented by some of the next generation of New York artists such as Larry Rivers and Alex Katz as well as other avant-gardists like composer John Cage. Many of them recall the importance of The Club in terms of a connection to a preceding generation as well as to a broader cultural network of like minds perhaps working in other media or in other parts of town. Katz described it as "a place where artists revealed their insecurities, defended and promoted their ideas, pled for understanding—before an audience of equals."[2] Rivers recalls that The Club provided him with "a feeling of importance about being an artist and a part of something."[3]

Alongside The Club were a number of galleries that opened along Tenth Street between Third and Fourth Avenues. Not exactly commercial since they generally failed to actually sell anything, the spaces were largely run as cooperatives and were in many ways the forerunners of what would be the artist-run startups of the East Village scene in the 1980s. Between 1952 and 1958 the work of a number of then-emerging '60s artists was shown for the first time at these venues. The early work of soon-to-be-figurative painters Alex Katz, Philip Pearlstein and Tom Wesselman was shown at the Tanager. Al Held, who was extricating himself from the grips of Abstract Expressionism and moving toward the hard-edged geometrics of his later style, had pieces with Brata Gallery (on the same block as the Tanager) along with the pedestal-free polychromes of sculptor George Sugarman.

Early work by George Segal, seminal to his later white plaster tableaux, was shown at the Hansa, which was originally located at 70 East Twelfth Street. At March Gallery, right across from the Tanager, NO!—a group of social-protest artists who put up shows with titles such as *Vulgar* and *Doom*—made some early curatorial forays into the political, the sexual and even the scatological. "Composed from ripped-up posters, news photos of corpses, and porno photos, much bondage, anything to make it ugly," Irving Sandler remembers, "they were brazenly perverse and nihilistic."[4] Other cooperatives at the core of the original Tenth Street community—the James, Camino, Phoenix and Area Galleries— were also known to the then small downtown art world for pioneering exhibitions by intrepid artists.

The Reuben Gallery was also on that East Tenth Street block but was technically a private, commercially run enterprise. It gave early showings to Robert Rauschenberg, Allan Kaprow, Red Grooms and Claes Oldenburg. Nearby, at East Second Street at a space called The Store, Oldenburg was exhibiting papier-mâché replicas of household objects and other oddities soon to be labeled Pop. In December 1965 the Film Makers Cinémathèque on Lafayette Street showed documentaries of early Happenings by both Oldenburg and Rauschenberg, and in 1967 Andy Warhol sublet the Polish National Social Hall on St. Marks Place and opened the Electric Circus. The Fillmore East on Second Avenue and

East Sixth Street, perhaps the most legendary East Village venue, was launched in March 1968, booking bands like the Allman Brothers, Jimi Hendrix, Frank Zappa and the Grateful Dead.

By the late 1960s, however, all of these artists had graduated to "real" galleries, and those galleries were uptown. Richard Bellamy at Green, Klaus Kertess at Bykert, Eleanor Ward at the Stable, as well as Martha Jackson, Sidney Janis and Leo Castelli, were the ones showing the new rebels. Even if these downtown artists had wanted to show locally, after the demise of East Tenth Street in the late '50s, there were actually no commercial galleries in the area. The renegade artistic energy that percolated through the East Village during the 1970s was manifested not in organized gallery venues but in impromptu, often illegally possessed spaces, at various short-lived underground clubs or grungy dive-bar joints that were a far cry from anything that might be considered the art world. The physical dangers of the neighbor-hood made the East Village unlikely territory for investment by any kind of commercial concern, much less one hoping to attract a mon-eyed clientele. The likelihood of your premises being vandalized and your visitors being held up at gunpoint put the neighborhood at a far remove from the shabby and underfed but fundamentally brotherly community of the 1950s. Quaint notions of honor in poverty no longer applied in 1975.

By the beginning of the 1980s, however, the behavioral habits and attitudinal bent of the new Punk generation, and the social practices and networks it spawned, had infused new life into the neighborhood. In reaction to the closing ranks of increasingly establishment SoHo, and perhaps sensing the advent of the Reaganite era of Wall Street–funded slickery, these unruly kids saw that something had to be done on home ground. The art was being made, was somehow finding its way out of studios and onto walls and film screens, was drawing crowds and even the beginnings of critical comment—no matter how excoriating at first. But it was pretty much chaos—underground, off the record and the beaten path, capricious in terms of where and how long it was on show and uneven in terms of quality. Someone was needed to step in, pull it together and put the work up in some better-organized way.

FAME—1981 TO 1983

Well organized is not necessarily the first thing that comes to mind when looking back on the launch in June 1981 of the East Village's earliest enterprise—Patti Astor's Fun Gallery. The self-styled Astor was not of the patrician New York bloodline but a Cincinnati girl with a taste for retro twinsets, pearls and pumps. Earlier, during her years at Barnard College, she was jailed three times for various acts of civil disturbance or political skirmish. An East Village denizen from the start, Astor both frequented the downtown clubs with Haring, Scharf and Basquiat and hung out in the South Bronx at Fashion Moda with Fab Five Freddy and Futura 2000. Working haphazardly on her underground acting career, she met filmmaker Charlie Ahearn at a rap music convention in Harlem and went on to star in his graffiti docudrama *Wild Style*, as well as Amos Poe's *Unmade Beds* and Eric Mitchell's *Underground USA*.

In 1978 Astor married Steven Kramer, an artist who was also the keyboardist for a downtown band called The Contortions. Their first art show took place when Astor threw a party in their East Third Street apartment to show off a graffiti mural that Futura 2000 had painted on their living room wall. Astor followed up a month later with an at-home exhibition of her husband's work. Attended only by those in the know from the downtown network, the show nevertheless sold out.

In September 1981 Astor opened Fun Gallery (a name suggested by the artist Kenny Scharf) in a room-sized storefront at 229 East Eleventh Street that rented for $175 a month. She put up an assortment of Scharf's spray paintings of Hanna Barbera, Flintstone and Jetson clones, nightmare renditions that deviated wickedly from the originals. In October, Fun showed Fab Five Freddy and then Futura 2000, who had just returned from a tour with The Clash where he had been painting backdrops for the band's concerts. At the end of the year Astor moved to a bigger space at 254 East Tenth Street between Second and Third Avenues, a stone's throw from where the artists' cooperatives of the 1950s had muddled along a quarter of a century earlier. The rent on her second space was seven times more than the first.

By now, news of the goings-on was spreading and art world aficionados like the European dealer Bruno Bischofberger were dropping in

on the shows. At the end of 1982 Basquiat, no longer a homeless unknown but with a show at Annina Nosei and some European exposure to his credit, agreed to a show at Fun. By this time his prices were as high as $10,000 per painting, and the work was being bought by wealthy collectors like the Schorrs, the Rubells and Elaine Dannheisser.

By the fall of '82, Astor the persona was staring back at everyday supermarket shoppers from the front cover of *People* and was well on her way to being quoted as a downtown icon in *New York Magazine*. Fun Gallery and the art it represented was also starting to be taken seriously by the art world press, and the East Village scene had entered the critical dialogue in well-respected journals like *Art in America, Flash Art* and *Arts Magazine*. It was probably Nicholas Moufarrege's *Arts Magazine* article "Another Wave, Still More Savage than the First: Lower East Side, 1982" that put the East Village incontestably on the art history map. What Jeffrey Deitch had presciently foreseen as a coming trend with his 1980 *Art in America* review of the *Times Square Show,* Moufarrege unhesitatingly corroborated two years later.

Moufarrege's article was important on manifold levels, not the least of which was its comprehensive coverage of the artists, the galleries, the clubs and the music; he described it all with passionately nuanced visual language, while at the same time evaluating the work with searching intellectual precision. Moufarrege grasped from the start that alongside the artistic diversity, a highly tangible, overarching and cohesive life force was driving the neighborhood's cultural scene. "Boomtown," he wrote, "a pulsing heart within the metropolis, the East Village, Manhattan, where different drummers unite in a Zeitgeist despite their varying and very personal rhythms. The need to communicate is overwhelming . . . the boundaries of art have gone beyond the stretcher and the canvas. The spirit of the age is apparent in the mélange of people that live in the neighborhood."[5]

A counterpoint review by Addison Parks, positioned directly beside Moufarrege's on the same page of the magazine, trashed the graffiti writers and demonized the work, calling it "the skin cancer of our civilization" and "repetitive, overstated and predictable."[6] A month later Suzi Gablik, a London-based American critic, added to the buzz with an *Art in America* piece entitled "Report from New York: The Graffiti Question."

Her six well-considered pages with full-color illustrations included inter-
views with Haring and Basquiat as well as the train writers Futura 2000
and Fab Five Freddy. René Ricard, a poet and Warhol acolyte, devoted
seven of *Artforum*'s oversized and impenetrably brainy pages to Patti
Astor's Fun Gallery. Illustrations included an alluring photograph of the
diva herself, replete with bosoms oozing from a retro cocktail gown and
martini in hand. Susan Hapgood, a graduate of New York's respected
Institute of Fine Art and an established curator, writer and critic, also re-
viewed East Village activity in the internationally read *Flash Art*. Serious
people were now taking the East Village scene seriously.

Gracie Mansion Gallery, which opened in the East Village in March
1982, was also discussed in the Moufarrege article. In fact, the *Village
Voice*'s Melik Kaylan had already written on its activities for Howard
Smith's influential "Scenes" column in April of that year. Interestingly,
for all the overlapping interconnectedness of East Village networks, in
the spring of 1982 Gracie Mansion (neé Joanne Mayhew-Young) was
not aware of Patti Astor and the Fun Gallery, and Astor had likewise
never heard of her.

Gracie had already made a couple of preliminary forays into the
world of exhibiting before she set up operations in the East Village.[7]
Popular legend likes to start with the Limousine Show, set up by Gracie
and artist friends Sur Rodney (Sur) and Buster Cleveland in the back of a
town car at the corner of Spring Street and West Broadway. Offering the
work of friends, the location was chosen in the hopes of attracting the
attention of Leo Castelli en route to his SoHo gallery. It didn't.

Next came an ill-fated effort in a SoHo space that her landlord in-
sisted on calling the Whorehouse Gallery. Understandable confusion on
the part of the largely gentlemen callers showing up in the later hours
led the initially indignant and ultimately unnerved director to move on
again. And so it was ultimately at 432 East Ninth Street, in her own
fifth-floor walk-up apartment, that the Gracie Mansion name really got
launched. This was the "show"—a collection of her friend Timothy
Greathouse's photographs installed in her tiny lavatory—that the *Voice*
covered that April.[8]

As Gracie recalls it, she had no particular vision of opening a gal-
lery as such and the "Loo Division" (as it became known) was part lark

and part generosity of spirit typical of the art-sharing community at the time. Only after the press coverage and several inquiries as to what she was planning next did she run around to her friends in the neighborhood and pull together the next show and then the next after that. Three · more followed until complaints from her East Ninth Street landlord led to subsequent exhibitions being put up in hastily borrowed spaces on St. Marks Place.

A second article in the *Village Voice* a year later included many cringingly bad puns on the bathroom theme but also news of the gallery's move to a more established space at 337 East Tenth Street between Avenues A and B. The inaugural exhibition, *East Village Art: Food for Thought,* presented work by twelve artists including Rhonda Zwillinger's marble, glass and glitter-encrusted assemblages, Stephen Lack's big muscular paintings of thuggish bully boys, Rodney Alan Greenblat's folk-inflected furniture objects, some early Mike Bidlo knock-offs and the *Arts Magazine* writer Nicholas Moufarrege's needlepoint. As Carlo McCormick, reflecting on it all in *Artforum* ten years later, said, "From the various one-night cash-and-carry hullabaloos to the infamous Famous Show to any number of theme shows (such as Sofa/Painting, in which artists created not only the paintings but the couches to match), each exhibition was a concept, an event, a party."[9]

By now, the gallery's activities were being covered not only by the neighborhood's own press like the *Village Voice* or the *East Village Eye* but were starting to make page 6 of the *New York Post.* By 1984 Mansion was ready for a move to a 1,500-square-foot space at 167 Avenue A between Tenth and Eleventh Streets where she would no longer have to take collectors out into the street to unroll the big unstretched canvases that artists like Stephen Lack were creating. With that move, however, came $1,800 a month in rent and build-out costs of some $40,000— money that Gracie was able to borrow through her connection to Jeffrey Deitch at Citibank. This was progress indeed from the 12-by–50-foot railroad tenement space. So what if that had only cost $500 a month? Gracie remembers 1985 as the peak.

Dean Savard and Alan Barrows opened Civilian Warfare in May of 1982 in a former ice cream store on East Eleventh Street. They put up the menacing depictions of muggers and their victims by artist Richard

Hambleton. Preying on the embedded urban anxieties of fear-infected New Yorkers, these terrifying shadow paintings, daubed onto walls of dead-end alleyways, had been leaping out of the dark with heart-stopping regularity for some time already. Civilian Warfare was also among the first to exhibit the furiously erotic paint and text protests for the sexually marginalized that were being spat out onto garbage can lids by David Wojnarowicz or the glam-horror doll sculptures created by the transsexual icon and East Village muse Greer Lankton. This work was dark, angry, and often gut-wrenchingly tough. No bright poppy colors here, no spray-paint swirls or guffaws of sophomoric laughter coursing across exuberant canvas. This was grim street work that operated beyond the canvas and outside the gallery and found you wherever you were. It turned heads but it often turned stomachs too.

Nature Morte at 204 East Tenth Street was also already launched by the time of Moufarrege's article.[10] Opening in May 1982, it operated in the East Village until 1988 as an artist-run space, started by the twenty-two-year-old Peter Nagy and his partner, Alan Belcher. Originally trained in communication and design at the Parsons School on lower Fifth Avenue, Nagy was raised in Fairfield, Connecticut, by parents who were regular consumers of New York City culture. He grew up on visits to the Whitney Biennials and shows at Castelli and Sonnabend. For Nagy, the Joseph Beuys retrospective at the Guggenheim in 1979 was an epiphanic experience.

Moving to SoHo at the end of the 1970s, Nagy lived at 476 Broome Street and the heart of the gallery hub. From here he was able to look at everything SoHo had to offer. He hung out at salon-type affairs at Joseph Kosuth's loft and (as he put it) "gorged" on Conceptualism. He met Belcher at a typesetting job in midtown and together they spent lunchtimes in the Fifth-Seventh Street galleries looking at Piero Manzoni, Lucio Fontana, Yves Klein and the French Nouveaux Realistes. It was dry stuff for the times—European, Conceptual or, if American, the New Imagists and Appropriation artists launched by Helene Winer's *Pictures* show of 1977. "By now," Nagy reminisced in a 2009 conversation, "I am reading Benjamin Buchloh, Laurie Simmons has been a life-changing experience and Louise Lawler is God."

Given this orientation, neither the graffiti and cartoon imagery at the Fun Gallery, the brash kitsch and funk assemblage of Gracie Mansion's stable, nor the guerilla Punk of Civilian Warfare interested Nagy in the least. While he and Belcher might hang at the Mudd Club with the rest of them, the art they promoted came out of a very different genetic strain. The work that interested the Nature Morte partners was heavy in institutional critique, Postmodernist irony and the New Feminism. Their program included devotees of all of the above—Gretchen Bender, Andrea Fraser and Steven Parrino, an artist Nagy knew from Parsons. Later came Barbara Bloom and Jennifer Bolande. As such it tended to make the gallery, in Nagy's words, "not of the neighborhood." These artists were brainy intellectuals, well-read art theoreticians and sociopolitical thinkers, a far cry from Fun's South Bronx graffiti writers or the Punk rebels and teenage runaways being shown a block away at Civilian Warfare. Four galleries, four programs but—despite some later attempts to label it so—no one East Village style.

FORTUNE—1983 TO 1985

By June 1983, the critical mass of galleries that had propagated in the area was becoming dense enough for Grace Glueck of the *New York Times* to make a trip down there and do one of the first round-ups of, as she perhaps originally coined it, the "Scene." In October 1983 the "where's where" of Manhattan gallery-going, *Gallery Guide,* included for the first time a section on the East Village. That same month Kim Levin, writing in the *Village Voice,* put the number of East Village gallery openings that season at fifteen, with twenty-five others on the way.[11] "Why this rapid proliferation, this boom?" she asked. "With West Broadway rapidly turning into Rodeo Drive, PS1 hosting museum shows, and the New Museum opening as a real museum with a $250-a-plate gala, it seems silly to ask."

Ominously, however, Levin also turned her scrutinizing eye on the "wave of galleries being opened not just by ex-art students and friends of artists but by relatives of artists, offspring of dealers, former gallery employees, former 'antique modern' furniture dealers, at least one art

historian, a business school grad, a former N.E.A. lawyer and a Japanese couple who barely speak English."[12]

Even this early in the galleries' development, there were signs of troubles to come. "What remains to be seen," mused gallery veteran and about-to-be downtown dealer Jay Gorney, "is which art dealers can survive in a cutthroat business, which artists will stick with the neighborhood and not use the East Village as a launching pad for SoHo."[13]

At the same time, the New York real estate market was also giving the East Villagers cause for concern. A May 1984 *New York Magazine* article entitled "The Lower East Side: There Goes the Neighborhood" put hard numbers on the escalating real estate market in the East Village with stories of once rent-controlled spaces of $115 per month now being let for $700.[14] The Christodora Apartments, on the far side of Tompkins Square Park, were proffered as a prime example of the usurious ways of the big-boy speculators and co-op developers. Constructed in 1928 as a settlement house providing food, shelter, education and health services for low-income and immigrant residents, the Cristodora and its wildly fluctuating fortunes had, over the years, turned into a veritable symbol of sociopolitical discord over affordable housing, community and capitalism. According to *New York Magazine,* since being sold by the city at a depressed rate in the dark days of 1975, the apartment building had undergone a fifty-fold price increase.

Operation Pressure Point, a Koch administration initiative to (finally) crack down on decades of blatantly practiced and nonchalantly tolerated drug dealing in the neighborhood also became a sociopolitical hot potato. The cynical view widely adopted in the neighborhood was that the long-overdue cleanup was a sop to the real estate industry's renewed interest in this ghetto. With the East Village in the media in so many guises, if you hadn't heard of it already, you certainly knew now.

Nevertheless, new galleries just kept on opening. Kenkeleba on East Second Street and Avenue B, 51X on St. Marks Place, New Math on Avenue A between Twelfth and Thirteenth Streets and Doug Milford and Elizabeth McDonald's Piezo Electric were all now on the map. Milford, another out-of-towner, from Winnetka, Illinois, had first become enthralled by downtown New York in the 1970s when his older siblings were working in theater and paying $500 a month for a

10,000-square-foot loft in SoHo.[15] Those deals were gone by 1981, the year Milford graduated as an English major from Columbia. His budget only stretched to the much riskier, but cheaper, Lower East Side. Despite its abandoned buildings, crack houses and the strong likelihood of regular muggings, Milford remembers it being the only place a twenty-two-year-old would want to live in those days.

On Clinton Street, he found two 850-square-foot floors for $500 a month close to CBGB, the Mudd Club and the rest of the music scene. There he started hosting dance performances and poetry readings. Gradually getting to know more visual artists, Milford was happy to offer his space to show their work. It was on Clinton Street that he showed the work of Keiko Bonk of East Village Orchestra fame. In an interview with the author in 2008, Milford recalled that during one of several hold-ups by junkies ransacking his place, he was cut with a razor blade and tied up with the wire from a table lamp. His blood got onto a Bonk painting. Twenty-five years later Milford still shrugged it off, saying, "It kind of added to the work."

Moving his operation to East Sixth Street and closer to the gallery cluster now developing north of Houston, Piezo Electric showed tough, figurative works such as Rick Prol's blighted Weimaresque landscapes, haunted by the spectral forms of emaciated Egon Schiele-like figures. Kiki Smith, who would go on for the next quarter century to produce some of the most eviscerating images of the human form ever, showed early work with Milford. Painter Walter Robinson, who was also a writer on the downtown scene (while working the door, the coat check and various other jobs at the Pyramid and several other clubs), showed brushy figure studies there as well. Meanwhile, having given up his apartment on Clinton for the gallery space on East Sixth Street, Milford was living between his grandmother's car and the hospitality of friends; the East Village gallery world was professionalizing—but not yet that fast or that much.

Gallery "representation" was still a very fluid thing in those early years of the 1980s; artists showed where they could and gallerists included whoever they liked without necessarily committing to an ongoing relationship. Piezo Electric showed Richard Hambleton's work; Hambleton also showed at Civilian Warfare. Stephen Lack was a Gracie

Mansion artist but had work up with Milford from time to time. The sense of community was still strong and people were generous with their talent and their space. As time went on, however, artists could afford the materials to make bigger pieces and sell them to a new wave of young, baby boom professionals who lived in larger apartments elsewhere in town. What Milford presciently recognized as "a second wave" of galleries began opening up in late 1983, this time run by trained art historians, youngsters with some previous gallery experience or established dealers from elsewhere. They all saw opportunity in the East Village.

In certain ways, Penny Pilkington and Wendy Olsoff, who opened PPOW in September 1983, were very much of this second wave.[16] Pilkington was the British-born daughter of London art dealers and Olsoff had an art history background from college. Both had worked in uptown galleries and Olsoff learned how to keep the books. She had studied Renaissance painting and Pilkington had been steeped in German Expressionism and the graphic viscerality of Otto Dix, George Grosz and the Weimar period. Work that was politically and socially charged, with the figure at its core, informed their aesthetic from the beginning and would continue to underpin their program. A studio visit to the unrepresented artist Sue Coe fired them up to look for a gallery space of their own. They were encouraged by Grace Glueck's *New York Times* article describing the burgeoning neighborhood and by their friend Deborah Sharpe, who had recently opened her own gallery on East Eleventh Street. Deborah sent them to high priestess Gracie Mansion to consult the augers and, in the spirit of camaraderie that still prevailed, they were told to come on down.

Their first location at 216 East Tenth Street was a ground-floor gallery space with a sixth-floor walk-up apartment thrown in for $1,000 a month—only $250 per month more than they were paying for their tiny uptown flat. Next door was a reggae studio but twelve months later when the tenant was evicted over the structural vibration the noise was causing, PPOW was able to double its space, though at twice the price per square foot paid a year earlier. After much thought they settled on the name PPOW—as in Pilkington, Penny and Olsoff, Wendy—since, as Pilkington put it, "We didn't want to sound like a law firm but equally knew that, if we survived, 'real' galleries had their names on the door."[17]

It is telling to reflect on PPOW's early signs of business acumen; Olsoff's's uptown bookkeeping days were paying off.

Their first show of Sue Coe's brutally rendered and politically outraged graphite drawings sold out and was reviewed in *Artforum*. Collectors like Barbara Schwarz were coming by, and both Pilkington and Olsoff thought they had died and gone to gallery heaven. They carried on, not just surviving but flourishing, ultimately adding to their program David Wojnarowicz's savage polemics, Martin Wong's desolate Lower East Side streetscapes and the uncompromising feminist work of both Nancy Spero and Carolee Schneemann. By 1986 PPOW had made enough money to take over the space vacated by the club 8BC on Eighth Street, hire an important architect and do a very nice renovation. They stayed there until June 1988, getting out just ahead of the Tompkins Square Riots in August of that year.

Pat Hearn opened the first of several gallery spaces (all of them pioneering moves) on the corner of Avenue B and East Sixth Street. Born in Providence, Rhode Island, she had studied video and performance art in college and early on had gotten to know Mark Morrisoe, Jack Pierson, Nan Goldin, David Armstrong and George Condo. Condo was in Hearn's opening show in November 1983 and alongside his strange, figured dreamscapes one could later see Donald Baechler's faux-naïf cacophonies, Milan Kunc's Eastern European Pop, and Peter Schuyff's biomorphic Op. Already out there on the bleeding edge of Avenue B in 1983, Hearn then upsized her space in 1985 with a move to a former teddy bear factory even farther east on Ninth Street and Avenue D. As artist Mary Heilmann noted much later, "Nobody went that far."[18] Hearn's longtime partner (and ultimately her husband) was Colin de Land, who started Vox Populi down on Clinton and Stanton in the space vacated by Piezo Electric and then American Fine Arts over on Wooster Street in SoHo.

With her individualist eye and independent taste, Hearn was the exception to every East Village rule. She was so personally stylish, in combinations of designer labels and vintage retro-chic, and her gallery spaces so *not* East Village grunge, that even heavy-duty art critics like Roberta Smith and Jack Bankowsky were dazzled. In addition to their serious reviews of her program, they couldn't help but appreciate her

"1950s-ish cursive letterhead" or the fact that "a grouted mosaic of tiny tiles glistened underfoot like a model-home bathroom."[19]

RISING CRESCENDOS AND DYING CHORDS—1985 TO 1988

Looking back on the East Village scene in an *Artforum* special many years later, writer, curator and art world thinker Dan Cameron proposed that "by the fall of 1986, a good litmus test of where you fell on the art-political spectrum was how you felt about International with Monument."[20] This "ponderously monikered" gallery, as Cameron called it, was the 1984 brainchild of the three artists Meyer Vaisman, Elizabeth Koury and Kent Klamen and was so named after a fragment of signage found partly obscured in the basement of their 111 East Seventh Street storefront.

Cameron's reference to "the art political spectrum" alluded to a particularly weighty conceptual axis of art making that was now developing in the East Village. The products emerging from this strand stood in stark stylistic contrast to the gestural painterliness and facture of not only graffiti but also urban figure painting and mock-glitz object-based work. Other cerebral programs of this type had been started up earlier by Oliver Wasow and Tom Brazelton at C.A.S.H on East Seventh Street, at Christminster Gallery on East Fifth Street and by Peter Nagy and Alan Belcher at Nature Morte. It was therefore no surprise that Vaisman, Koury and Klamen were early exhibitors of Nagy's own ironic, text-based critiques or that Nature Morte and International with Monument cohosted two weighty 1984 shows—*Still Life with Transaction: Former Objects, New Moral Arrangements and the History of Surfaces* and *Civilization and the Landscape of Discontent*.

It was International with Monument that would "up the ante," as Cameron put it, by being the first to exhibit the dumbfoundingly radical work of Jeff Koons, Peter Halley and Ashley Bickerton. Koons was presenting liquid-filled vitrines of floating or semi-submerged basketballs and, with brazen Duchampian aplomb, calling it art. The work ostensibly posed questions of inside and out, breath and breathlessness and other existential conundrums. Koons's chilly, readymade assemblages

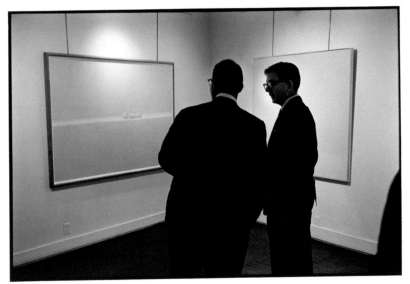

Elliott Erwitt, *New York City, (57th Street Gallery)*, 1963, gelatin silver print.
Courtesy © Elliott Erwitt / Magnum Photos

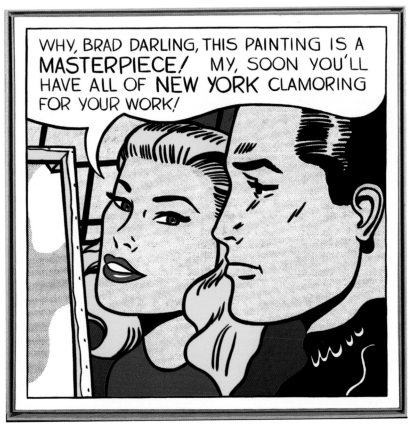

Roy Lichtenstein, *Masterpiece*, 1962, oil on canvas, 54 × 54 inches (137 × 137 cm).
Courtesy © Estate of Roy Lichtenstein

Babette Mangolte, *Roof Piece (Trisha Brown)*, 1973, photograph of Trisha Brown's *Roof Piece* performed from 53 Wooster to 381 Lafayette Street, New York City, 1973. Courtesy © 1973 Babette Mangolte, all rights of reproduction reserved

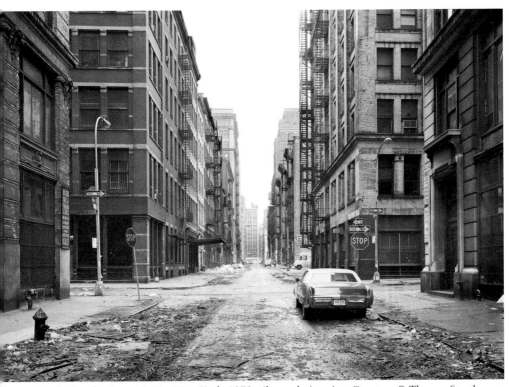

homas Struth, *Crosby Street, SoHo, New York*, 1978, silver gelatin print. Courtesy © Thomas Struth

Julian Schnabel, *Portrait of Andy Warhol*, 1982, oil on velvet, 108 × 120 inches (274 × 304 cm). Courtesy of Julian Schnabel

Elisabeth Kley, *Jack Smith, Ethyl Eichelberger & Candy Darling*, 2006, pencil, ink, gouache and collage on Japanese paper, 72 × 54 inches (182 × 137 cm). Courtesy of Elisabeth Kley and Momenta Art, NY

Robert Longo, *Untitled (From Men in the Cities)*, 1981, charcoal and graphite on paper, 96 × 60 inches (245 × 152 cm). Courtesy of Robert Longo and Metro Pictures, NY

Francesco Clemente, *I*, 1982, watercolor on paper, 14.25 × 20 inches (36 × 51 cm). Courtesy of Francesco Clemente and Mary Boone Gallery, NY

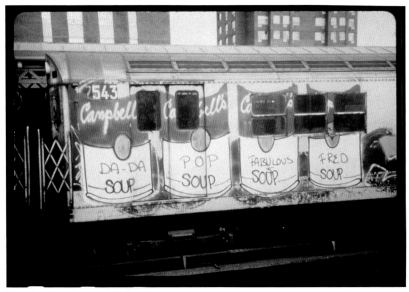

Fab Five Freddy, *Campbell Soup Train*, 1980, graffiti on subway car, dimensions unknown. Courtesy of the photographer Charlie Ahearn

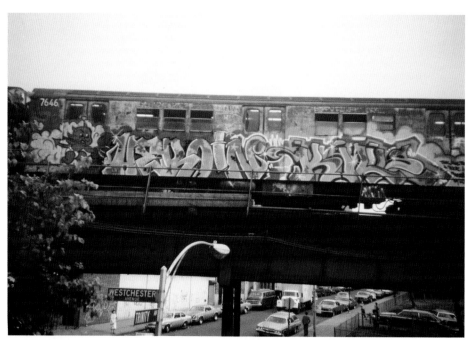

Dondi Zephyr Charlie A, *Heroin Kills*, 1981, graffiti on subway car, dimensions unknown. Courtesy of the photographer Charlie Ahearn

Anton Van Dalen,
*Evangelical Christian
Church,* 1983, oil on
canvas, 48 × 64 inches
(122 × 163 cm). Courtesy
of Anton Van Dalen and
Adam Baumgold Gallery,
NY

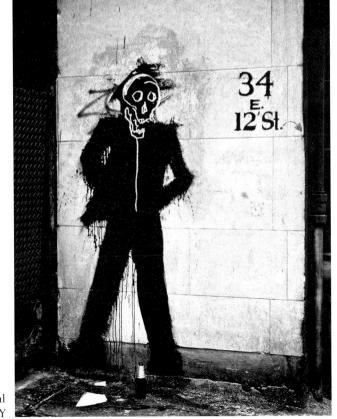

Richard Hambleton and
Jean-Michel Basquiat,
*Shadowmen (34 E.
12th Street),* 1981-
82, mural, dimensions
unknown. Courtesy of the
photographer Hank O'Neal
and Woodward Gallery, NY

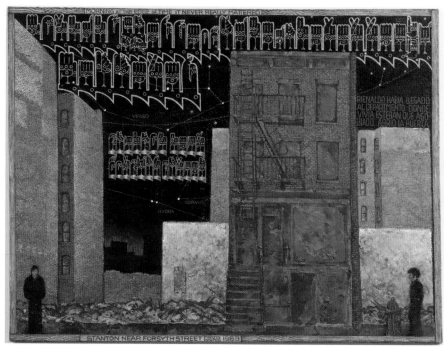

Martin Wong, *Stanton Near Forsyth Street*, 1983, acrylic on canvas, 48 × 64 inches (122 × 163 cm). Photo by Adam Reich. Courtesy of the Estate of Martin Wong and PPOW Gallery, NY

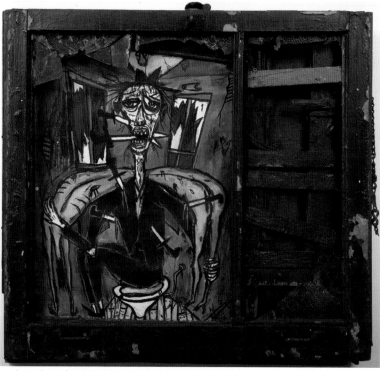

Rick Prol, *Soil*, 1982-83, mixed media on broken window, 29.5 × 32 inches (75 × 72 cm). Courtesy of Rick Prol

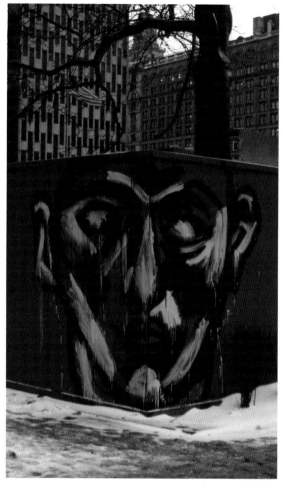

Luis Frangella, *Untitled*, 1983, paint on construction site fencing, dimensions unknown. Courtesy of the family of Luis Frangella, Visual AIDS and Hal Bromm Gallery, NY

Keith Haring, *Ignorance = Fear*, 1989, off-set lithograph on glazed paper, 24 × 43 inches (61.2 × 109. 5 cm). Courtesy © Keith Haring Foundation

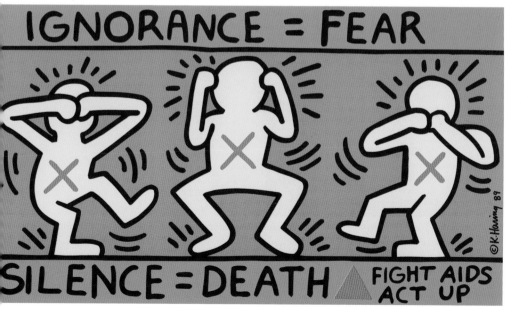

Felix Gonzalez-Torres, "Untitled", 1991, billboard, dimensions vary with installation. Installation view of Projects 34: Felix Gonzalez-Torres. The Museum of Modern Art (MoMA), New York, 1992. Location #1 31-33 Second Avenue/East 2nd Street. Manhattan, © The Felix Gonzalez-Torres Foundation. Courtesy of Andrea Rosen Gallery, NY

chel Whiteread, *Watertower*, 1998, translucent resin and painted steel, 12 feet 2 inches (370.8 cm) high ×
feet (274.3 cm) in diameter. Courtesy of Rachel Whiteread, Luhring Augustine, NY, Gagosian Gallery, and
ie Public Art Fund, NY

Ward Shelley, *The Williamsburg Timeline Drawing*, 2002, (Detail 1), serigraph, after an original drawing from 2000, 29 × 59 inches (73.6 × 150 cm). Courtesy of Ward Shelley and Pierogi Gallery, NY

Ward Shelley, *The Williamsburg Timeline Drawing*, 2002, (Detail 2), serigraph, after an original drawing from 2000, 29 × 59 inches (73.6 × 150 cm). Courtesy of Ward Shelley and Pierogi Gallery, NY

James Cathcart, *South 3rd St. And Hewes St. (2), Williamsburg, Brooklyn,* 1988, silver gelatin print. Courtesy of James Cathcart and Causey Contemporary Gallery, NY

Greg Lindquist, *McCarren Pool in the Dawn of Luxury,* 2006, oil on linen, 22 × 44 inches (56 × 112 cm). Courtesy of Greg Lindquist and the collection of William J. Lindquist

Eric Heist, *Ex (72 Berry)*, 2008, graphite on paper, 22 × 30 inches (50.8 × 76.2 cm) Courtesy of Eric Heist and Schroeder Romero Gallery, NY

Erik Benson, *Brownfield (site)*, 2010, acrylic on canvas over panel, 60 X 94 inches (152.4 × 238.8 cm). Courtesy of Erik Benson and Edward Tyler Nahem Fine Art, NY

Meryl Meisler, *Cars on Palmetto Street, Bushwick, 1985/2013*, 2013, archival pigment print. Courtesy © Meryl Meisler

borah Brown, *Dick Chicken #1*, 2010, oil on canvas, 78 × 96 inches (198 × 244 cm). Courtesy of borah Brown and Lesley Heller Workspace, NY

Bernard Guillot, *12th Avenue, (dedicated to Orpheus and Euridyce), Plate LX111*, 1977, gelatin silver print. Courtesy Bernard Guillot and Skoto Gallery, NY

Efrain Gonzalez, *Transgender Girls Working on West Street in Greenwich Village*, 1986, black and white photograph. Courtesy of Efrain Gonzalez

Peter Hujar, *David Lighting Up Manhattan-Night (1)*, 1985, vintage gelatin silver print. Courtesy © The Peter Hujar Archive LLC, Pace/MacGill Gallery, NY and Fraenkel Gallery, CA

Joel Sternfeld, *Looking South on a May Evening (the Starrett-Lehigh Building)*, May 2000, negative: 2000; print: 2009, digital C-print, 39.5 × 50 inches (100.33 × 127 cm). Courtesy of Joel Sternfeld and Luhring Augustine, NY

Frederick Brosen, *West 25th Street*, 1996, watercolor, 32 × 46 inches (81 × 117 cm). Courtesy of Frederick Brosen

Stephen Wilkes, *Highline, Day to Night*, 2009, digital C-print. Courtesy of Stephen Wilkes and ClampArt, NY

Andy Yoder, *All Your Eggs*, 2009, 23-carat gold, clay, wood, excelsior, and shredded U.S. currency, edition of 100, plus 10 Aps, 4.25 × 7.25 × 7.25 inches (10.8 × 18.4 × 18.4 cm). Courtesy of Andy Yoder and Winkleman Gallery, NY

Susan Graham, *Vessel for Safekeeping (Survivalism)*, 2009, hand-glazed porcelain and pewter, 1 × 4 × 3 inches (2.5 × 10 × 7.5 cm). Courtesy of Susan Graham and Schroeder Romero Gallery, NY

William Powhida and Jennifer Dalton, *Our Condolences, Volume 1 (Original Card #5 [All Good Things . . .])*, 2008, watercolor and pencil on paper, 2 panels; 6 × 9 inches (15.4 × 22.8 cm). Courtesy of William Powhida and Jennifer Dalton, Schroeder Romero Gallery and Winkleman Gallery, NY

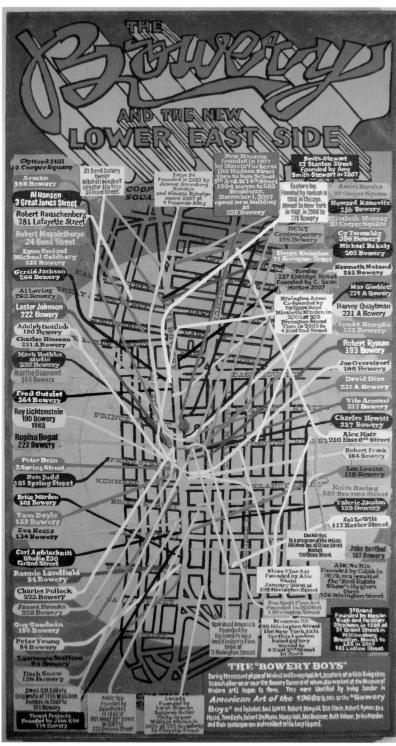

Loren Munk, *The Bowery and the Lower East Side*, 2009-10. Oil on linen, 66 × 36 inches (168 × 91 cm) Courtesy of Loren Munk and Lesley Heller Workspace, NY

Kiki Smith and Deborah Gans, *The East Window, Eldridge Street Synagogue*, 2010, stained Lamberts antique flash glass, 16 feet in diameter (4.87 meters). Courtesy of The Eldridge Street Synagogue and the photographer Peter Aaron/OTTO

Kazuyo Sejima and Ryue Nishizawa (SANAA), New Museum of Contemporary Art, 2007 and Ugo Rondinone, *Hell Yes!* 2011, illuminated sign, dimensions variable. Courtesy of the New Museum of Contemporary Art. Photo: Dean Kaufman

Inka Essenhigh, *Lower East Side*, 2009, oil on canvas, 70 × 74 inches (178 × 188 cm). Courtesy of Inka Essenhigh, 303 Gallery, NY, and Victoria Miro Gallery, London

stared back coolly at the scorching blast of Peter Halley's searingly colored Day-Glo conduit paintings, all nubbly Roll-a-Tex surface and garish vibrancy but at the same time claustrophobic as a rat maze. Bickerton randomly plastered name-brand icons onto machinelike objects whose apparent uselessness scoffed wickedly at the great American conglomerates whose logos they wore. All of this work, including early photography-based pieces by Richard Prince, Sarah Charlesworth and Laurie Simmons, were maddeningly unresolved, leaving viewers wondering what exactly was going on.

In December 1984 Postmasters Gallery, another thinking man's venue, opened up on Avenue B, conceived and launched this time by two European émigrés, Magdalena Sawon and Tamas Banovich.[21] With a master's degree in art history from her native Poland where she had been educated only in the established canon of dead artists, Sawon left the prospect of a life in Eastern-bloc controlled academe and partnered up with Banovich, a Hungarian trained in sculpture and set design. A little older than many of the East Village kids and laboring under some early language difficulties, Sawon and Banovich were never a part of the clubs and drugs scene, preferring instead to observe, probe and discuss their strange new sociopolitical landscape. The gallery name was a hybridized riff on life and art post the European masters, on Postmodernism and an early interest in the Dada of mail art and its distribution by the humble post office.

With networking leads from Valerie Smith at Artists Space, Postmasters built up its roster of artists (Aimee Rankin, Perry Hoberman, Wallace and Donahue) and showed them in a thoughtfully installed, cleaned-up white cube environment far from the cacophonous pile ups of the ubiquitous storefront aesthetic. At the same time, mentored in orderly business practices by International with Monument's Meyer Vaisman, Sawon and Banovich also learned how to prepare a consignment sheet, write an accurate invoice and charge sales tax.

Looking back, Sawon remembers very clearly that already in late 1984, what she describes as "two very separate tunnels" were developing—intellectually, stylistically and now institutionally. While cooperation and community spirit continued intact, a more serious strain of gallery, showing what would prove to be more enduring art, was

pulling away from the early start-ups. The scene was changing as scenes always do and soon the galleries whose programs were solely posited on it would begin to close.

By 1984 the increasing number of galleries sprouting up in the East Village had led an enterprising writer named Roland Hagenberg to put out a publication called *Untitled '84: The Art World in the Eighties*. In addition to an essay by curator and critic Robert Pincus-Witten, the first issue included a host of ads for the newly established galleries. By 1985 Hagenberg was including a map of the neighborhood with the key galleries marked. The 33 on the map in 1985 had swelled to 48 in the 1986 issue. Other commentators on the growth put the numbers at 60 by January of 1985 (Grace Glueck), and 124 by the end of the year (Liza Kirwin). Of the galleries that survived long enough to redefine themselves elsewhere later, Jay Gorney, Hal Bromm, Barry Blindermann's Semaphore East and Leslie Tonkonow's Art City were all in the East Village mix by 1986. Jamie Wolff, Massimo Audiello and Jack Shainman had also launched new ventures.

In January 1985 Grace Glueck opened the new art year with the exclamation "No doubt about it, the East Village scene is a howling success."[22] She was not only referring to quantity but was also grasping the depth and breadth of the work coming out of the neighborhood. Resisting any tendency to broad-brushstroke an EV style, she acknowledged everything "from graffiti to New Surrealism, from cartoon to message art, from Minimal to Neo-Pop and New Wave, from pure kitsch to solid substance."[23] Tellingly, however, the rest of her review covered not a show in an East Village location but a packaged version that had now been brought uptown. *57th between A and D: Selected Artists from the East Village* ran at Holly Solomon's 724 Fifth Avenue space. Glueck's article also referenced the first instances of museum attention being given to the work, one in Philadelphia and the other in faraway Santa Barbara.

Meanwhile, it was being noted elsewhere that Jean-Michel Basquiat was the darling not only of Fun Gallery but of Mary Boone and Annina Nosei, both SoHo based, as well as Californian kingmaker Larry Gagosian. By now Basquiat's work was being included in major museum exhibitions in London and Paris, and with prices in the tens of thousands,

he had a regular table at the swanky Mr. Chow. In a November 1985 article entitled "Youth—Art—Hype: A Different Bohemia," the *New York Times* writer Maureen Dowd (a general editorial commentator, not an art critic) set the East Village scene into a broader historical continuum of la vie bohème, describing this one as already "blue-chip . . . where artists talk tax shelters more than politics, and where American Express Gold Cards are more emblematic than garrets. In this Day-Glo Disneyland," she continued, "the esthetic embrace of poverty has given way to a bourgeois longing for fame and money."[24] The enfant terrible, it seemed, was growing up and was about to leave home.

A few months earlier, in July 1985, the Fun Gallery, the first to open in the East Village in 1981, was hit with huge shipping bills from the Zurich Art Fair and was forced to close its doors. Patti Astor made a variety of valiant last-ditch attempts to avert the gallery's demise, including a fire sale show called *Sink or Swim* in which she as good as begged collectors to buy. Always sidetracked by her film career, Astor never invested sufficiently in the gallery and by 1985 her rent had escalated from $175 to $1,800 a month. Additionally, her graffiti artists' on-the-fly mural work failed to translate effectively to canvas; its artists, primarily black and Hispanic teens, were never fully accepted by the uptown collector or museum base; and American graffiti didn't export well to Europe. Someone spray-painted "No Mo' Fun" across the gallery's abandoned storefront. Civilian Warfare and New Math, also early pioneers, would soon follow. Meanwhile, in an uptown hospital, the artist-writer Nicholas Moufarrege, who had first set it all in motion, was dying of a mysterious new autoimmune disease about to be labeled AIDS.

Looking back twenty-five years later, Gracie Mansion remembered that summer of '85 as, literally, the point at which the fun went out of it; certainly, a closer look at the astonishingly rapid sequence of events of the next twelve months reveals that all of the signs of the coming end were already in place. That summer Robert Hughes, the reactionary but nevertheless influential critic of *Time* magazine, reviewed the 1985 Whitney Biennial's East Village component and labeled the work "young, loud and, except in its careerism, invincibly dumb."[25]

By the spring of 1986, as new gallery openings in the neighborhood were outnumbered by closings or moves elsewhere, Judd Tully ran a

cover story in the *New Art Examiner* asking "Is the Party Over?" The critical press, which had in so many ways created the monster back in 1982, now just as quickly turned on the beast. By February 1987 Roberta Smith was headlining "Quieter Times for East Village Galleries," while *New York Magazine*'s Amy Virshup declared "The Fun's Over: The East Village Scene Gets Burned By Success." She cited as a source gallerist Jay Gorney who, she claimed, "cheerfully pronounces the East Village dead."[26] Douglas McGill added fuel to the flames in the *New York Times* with "Art Boom Slows in the East Village." What exactly was happening here?

8

THE STATE OF THE ART

Into the Nineties

"Tis there, dread DULLNESS dwells in sweats and glooms,
Gnaws her brown nails, and shakes her sable plumes;
FRIVOLITY extends her flittering hand
O'er the distracted, fashionable band."
—Robert Hughes, *The SoHoiad: or, The Masque of Art,* 1990

Seemly and serious as so much of the art world still was in the late 1980s, good behavior was less interesting than bad for the purposes of media reporting and modest openings at steady-state exhibition spaces less newsworthy than the extravaganzas at celebrity galleries. The daily cycle of toil familiar to most artists had so much less buzz than the meteoric rise and potentially precipitous fall of stars like Basquiat, Schnabel and Koons. By the last years of the decade, critics, scholars, art world commentators and popular press journalists alike were all beginning to wallow in the worst of it.

DEGENERATION

Even before the decade's midpoint, critic Robert Hughes began to lash the SoHo scene with his vitriolic tongue. He published a brilliantly witty piece in rhyming couplets in a 1984 issue of the *New York Review of Books* lampooning contemporary artists (Keith Boring, Jean-Michel

Basketcase, Julian Snorkel and David Silly), dealers (Mary Spoon), critics (Peter Shellduck, John Rustle and Rene Retard) and even museum curators (Henry Goldbug). In close to 300 lines, Hughes made room for virtually everyone involved in what he clearly saw as the ridiculous downtown circus. Warming up in the opening stanzas with "*Opinion* bows and scrapes, to *Trade* defers, / As Disco-Owners turn to Connoisseurs" he was clearly enjoying himself by verse five as he went on, "Behind, a pliant and complaisant throng / Of Art-Reporters flatulates along / With tongues awag and wits made dull by rust, / Trustees who deal, and dealers none may trust."[1]

By January 1986 Michael Brenson was sounding the alert to his *New York Times* readership when he lamented, "With prominent artists of all kinds having one and sometimes two shows a year, in one, two and even three galleries simultaneously; with museum shows for 30-year-old artists now commonplace; with ceaseless critical and curatorial attention; with the marketing methods of art dealers now material for television business programs; with artists puffed up like rock stars, courted like princes and displayed in the pages of trendy magazines like Hollywood prima donnas, there has been a wide spread feeling of 'enough!'"[2]

In a June 1988 *Arts Magazine* piece cannily entitled "The Business of Art: Catalogue Culture," writer Alan Schwartzman derided the ludicrously foreshortened life cycle of the rising art star by parodying the breakneck speed of a now typical ascent. The young up-and-comer begins the season in September with just the right studio assistantships behind him (Salle, Chia or Robert Longo perhaps), gets some smart review pieces well placed in the pages of *Artforum* or *Flash Art*, has work picked up by those in the know at White Columns and before long is well on his way to a soon-to-be-hot European gallery. So-called mature paintings are ready by November, Annina Nosei is doing studio visits, Jeffrey Deitch places a few of the works and before you know it, the just recently unknown has a waiting list.

In *The Nation*, Columbia University professor Arthur Danto noted that each season was now expected to bring forth something brand new and that the art world seasons themselves were getting shorter and shorter. The good dealer was the sharp dealer who spotted the latest energies quickly and made the savvy connections with the right

collectors, museums or publicists. In this way big bucks were assured all around.

Uneasiness about the long-term effects of the decade's excess was also being felt in artists' studios. Even those benefiting from the rapidly sequenced exhibition schedules, hyped critical exposure and inflated collector prices had misgivings. Success in the gallery system had certainly helped bank balances, and the time off from plumbing, sheet rocking and waitressing gave artists time to concentrate and expand. But the commercial emphasis on saleable art made the creation of riskier, boundary-breaking work, cross-genre street, film, video, dance and music pieces or site-specific installations much less likely.

Even the original homesteaders of the SoHo arts community were anxious as they found it more and more difficult to go about their work-aday lives. The writer Richard Kostelanetz lamented that, especially on Saturday afternoons, the sidewalks had become so clogged with peddlers and their browsing customers that residents such as himself were forced into the street to get a normal walking speed. He mourned the revamping of Fanelli's into a yuppie bar, and the closing of Food, the one restaurant that had catered to neighborhood tastes and employed SoHo people.[3]

Likewise in the East Village, the conflation of circumstances that had favored the birth of the "scene" a decade before now came together to its detriment. With a last count of more than 200 galleries ostensibly opened (and often as quickly closed) by the end of 1988, it was inevitable that quantity would come to rule quality. When Lucy Lippard had called the *Times Square Show* of 1980 "a ghastly glance into the future of art" she spoke for many.[4] Kim Levin had savaged the Sidney Janis post-graffiti show in the *Voice* and Danto referred to the artists as pretty feeble. "Their trouble" he wrote, "is knowing too little and knowing how to do too little. They need the benefits of a good art school. Energy alone can only carry you so far."[5]

In one of the East Village's own publications, Michael Kohn called the work uninteresting and shallow and cautioned that media attention does not equal critical attention.[6] Even Nicholas Moufarrege, who had done so much to support the work at the outset, despaired at times. He challenged the now local ruling that no art is unshowable and

complained that volume output had done nothing for the meaningful, the powerful or the beautiful. "The boys and girls are gone hog wild with liberty," he wailed, "and the effect is not of shock but of something more dangerous: tedium."[7]

To some extent, the demographics of the era played as much of a role as matters of taste when it came to the quality of the art. The glut of fresh-baked graduates that had been tumbling out of art schools over the past two decades meant that of the nation's one million self-titled artists, some 90,000 were living in New York City. The education was expensive, and while parents were happy to fund a first year or two, a career somewhere in the $2 billion New York art market was now in order. As writer, filmmaker and cultural commentator Gary Indiana pointed out "Reagan was President, Communism was dead, and the idea of doing anything that didn't make money had begun to look ridiculous to most people."[8] Fortunately for many of these young and willing art producers, there was plenty of Wall Street money in the hands of impatient nouveaux collectors who needed shiny new collections.

At the same time, much of the art *was* good. For every ten galleries that closed because the work of their artist-directors was unsaleable, there was a handful that could afford to shut down their gallery spaces and live solely off their art. Peter Nagy closed Nature Morte in 1988, and Meyer Vaisman sold his share of International with Monument, in part because the work they were creating themselves was successful enough to be self-supporting. Other artists also amounted to more than the sum of their East Village parts, as the embrace by SoHo of the stronger work of Halley, Bickerton, Vaisman and Koons showed.

Sonnabend, Castelli, Holly Solomon, Pace's Arne Glimcher and others, of course, had the luxury of perusing the goods and putting in a bid during the East Village's convenient weekend opening hours (almost always necessitated by the fact that everyone still had a Monday-to-Friday job somewhere else). Sunday was SoHo's day off, but the scouting of talent was an all-week thing. As Robert Pincus-Witten so colorfully observed, "Alert young dealers West of Broadway in SoHo extended antennae into this nutrient mass, absorbing back into their more conventional venue the talisman of the yeastiness."[9]

By 1987, galleries like Jamie Wolff, Piezo Electric, Massimo Audiello, Jack Shainman, PPOW, Postmasters and even the mythic Gracie Mansion were having trouble holding onto their no-longer-emerging but now moneymaking artists. Those artists wanted to be in SoHo, where bigger gallery spaces meant that they could make bigger, not to mention higher-priced, work. The busier foot traffic of the increasingly chic SoHo streets meant more visibility, more attention in the critical press and, well yes, more sales. For the dealers, storage space and a real office would also be nice.

By March 1987 all of the galleries mentioned above were leaving the down-and-dirty East Village, trading their business youth for attractively packaged offers in previously enemy territory on the other side of the Bowery. While West Broadway and the more prestigious addresses on Wooster and Greene were still not available to most of them, newly vacated spaces on the eastern edge of SoHo emitted an irresistible siren's call. Savvy real estate interests like Newmark Realty were actively re-positioning the old Broadway light industry floor-throughs and aggressively marketing them as "Gallery Buildings." The go-to realtor of the moment (and practically ever since) was the ubiquitous Susan B. Anthony, a Cooper Union painting graduate who had gotten to know all of the dealers earlier in her career when selling advertising space for both *ARTnews* and *Art in America*.[10] She had an instinctive understanding of the needs of gallerists and the artists they showed and a canny ability for moving them around.

Jamie Wolff was the first to go, moving in March 1987 to a 5,000-square-foot second-floor space at 560 Broadway on the corner of Prince; he was joined by Piezo Electric and Jack Shainman Gallery. Gracie Mansion and PPOW moved over to equally expansive quarters at 532 Broadway between Prince and Spring and, like their 560 counterparts, took on much higher rents for much, much bigger spaces. Across the street, 568 was also ready and waiting at $12 a square foot for a ten-year lease.[11] By the late 1980s rents had almost tripled in the East Village. More dollars were required for SoHo, but the value per square foot was a much better deal. And with the success of their stable now looking assured, why wouldn't the more ambitious dealers see their futures as bright?

COLLAPSE

But the time of plenty was about to be over. On October 19, 1987, the Dow Jones went into a free fall and dropped 508 points, a full 25 percent of its value in one day of trading. New York's economy, whether it knew it or not, had in fact embarked on the most catastrophic recession since the horrors of the mid-1970s. In the New York City of the late '80s where Wall Street generated over 20 percent of the city's cash income, a slowdown in the financial sector would have crippling ramifications for those farther along the economic food chain. Beginning in earnest in 1989, New Yorkers began to lose their jobs in droves as the financial sector shed middle management, automated back-office operations and cut overheads.

By June 1989 the vacancy rates in Lower Manhattan office space had climbed to 17.8 percent, commercial real estate prices slumped, and new construction in the now-saturated market ground to a screeching halt. Employment in the architecture industry dropped 23 percent—from 8,424 jobs in 1989 to 6,482 in 1991—and even the celebrated skyscraper behemoth Skidmore, Owens and Merrill halved its staff.[12] Architects and interior designers were no longer calling art advisors or the galleries they patronized.

Most gallery owners recall that it was around early 1990 that the phone just stopped ringing. If collectors did call, it was often to step away from agreed-to purchases or to discuss terms for putting works already in their collections back on the market. Many simply disappeared altogether. The scramble for cash required to keep gallery landlords at bay, staff payrolls funded, and heat, light and insurance in place often required deeply discounted liquidation of inventory. Some dealers even sold—with great pain—their own private collections in the hope of staying open.

By the time the fall auctions came around in November of that year, only 332 of 554 artworks offered at the two principal auction houses actually sold, and those at $49.6 million dollars below their combined low estimates. As *New York Times* writer James Servin noted with a certain degree of relish, "At Sotheby's, a Julian Schnabel canvas failed to elicit a single bid. After some silence, cynical laughter and a round of applause followed."[13]

By February 1993 Deborah Solomon was looking back both clinically and cynically on "The Art World Bust" of the early 1990s. "It's impossible to have a bacchanal like the '80s without paying for it later," she wrote and noted the rising numbers of artists now leaving full-time pursuit of their art to teach or drive a cab.[14] Solomon put the number of gallery closings at around seventy and rightly observed that those still surviving were mounting fewer exhibitions and leaving shows up a week or even two beyond the normal three-week cycle.

With galleries closing or cutting back, artists who had ridden the crest of the 1980s wave saw sales dry up, prices plummet and their galleries cut them loose. "I can walk into the Odeon or Barolo or the other places that artists go and speed-read my place in the art world," one artist noted. "If you're not hot, there's a lull when you pass through the door."[15] Even former big-ticket luminaries such as Eric Fischl complained that for the first time since 1982 his work did not sell out before the opening. Meanwhile, Mary Boone was considering less razzle-dazzle talents such as Sean Scully and Bill Jensen, both revered abstractionists with a couple of decades of steady art production, consistent exhibition histories and sound critical attention behind them. Their loyal collector bases were also noted.

Peter Halley—the Neo-Geo king and always a thinker and a writer—recognized that the damage was far more serious than simply a drop in prices at the top end. "The tragedy of the '80s," he suggested, "is that art has lost its claim to integrity. Art is now seen as a sham by the public."[16] And he was right. The mood around town was that the collector had been duped in some way and that the art world–infatuated had somehow been taken for a very costly ride.

DEVASTATION

For more than a decade, meanwhile, a crisis of a very different kind had been creeping insistently through the downtown community. In June 1981 the Centers for Disease Control and Prevention in Atlanta reported five cases of pneumonia in otherwise healthy gay men in Los Angeles. Doctors in New York and California (then the principal centers of the gay community) went on to cite forty-one cases of a rare and rapidly

fatal cancer in homosexuals. By the end of 1981, 121 people had died of the new disease. While it would take President Ronald Reagan six more years to publicly acknowledge acquired immunodeficiency syndrome or AIDS, by the mid-1980s the virus was already taking a rapid and aggressive hold on the arts community.

By mid-1987, 20,000 of the 36,058 Americans diagnosed with the illness were already gone.[17] Klaus Nomi (1981), Nicholas Moufarrege (1985), Peter Hujar (1987), Robert Mapplethorpe, Mark Morrisoe and Cookie Mueller (1989), Keith Haring, Tseng Kwong Chi, Luis Frangella and Arch Connelly (1990), David Wojnarowicz (1992), Timothy Greathouse and Dondi White (1998), and Martin Wong (1999) were all dead by the end of the decade. Carlo McCormick put the loss at a third of the creative community.

In 1987 ACT UP (AIDS Coalition to Unleash Power) was established in reaction to what was perceived as the political impotence of the Gay Men's Health Crisis, then virtually the only organized force in AIDS awareness. ACT UP's mission was to instigate direct and militant action on behalf of the escalating numbers of HIV-positive sufferers. A provocative little poster of a pink triangle against a black background began to show up around the city bearing the slogan SILENCE=DEATH.

Over the course of several months in late 1987 and early 1988, an internal offshoot of ACT UP calling itself Gran Fury (after the Plymouth squad car favored by the NYPD) came together as a collaborative with the express mission of agitating as an ACT UP propaganda arm. Creating confrontational works of art that foregrounded the crisis, they installed an illuminated version of the SILENCE=DEATH watchword in the Broadway windows of the New Museum of Contemporary Art, calling out Ronald Reagan, New York's mayor Ed Koch, and John Cardinal O'Connor as negligent Nuremburg-like criminals in the war against AIDS. 1988 saw the launch of the "Read My Lips" and "Kissing Doesn't Kill" wheat-pasting poster campaigns; similarly inflammatory exhortations to action were emblazoned on T-shirts, street banners and billboards around the city.

Artists such as Ross Bleckner, Keith Haring and Nan Goldin had been addressing the AIDS crisis in their work since the mid-1980s to

increasing critical attention. Goldin's *Ballad of Sexual Dependency* was screened at the Whitney Biennial in 1985 and was reviewed by Andy Grundberg in the *New York Times,* J. Hoberman in the *Village Voice* and Max Kozloff in *Art in America.* In 1989 David Wojnarowicz's incendiary catalogue essay for the Artists Space exhibition of Nan Goldin's *Witnesses: Against Our Vanishing* led to a highly publicized battle with the National Endowment for the Arts which threatened to withdraw funding from the show.

The somber shift in mood and the darkening of the cultural zeitgeist became gradually more apparent. As the fin-de-siècle decade began, the new line-up at the Whitney Museum of American Art's Biennials spoke volumes about the state of the not-so-brave new art world. Invariably criticized for its selection of works, berated both for what they included and what they omitted, the Biennials were still largely, if begrudgingly, accepted as a game attempt to showcase the most representative art of the preceding two years. In the six Whitney Biennials mounted between 1981 and 1991, Julian Schnabel was included in four, Eric Fischl and David Salle in three, and Ross Bleckner, Jeff Koons and Peter Halley in two. From 1983 through 1991, at least one of the *Pictures* artists had been included in every show, with four of them in 1983 and six in 1985.

By 1993 only Cindy Sherman's work was still there, but no longer the glamorized faux divas of the early film stills. Her gruesomely disfigured mannequins with Gorgon heads and mutilated genitalia kept company now with Kiki Smith's torched and flayed females who crawled on all fours across the gallery with entrails dangling and Nan Goldin's unflinching portraits of her often sick and dying demimonde. The erotically posed African-American male nudes in Glenn Ligon's multipart photographic installation shamed the all-white art world into seeing black, and Robert Gober's nonchalant inclusion of a cross-dressed bride in an otherwise straight newspaper feature outed its homophobia. Sue Williams exhibited crudely graphic drawings of sexual abuse and topped them off with a very convincingly rendered pool of vomit splashed onto the Whitney's well-polished floor. Perhaps most pointedly, curator Elisabeth Sussman elected to include George Holliday's home video of the beating of Rodney King at the hands of the Los Angeles police.

RETREAT

Meanwhile, back on the streets of the East Village and beyond the narrow confines of its art world, broader economic changes were underway. By the start of the 1980s, the '70s-style property speculator who had bought up derelict building stock in and around the East Village for bargain prices and rock-bottom tax obligations had given way to the more medium-term real estate developer. This new cohort of capitalist—no longer able to simply pick off property, hold it for a period and flip it for profit a few years later—did make repairs and improvements in order to ready a building for resale. But in the process they often evicted many of the remaining low-rent residents, often using shamefully illegal methods to do so. Tenants on block after block were persuaded with hefty buy-offs or forced through service cut-offs or intimidation from hired drug addicts to vacate their homes and businesses. As longtime residents left, their buildings underwent conversion into co-ops and condominiums.

As the city's Reaganite population swelled with well-heeled young urban professionals, Operation Pressure Point turned up the heat on the illegal drug trade. At the same time, New York University was encroaching on the area from the west, and growing numbers of industrious Chinese immigrants were pressing in from the south. As SoHo was pulling more of the art world in with its promise of bigger, more economical and professional spaces, the East Village was pushing it out with rent hikes from newly aggressive landlords. It would be another decade before the neighborhood became what Michael Musto described as "a spruced up, expensive culture vulture haven that teems with tourists on the weekend," but the sea change was already being anticipated by those who stood to make money from it.[18]

Ironically, it was the artists themselves—not just the visual artists but the writers, poets, dancers and musicians—who, having created a mystique that could be relatively quickly commodified, now stood to pay the (inflated) price. The packaging and promotion of "difference" had transformed what had once been threatening and subcultural deviance into a trendily palatable lifestyle. The marginal and the seductively dangerous frisson of the East Village came with an increasingly easy-to-replicate wardrobe of clothing, footwear, hairstyles and accessories. The

social behaviors required to round out the persona could be co-opted for an evening at the Pyramid Club then left at the door on the return uptown. By late 1985 the downtown diva and club performer Ann Magnuson was wryly suggesting building a monorail through the neighborhood: the East Village as Epcot Center.

As Tish and Snooky Bellomo saw their clothing designs knocked off by Seventh Avenue fashion merchandisers and offered for sale in Bloomingdales, their rent was quadrupling. After eight years they were forced to close Manic Panic. Club 57 succumbed to the pressure of fire and noise violation fines and Steve Mass, convicted of tax evasion, closed the Mudd Club. Theater and performance groups that needed bigger audiences or practice spaces were put under pressure, and even the tiniest storefront galleries saw their rents double and triple. Five-year leases were reduced to two at most. For those who had not professionalized their operations or whose artists continued to carry "emerging" sticker prices, overheads became impossible and the closings continued. Most commentators who put the 1985 East Village gallery number at somewhere upward of seventy remember over half closing within the next twelve months.

By 1988 the sight of Jean-Michel Basquiat's twenty-seven-year-old, overdosed body being removed from his Great Jones Street studio also reminded those who needed reminding that death, no matter how flamboyantly staged, had no second act. Basquiat's landlord Andy Warhol had died the year before—not from AIDS or drugs but from complications following routine surgery. It seemed, nevertheless, that the era of live-fast-die-young was coming to an end. The loss of so many artist, writer, dealer and collector friends, many before their fortieth birthdays, had a deeply sobering effect on those left behind. The kids who had been not much more than twenty when they started out in the early 1980s were now well into their thirties, and perspectives were changing.

While cocaine usage would continue to be a part of art world practice throughout the '90s, there was a growing realization that no one lived for long on heroin. The progression to hard drugs started to abate among all but the most far gone, and, with bodies feeling older and more fragile the morning after, the excesses of the decade were tempered. Moreover, by 1987 what started as a lark was now a going concern.

Many newly recognized artists, and the newly profitable galleries that represented them, realized that to keep their heads above water they would need to keep their heads clear. And as PPOW's Wendy Olsoff told Phoebe Hoban, "There was something about going to a slum that faded after four years of stepping over drug dealers and garbage cans to get into the gallery."[19]

At about this same time, a late-1980s change in New York law brought large numbers of the mentally ill out of the city's psychiatric hospitals and onto the streets. Despite the upswing in the area brought on by the beginnings of gentrification, the newly indigent were still drawn to the familiar dereliction of the East Village and its access to alcohol, drugs and a relatively hassle-free place to sleep. Need, suffering and imminent death were walking right in through the gallery door, and East Village openings were often made uncomfortable by the homeless seeking food, wine, or just a little warmth. Tompkins Square, the only New York City park left that had no curfew, began to fill up with make-shift shelters. The modern-day Hooverville festering there (shortly to be hailed as Dinkinsville in a jab at the incoming mayor) teetered on the edge of a major conflagration.

On the brutally hot night of August 6, 1988, Tompkins Square erupted into full-scale inner-city violence when a mixed bag of resident homeless, civic activists, political radicals, and just plain neighborhood folk clashed with police from the local Ninth Precinct over Parks Commissioner Henry Stern's attempt to impose a 1:00 A.M. lock-up on the city's last remaining twenty-four-hour public park. The NYPD's Manhattan South Task Force riot squad moved in as back-up, streets were barricaded, stores along Avenue A were shuttered and a helicopter circled overhead. Visibly spooked police clubbed protesters, and rioting spread to neighboring blocks, raging on until after dawn. A fragile order was restored for the rest of that year, but neighborhood tensions simmered. Further rioting occurred in December 1989, in May 1990 and again on Memorial Day 1991.

By late 1991 the park had been cleared of its estimated 300 homeless, and Tompkins Square was forcibly closed for renovation. It reopened the following year as more of a zone of policed urban discipline than a free public space. The once-vital arts scene shriveled and the neighborhood's

descent into bourgeois ignominy was by then being confirmed by Alan Moore and Josh Gosciak, who described the East Village as "a kind of suburban weekend punk shopping mall, where nearly all galleries have folded, and many writers and artists have moved on to cheaper environs, if not country pastures."[20] By the time Rudolf Giuliani was elected mayor on a 1993 ticket of restoring law and order, the assault on the libertine ways of the East Village was proceeding with skull-crushing vigor.

By 1988 Operation Pressure Point had begun to take effect, and the drug suppliers, dealers, addicts, prostitutes and assorted camp followers had picked up and moved their trade right across the river to the Williamsburg section of Brooklyn. There they quickly blighted the blocks on which they settled, very much as they had done on Manhattan's Avenues A through D. Bedford Avenue, one short stop out on the L train for even the most addled junkie, soon became as hellish a landscape for neighborhood residents as Alphabet City had once been. As crack houses and shooting galleries opened up, particularly on the south side below Metropolitan Avenue, such blocks as South Third to South First Streets became a war zone of killings by competing dealers, muggings by desperate addicts and flagrant prostitution by hookers and their pimps. It was not long before landlords felt the concomitant effects on the value of their properties.

As the 1980s turned into the 1990s, however, Manhattan was quite literally cleaning up its act. The so-called Broken Windows program of Giuliani and Chief of Police Bill Bratton led to the roundup of turnstile jumpers, aggressive panhandlers and intimidating squeegee guys. The courts, discovering that these minor offenders guilty of nuisance misdemeanors often harbored more serious records, incarcerated many of them. The crime rate in New York City began to drop. By the mid-1990s the economic downturn of the late 1980s was cycling back upward, and Wall Street was again fueling the good life in the Big Apple. As the fashionistas and the foodies drove rents up in SoHo, and the East Village staggered from its derelict status to something more chichi, working artists were once again asked to move along.

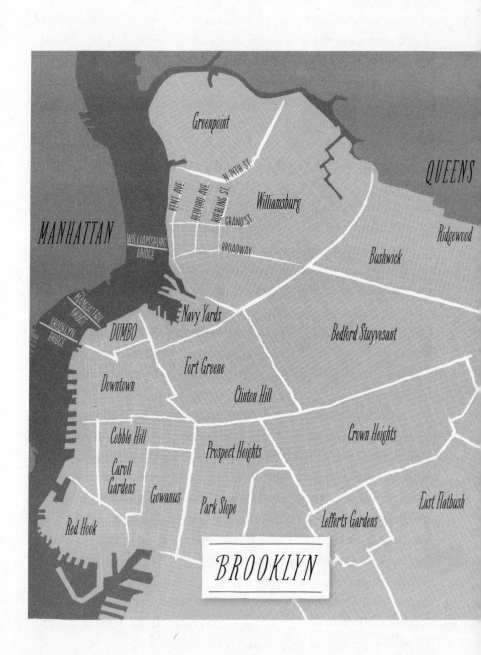

9

WILD TIMES

Williamsburg 1990 to 2000

"Williamsburg, Brooklyn, lies directly across the East River from Manhattan's Lower East Side, to which it has been linked since 1903 by the Williamsburg Bridge, and with it shares a history of immigration and poverty and of decline followed by an astonishing rebirth."

—Victor Lederer, *Images of America: Williamsburg*, 2005

*W*illiamsburg is a larger section of Brooklyn than is commonly believed. Fanning out some three square miles to either side of the Williamsburg Bridge, it is large enough to be represented by two separate districts of the City Council and qualifies for its own NYPD Precinct. Its 1990s population of over 125,000 was made up of a diverse ethnic mix of immigrants, many of whom had fled the terrors of Nazi Europe in the 1930s or had come from Puerto Rico or the Dominican Republic in search of work in the 1950s. Poles settled across the neighborhood with Italians preferring the North Side above Metropolitan Avenue and Hasidic Jews their own tight enclave on the South Side below Broadway.

As far as the 1990s art world was concerned, however, the roughly seven by seventeen blocks that mattered lay between Broadway at the southern end, McCarren Park to the north, with the East River on its western, Manhattan-facing side. Going farther inland, beyond the Brooklyn-Queens Expressway that bisects the neighborhood, Williamsburg abuts

Bedford-Stuyvesant to the southeast and Bushwick to its northeast. Far-ther still, for those who dared to go, were Brownsville and East New York, neighborhoods that struck fear into the hearts of interborough cab drivers well into the new millennium. As the East Village cracked down, shaped up and pushed out the working artists in the late 1980s, it was Williamsburg that took them in.

By the mid-1980s Williamsburg was already rife with the same cycle of building deterioration, property foreclosure, in rem city ownership and block-by-block abandonment that had sent rents plummeting in the East Village a decade earlier. Once again, besieged landlords were open to any bid and were not inclined to look too closely at the legalities of the arrangements of the rare tenant desperate enough to brave the neighborhood.

TO THE LEFT OF THE TIMELINE—
THE EARLY 1990S

As of 1990, artists had already been working and living illegally in Brooklyn's vacant factories and warehouses for several decades, albeit in small numbers and isolated clusters. The elder statesmen Mark Rothko, David Smith and Barnett Newman all lived and/or worked in the bor-ough. Fluorescent light artist Dan Flavin moved into the Williamsburg section as early as 1964 and sculptor Mark di Suvero a year or so later. Joel Shapiro, Robert Grosvenor and Bill Jensen followed in the 1970s. By 1975 there was enough art production going on in the neighborhood for an improvised show to be hung on the fence of the Williamsburg Savings Bank and by April 1, 1982, enough local brawn for volunteers to clear a landlord's South Fourth Street commercial building of decades of baled rags and other debris in exchange for putting up the *All Fools Show.* During the first half of the 1980s, artists such as Amy Sillman and Joyce Pensato settled there as did Vito Acconci, Malcolm Morley, Fred Tomaselli, Ashley Bickerton, and Roxy Paine. [1]

As in SoHo in the 1960s and early '70s, most of these working artists occupied their lofts not only covertly, under the radar of city authorities, but in the earliest days also unbeknownst to each other. The scattered and clandestine nature of the colonization accounted in part for the lack

of a prevailing aesthetic movement or Brooklyn School. Artists worked independently, largely ignorant of their neighbors' basic living arrangements or daily pursuits, much less their artistic bent. As long-time resident and artist Jane Fine commented, "Nothing could begin until we found each other."[2] As a result, Williamsburg artists went about their business, bothering little with Manhattan and not much bothered by it.

In the summer of 1992, however, Williamsburg blipped on *New York Magazine*'s radar. In "The New Bohemia: Portrait of An Artists' Colony in Brooklyn," journalist Brad Gooch reported that thousands of artists had settled in Brooklyn, many along the waterfront stretching from Greenpoint to Red Hook. Of these, he estimated that as many as 2,000 were clustered in Williamsburg. "The used overcoats are moving in," he announced. "It's like an army. They march off the train in their thrift store clothing carrying their art supply bags and stretchers on the way to the health food store."[3] Gooch's article may well have been classic *New York Magazine* hype, and it was received in the Brooklyn community with a good deal of eye-rolling ridicule; however, he was on to something.

In 1998 Roberta Smith trekked out to Brooklyn to survey what she still described as the struggling gallery scene in the Williamsburg section, but she suggested that this haven for art was actually heating up.[4] Smith astutely recognized that Williamsburg was a place where artists seemed to like to operate autonomously, preferring artist-run spaces that were not even encumbered by the rules of not-for-profit status. She described the loose amalgam of tenement apartments, street-level garages and lofts that served as exhibition venues, noting that Williamsburg was still content to make a virtue out of its own insularity: if crowds got too big, mailing lists were quickly dispensed with and organizers would simply revert back to word of mouth or bulletin board networks to spread the news.

Given the minimal attention from across the river, it was therefore no surprise that it was not a Manhattan reporter but a Williamsburg habitué who first began to pick seriously at the tangled knots of the neighborhood's early art world history. Installing himself at a North Seventh Street exhibition space called Eyewash in September 2000, artist Ward Shelley offered pretty much any Williamsburger willing to stop by

an opportunity to contribute to what would become a text-heavy linear drawing. By 2001 Shelley had finished the part interactive performance piece and part oral history project that he called *The Williamsburg Timeline Drawing*. A *New Yorker* review would later describe the finished *Timeline* as a mapping out of "the multifarious curatorial, amorous, and incidental relationships that have shaped the local scene."[5]

A hybridized and wildly irregular composite of inputs, deletions and revisions, shaky facts, colorful fiction, and highly personal recollections (reliable and otherwise), *The Williamsburg Timeline Drawing* twists, turns and doubles back on itself, documenting eras variously tagged "When Giants Walked the Earth" (Pre-1980s), "The New Frontier" (1984 to around mid-1991), "The Golden Age" (1991 to 1994), "The Second Wave" (1994 to 2000) and a final miasmic, new millennial phase drifting clean out of the picture plane on the right, dubiously called "williamsburg.com??" Unorthodox and of uneven accuracy according to some commentators (perhaps those who were, literally, left off the map), Shelley's *Timeline* got more right than it got wrong. Both the Brooklyn Museum and New York's Museum of Modern Art bought a print version of the drawing.

The Williamsburg story recalled by these collaborating cataloguers was quirky and nebulous: a complexly interconnected and often egomaniacally self-referential milieu. The local scene was made up of an idiosyncratic amalgam of painting, sculpture, film, video, installation, performance, rock music and a great deal of talking about all of the above. Dates on the *Timeline* were fuzzy, exact addresses wanting. Who started what, when and with whom is still hotly contested. Did the name of an art venue denote a location or stand for the mass action itself? Work was often ephemeral, legal occupancy of a space chancy and durations of exhibitions unpredictable; "events" came and went capriciously. Late nights, copious amounts of alcohol and liberal use of less legal stimulants also contributed to the fogginess of recollections.

Cat's Head I and *Cat's Head II* of July and October 1990 were typical early era extravaganzas—more spontaneous combustion than organized affairs. *Cat's Head I* took place on Bastille Day and was essentially a waterfront party organized by eight core volunteers at the Old Dutch Mustard factory on Metropolitan Avenue. About 250 people

were expected to look in on the installation work of six artists and listen to the handful of bands invited to play. When 750 people showed up and the police shut it down, the party simply moved outside; several of the officers returned later to join in the fun. *Cat's Head II* followed in October in an abandoned warehouse the size of two football fields. "Sheet metal streamers hung from the ceiling," Brad Gooch reported in his 1992 *New York Magazine* article, "and guests used sticks and batons to play non-stop for a full nine hours."

A *Cat's Head III*, in June of the following year, was renamed Fly Trap after two of the original organizers moved to Berlin. Gooch reported that a crowd of "more than 2000 paid $6 a head to watch five bands on two stages and see Fluxus-style works by a hundred artists: Infrared sensors went off when they detected a human body; water guns were aimed at electric fences; a 'plastic fog' was made from 1000 square feet of clear plastic strips. Limousines and private cars arriving from Manhattan created a blinding glare of headlights on Kent Avenue." Another witness called it "a seething cultural hydra. Thousands of people, interactive machines, border-free performers, and live music, all percolating on a hypnotic hot-plate of poverty-induced good will in the summer of 1991."[6]

The earliest (relatively) fixed venues to present this cacophony had names such as A Place Apart on North Sixth Street and Driggs and The Zone on South Fourth Street and Bedford Avenue. Both were operating as of 1983–1984. Mo Bock's Minor Injury got underway in 1985, first on Metropolitan Avenue then moving to Grand Street, and Rub-a-Dub (its evening hours' tag but plain Paul and Dave's Woodshop by day), started operations around 1987. Lizard's Tail, just down the street on South Sixth and Berry Streets, opened sometime around 1989. All were multimedia exhibition and performance spaces as well as rock music venues where the prime impulse was simply to get the work out into the world for discussion. The likelihood of actually selling, or being offered a paying gig, was slim to none.

In December 1989 local artist Roxy Paine helped establish an artists' collective called Brand Name Damages. The group set themselves up on Bedford Avenue at South First Street, and it was here that Paine first showed the kinetic sculptures and painting machines that brought him

Chelsea representation and international recognition some twenty years later. One work, *Viscous Pult,* was made up of an automated paintbrush that daubed paint, ketchup and motor oil onto the gallery's window in what one reviewer saw as a sly take on Action Painting. Paine later shared studio space with Ward Shelley at 72 Berry Street, paying around $2,000 a month for a staggering 6,000 square feet.[7]

Sauce at 173 North Third Street, named for its location on top of a pasta storage warehouse, began in 1992. It was launched by a collaborative of four artists in an eccentrically spaced gallery that adjoined a warren of studios and the group presented four shows a year. Programming included performance, music, video and film screenings and gave a free rein to independent curatorial projects. It survived as Sauce until 1996 when it morphed through various iterations becoming Feed, Arena@ Feed and ultimately the Schroeder Romero Gallery.

Just as the veterans of the East Tenth Street days had had their Cedar Tavern, SoHo its Food and the East Village crowd their Life Café, early Williamsburg arts denizens also fed and watered at certain preferred haunts. The Ship's Mast on Berry Street at North Fifth, considered perhaps the most important artists' hangout of the early days, dated from around 1981 and survived until 1992—miraculously so, since it gave out free hot dogs and servings of macaroni and cheese to its artist patrons. Its proprietor, John Gallagher, had once been the singer in a defunct Queens band called Moving Violation, and he was happy to host jazz concerts, performance art, poetry readings and open mike nights. In 1998 Gallagher tried to launch Ship's Mast 2, but by then Williamsburg just wasn't the same.

The Bog was started at South Fourth Street and Driggs Avenue in 1987 by dancer, choreographer, comedian and performance artist Marc Singer as a place where he and his friends could share works in progress. A small admission fee was charged, but by the time the beer and the cannolis from Veniero's on Eleventh Street were paid for, very little money was made. In December of '88 Singer moved The Bog to Grand Street, expanding the music program and adding film nights, literary evenings and poetry readings. Its spreading fame and swelling attendance numbers brought with it citations for noise violations, operating without insurance and defacing public property with flyers posted on lampposts.

"And honestly," Singer admitted, "it wasn't what I originally envisioned anymore . . . So I wasn't so unhappy when we got shut down after a few months. I think it was April 1989."[8]

Right Bank, a key watering hole on Kent Avenue, was described by one patron as late as 2002 as, "warm and dingy and dim and welcoming . . . off the beaten path enough not to suffer from the decrepitude of most of Williamsburg." In classic isolationist defiance the writer confidently claimed, "It will never, ever, ever catch on with people looking for some new place to make trendy."[9]

EFFORTS TO ORGANIZE—MID DECADE

A young woman called Annie Herron is credited by many veterans of Williamsburg's fledgling days as being the first to try and put structure around the creative mishmash of the scene.[10] In fact, two earlier pioneers, Laurie Ledis and Robert Flam, were there a good five years earlier, opening a gallery on North Sixth Street in 1982, but lack of attention from either critics or purchasing collectors drove them back to SoHo in 1990. In 1989 Licha Jimenez and Mitchell Algus also pioneered a space on South Eleventh Street, but they likewise soon decamped back across the river.

Herron was therefore generally perceived to be the original bush-whacker. She moved to Williamsburg in 1987, having spent the earlier 1980s in the East Village as a co-director with Barry Blinderman of the gallery Semaphore East on Avenue B and Tenth Street. There they showed the bodega security gate murals of Martin Wong as well as paintings by other East Village denizens like Keith Haring, Mark Kostabi and photographs by Tseng Kwong Chi. Herron was known for her excellent eye and finely tuned radar, and, as she saw energy wane in the East Village, she turned her scanners on Williamsburg. In 1991 she created one of the first fixed-abode art spaces on the Williamsburg landscape in a 5,000-square-foot, former Chinese auto repair shop on North First Street. She called it Test-Site. A certain anti-commercialist element in Williamsburg (noting that Herron came out of a gallery background and had every intention of trying to sell the work she exhibited) actually boycotted her shows.

Thousands of others did not, however, and the huge space crackled with energy from 1991 through 1993 when loss of interest by her backer forced her to shut up shop. During her brief stewardship, she debuted Roxy Paine's paint-pouring contraptions, Ken Butler's hybridized musical instrument pieces and cultural networks essayist Ebon Fisher's strangely futuristic, computer-generated graphics. In 1992 she put up the ominously titled *Salon of the Mating Spiders*. James Kalm (aka artist Loren Munk) wrote in *The Brooklyn Rail* that "half the artists in Williamsburg began their careers with Mating Spiders, a street fair, New Music performance, picnic and art happening, all rolled into one." Artist Jane Fine put the number of participants at over 600. "No one was refused," she remembers. Herron also curated a number of shows for other venues in Williamsburg and beyond, including her multipart Dyad, but in each she promoted the Brooklyn talent she so much believed in.

In 1995, while continuing to live in Williamsburg, Herron took her gallery skills back to Manhattan and briefly ran a SoHo-based program called Black + Herron. She was back in Williamsburg by 1997, however, to co-launch a space called Eyewash with local artist and Brooklyn commentator Larry Walczak. The gallery gave a first solo exhibition to Amy Cutler, who was developing her otherworldly landscapes of strangely self-involved females. Eyewash stayed on North Seventh Street until 2002 and then curated nomadic shows that were appreciatively hosted at various Brooklyn venues.

In 2000, Herron approached photographer Timothy Greenfield-Sanders to create a Williamsburg version of the iconic art world group portrait *The Irascibles* that Nina Leen had taken in 1950. Originally published in *Life* magazine in January 1951, Leen's group shot had featured fifteen stiffly postured abstract artists of the New York School. Included were de Kooning, Pollock, Motherwell, Rothko and Clyfford Still. Greenfield-Sanders had then reprised *The Irascibles* pose in 1985 with habitués of the East Village scene, including David Wojnarowicz, Richard Hambleton, Stephen Lack and Judy Glantzman and the dealers Patti Astor, Gracie Mansion, Peter Nagy and Doug Milford. Determined that her Williamsburg world gain equivalent historical footing, Herron corralled artists Fred Tomaselli, Ken Butler, Amy Sillman and Billy

Basinski for the group picture, along with Williamsburg's gallery own-
ers, nonprofit program directors and dealers. Tragically, Annie Heron
died of a rare form of cancer in 2004. She was just fifty.

Another widely respected arts operation characteristic of early '90s
Williamsburg was Four Walls.[11] Artists Adam Simon and Michele Araujo
started Four Walls back in 1984 following Simon's first big exhibition
at a Fifty-Seventh Street gallery. The show looked good and a couple of
things sold, but Simon was hugely disappointed in the paucity of criti-
cal debate, either positive or negative, that followed. Sharing his sense
of letdown with a number of other artists in the Hoboken, New Jersey,
loft enclave where they lived and worked, they all acknowledged the
urgent need for dialogue, debate and an exchange of ideas about the art
they were making. It was this founder group that went on to collectively
shape Four Walls.

Four Walls held court over in Hoboken just one night a month from
1984 to 1988. Two artists would be paired up to install their work in
the half of the live/work space not occupied by Araujo and Simon. After
a couple of hours to examine the art and drink the beer, wooden planks
were spread across milk crates and the crowd would sit to caucus. Chris-
topher Wool and Joyce Pensato were the first artists paired and Mark
Dion and curator-in-waiting Lawrence Rinder were early participants.
Leon Golub and Nancy Spero came over from Manhattan to hear what
was going on. Fueled in part by the voguish Post-Structuralist rhetoric
that ruled the art world airwaves in the mid-1980s, the talk regularly
invoked Derrida, Lacan, et al., but also gender politics, censorship and
the tinting properties of oil paint.

By 1988 audiences were growing, but the young couple was finding
it hard to work a day job, produce their art and continue the Four Walls
evenings in their Hoboken home. They decided to suspend operations.
By this time, however, the events had such a following that the Manhat-
tan venue White Columns offered to host them. Typical of the kind of
affairs that they mounted in these interim years was their Election Day
event of 1988. Charging $1 at the door and $2 for beer, an audience of
mostly Democrat artists gathered amidst the art and, with TV monitors
humming, glumly watched George H. W. Bush beat Michael Dukakis to
become president of the United States.

The Four Walls formula moved to Brooklyn in 1990 when Amy Sillman introduced Simon to artist Mike Ballou; the size of the artists' community there made it fertile ground for a resuscitation of the project. Encouraged by White Columns' Bill Arning and re-energized by Ballou, Sillman and Claire Pentecost, Four Walls flourished as one of the principal fixtures of the Williamsburg scene from 1990 until 1996. In an old ground-floor garage space on Bayard Street beneath Ballou's unheated quarters, it mounted such events as the *Neurotic Art Show,* the *Quilting Club,* the *Joke Show* (with a stand-up comedian recruited from a comedy club), and the *Slumber Party,* a storytelling sleepover that Ballou subtitled *Bed Bugs at Snore Walls.* Expert input was often sought from beyond the arts community: psychoanalysts and even priests were drawn into the fray.

An atmosphere of freedom and experimentation was paramount. As Gregory Volk later described it, "Risk and nutrition were in the air, friendship fuelled everything, and the whole situation was wonderfully human and refreshingly unpretentious."[12] The concepts surrounding a body of work were considered to be of greater importance than the finished object, process more important than product, and the momentary took precedence over the enduring. It was part clubhouse, part laboratory. While a small funding grant was welcome once in a while, not-for-profit status was never seriously pursued because that required a forecast of the programming. Four Walls rarely knew what was coming next. In a conversation with the author in 2008, Adam Simon recalled once overhearing a Four Walls enthusiast encourage another would-be exhibitor. "Just go do a show," he said, "If it's a flop, they don't care." Simon smiled. Clearly they didn't.

Four Walls continued with the bizarre combination of iconoclasm, cerebral ambition and zany nonsense that had always been its claim to fame. Invited in 1993 to produce a work for Alanna Heiss at PS1 in Queens, Ballou pulled together a collaborative that included Fred Tomaselli, Jessica Diamond, Sue Williams, Lawrence Weiner and Cady Noland. Together they built a miniaturized scale model of the Four Walls space, complete with tiny exhibitions hung inside it. It sold to an out-of-town collector and, in typical Four Walls fashion, the proceeds were split equally among the participating artists.

When Simon moved on to other ventures around 1996, Four Walls gradually morphed into the Four Walls Film and Slide Club, an equivalently inclusive enterprise open to anyone looking for a forum to show their 35 mm slide pieces or Super 8 films. Both mediums were cheap to work with at the time, and no one really got upset if a projector burned out or a light bulb exploded mid-screening.

When Ballou moved out of Bayard Street in 2001 and Four Walls faded away, the space was taken over by a digital enthusiast named Marcin Ramocki who used the site for a new-media art venture called VertextList. There he produced a documentary called *Brooklyn D-I-Y* that gained some celebrity, including a screening at the Museum of Modern Art. Vintage film footage of some of the early events and interviews and commentary from many of the veteran players vividly captured much of the make-it-up-as-you-go lunacy of the early Brooklyn days.

THE SECOND WAVE—THE LATER 1990s

It is difficult to know where best to place Joe Amrhein and Pierogi 2000 on the *Timeline*'s continuum. The Sacramento-born artist first came to Williamsburg in 1989, hung out at Four Walls and certainly had roots in *The Williamsburg Timeline*'s early 1990s golden age. Amrhein's aptitude for what the *Timeline* later labeled "Consolidation and Professionalism," however, and the futuristic name of his gallery also implied something forward thinking.

Pierogi 2000 was named after the small Polish dumplings that could still be savored in Williamsburg, a backward nod of respect to the history of the neighborhood. The "2000" was more a talisman for having the space survive at least until the new millennium. Like the Four Walls brotherhood he was once a part of, Amrhein strove not only to get good new work up but also to stimulate an interchange of ideas that would last after the show came down. In words that might have been written by Adam Simon, Amrhein described his idea of community as being about "dialogue after the initial meeting, some continuance, rather than just a fleeting moment or voyeuristic thing."[13]

Amrhein was a protégé of Test-Site's Annie Herron. It was Herron who suggested that, since his studio building on North Ninth Street had

nice wide doors, why not open it up to other artists work? She funded $200 to get him going and gave him an installment of her Dyad exhibition to put up as a starter. Subsequent exhibitions were mounted while Amrhein held down various day jobs to stay afloat financially. "When I started here I didn't have a fundamental mission in mind," he recalls. "I was an artist working in New York . . . trying to get a space where I could be more pro-active and get people involved. It wasn't about representing artists or selling work, it was about getting a dialogue going . . ."[14]

The original concept of one artist, one show gradually changed as more and more emerging but rapidly evolving talent surfaced and seemed to deserve second and third exhibitions. Gradually Amrhein found himself the champion of these developing but still unrepresented artists, and sales began to occur. He ultimately gave up his day jobs and Pierogi 2000 transmuted into something closer to a commercial gallery.

Inevitably, as the program matured, some of the free-for-all cacophony of artistic styles evened out and Amrhein exercised his eye for skillfully rendered, often complexly detailed painting and drawing (Jane Fine, Jim Torok and Dawn Clements) and finely executed, brainy sculpture (Robert Lazzarini, Patrick Jacobs, Jonathan Schipper). At the same time, he found room for the cerebral but incendiary (Mark Lombardi) and the totally zany (Tony Fitzpatrick and Kim Jones). Although small commissions were taken on sales in order to support the gallery, and a more predictable schedule of programmed exhibitions was put in place, little else about Pierogi 2000 compared to the art-mart vibe going on across the river. Beer and pierogis were still served at openings, gallery hours often extended well into the night if the conversation was good, and artists not yet ready with a full body of work were encouraged to apply for inclusion in Pierogi's soon to be famous Flat Files.

Once a work on paper presented for Amrhein's consideration passed muster under his gentle critique but rigorous eye, it was deposited in the big Flat File drawers out front in the gallery. The artist's name was added to the inventory and all comers were encouraged to take a look. The only requirement for access to the Files was the donning of one of the readily available pairs of white cotton art-handling gloves. Other than that, visitors were left alone to peruse the clearly price-marked work and were free to buy.

The Flat Files began with 20 artists but by 1997 the number was up to 400. The year 2000 saw Pierogi survive its self-imposed sell-by date and, with its shelf life still good, it dropped the "2000" from its name. By 2002 there were over 1,200 artists in the drawers and a second set of the files was circulating around venues in Los Angeles, London and Vienna. Over the years the drawers have held such treasures as Fred Tomaselli's hallucinogenic pill and plant collages, James Siena's taut, mathematically based but gorgeously fluid drawings and Amy Sillman's ever-metamorphosing abstractions. Before Polly Apfelbaum was showing her scattered-velvet-petal installations with Marianne Boesky in Manhattan or Ryan McGuiness's densely layered street culture paintings reached Jeffrey Deitch's super-cool SoHo walls, their smaller works were humbly housed in Pierogi's Flat Files. Like the slide registries at Artists Space, White Columns or the Drawing Center, they became a destination for serious collectors and major museum curators looking to keep a finger on the pulse of emerging or overlooked talent. They were ultimately digitalized and made available online.

Meanwhile, in the galleries, Pierogi gave wall space to Lisa Kereszi's gritty photography, Josh Dorman's reworked antique map pieces and Yun Fei Ji's Chinese scroll-inflected but acerbically political ink works. The commercial success of these works in relatively traditional media generated the revenue to allow the gallery to stay open. At the same time Amrhein made space for—and often put non-recoverable funds into—such ephemeral projects as Tavares Strachan's explorations of climatic events and homeostatic systems, as well as the shoehorning of a huge felled tree into the tight gallery space in a re-enactment of Robert Smithson's *Dead Tree* piece of 1969. In 2004 Ward Shelley lived inside the walls of the gallery in a three-foot-wide crawl space for five weeks—a work he called *We Have Mice*. In 2009 Amrhein opened a second space called the Boiler over on North Fourteenth Street specifically to accommodate more of these tough-to-install and probably impossible-to-sell works.

Momenta Art opened in Williamsburg six months after Pierogi but, like Four Walls, it had had an earlier life elsewhere.[15] Launched in Philadelphia in 1986, it began life much as it has continued, a small, artist-run enterprise that was simply about putting up new art and getting it talked

about. At the outset, director Eric Heist and the original artist founders cut a deal with a local real estate owner to borrow a 20,000-square-foot rent-free space in an empty building. They scoured the local artist community, dug up good work and organized exhibitions. "We felt very isolated in Philadelphia," Heist recalls, "and there was not a lot of interest in what we were doing, so we decided to support each other." Word spread, and "all of a sudden we had fifty artists together in one space and we felt we had this community that you didn't even know was there . . . a lot of them working on their own, all having day jobs." Unknowns then perhaps, but by the end of that Philadelphia period, Momenta had given first or early exposure to artists such as Jim Hodges and Karen Kilimnick; Hodges's intricately cut and layered wall hangings would go on to attract the attention of Barbara Gladstone, and Kilimnick, one of the earliest to work in scatter installation, would be picked up by 303 Gallery.

Once this free space deal ended, Heist and company found two upper stories of an empty loft for $700 a month. They covered those costs by pooling their carpentry, plumbing and other construction skills and subdividing the upper floor into rentable artists' studios. None of them knew how to sheetrock a wall, so they used empty pizza boxes and joint compound. With the modest but self-sustaining revenue stream from the studio rentals, the nimbly mounted but always-germane exhibition program continued for another couple of years.

In 1988 Heist moved to New York for the MFA program at Hunter College and re-launched the Momenta concept in New York City. Here he met the video and installation artist Laura Parnes. Together they kept Momenta going on a nomadic basis for another three years, putting up shows in empty galleries around SoHo. Cheap square footage was available back then to those hungry enough to look, mostly in the now-vacant spaces of the large gallery buildings along Broadway hit by the art world downturn of the early 1990s.

Still drawing on the donation of work from their artist community, Heist and Parnes organized fundraisers at venues like the Old Dutch Mustard Factory. They also produced small, limited edition prints and multiples that they put into silk-screened manila envelopes and sold door to door for $30 a shot. A bag of fake skin from Sue Williams and a

Janine Antoni lipstick found their way into those packets. Once enough money was raised, they would finance a show. Sue Williams, Tony Feher, Marlene McCarty and Jude Tallichet were among artists featured in these impromptu exhibitions. Important critics like Michael Kimmelman and Jerry Saltz came to have a look.

Encouraged by their success, Momenta began to search for permanent space and looked briefly at a former printing plant on Twenty-Ninth Street in what was then still quaintly known as West Chelsea. It was available for the now laughable price of 50 cents a square foot. An article touting the potential of the Chelsea real estate market in that weekend's *New York Times,* however, inspired the landlord to quadruple his asking price, and Momenta was out of the running. In any event, "It really never felt comfortable," Parnes remembers, "and was not connected to what we were or wanted to do. Momenta was an alternative space serving artists and it made sense to stay in that community."[16] It was in Williamsburg that Parnes sensed something was ready to happen.

So in 1995 when a 5,000-square-foot, subdividable space became available at 72 Berry Street, close to the Bedford Avenue L train and a few blocks from Four Walls, Momenta signed a ten-year lease. Two modest exhibition spaces were carved out, just big enough to accommodate but not overwhelm developing artists who might not yet be producing prolifically. The remainder was again converted into below-market artist studios. Carl Fudge, Rico Gatson, Rochelle Feinstein, Wangechi Mutu and Rina Banerjee all made work there; they all went on to powerful Manhattan gallery representation, international museum shows and important corporate and private collections.

The programming was always thought provoking, if not outright provocative, and Momenta often encouraged deliberately renegade curatorial statements around topics being debated in and around the studios. *The Gaze* of 1997 gave early voice to issues of female objectification well before it became a staple of graduate school term papers. *Nobody's Home* of 1999 looked at the seemingly endless creation of capitalist-generated lifestyle markets, the increasing homogenization of domestic culture and the growing sense of alienation it all spawned.

In 2000 fellow artist Michael Waugh joined Heist and Parnes. Under Waugh's stewardship Momenta developed its video library, a publicly

accessible repository for the viewing of the newly important art form. By this time the organization had incorporated as a 501(c)3 not-for-profit. It continued to operate, though, as an artist-run organization, the majority of its board being artists, and crucial funds were still raised through donations from its Brooklyn artist community.

In 2006 the whole Momenta operation was forced to leave its Berry Street quarters—gallery, artists' studios and all—when the building was converted into condominiums. Taking the only space they could afford, they decamped down Bedford Avenue to a dilapidated South Side social club on South Fifth Street near the ramp to the Williamsburg Bridge. In 2011 they left Williamsburg altogether for the newly studio-dense Bushwick where Momenta's legendary presence anointed another embryonic arts hub and created a buzz around Bogart Street and the Morgan Avenue stop on the L Train. For both moves Momenta called on their artist community of plumbers, electricians, masons and anyone who could paint a wall or push a broom. It was hard to imagine that happening in Chelsea.

At least two other founding fathers demand inclusion in the Williamsburg history of this waning 1990s decade: Richard Timperio of Sideshow and Daniel Aycock at Front Room. Timperio had first moved to New York in 1969 and to Brooklyn in 1977. For $300 a month he found a 3,000-square-foot loft space on Broadway, right under the Williamsburg Bridge. Down the block from him in those days was a small commune of African-American artists who were referred to at the time as Black SoHo. "Otherwise"—aside from the stripped cars and packs of feral dogs, Timperio recalls, "man, there was nothing!"[17]

In the mid-1980s Timperio was evicted from this Broadway space. By now, however, the Loft Law movement that had wrought such change in SoHo had found its way across the East River, and artists in Brooklyn were fighting back. With the modest award he won from his eviction appeal, Timperio was able to move into a building on nearby South Fifth Street. In 1986 alone, he remembers, there were fourteen killings in the area. The drug trade operated from six payphones up and down the street and by 5:30 in the morning strung-out junkies were lined up around the block. The business was such a smoothly run enterprise that dissatisfied users could return bad drugs at a complaint window outside Timperio's door.

Ironically, living as a visibly harmless artist in the eye of the storm gave Timperio a relatively safe haven since no one was looking for outsider trouble or the unwanted attention of the feds. Not everyone agreed about the comfort to be had from the protection of pushers, but in 1991, Timperio, seeing an opportunity few others would be lunatic enough to take, purchased 5,000 square feet on two floors of a former matzo factory in that same blighted zone of Bedford between South Second and South Third Streets. The seller had simply had enough of the danger.

Somewhere around 1993, perhaps 1994, Timperio recalls that things started to change. Heroin had given way to the more rapidly addictive crack, and the downward spiral of addicts sped up exponentially. The prostitutes now simply died of AIDS. Giuliani's drug enforcement agents, empowered by the clean-up of the East Village, moved in and clamped down and the South Side began to turn around. In 1995, while still working on his own art, Timperio started putting together small shows of local work and mounting them on the walls of the Williamsburg restaurant Planet Thailand. In 1997 he opened a narrow little space up on Bedford Avenue between North Sixth and Seventh Streets and wryly called it Sideshow. Whether the name riffed on the far more established programs at Four Walls, Momenta and Pierogi or was a Brooklynite dig at Manhattan's self-importance, Timperio wouldn't say.

By 1999 Timperio was able to survive financially without renting out the second floor of his South Side property and he moved his home and studio upstairs and his Sideshow gallery into the ground floor space. From there he developed a program rich in both young as well as veteran talent. He mounted the sound works of Billy Basinski and the avant-garde film of Billy's partner, James Elaine. He also showed soon-to-be *Brooklyn Rail* publisher Phong Bui's architectonic constructs and the anonymous artists' collaborative TODT, who filled the gallery with bizarre fusions of organic matter and urban detritus. The work of an older generation of established artists could also be seen at Sideshow, ranging from the swirling, impasto-heavy canvases of abstract painter Larry Poons to the rigorously tight geometrics of Alfred Jensen. The diaristic films of the legendary Jonas Mekas were also screened. The Sideshow Bass Choir of anywhere from six to fifteen upright basses performed on

a monthly basis in the gallery, and a group called the Line Tamers periodically staged readings.

Timperio also showed Loren Munk, the writer who published under the pseudonym James Kalm but who was also a skilled painter. Munk had also long been known locally as "the guy on the bike." A ubiquitous presence not just in Williamsburg but across the New York art world, Munk depicted, documented and as often as not skewered the goings-on of the scene in diagrammatic paintings, acerbic articles and rough-and-ready but surprisingly informational video cam recordings. With the advent of YouTube he began to stream them on the web. Biking from one gallery opening to the next, Munk provided breathless commentaries, catching "the noisy opening night parties, with their shouted greetings and clinking wine glasses . . . the sunlit rooms where technicians and gallerists are making last minute decisions about how to install work."[18]

Looking back from 2008, Timperio identified the years shortly after the turn of the new century as the period when the quality of work and the purity of the artistic mission in Williamsburg began to falter. New galleries, not always of the right caliber, started to proliferate, and a far more commercial impetus began to take hold. As Williamsburg came up on the screens of Manhattan galleries, Brooklyn artists were poached. The quality of locally produced work left to show in Williamsburg deteriorated; there was less experimental risk and heterogeneity and more caution and conformity.

Daniel Aycock, from his Front Room Gallery five blocks north on Roebling Street and Metropolitan Avenue, would beg to differ.[19] Aycock had come to New York for graduate studies and moved to Williamsburg in the mid-1990s. He opened the artist-run Front Room in 1999, started producing a broadsheet called *WagMag* in 2001 and ultimately became president of a Williamsburg Gallery Association that got going in 2002. Throughout, he has kept faith in the importance and continuing relevance of the art produced in Williamsburg. Trained in photography himself, Aycock showed video and large sculptural installations, hosted performance pieces and enthusiastically embraced the conceptual and the ephemeral. Balancing these commercially nonviable works with a democratically affordable program of prints and multiples helped Front Room keep its doors open.

Front Room's program was typical of the artists-supporting-artists ethos of the Williamsburg community. All within walking distance, Leah Stuhltrager, of Dam, Stuhltrager, had shown at Front Room; Stuhltrager, in turn, showed *Brooklyn Rail*'s James Kalm, (Loren Munk), as well as the nonprofit NURTUREart's Karen Marston and Carol Salmanson. Both Elana Herzog and Marsha Pels, who had shows at Momenta Art, had also had work up at Front Room and Larry Walczak, former partner of Annie Herron at Eyewash, local documentarian, blogger and all-around neighborhood majordomo, had curated there.

It was by virtue of Aycock's position at the heart of things that the *Williamsburg and Greenpoint Monthly Art Guide*—or WagMag, as it quickly became known—flourished. Williamsburg had a particular need for a navigational tool since the nature of the Brooklyn terrain was far more intimidating to a Manhattan visitor, the choreography of a gallery route less obvious, and its far-flung and eclectic exhibition spaces near impossible to find. Capricious opening hours in these largely artist-run spaces where "directors" could just as easily be in their studio or at any one of a multitude of day jobs made a trip out on the L train an even bigger gamble. Something had to be done to join the dots and provide the gallery-going public with a fighting chance of spending its time in the outer borough profitably.

Financing the operation through small ads from local businesses, Aycock started his first issue with around fifteen names, some of them slightly outside of Williamsburg proper. By March 2002 there were thirty galleries listed; a year later the number was up to forty-eight. By April 2004, at what was perhaps the peak of the modish Williamsburg era, fifty-nine galleries were listed and there were probably closer to one hundred in the neighborhood overall.

The Williamsburg Gallery Association came together in 2002 and included not just galleries but curators, artists and local community members. Aycock chose not to be involved in the first few years of the group's operations as it struggled to define its mission. There were those like Aycock who felt that, while aesthetic standards should be maintained, the association should aim to be fundamentally inclusive. Others sought a more exclusive (and excluding) approach with a view to establishing a Williamsburg elite and raising things unapologetically above the average.

As the new millennium and a steadily rising art market got under way, more and more galleries opened in Williamsburg, and the neighborhood found itself increasingly at the forefront of art world buzz. With this, the Gallery Association was pressed even harder to clarify the ambitions of its members. Should they stick to their origins as an incubator of emerging and risk-taking work? Continue in an atmosphere that was always long on camaraderie and short on censure? Or should they now capitalize on Manhattan's long-time-coming recognition of the talent that had always been right there in Brooklyn? As the galleries in the Association took their positions on one side or the other of this debate, so went the future course of who stayed on in Williamsburg, and who left for more profitable climes.

10

WHITHER WILLIAMSBURG?

2000 to 2005

"Less than a decade ago, Williamsburg was still a desolate haven for vast, raw, dirt-cheap lofts and an emerging art scene that imagined itself an ambitious underground alternative to the narcissism of SoHo and Chelsea."

—Daniel Baird, *The Brooklyn Rail*, 2000

*W*ith the turn of the new millennium, a number of museum exhibitions started to spotlight Brooklyn-based talent. The Brooklyn Museum's decade-long *Working in Brooklyn* series gained a particularly strong following, and its *Current Undercurrent* show of late 1997 was featured in the *Village Voice*. That same year artist Bruce Pearson's *Just What Do You Think You're Doing Dave?*—a show of some fifty-five local artists installed at the Williamsburg Art and Historical Society—also got press. Meanwhile, with a better-organized approach developing in the Williamsburg community, the ground was now well primed for the burgeoning of a whole crop of new galleries

IN, UP AND AWAY

Not all of the new gallery directors, principals or backers were necessarily recent arrivals to the art world, and many were already professionals with solid beginnings elsewhere, even proven track records. In the

summer of 2001 Lisa Schroeder and Sara Jo Romero combined forces to launch Schroeder Romero, their debut exhibition opening just ten days after the attacks on the World Trade Center.[1] Schroeder had moved to New York from Kansas to study film and began living in Brooklyn in 1992. She moved into the 6,000-square-foot loft on North Third Street at Metropolitan Avenue with the four artist graduates from NYU and Yale who had started Sauce. They split the $1,750 a month rent five ways, but the first year was free because there was no heat in the building. They lived in the back and opened the front up to large group shows of highly experimental work, allowing the artwork itself to suggest themes and groupings rather than their imposing curatorial preconceptions.

In 1995 Sauce (along with Four Walls, Momenta and Pierogi 2000) was included in *Other Rooms,* a seminal exhibition hosted by the ever-ready dealer and barometer of quality Ronald Feldman in his SoHo gallery. As the press release explained, "Conceived, programmed and financed solely by artists, these alternative spaces represent the response of artists who, through need and desire, have devised new ways to have their art seen within the context of a depressed economy and cutbacks in government funding."[2] The show was a huge success, garnering much critical attention. The notion that something was happening in Brooklyn had caught on with the gallery-going public.

The untimely death in 1996 of one of the original protagonists of Sauce put some serious strain on the dynamics of the group, and Sauce reconfigured. Around 1997 the gallery renamed itself Feed. By 1998 Schroeder, who had been struggling to maintain the space while juggling two other day jobs, needed help. She was joined for a brief period by Renée Riccardo, whose Arena project space had been operating since 1991 but the fused entity, Arena@Feed, was short lived and Schroeder started to look for a new partner.

Sara Jo Romero arrived in New York in 1989, stayed with the one and only person she knew and started scouring the pages of the *Village Voice* for a job.[3] At the bitter end of a fruitless month, she was offered an $8-an-hour assistant job at the Paula Allen Gallery at 560 Broadway. Exploring the SoHo terrain, she got her first glimpse of such strange-looking new work as Fred Tomaselli's pill- and medicinal herb–encrusted collages and Rikrit Tiravanija's participative gallery-based cookouts.

When Paula Allen closed in 1990—during the art world downturn of those years—Romero joined veteran dealer Charles Cowles. After five years and a steep learning curve with Cowles at the legendary 420 West Broadway, she was hired by Holly Solomon. She worked for Mrs. Solomon right through the '90s until failing health caused her to close the gallery and operate privately out of the Chelsea Hotel. Solomon's artistic eye and her business wisdom made a strong impact on Romero, but at the same time the older mentor always encouraged her to find her own voice. When Romero heard that Lisa Schroeder was looking for a partner she decided to cross the river.

Despite opening immediately after the September 11 tragedy, Schroeder Romero's timing proved right. With a gutsy program of politically and socially trenchant work, their business flourished as the Brooklyn scene began to blip on the Manhattan art world radar. Among their uncompromising offerings was work by Momenta's establishment baiters Eric Heist and Michael Waugh, Susan Graham's delicate but deadly sugar-spun guns, Marsha Pels's *Hitler Vitrines* and the Klan-hooded wedding dresses of the unapologetically queer Robert Boyd. Their *Decade Show* of 2003, celebrating the ten years that provocative art had been shown in the Sauce-Feed-Schroeder Romero space, read like a who's who of the 1990s Brooklyn scene. So fierce was the attention they attracted that within their first two years, their gallery got a total of twelve mentions in the *New York Times*.

In fact, by this time New York critics were swarming all over Williamsburg. As early as the spring of 2001 *Brooklyn Rail* writer Lori Ortiz was describing a "Brooklyn Pastiche" of galleries including "those operating within a more traditional commercial model, those with a more educative and social focus, and those dedicated to cultural discourse. "Spaces for art," she noted confidently, "are pasted on the Brooklyn map in increasing and changing locales."[4] In just two seasons the critics at the *New York Times* published more than forty reviews on galleries in Williamsburg. During the same period, Momenta Art was covered in *Time Out, The New Yorker, Artforum* and *Flash Art,* and Pierogi's Flat Files received a full page in *Art on Paper.*

Another gallery attracting attention was Roebling Hall on Williamsburg's still sketchy South Side. Roebling Hall's Joel Beck moved to New

York in 1984 and paid his rent on an apartment in the East Village by renovating gallery spaces for dealers on Fifty-Seventh Street. Beck had a studio on East Ninth Street between Avenues C and D, next door to Eric Fischl and Christopher Wool. Downstairs was Pat Hearn's gallery. He lived for six years in five different places in the East Village—each one more dangerous than the last.

In 1992 Beck moved to Brooklyn, took a seven-year lease on 12,000 square feet on the north side of Roebling Street, kept a quarter of the space for his own studio needs and sublet the rest. In 1996, he started to do some curatorial projects with Jessica Murray, a friend of one of his tenants. They called the enterprise Salon 75 and put up shows that would hang for about two weeks. After eighteen months Beck and Murray decided that their ambitions differed and they should each follow their own trajectories.

Beck found a new business partner in Christian Viveros-Fauné, a smart and articulate art world impresario who would later, very briefly, take Jerry Saltz's job at the *Village Voice.*[5] Beck called the new gallery Roebling Hall though it was located not on Roebling Street but farther west on Wythe Avenue at South Fourth Street. Hall was added to Roebling (the architect of the Brooklyn Bridge) for its ludicrous grandiosity. The two directors were both sons of academics and were raised on college campuses so the pretentious name had great sophomoric appeal.

From 2000 to 2004, Beck and Viveros-Fauné ran their multimedia program of painting, photography, video, film, sculpture and performance from the South Side Williamsburg location. They showed work as varied as Nancy Drew's glitter paintings, Christopher Draeger's ominously dark Black September series, Sebastiaan Bremer's dot-embellished color photographs, Joe Amrhein's word paintings and Eve Sussman's Velázquez-inspired *89 Seconds at Alcazar.* Thematic shows such as the 2005 *Wasteland: 21st Century Landscape* included Erik Benson, Davide Cantoni, Adam Cvjianovic, Yun Fei Ji and Justine Kurland.

During the first years of the new millennium, hype over the growing scene in Williamsburg added to the sense of a new Bohemia out along the L line. In the summer of 2001, the *freewilliamsburg* writer Greg Moser, principally spotlighting the growing music scene in Brooklyn, quoted twenty-year-old sages announcing, "People are burned out

in Manhattan. The scene there is dying and over with."[6] In September 2002, *New York Magazine* picked up on the theme with a piece called "The Scene: Generation W—Down and Out in Williamsburg? Not Exactly." The writer referenced all of the key coordinates on the scenester landscape, sashaying, well-bedecked, out of the subway on Bedford Avenue, checking out the brick wall with its cluster of flyers for apartment shares, all hand written with Sharpies, strutting the look to the L Café or Fabiane's, or dipping into Reel Life to sift through their video racks.

By 2002 the Williamsburg art world had entered the international arena. In April of that year eighteen galleries, nine in Brooklyn and nine in Paris, launched the transatlantic Paris/Brooklyn Exchange. The Parisian galleries showed forty-five Brooklyn artists and Brooklyn likewise received the French. Among the Brooklyn hosts, besides the longer-established Pierogi, a combined Momenta@Four Walls unit and Schroeder Romero, were several brand-new galleries that had opened between 1999 and 2000.

As press coverage and collector activity intensified, new dealer hopefuls were seizing the moment to launch fledgling endeavors or transplant existing enterprises into the neighborhood. But the Williamsburg ethos of endurance, longevity and loyalty so core to the original pioneers was not necessarily in the makeup of all of the new settlers. Many of the new arrivals brought to the table quality fare, and most infused the local gallery scene with a more varied range of offerings. But, as we shall see, several were destined to eat and run.

One of the new arrivals was Plus Ultra, launched by Edward Winkleman and artist Joshua Stern in a subdivided section of Stern's studio on South First at Havemeyer Street. Winkleman was raised in Ohio, arriving in New York in 1994 via Washington, DC, where he had gained some gallery experience, principally with Modernist works on paper.[7] In the late 1990s he started putting up a series of what he called guerilla-type, hit-and-run shows comprising an opening on a Friday with a performance on Saturday, viewing on Sunday and all done and down by Monday. Modeled on the music world's raves, these events were staged at various make-do venues around town—two on the Lower East Side, one on West Thirty-Seventh Street, another on Pier 40 and the Hudson River. To find the show at all, you had to be in the know.

Plus Ultra's opener in the spring of 2001 was a group show about sleaze culture and the ongoing Disneyfication of New York City, and it received a gushing review in the *New York Times*. Subsequent exhibitions of artists including painter Joe Fig, installation artist Jennifer Dalton and sculptor Andy Yoder also got regular attention in *Artforum, Art in America, Flash Art* and most of the local New York weeklies.

Bellwether Gallery's Becky Smith was a painter schooled at Carnegie Mellon, Yale and Skowhegan who was drawn away from her studio practice and into curating shows with a couple of fellow artists in a studio-cum-project space in Greenpoint.[8] She didn't arrive in New York until 1999 and from the outset had something of a carpetbagger status with the Williamsburg crowd. Not that this smart and ambitious young go-getter was necessarily troubled by her reception. When her partners went their various ways, Smith decided to go it alone in a full-fledged gallery operation. The Bellwether name was apt; from the start Smith was determined to set the pace and lead the flock in terms of contemporary art marketing.

She made a gutsy move into a space on the still dodgy western end of Grand Street and opened on September 9, 2001. Her new venture survived the stunned incomprehension that beset the art world as the Twin Towers fell—the unfolding of which was horrifyingly visible from Williamsburg's rooftops directly across the river. Smith forged ahead with a brainy program of technically flawless, visually stunning shows. Luminaries of the art world attended her openings: writers and critics like Deborah Solomon and Jerry Saltz were there as were Manhattan dealers like Jay Gorney. Even the hottest artists of the day such as Elizabeth Peyton and Catherine Opie came over to see what she was up to.

Meanwhile, Smith's relations with her Williamsburg neighbors were becoming strained, particularly over the direction of the newly formed Williamsburg Gallery Association. Unapologetically ambitious for the status of the organization, Smith butted heads with other members who still believed in the inherent collegiality of the Williamsburg scene. Smith, as she put it to the author in a 2008 interview, "did not start a gallery to be part of a scene."

31 GRAND's Megan Bush came out of a very different lineage than the studio trained Smith and the program she developed reflected it.[9] A

stylist and fashion designer from Alaska, she had first tested her entrepreneurial skills with an East Village clothing store named Flood. She took space on Grand Street in 1999 to develop her clothing line but little by little she found herself morphing 31 GRAND into a space for art rather than fashion.

In 2000 she met Heather Stephens, a graphic designer from Greenville, South Carolina, and a graduate of Brooklyn's Pratt Institute. Out-of-towners like almost everyone who found their way to Williamsburg, both women thrived on the Brooklyn vibe. Surrounded by so many artists, Stephens developed a valuable network in the arts community through her very early website Studio/Visit.com where she posted a monthly interview with an emerging artist.

After inviting Stephens to put up an exhibition in her space, Bush decided that their combined eye for the contemporary could make something happen in Williamsburg. No intellectual slouch, Stephen's first curatorial effort was *The Life You Save May Be Your Own,* after the Flannery O'Connor Southern Gothic of 1955. The show was a huge success. It also gained a good deal of notoriety when a prankster at the opening—a friend of the up-and-coming photographer Ryan McGinley—decided to make off with a work from the exhibition. Stephens went in pursuit and the scene turned nasty (seeming to echo the title of the show) as Stephens was dragged into the back of a getaway SUV and the car went careening down Kent Avenue with a colleague from the gallery clinging to the hood. An ugly court case ensued, followed by jail time for the thief. Despite (or perhaps in line with) their sensational beginnings, Bush and Stephens went on to run a lively, well-respected program for the next six years.

Two galleries run by European émigrés also found comfortable homes amid the late-century industrial decrepitude of early 2000s Williamsburg: Priska Juschka and Tatyana Okshteyn's Black and White. Both the German-born Juschka and the Russian Okshteyn were drawn to the multicultural and polylingual cacophony of the neighborhood and believed their clients might be as well. Neither the rough architectural spaces nor the out-of-the-way locations would be off-putting to the generally intrepid European collectors used to traveling far and wide in pursuit of their art.

Priska Juschka was educated in West Berlin in the 1980s, coming of age in an atmosphere of political and social activism and intellectual inquiry.[10] Reunification after the fall of the Berlin Wall in 1989 and the period of cultural turmoil that followed fuelled her curiosity and a restlessness to explore beyond the confines of Germany. Her first visit to New York in 1991 was pure adventure with no contacts and no plan. She started out around the downtown music and performance spaces, at open mike nights and at La MaMa Experimental Theater Club on East Fourth Street. She got to know the painter Lisa Yuskavage, who had just started to show her zaftig figure works with Marianne Boesky Gallery in SoHo; Juschka found a way to support herself as a studio model for Yuskavage. She also worked as fit model for design students at Parsons and the Fashion Institute of Technology.

Although she was drawn to the contemporary, Juschka was shrewd enough to know that with an international background, a command of several languages and a number of European currencies weak against the US dollar, her niche might initially be sales of Modernist works in the secondary market. With a lot of younger-generation Europeans inheriting art that they would off-load for the right price, New York had the buyers. She brokered that market for five years—but always with ambitions for a gallery of her own.

By 2000 she still lacked the financial means for either SoHo or Chelsea. But Williamsburg was affordable and felt both physically and psychically akin to what she knew in Berlin. The slump in the real estate market that followed the September 11 attacks freed up a vacant double-frontage garage on Berry and North Ninth Streets. Momenta Art was just up the street, the ever-magnetic Pierogi and the L Train only a couple of blocks away.

Now with her own space, Juschka shifted from Moderns to fresh contemporary work but retained her taste for things European. While showing a number of strong Americans (the painters Aaron Johnson and Tim Doud and installation artist Amy Rathbone), her expertise in and around the newly opening eastern European talent (Kazakhstanian photographer Almagul Menlibayeva or the Hungarian figurative painter Attila Szucs), gave her a strong edge as those markets expanded in the

new century. As fresh appetites grew for work coming out of the Middle East and even farther afield, Juschka was there to satisfy it.

Black and White's Tatyana Okshteyn was also a relatively recent immigrant. Initially branded an upstart by the incestuous Williamsburg community, the Soviet-born Okshteyn refused to apologize for having made her seed money as a banker on Wall Street.[11] She and her artist husband had immigrated to the United States in the 1980s as political refugees from the Soviet Union, where she had grown up in a culturally sophisticated family. When she was a young woman, her architect father found her space to curate informal—and strictly unofficial—exhibitions of Soviet artists. Understanding little about the geography or sheer size of the United States, but knowing that she wanted to study and her husband wanted to exhibit, they decided to settle midway between Boston and New York. Springfield, Massachusetts, had the immigration quota to take them. The couple's move to New York and their introduction to the New York art world came about when Ivan Karp at O.K. Harris Gallery took on her husband.

On September 11, Okshteyn narrowly escaped tragedy when she was trapped a block away from the collapsing Twin Towers. Like so many New Yorkers that day, she found herself feeling that life was fragile and, reflecting on when she had been most happy, she thought back to her makeshift Soviet art exhibitions and she determined to open a gallery.

As Okshteyn's husband paid more and more for less and less studio space in rapidly gentrifying TriBeCa, he heard of a big floor with good light on Metropolitan Avenue and Roebling Street in Williamsburg. Stepping off the L train for the first time on a visit to see the studio, Okshteyn immediately responded to the low buildings, the open sky, the multilingual population and the multicultural spirit of the place. When her husband called later to describe a small building for sale on Driggs Avenue between North Ninth and North Tenth Streets, she agreed that he should go in and buy it instantly.

With a space but no stable of artists, Okshteyn picked her way through Joe Amrhein's Flat Files, went in search of unrepresented artists in the group shows at Momenta and Schroeder Romero, followed up with studio visits and listened carefully to artist recommendations. Over

time she developed an intriguing program that included KK Kozik's storybook-inflected paintings and drawings, Jordon Schanz's suddenly ominous post-9/11 airplane imagery and Megan Foster's stylized renderings of the interiors of cult movie sets. Once inside her sight-unseen purchase on Driggs Avenue, Okshteyn discovered an ample courtyard space out back—a perfect place to show sculptural work or large outdoor installation pieces. There she presented the curvilinear space contortions of Dewitt Godfrey and Tony Stanzione's steel and water piece *Cold Storage*. Choreographer Noemie Lafrance also performed the site-specific work *Melt*.

In 2004, at perhaps the height of Williamsburg's glory days, *Wag-Mag* had entries on close to sixty neighborhood art spaces and in 2010 there were still forty-seven venues on its list. Yet somewhere around mid-decade—Schroeder Romero dated it late 2003—the perception of the Williamsburg scene in the minds of the art world insidiously began to shift. Not only did Manhattanites seem to be growing bored with the outer borough but even in Williamsburg itself serious misgivings seemed to be mounting. Was a rags-to-rags rise and fall underway, and had Williamsburg's riches already peaked?

Doubts about the neighborhood's long-term future as a hot arts community were first put into print in January 2006 when *Artnet* magazine's Stephen Maine posted his enigmatically entitled article "Whither Williamsburg?" Referring to what he called a revolving door syndrome, Maine pointed out that, "As soon as a Williamsburg gallery finds a modicum of success, it moves across the East River to Manhattan."[12] Reeling off a list of eight local galleries that had flown the Brooklyn coop in the preceding two years, Maine bluntly addressed the elephant in the room by reminding his Brooklyn readers that "despite the undeniable appeal of the Williamsburg art scene, Manhattan is where the art market is." And of course he was right.

Leading the charge to Chelsea in May 2004 was the last-in-first-out Becky Smith; she packed up her Bellwether Gallery and decamped to Tenth Avenue at West Eighteenth Street, close to the well-respected Alexander and Bonin partnership. Joel Beck initially held on to his Williamsburg Roebling Hall space, but he also succumbed to the lure of Chelsea and opened a second gallery on Eleventh Avenue at Twenty-Seventh

Street. Priska Juschka left Brooklyn in the spring of 2005 and was followed in March 2006 by Schroeder Romero, who took space in what was familiarly known as The Tunnel, a former '80s nightclub venue. Ed Winkleman opened up across the hall and Tatyana Okshteyn's Black and White Gallery moved in too. Such smaller but important programs as Jessica Fredericks Projects, Monya Rowe, Foxy Production and Sixty-Seven Gallery had also deserted Williamsburg. 31 GRAND would be gone by the following year, and the density of the Williamsburg gallery terrain was noticeably thinner.

A ONCE GLORIOUS FUTURE

What had happened to "We all love it right here in Williamsburg"? With its free-fall experimentation and noncommercial production, its tightly knit system of peer review and its almost complete imperviousness to the judgment of outsiders, pre-millennium Williamsburg had been a law unto itself. Artists had been happy to work there, largely accepting that the art they created was rarely seen or appreciated outside of the local, artist-run spaces where it was haphazardly shown. A write-up in one of the bigger circulation art journals was rare, and the prospect of an actual sale even more remote. But this was, rather like Tenth Street in the 1950s, the Williamsburg way.

By mid-decade in the new century, however, a new kind of ambition was taking hold. It was manifested not just in terms of commercial expectations but in a thirst for critical attention in the wider, increasingly international, art world. The notion of producing art for profit was no longer anathema to the newer Williamsburger. Similarly, passive acceptance of small numbers at openings and column-inch neglect in the critical discourse was beginning to rankle. The causes of this shift were manifold, but one new phenomenon fueling the change was the growing importance to the American collector (and hence to the gallery system) of the international art fair circuit.

These see-and-be-seen opportunities had long been a staple of the European cultural calendar (Art Cologne launched in Germany in 1967, Art Basel in Switzerland in 1970, FIAC in Paris in 1974 and the Maastricht Fair in the Netherlands in 1987), but until the advent of Art Basel

Miami Beach, the United States had nothing to rival them. First planned for December 2001, Art Basel Miami was postponed after the events of September 11. The debut in 2002 of both the main fair and a satellite enterprise called Scope was very successful. The following year saw the formation in New York of a new gallery association, the New Art Dealers Alliance, and that same year they launched their own Miami Beach offshoot fair called NADA.

Over the years more and more satellite fairs were born including Pulse, Aqua, Volta and a New York version of London's Frieze. Many of these fledglings were reactions to the exclusionary practices of the bigger fairs that set stringent criteria for a new gallery being accepted. Those shut out went off and did their own thing—a modern-day Salon des Refusés. Within a few years, however, these smaller entities were proving as hard to get into as the mother ship originals, so lucrative were they for the chosen few.

By 2003 several of the Williamsburg galleries were deemed sophisticated enough to rank as players in the new Miami Beach bonanza. The still small-scale NADA section was particularly appealing to Williamsburg's dealers; Schroeder Romero made more money in their 2005 NADA booth than in all their previous gallery years combined. It was this windfall that in large part enabled their move to Chelsea. Becky Smith's relocation was similarly fueled by funds from NADA, as was Joel Beck's opening of the second Roebling Hall space in Chelsea.

Beyond sales made during the course of the fairs themselves, the coverage in the national and international art press was also empowering. Reviews led to post-fair follow-ups, and critical endorsement was noted by private collectors and museum curators alike. Priska Juschka and Black and White's Tatyana Okshteyn were similarly enriched by their successes in Miami, both in terms of cold hard cash and international attention.

But Maine's "revolving door" reference was more than a case of new money burning holes in the pockets of previously strapped dealers. As quickly as galleries seemed to fly in and fly out of the neighborhood, artists flew in and flew out of the galleries. Despite their protestations of being above the commerce of it all, when push came to shove in the exhibition queue, Williamsburg's artists were no less attention hungry than

their East Village predecessors had been. By 2004 the galleries that were most successful commercially and those that had most raised the visibility and status of their artists felt sufficiently threatened by the prospect of defection that migration to Manhattan became a must.

By the time Edward Winkleman moved Plus Ultra out of Williamsburg in 2006, the gallery had already lost the self-parodying performance artist Kate Gilmore to a Manhattan competitor and, as the emerging artists he had discovered grew in stature and exposure, they demanded that their next show be in Chelsea. Like several other dealers serious about the quality of their program, Winkleman was intent on keeping his line-up fresh with provocative, sometimes room-sized, but often commercially risky installations. Such shows demanded strong revenues generated by other, more financially viable gallery artists. Winkleman could not afford to lose his moneymakers, and Chelsea looked like being more able to sustain his needs than Williamsburg. Before 31 GRAND moved across the river in 2007, they too had lost some early discoveries such as Ernesto Caivano and Mike Cockrill (their successful Scope 2004 featured artist) to Manhattan galleries.

With the higher profile galleries gone by 2005, collector foot traffic and attention from critics took a serious downturn. As Winkleman lamented to Maine, "Some shows that we really believed in had pitiful attendance. That begins to break your heart after a while." Plus Ultra had always suffered from its distance from the L train's Bedford Avenue stop and the core of the Williamsburg action. Visitor numbers were noticeably thinner on opening nights, with particularly costly differences in foot traffic during New York's own lucrative art fair, the Armory Show. Even though shuttle buses ferried collectors from Manhattan's West Side piers to Brooklyn through the chilly March wind, there was still a cold and tediously gallery-free ten-block haul from the epicenter around Pierogi to Plus Ultra or 31 GRAND.

To make matters worse, the Mass Transit Authority's 2004 maintenance work on the L train—which Maine rightly called "the neighborhood's transit life line"—severely undermined Williamsburg's capacity to promote its "so quick on the subway" proximity to Manhattan. The L train runs the entire breadth of Manhattan along Fourteenth Street, hitting every other subway line in the city and made ease of access to

Bedford Avenue, one stop out of Manhattan, a regularly touted reason to go. Service reductions, delays, circuitous rerouting of trains or total shutdowns during Williamsburg's weekends-only gallery hours crippled attendance at exhibitions in the 2004 season. Too many bad trips sapped a visitor's energy for making the excursion again and without a cab, a car or a limousine, many would-be gallery-goers came no more. Perhaps as importantly, the critics who had made such darlings of the Williamsburg galleries since 2001 now seemed to feel that Brooklyn was a bridge too far.

For many commentators, however, the demise of Williamsburg's reputation as a center of serious art making came not from lack of foot traffic but risk of stampede. According to many visual artists, their brethren in the underground music biz were mostly to blame. Youngsters swarming across the river for drug-fueled avant-rock raves in illegally occupied warehouses were becoming the regular media definition of the Williamsburg scene. Concert promoter Larry Tee's publicly pronounced assurances that his events were a guaranteed venue for getting laid added to the allure for local adolescents of all sexual persuasions.[13] The Manhattan media, including the *New York Times* and *New York Magazine,* were happy to add to the hype.

POLITICOS, POLLUTION AND PUNKS ON BIKES

Stephen Maine touched another raw nerve in his "Whither Williamsburg?" piece: his discomforting allusion to the recent zoning changes encouraging development of the Brooklyn waterfront. On March 14, 2005, the City Planning Commission passed Mayor Michael Bloomberg's 110-block Williamsburg-Greenpoint Rezoning Plan, effectively opening up that stretch of Brooklyn's largely abandoned waterfront to urban planners and real estate developers. The probable rise in real estate prices and the accompanying invasion of the neighborhood by a new species of gentrifying bourgeoisie was not lost on those who had already been squeezed out of SoHo or the East Village. The cycle of evictions of artist renters from illegally occupied buildings and the impossibility of

finding any other affordable space was just as likely to occur in Brooklyn, and the Williamsburg art community knew it.

As early as March 2001 Stephanie Cash had written in *Art in America* that in Williamsburg, Dumbo and Greenpoint illegal resident numbers were estimated to be as high as 25,000.[14] She cited Dumbo's notorious Joshua Gutman and Williamsburg's Lawrence Krasne as landlords leading the tenant evictions and talked to residents in the besieged buildings who were facing rent increases from $3,000 to an impossible $25,000 per month. Cannily, she linked the struggle to Lower Manhattan's Loft Law history.

That same year a small army of writers at the widely read *Brooklyn Rail* began a veritable crusade around the eviction issue. Robin Rogers-Dillon, an associate professor of sociology at Queens College and no mere left-leaning zealot, gave the *Rail* an article entitled "Zoning Out: The Politics of North Brooklyn." She documented her own ousting from her Williamsburg apartment in the summer of 1997. Eight months pregnant and in no condition to fight back, she had meekly evacuated.

Rogers-Dillon quoted artist Eve Sussman (a Roebling Hall and Winkleman Gallery filmmaker) who was already labeling Williamsburg "a conceptual war zone." Sussman had been a squat and homesteading activist in the late '80s East Village. Sculptor Deborah Masters had fought the same fight in Dumbo.[15] Both of these artists were about to become mired again in a similar battle against pressure and harassment from city authorities in Williamsburg. This particular confrontation would result in the widely televised eviction of the mostly-artist residents of 475 Kent Avenue on a freezing cold night in January 2008.

Rail contributors Williams Cole and Theodore Hamm followed in the summer of 2002 with an article entitled "Inequality in Brooklyn" in which they skewered Bloomberg as the newest mayoral nemesis and hammered their opposition to his proposed rezoning scheme in articles variously titled "Showdown over the North Brooklyn Waterfront" and "Save Our City." By the winter of 2003 David Vine, in a piece entitled "Billions for Brooklyn—No Questions Asked," had revived but redefined the derogatory tag "Brooklyn Booster," thrown the name of community wrecker Robert Moses into the rhetoric, and nimbly linked it

to New York real estate developer Bruce Ratner. In May 2005, Jane Jacobs (the doyenne of neighborhood preservation) signed a deeply oppositional "Letter to Mayor Bloomberg and the City Council."

Ratner's bucolically named Forest City Enterprises was already the building force behind a whole host of bitterly controversial local construction projects, all of which neighbored on Williamsburg. Virtually all of these initiatives were attacked from the outset as heavily tax-advantaged sweetheart deals that had been arrived at with next to no community input despite steep public subsidy. Ratner routinely laid questionable claim to an infusion of jobs, improved cultural and recreational life and resuscitated levels of spending, but his projects always became mired in conflict. At issue were employment opportunities (which favored white, middle-class job seekers), megastore retail outlets (geared principally to higher-income consumers), affordable housing provisions (non-binding and easily sidestepped), and the exploitation of water frontage for private condominiums rather than public parks.

At the same time, however, as much as these anti-rezoning activists abhorred the bland homogenization and gentrification that would come with the change to residential zoning, many also acknowledged the dangers of leaving the area zoned *only* for industry. By mid-decade, the Brooklyn waterfront had already been the victim of several environmental crises, including some nasty oil spills and pollution from toxic waste. Since the late 1980s such community groups as the Toxic Avengers and NAG (Neighbors Against Garbage) had mobilized successfully against the notoriously violation-prone Radiac Research Corporation and its hazardous waste storage facility on Kent Avenue and Grand Street.

In the spring of 2001, the online *wburg.com* writer Carol Schwartzman unleashed an article entitled "Diary of an Air Addict, or Where's the Crisis," drawing attention to New York State's plan to build at least three new electric power generation facilities along Williamsburg's East River frontage. She inflamed the debate with both incendiary text ("all proposed plants throughout the City are being targeted in poor neighborhoods less likely to fight back") and gruesome photographs (giant skulls skewered on poles and placards declaring Williamsburg "A Cauldron of Environmental Horror.")[16] There were regular calls to arms and trips to Albany from other activist groups such as Williamsburg

Watch, Stop the Barge and Communities United for Responsible Energy
(C.U.R.E.).

Some unpleasant intergenerational and ethnic conflict further
shifted the perception of Williamsburg from freedom-loving utopia to
fractured hotbed of social and political tension. As scantily dressed hip-
sters offended the conservative Orthodox Jews on Williamsburg's South
Side, and housing much needed by their often large families went to
apparently dissolute and unemployed "artisten," the race for space got
spiteful. Additionally, the new Bloomberg-endorsed bike lanes, which
interfered with both roadside parking and foot access for shoppers, set
off an un-neighborly squabble between the green youngsters, whizzing
to and from Manhattan on their bicycles, and the local Dominican and
Puerto Rican merchants whose terrified customers no longer dared cross
the street.

Members of the arts community regularly played an active part in
all of this agitation. Whether driven by the genuine sense of social jus-
tice so often part and parcel of the artistic spirit, or more pragmatically
convinced that as working artists they themselves would always be poor,
most artists have leftist leanings. Inevitably, these convictions also mani-
fested themselves in a good deal of their art. As the art market started
to take off again in 2004 and the good times began to roll, much of the
earnest social and political content coming out of Williamsburg began
to look a bit dated.

By 2005, therefore, the Williamsburg arts community was facing
many of the same challenges that had beset the East Village at the end
of the 1980s: gallery relocations to a hotter market neighborhood, art-
ists abandoning the galleries that had nurtured them, and a perceived
diminishment in the quality of the art that was left. As in SoHo, there
were evictions and rising rents on illegally occupied studio space, gen-
trification and the invasion of the neighborhood by obnoxious yuppies
(now called hipsters) and the accompanying complaints about crowds,
late night noise and littering. But in addition, angry meetings between
the Mass Transit Authority and frustrated users of the L train, fights
with the mayor over zoning schemes, Community Board protests around
issues of environmental protection and neighbor-against-neighbor con-
frontations along racial and religious lines made things even more ugly.

To the Manhattan art world with its notoriously short attention span, these headline-dominating aspects of Williamsburg further undermined the neighborhood's Left Bank mystique.

The final act of euthanasia was a very public affair in June 2006, just six swift months after Maine's prognosis of terminal illness. At an event hosted by Eyewash's Larry Walczak and attended by other elder statesmen of Williamsburg's glory days, a local renegade named William Powhida fabricated a mock tombstone and staged a piece entitled *Eulogy to Williamsburg*. "We have gathered here tonight," he began "to celebrate art in defiance of the sad fact that the Williamsburg art scene is dead."[17] Citing "a series of crushing illnesses, including rampant hype, arterial congestion, hyperinflation, egotism, greed, gentrification, and collector anemia," Powhida spared no one. He urged everyone gathered to "bring your mementos, photographs, invites, reviews and tape them up on the walls, over the memorial itself, until there is nothing but the once glorious future of Williamsburg's past."

STAYING ON

Powhida, as it happened, was already well on his way to making a lucrative career out of biting the art world hand that fed him. But, despite his hyperbole, for all of the proverbial Williamsburg piggies that went to market in Chelsea, plenty of others stayed happily at home. They basked in the attention showered on them in the heydays and struggled through the cooling of affection that followed. They stayed on nevertheless, faithful to their programs, their collectors and, most importantly, their fellow artists. As the critical tide began to turn, they clearly did not believe themselves to be, in Roberta Smith's words, "Too Legit for Williamsburg."[18]

All of these Brooklyn loyalists had come to the neighborhood for a particular reason that was not likely to be satisfied elsewhere. They continued to believe in the local talent and enjoyed the more eclectic and multi-genre nature of the art produced. They also embraced the heterogeneity of the players and were happy (indeed relieved) to be operating outside the market frenzy of Manhattan.

Tracy Causey-Jeffery started Causey Contemporary in leased space on North Third Street and Kent Avenue in 1999.[19] Two years later she put down deeper roots by buying and gutting a building among the cluster of galleries that by 2001 were strewn along Grand Street. Originally her gallery was named Ch'I Contemporary, a taste for things Eastern having come out of a BA in Oriental Studies and a summer at DongHai University in Taiwan. Through the 1990s she owned a gallery in Maryland, honing her skills with local artists and collectors in Washington, Baltimore and Philadelphia. Encountering not much more in the local taste spectrum than what she described as "Birds, boats and barns," she set about mining a wealth of undiscovered talent. By 1999 she decided it was time to take on New York.

Her first lease in Williamsburg gave her 2,000 square feet for $2,800 a month. In Chelsea twice that amount would have netted her half the space. More importantly she felt that her strength lay in cultivating long-term artist-collector relationships and that those dialogues could be better developed in Williamsburg, where so many artists lived and worked, than in the freneticism of Chelsea. As time went on, her program came to include pan-global as well as local artists. It still favored the mystic but it also embraced a distinctively textured kind of abstract figuration.

She became active in the newly formed Williamsburg Gallery Association and by 2010 her gallery was sufficiently successful for her to expand again. Still confident that Williamsburg not only met her needs but enhanced her ambitions, she moved to an even larger space on Wythe Avenue at North Tenth Street where she is still an important player and a strong advocate of the Williamsburg infrastructure.

In early spring of 2000, Randall Harris, an artist known and respected in the Williamsburg network, opened up Figureworks, a tiny workspace and gallery in a house on North Sixth Street. As its name signified, it was dedicated to figurative work, and Harris offered life study classes in his intimate but unpretentious atelier on the second floor. Visitors who climbed the stairs during the gallery's weekend afternoon opening hours would be invited in with a welcome and either left alone to browse privately around the small exhibition or engage Harris in conversation about the work and its makers.[20] A reception of this ilk was a

rare thing across the river. Compact in its mission as well as in its quarters, Figureworks was as modest and quietly spoken as so much else in the art world was ebullient and strident.

British artist Alun Williams, one of the instigators of the Paris/Brooklyn concept, opened a gallery called Parkers Box at 193 Grand Street in 2001.[21] A graduate of the important Goldsmiths' College of the University of London, Williams was an MFA candidate two years ahead of Damien Hirst and the undergraduate class about to become known as the YBA's or Young British Artists. He was represented in London by Maureen Paley Gallery and funded his four-day-a-week studio practice with a three-day-a-week job as a bicycle messenger. A British postal strike in the days before even fax machines were universal, much less e-mail, meant that Williams could log a hundred miles a day on the bike, bank about as many pounds sterling, and arrive at the studio in what he described as the perfect state of exhausted euphoria to create art.

Williams spent a college exchange year in France and launched various arts initiatives in Nîmes, Nice and Marseilles, including a French branch of the British sculptor Anthony Caro's Triangle Arts. This was a three-way international workshop and residency program that ultimately found a US base a bridge south of Williamsburg in Dumbo. As he spent more and more time on projects in New York, Williams succumbed to the magnetic pull of Brooklyn's energy field.

At Parkers Box he continued to exercise his skill as a curator across international boundaries but also maintained his strong commitment to local talent in and around Williamsburg. In 2008 the gallery mounted a twenty-three-artist show called *From Brooklyn With Love* and included, among others, the art of Pierogi's Joe Amrhein, Four Walls' Mike Ballou, Momenta Art's Eric Heist, Laura Parnes and Michael Waugh and Triangle's Gregory Forstner. Despite losing artists he had launched or nurtured to Manhattan galleries, Williams was not to be seduced away.

Like Parkers Box, Southfirst remained in place on North Sixth Street and Kent Avenue. With a stimulating roster of guest curators and provocative shows with titles like "New York Fucking City" (probably too risky for Chelsea), Southfirst has shown such veterans as Alice Neel, Alison Knowles, Cindy Sherman, photographer Stephen Shore and British Turner Prize nominee Liam Gillick as well as up-and-comers like Jessica

Jackson Hutchins, Dike Blair, Matt Keegan, Liz Magic Laser and the lower-case-only collaborative named 'assume vivid astro focus.' They also showed a stimulating mix of complete unknowns, relishing their freedom to do it their way in the outer borough.

Art 101 opened in 2005, stayed in Williamsburg and chose to make a virtue of "a particular emphasis on Brooklyn artists, especially the increasingly endangered Williamsburg species."[22] In the spring of 2011, longtime Brooklyn artist, curator and writer Larry Walczak put up a show at Art 101 called *Williamsburg2000,* a group exhibition of some fifty local artists. The roster of exhibitors read like a roll call of the definitive Williamsburg Hall of Fame.

Don Carroll's Jack the Pelican Presents on Driggs Avenue was perhaps the most colorful of the lot that started, stayed and flourished in Williamsburg until decade's end.[23] Named after one visiting drunkard's attempt to recall the name Jackson Pollock, the raucous openings, outlandish installations and outré performance pieces (but often searchingly intelligent exhibitions) were reminiscent of early–1990s Williamsburg. Opening hours were hopelessly unreliable; once inside, the debris of last night's party was occasionally mistaken for a new installation, and the gallery survived (indeed thrived) on behaviors and practices that could never have been sustained in mainstream Manhattan.

In 2003, Carroll mounted the wildly popular David Shapiro show, an oddly good-looking bodega-sized collection of garbage, all neatly arrayed on commercial shelving. Other offerings included such groundbreaking performance work as the all-girl Icelandic Love Corporation, and the painter David Hutchinson's cerebral *Translations from Jean Genet,* which the gallery press release accurately described as "slim vertical stripes of pure color beautifully abuzz with retinal vibration." Stephen Maine captured the spirit of the directors perfectly when he referred to an "impresarios sense of showmanship and a gleeful enthusiasm for obnoxious contraptions."[24] When asked about moving to Chelsea, Carroll was perhaps invoking the spirit of those who had been at Cat's Head I or some of the more outrageous Four Walls extravaganzas, when he asked "What fun would that be?"[25]

And so as the new millennium got underway and the *Brooklyn Rail's* Daniel Baird, with whom we started this chapter, looked around, he saw

a vastly changed Williamsburg. The desolate haven for vast, raw, dirt-cheap lofts and the emerging arts scene that seemed in the early 1990s to hold such promise had all but disappeared. With it went any belief that Williamsburg could not only become but actually remain that "ambitious underground alternative to the narcissism of SoHo or Chelsea." Those days of creative energy and individuality, of independence and optimism, Baird lamented, were all "before the explosion of restaurants, bars, clubs and stores, before the real estate market rocketed, before Bedford Avenue teemed with clean-cut, elegantly tattooed, cell phone toting kids with IT jobs and lots of cash."[26] This was Williamsburg now.

11

FLEEING TO CHELSEA AT THE END OF THE CENTURY

"There were streetwalkers on 11th Avenue, and every three or four years something would go wrong, I suppose, and you'd find a body in a parking lot. Let's just say it was not a place where you would want to spend much time."

—Jack Fuchs, a longtime Chelsea landlord, 2006

As the art season opened in the fall of 1997, a sharp eye at *Art in America* seems to have noticed that the August *Annual Guide to Museums, Galleries and Artists* might be signaling the emergence of a new arts district in New York City. They were sufficiently intrigued about the small enclave of galleries beginning to cluster around the West Twenty-Second Street Dia Center for the Arts to start printing a slim, four-page foldout called *Chelsea Art*. Its first issue, available free from front desk galleristas, indicated the existence of at least forty galleries in the Chelsea neighborhood. They were all huddled between Tenth and Eleventh Avenues but thinly strewn out from West Twentieth up to West Twenty-Sixth Street.

HORSEMEN OF THE APOCALYPSE

It was an ambitious young dealer called Matthew Marks who first set this gallery migration in motion back in 1994 when he moved, not from SoHo, but from a modest two-floor space uptown. Marks hailed from a

privileged educational lineage via the Dalton School, Columbia and Bennington College and had cannily landed himself commensurately prestigious summer internships at the Metropolitan Museum of Art and the Guggenheim. Apprenticeships with Anthony d'Offay in London and at Pace Gallery in New York had failed to seduce this young but independent eye into a long-term commitment with an established gallery, and he went out on his own in March 1991.

He initially set himself up on a tony block of upper Madison Avenue, but by 1994 Marks was in need of more space to show the capacious work of blue-chip artists like Ellsworth Kelly, Brice Marden, Cy Twombly and Richard Serra who, despite his youth, he was managing to attract. But SoHo could offer him nothing that was just right. Space-interrupting columns, wooden floors of dubious weight-bearing strength and no loading docks or reliable elevators for big paintings and heavy sculpture were a problem.

A devotee of the scale-defying programs that the Dia Foundation had been mounting around town since the 1970s, Marks was regularly in Dia's latest cavernous, if remote, incarnation on Chelsea's otherwise desolate West Twenty-Second Street. Since opening there in 1987, Dia's echoing halls had comfortably accommodated Joseph Beuys's sprawling installation pieces, John Chamberlain's massive *Gondolas* series and Francesco Clemente's mural-scale *Funerary Paintings*. Marks decided that rather than lease an overpriced and inadequate gallery in SoHo, he would buy one of the near derelict buildings right in among the taxi garages and gas stations near Dia. If people would come that far for Dia, he thought they might come to see him as well. Over 1,000 showed up at the opening of his beautifully renovated 5,000-square-foot gallery.

In February 1995 the East Village doyenne Pat Hearn moved her business from SoHo and, along with dealers Paul Morris and Tom Healy, leased space a few doors down from Marks on that same block between Tenth and Eleventh Avenues. Annina Nosei followed in the fall. Meanwhile, Paula Cooper had purchased two buildings on West Twenty-First Street for $500,000, and by 1996 the ruined shells of a duct and ventilator company had been stylishly transformed into a soaring, cathedral-like gallery space under the visionary eye and masterly hand of architect Richard Gluckman.

In 1996 Marks followed his 5,000-square-foot purchase on Twenty-Second Street with a second at 523 West Twenty-Fourth Street. By then he had been approached by Barbara Gladstone, whose lease at 89 Greene Street was at an end. She had no interest in renewing in SoHo, and she and Marks split a cavernous 29,000-square-foot former cutlery factory in a $2 million, three-way deal with Helene Winer and Janelle Reiring of Metro Pictures, each taking 50 feet of street frontage in the 150-foot-wide building.[1] The space was dubbed the MGM Building for Metro Gladstone Marks.

By 1997 when the *Chelsea Art* map came out, the West Twenty-Second Street block was also home to SoHo's Max Protetch, Lisa Spellman's younger but already important 303 Gallery and the D'Amelio Terras partnership. Midtown's Jason McCoy was also there trying things out. They all took space in the same building on the north side of the street and made up one of the seven multi-gallery buildings that were on the Chelsea map by this time. On the corner of Tenth Avenue a young dealer called Linda Kirkland bought the only brownstone on the block at 504 West Twenty-Second Street. The building had been sealed shut in the 1960s and Kirkland was opening it up after decades of abandonment. Three more galleries joined her there.

The veteran Richard Feigen pushed the burgeoning neighborhood a block farther south of Paula Cooper when he launched Feigen Contemporary at 535 West Twentieth Street; in the building next door to him were ten more galleries. Cheim and Reid held the center, standing alone on the Twenty-Third Street block in a space once briefly (and prematurely) occupied in the mid-1980s by Larry Gagosian. That partnership had grown out of John Cheim and Howard Read's splitting off from the Robert Miller Gallery in Fifty-Seventh Street's Fuller Building and so they, like Matthew Marks, had gone to Chelsea directly from uptown, not via SoHo.

The northwestern reaches of the neighborhood were anchored by a lone outpost on the other side of Eleventh Avenue that housed SoHo's Pamela Auchinchloss and East Village transplant Leslie Tonkonow. Slightly to their east, nestled in the labyrinthine corridors of 508 West Twenty-Sixth Street, was Greene Naftali. This was to be an important building: Raymond and Gloria Naftali were intriguing landlords

and Carole Greene a visionary curator. The Naftalis had bought the 156,000-square-foot Wolff Bindery Building from a book manufacturer in 1974 but, always an art lover and patron, Gloria held onto a dream of filling the building with creative types. Since it was hardly located near the heartbeat of the SoHo art scene, she offered below-market rates and wide-open spaces to artists, filmmakers, writers, architects and designers—particularly those whose oeuvre might not yet be mainstream or output commercially viable.

The young Carol Greene had had gallery experience already (not all of it happy) throughout the highs of the moneyed 1980s and the lows of the early 1990s.[2] Her eye and mind had always been drawn to the conceptual, the ephemeral and the often downright difficult, and she had an unshakable conviction that work that was already demanding needed to be shown in surroundings that did not compete. The unadorned industrial functionality of the Naftalis' light-filled building felt right and the deal was affordable, given the rule-breaking and probably tough-sell work she was planning to show. As she remarked during a conversation in January 2009, "Matthew made it a street, we made it a neighborhood." Perhaps—but as she also acknowledged, it was another four years before Chelsea got real traction and Greene Naftali got a review in the *New York Times*.

On the crushingly cold day in the winter of 1997 that this author— in a hooded parka and hiking boots—first visited the decrepit and still desolate area, those galleries, strung out between Greene Naftali in the north and Richard Feigen in the south, were all there was to the new Chelsea art neighborhood. Other early visitors were clearly just as skeptical about its chances of success. In December the ever-ornery Charlie Finch was complaining in *Artnet* magazine that "there is no light at night (4:30 P.M. this time of year), the river wind makes it feel like Chicago and ghosts, goblins and worse appear in every nook and cranny." "The streets," he went on crossly, "are littered with condoms and crack vials tossed from the rustling railroad bridges overhead, trysting sites for the rough trade that's glorified in the galleries below." The Chelsea neighborhood, he concluded, "is simply the worst strip of turf on which to see art in the history of the New York art world."[3] What were these dealers thinking?

FIN DE SIÈCLE

There was in fact a good deal to think about. As the new decade got underway; the Soviet Union had collapsed; the United States was at war in the Persian Gulf; Rwandans, Bosnians and Croats were being slaughtered in the tens of thousands; and a bizarre spate of cultlike group suicides, execution-style mass murders and acts of political terrorism were shaking the American heartland. It was no wonder that dark prophecies and apocalyptic thinking began to pervade the cultural zeitgeist.

Almost immediately, art world commentators recognized that in the evolving work of the new decade an end-times mood prevailed. "The world is . . . so different from what it was only recently," wrote Arthur Danto in December 1990, noting a demotic strain in the new art that he described as "anti-aesthetic, palimpsestic, fragmented, chaotic and hybridized."[4] Irving Sandler was quick to recognize the pervasion of what he called a fin-de-siècle gloom.[5] "Now, after the carnival, comes the hangover," cautioned Robert Hughes.[6]

Curators of museum exhibitions clearly sensed this mood of both deepening decline and mounting anxiety. In the fall of 1991 the Museum of Modern Art's Robert Storr put up his *DISlocations* exhibition. Evoking what he perceived as a world out of joint, Storr presented work that "offers a mirror to reality but violates expectations by distorting, fragmenting and editing the reflection it gives."[7] He introduced the societal disjunctions and incongruities that were to intensify as the decade progressed.

Almost concurrently and in the same museum, Peter Galassi's *Pleasures and Terrors of Domestic Comfort* explored contemporary photography's narcissistic withdrawal from the world's troubles into what should have been the secure domestic cocoon. As his cautionary title suggested, however, the dark side of domestic life seemed so often to predominate, making the home itself rather more ominous in mood. Galassi acknowledged that in much of the imagery he presented, "life is unresolved, under stress, a mess of one sort or another; people are at a loose end or awkward, or sad; very often they are alone if not also lonely."[8]

Jeffrey Deitch's *Post Human* examined the unnerving convergence of rapid advances in biotechnology and computer science with society's

traditional social and sexual roles and suggested that these might require a redefinition of human life. The Whitney Museum's Independent Study Group's offering in 1993 was titled *Abject Art: Repulsion and Desire in American Art.*

At the same time, however, with so much backward-looking pessimism pervading the culture as the end of the second millennium approached, a craving for fresh starts was also afoot. Just as in earlier fin-de-siècle periods, the 1990s cycle of degeneration, alienation, anxiety and morbidity would be succeeded by signs of rebirth and new growth. Both in terms of the art being produced and the environments needed to show it, something different was happening. The center was shifting again, and what had worked well in SoHo in the 1970s, and well enough throughout the 1980s, was now beginning to feel stultifying. The gentrification of SoHo was undoubtedly pushing the art world out, but a new kind of art and a new kind of dealer were restlessly seeking a revised set-up.

REGENERATION

The stock market collapse of 1987 and the recession of 1989 took about another year to roll through the art world. The 1990 and 1991 seasons were both bleak with all of the principal auction houses taking a hit in both the May and November sales. Gallery business was down, and there were rumored to be as many as seventy closings.[9] But belts were tightened. Shows stayed up longer, expensive catalogues and extravagant opening parties were dispensed with and many dealers even worked the phones from home when the galleries were closed on Mondays. The art handling and shipping businesses cut back, reducing truck runs and laying off night staff.

The period of slump was, in fact, shorter than had been feared—particularly by those who had lived through the much deeper and longer malaise of the 1970s. In a February 2008 *New York Magazine* article looking back on "The Stench of '89," Michael Idov maintained that nationally the recession had lasted only nine months. Even allowing for the fact that what he called "the city's ringside seat at the Wall Street follies" caused a harder and longer downturn in New York, he still dated

the turning of the tide in the Big Apple at around December 1991. Despite another 67,000 job losses throughout the region between 1992 and 1993, financial sector incomes jumped by a shameless 45 percent. "With big bonuses coursing through the city's financial veins," Idov wrote, "New Yorkers started spending again."

In 1993 New York City got itself a new mayor in the person of former US Attorney Rudolph Giuliani whose aggressive take-no-prisoners pursuit of law enforcement had led to just the sort of grand-spectacle shakedowns that so many New Yorkers found irresistible. In 1986 all of the so-called Five Families of New York's mafia got whacked when eleven of their leading figures were indicted on charges of racketeering and corruption. In 1989 insider traders Ivan Boesky and Mike Milken were unceremoniously marched off their Wall Street trading floors under the stunned gaze of scores of would-be Masters of the Universe. By 1993 New York had tired of Mayor David Dinkins's well-intentioned ineffectuality and the sterner stuff of Giuliani's kick-ass methods was what New York's oversized ego now seemed to need (even if he was a Republican).

By the closing paragraphs of her February 28, 1993, *New York Times Magazine* article "The Art World Bust," Deborah Solomon was taking a retrospective tone, dating the bottoming out of the market as already two years past. By April of the following year Roberta Smith observed tentative but hopeful regrowth on the art world landscape. "As the market contracts and the big 80s-style art galleries dwindle," she wrote, "small unorthodox galleries are increasingly evident at the bottom and around the edges of the downtown scene."[10] Around the edges they were, as many of the sapling enterprises she cited literally sprouted up in the upper reaches of SoHo (Friedrich Petzel), beyond the eastern edge of Broadway (Bill Maynes), virtually in the West Village (Paul Morris) or even close by the entrance to New Jersey's Holland Tunnel (Gavin Brown's Enterprise).

By the early 1990s, SoHo Central—namely, West Broadway and the core gallery blocks feeding into it—were irretrievably congested with tourist traffic and awash with high-end fashion, pricey food joints and a slew of tacky art emporiums. There were, however, as Smith had discovered, still enclaves to be found downtown that had escaped the

gentrification and still retained some of the original grittiness of '70s SoHo. Recoiling from the crush at the center, dealers were again withdrawing to the fringes and, in addition to the fledgling spaces that she discovered, a number of other not yet fully evolved but to-be-important programs started up in peripheral nooks and crannies. Rather than excusing their raw environments, they made a virtue of their pared-down economic circumstances and the darker mood of the current times and actively embraced another new wave of emerging, distinctly '90s art.

The young dealer Gavin Brown perhaps called it when he cheerfully told Smith, "With the money gone, nothing is at stake; anyone can do what they want."[11] This had always been true of artists who regularly pushed themselves into riskier areas of creativity when no collector was in sight anyway. Now curators and gallerists seemed to be feeling the same sense of abandon. Already part of what one of his fellow adventurers was calling "a motley generation of starving dealers," Brown was speaking from one of several sites that he would occupy over the next two decades of his restless existence. Nomadic from the get-go he moved to New York from England and put up his first show—portraits by the young and hip Elisabeth Peyton—in a room in the Chelsea Hotel. Visitors had to ask for the key to go up and see them.

He took a more permanent space at the far end of Broome Street in 1994, and let the British artist Steven Pippin transform it into a room-sized camera obscura. In 1997 he moved slightly closer to the (albeit still small) Chelsea cluster when he set up on Tenth Avenue. This tiny gallery was, however, on West Fifteenth Street and more in the Meatpacking District than in Chelsea proper. Here he put up the first of two installments of *Drunk vs. Stoned,* a group show that explored a work's capacity to induce either woozy inebriation or trippy remove. Right next door, Brown opened Passerby, a bar illuminated by artist Piotr Uklanski's flashing disco dance floor tiles.

Thinking better of even this arm's-length proximity to the now swelling numbers in Chelsea, in 2003 Brown moved away to Greenwich Street in the West Village. Extravaganzas here included a work by Swiss artist Urs Fischer that involved gouging a huge crater out of the gallery's floor; visitors were invited to (gingerly) descend into the dirt and debris of the city beneath.

Gavin Brown's maverick program, and how and where he presented it, was in fact representative of several other new enterprises launched in the economically grim days of the early 1990s. Lisa Spellman at 303, Chris D'Amelio and Lucien Terras, the Luhring Augustine partners and Andrea Rosen would also intuit a shift in the cultural barometrics, root out and nurture new talent and change the circumstances under which this work was shown. As Jerry Saltz later recalled, "Dealers pooled information, formed informal coteries, maxed out credit cards, and made it up as they went along."[12] Saltz acknowledged that the money, of course, caught on later, but by then a new network had formed and "in that nebulous lacuna, a new generation of artists, dealers, critics, and curators took the stage and remade the world."

Lisa Spellman first started to show work that interested her in the rent-controlled apartment she occupied at 303 Park Avenue South, conveniently close to the School of Visual Arts on East Twenty-Third Street where she was studying photography.[13] Even at an early age, and barely into the 1980s, she had an eye for work that her professors at SVA were overlooking; no one at school had even heard of Cindy Sherman, Richard Prince or the *Pictures* photographers.

In 1986 Spellman took space in the East Village and continued to devise her own exhibitions of under-the-radar artists as well as inviting new 1990s voices like the painter Christopher Wool or the sculptor Robert Gober to curate for her. Following the Tompkins Square Riots in 1988, she moved to SoHo, settling on 89 Greene Street—not as close to the dilapidated fringes as she would have liked to be but at least far from what she described as "the shiny gallery" venues of now old-school SoHo. Spellman clearly sensed that the pumped-up slick of the old decade was giving way to a kind of emptied-out desolation, and her vision of her program and the gallery space she needed to present it were beginning to coalescence.

The German photographers Thomas Ruff and Andreas Gursky were already on Spellman's roster by the late 1980s. Both were students of the Düsseldorf Kunstakademie professors Bernd and Hilla Becher, whose frontal, virtually documentary studies of abandoned grain silos, inactive factory chimneys and disintegrating nineteenth-century industrial plant were influencing a whole new generation of young photographers.

Ruff and Gursky were still working small in those early days, in black and white and in series like their mentors, but Spellman spotted the relevance of Ruff's deadpan portraiture and Gursky's vacant landscapes. She also recognized the relevance of Doug Aitken's filmic work as his meditations on entropy and emptiness gave voice to the ominous sense of dystopian isolation that permeated even the densest of urban centers.

Spellman also took on a powerful line-up of rule-breaking women. The brutally confessional works of Sue Williams were included in the 303 Gallery program from the earliest days. With irony-laden titles like *It's a New Age* (1992), searing images of sexual abuse, emotional degradation and every other form of human abjection were laid out on the picture plane by this uncompromising painter. Scatter artist Karen Kilimnick was creating grim installations such as her 1991 *Suicide by Overdose and Enormous Loss of Blood,* and the sisters Jane and Louise Wilson were producing hauntingly surreal video studies of abandoned and decaying East European politico bases.

At the same time, however, Spellman instinctively sensed that this age of alienation and despair would ultimately give way to one of nurturing and regrowth and that the spiritual and immaterial would take precedence over the concrete but disintegrating. She was one of the first to risk giving over her gallery to the young Thai artist Rikrit Tiravanija, who promptly removed the entire contents of 303's office, kitchen and storage spaces and set them up as an installation in the gallery. From there he prepared curried food and served it to oftentimes uncertain gallery visitors.

Late in the game in her moves to both the East Village and SoHo, Spellman was right on time for Chelsea's West Twenty-Second Street. By 1995, overcrowded SoHo was becoming unworkable for serious gallery visitors, and both Pat Hearn and Paul Morris were calling on a daily basis, encouraging Spellman to move to Chelsea. In 1996 she leased a 3,200-square-foot ground-floor space (without the collector-terrorizing elevator of her previous locations), with close to as much space again in storage below. Like Carol Greene, Spellman acknowledged that the first year or so was hard. The Dia Center put up long-term installations and therefore openings were few. The first twelve

months even required Sunday hours if visitors were to be lured to Chelsea's still-rough terrain.

Next to settle in alongside 303 on West Twenty-Second Street were Chris D'Amelio and Lucien Terras, who opened their joint venture in November 1996.[14] While they had not previously had their own gallery in SoHo, both had worked for Paula Cooper. The French-born Terras had come to Cooper (and New York City) via the Yvon Lambert Gallery in Paris, where he worked with artists like Carl Andre, Jonathan Borofsky and Robert Wilson. Cooper was the New York representative for several of Lambert's artists, and she had seen the young Terras in operation around the European art fairs. A native French speaker with a local's understanding of European collecting tastes, Terras was a prudent addition as Cooper intuitively acknowledged the importance of the expanding global arts arena.

Like so many of the great dealers before her, Cooper had the vision to recognize and recruit the fresh talent scouts coming up in the next generation. While a veteran's eye generally endures, it was nevertheless wise to engage younger antennae. After four years, however, she understood that her deputies needed to explore their own curatorial visions and endorsed their conviction that the future was in Chelsea. It never, in fact, occurred to the two new principals to open in SoHo's wood-floored, be-columned loft spaces; instead, they envisioned something closer to the bunkeresque concrete structures that architects like Herzog and de Meuron were producing for *Kunsthallen* in Europe.

Like Cooper thirty years earlier, Terras was convinced that it was time to show art in a new setting, and he was confident of his ability to present the new forms coming out of the studios. Less about complex fabrication, finished surface or even weighty physical presence, the gallery took on artists who worked in modest or unorthodox materials or sometimes with almost no materials at all. Dario Robleto's *Living with Death as Something Intimate and Natural* was made up of "oak tree twig carved from the dissolved audio tape recording of the heartbeat of an unborn child and the last heartbeats of a loved one, dried flowers picked on foreign battlefields sent home by foot soldiers from various wars and the thread and fabric from military uniforms."[15] They also

showed Heather Rowe, whose gaping scaffold constructions of timber, mirrors, ceiling tiles and fake glass were as much about the yawning spaces between the gate-like structures—the fractures, the absences—as they were about what was there.

As Twenty-Second Street developed heft in 1996 and 1997, the following year saw two important additions to Twenty-Fourth Street as the line-up of power dealers pushed its way west of the MGM cluster near Tenth Avenue and extended gallery colonization almost the length of the block. In October 1998, Lawrence Luhring and Roland Augustine purchased and split a building with the increasingly influential Andrea Rosen. Luhring, Augustine and Rosen were hardly neophytes in the art world when they launched their ventures in SoHo, but both galleries were to become much bigger fish in a far larger pond after their relocations to Chelsea.

The Luhring Augustine team dated back to 1983 when the two young dealers worked together on West Fifty-Seventh Street.[16] Lawrence Luhring arrived in New York in 1979 with an art history degree from the University of Virginia and apprenticed under Annina Nosei on Prince Street. Nosei was teaching at SVA at the time and, as Luhring describes it, she had her finger on the pulse of everything and everyone that was important in the early 1980s. Through her he was exposed to the work of Jean-Michel Basquiat and Barbara Kruger and met Eric Fischl and Julian Schnabel. Luhring's subsequent fearlessness around the provocative work he would later show clearly started here.

Roland Augustine followed his Georgetown undergraduate years with independent studies in piano and jazz improvisation but then, rather randomly, he took a course in printmaking.[17] From that point on, the world of art rather than music began to draw him in, and in 1979 he moved to New York. While Luhring was running around the pulsating contemporary scene in SoHo and the East Village, Augustine worked on Fifty-Seventh Street refining his scholarship and curating shows of European masters such as Edvard Munch and Chaim Soutine. Once the two dealers joined forces and launched their own program in 1985, they combined their sensibilities and, as Augustine put it, "forged a path that punctuated historic exhibitions with a foray into the contemporary field."[18]

They moved their operation to the Bakery Building at 130 Prince Street in January 1990 (working with architect Richard Gluckman on the renovation) while opening a second gallery in Santa Monica with the German specialist Max Hetzler. They were able to maintain both programs until the pressures of the recession on the New York gallery required closing the West Coast space. They were co-tenants in the Prince Street building with Sean Kelly, Andrea Rosen and the Cable Gallery partners Nicole Klagsbrun and Clarissa Dalrymple. Things got so bad financially around 1991 that they were all forced to approach the owner for a rent reduction. Contrary to the popular notion of the New York City landlord as rapacious villain, this one responded to their plight and their programs survived.

In the SoHo years Luhring Augustine continued an early commitment to Christopher Wool's nihilistic word paintings and added Robert Gober's disturbingly intimate sculptures of flesh-sluicing sinks and drains. Photographer Larry Clark unflinchingly documented lives lived at the social margins and Jack Pierson created strangely melancholic color-saturated studies. Paul McCarthy's nightmarish mannequins deployed brutally rendered genitalia against each other in every variety of penetration and defilement. Mike Kelley's sad accumulations of home-crafted afghan blankets, tattered sock dolls and other soiled garage sale detritus spoke more quietly, but equally gave voice to the decade's preoccupation with the abject. Ultimately such work gave rise to a new 1990s ism—Pathetic Aesthetic.

As the decade progressed, Luhring Augustine was earning a reputation for combining well-considered exhibitions of historical greats with canny displays of contemporary groundbreakers. Fine selections of European modern masters (Günter Förg, Blinky Palermo and Imi Knoebel) were interspersed with shows of British photographer Richard Billingham—tender studies of domestic havoc wreaked by an alcoholic father and a slovenly working-class mother. Gregory Crewdson was setting up noirish tableaux of an increasingly unhinged American underbelly and photographing them under the eerie light of late-millennial demise. Janine Antoni explored the mortification of the flesh as she gnawed on blocks of raw chocolate and licked at soap sculptures until her mouth blistered and bled. Luhring Augustine showed it all.

By mid-decade, and despite their pristinely renovated space, good foot traffic and the growing importance of their program with collectors, museums and the critical press, both directors began to think that the work they were showing might now need a new context. Some of their longer-standing artists had already had six, even seven shows in the SoHo space and, as Luhring pointed out, artists as well as dealers get restless for a new environment. He first spotted 525–531 West Twenty-Fourth Street on an early foray into Chelsea with Barbara Gladstone, but the owner was not ready to sell. It was not until 1998 that Luhring Augustine were able to purchase the space. A wealthy collector who had recently acquired a savings and loan bank in Cleveland financed the deal (and several others in this first phase of Chelsea); they split the property with their neighbor Andrea Rosen and again brought in Richard Gluckman to renovate it.

Andrea Rosen was moving from Ontario to New York City in 1984 at about the same time that Lisa Spellman was starting to put up work at 303 Park Avenue South and Luhring Augustine's fusion of historical and contemporary was beginning to take shape uptown. Like Spellman, Rosen harbored ambitions of being an artist, but she also set them aside in the interests of getting what she knew was better work than hers into the public eye.[19] She had already had some gallery experience in the mid- through late 1980s in the East Village and SoHo but, like the new generation of dealers that she considered her peers, she was undeterred by the early '90s recessionary climate and believed that with the new decade would come new art. "I hadn't started out with the idea of having a gallery of my own," she said, but she became increasingly aware that "a new generation of artists existed, and I felt it was imperative to create a context for them."[20]

Rosen opened in SoHo's Bakery Building in January 1990. Her inaugural show was of the hauntingly ephemeral work of the thirty-two-year-old Felix Gonzalez-Torres. Free-for-the-taking stacks of prints, there-for-the-eating candy spills and hang-as-you-like strings of electric bulbs made up Gonzalez-Torres's light-as-air but indelibly weighty installations. Always open ended, always *"Untitled,"* the work and the artist resisted statement. A pair of clocks ticking in unison or the indent of an absent head on a pillow spoke, however, with eloquent dignity to

the specter of the virus that would take his partner's life in 1991 and his in 1996. But as Rosen clearly sensed, the work was beyond personal. It held a power of universal resonance among a generation that was looking tragically back on its losses but was deeply anxious for its future.

Rosen went on over the next decade to discover more artists who were seamlessly in step, if not uncannily ahead, of the peculiar social zeitgeist of the 1990s. She was the first to show John Currin's ghoulish females, at once haggard with their pocked faces and emaciated arms and legs but bodacious in their pneumatically sexualized breasts and buttocks: twenty-first-century cosmetic prostheses grafted onto fifteenth-century Lucas Cranach nudes. Matthew Ritchie's unruly installations often moved from two to three dimensions and back again, creeping onto ceilings, crawling across floors and rounding corners of the gallery space like a mutating spore. His work routinely worked a continuum between the dark mythologies of an ancient past and the intergalactic glare of a terrifying future.

Moving to the new Chelsea space in 1998, Rosen became one of the prime dealers in the late-millennial, now post-apocalyptic aesthetic that seemed to pervade the times. Sculptor David Altmejd concocted inhuman fusions of decomposing rot with store-bought gloss as his hybridized half-creatures languished on the shiny display surfaces of high-end fashion stores, their putrefying forms encrusted in jewels, feathers and other incongruent contemporary finery. Sculptor Matthew Ronay's vast haunting forest of symbolic forms would similarly work the continuum of opposing worlds—male and female, life and death, reality and unreality.

At the same time, however—and particularly after the inception of her Gallery 2 program in the smaller space behind the main room—Rosen, like Luhring Augustine, put up re-contextualizing shows of historically important artists like Walker Evans, Carl Andre, Lynda Benglis and Richard Tuttle. Presenting this older work as she did in rigorously selected and intelligently hung exhibitions, she succeeded in refreshing the way the work was seen and revitalizing the public's interest in art that was essentially timeless.

Reflecting on her 1998 move to Chelsea ten years later, Rosen recalled that her departure from SoHo was less a reaction to the physical

overcrowding or even the price rises, but more to its increasingly self-involved and overly inflated sense of importance in the arc of art production. SoHo had become pseudo-elitist and, as a result, exclusionary. The insider boom had gone on longer than it should. Artists, galleries and collectors alike felt pressured by the SoHo machine into priming the pump, depleting the work, homogenizing the programming and overextending the previously prudent collector. The move to Chelsea would, she felt, demand new beginnings and it would result in a fresh democratic theater for the viewing of art, freely available to those committed enough to seek it out. The new galleries would serve as contemporary art museums, and pilgrimage to this more removed destination would be part of the ritual of discovery. The art was new again and judgments were still pending. Wouldn't Chelsea in the new millennium provide a clean slate?

12

INTO THE AUGHTS

"By 1999 the galleries had grown to a significant number, and the Comme des Garçons store opened on West 22nd Street. That was a trigger for fashion magazines, style magazines, and design magazines to turn their attention to the neighborhood, and I got assigned an article about changes happening in Chelsea."

—Joshua David, *High Line: The Inside Story of New York City's Park in the Sky*, 2011

As it turned out, the young style writer Joshua David had no clue, as he obediently turned his scanners on Chelsea in 1999, just how big a part the neighborhood was about to play in his future. Nor could Chelsea possibly have seen then what was (literally) coming down the tracks in terms of the neighborhood's resuscitation. But for the gallery enthusiast still needing to walk off a lingering hangover as heads cleared from millennial revelries? What they saw, from even a bleary-eyed glance at the January 2000 *Chelsea Art* guide, was a much bigger map.

The 40 galleries in the guide in the fall of 1997 had increased to 118, and the humble Empire Diner on Tenth Avenue was but one of nine restaurants, cocktail bars or newly insouciant "lounges." The Starrett-Lehigh Building, which only three years earlier had housed just two intrepid gallery tenants, was now home to ten more. Carol Greene had been joined in the Gloria Naftali building on West Twenty-Sixth Street by twelve other galleries, including such veterans of both the East Village and SoHo as Massimo Audiello, Caren Golden and Cable Gallery's

Nicole Klagsbrun. The uptown veteran Robert Miller had moved over, and the young but well-respected architectural historian Henry Urbach had opened a gallery. In 529 West Twentieth Street (no longer the southern boundary) there were twenty-seven galleries including SoHo's John Weber, Bill Maynes, Deven Golden and Andrew Kreps. Thirteen more listings now dotted the lower extremities of the map from West Twentieth down to Fifteenth Street.

CHEERLESS CHELSEA

Despite the fact that the number of galleries in Chelsea was up to 170 by 2002 and had risen to somewhere around 230 by 2004 (twice the number in SoHo at its 1990s zenith), the stubbornly adhered-to belief among the new neighborhood's art world was that what had happened to the East Village and SoHo could never happen to Chelsea. The rapid colonization, gradual saturation, eventual dilution and ultimate contamination of a once-pure arts community would not repeat itself here.

First, Chelsea would remain a stronghold of serious art because it was hard to reach. Given the dearth of public transport serving the far West Side, only the dedicated follower of contemporary art would struggle to get there. True, there was an Eighth Avenue subway stop on West Twenty-Third Street but this was two very wide and windy blocks from even the epicenter of the Chelsea art district. To see a show in the upper reaches on Twenty-Ninth Street or take in the programs on lower Tenth Avenue as far down as Thirteenth Street was a heave and a haul, daunting to all but the most determined. It would certainly be off-putting to the day-tripping tourist. Equally, by the time the crowded M23 bus lumbered its way across Twenty-Third Street through Manhattan traffic, the casual visitor was hot, bothered and out of time.

Second, Chelsea was not even nice when you eventually got there. Its architecture was ugly, with low, boxy buildings, long stretches of windowless industrial frontages and heavy metal security gates. Its cross streets were empty of people and it lacked the cachet of having once been a bohemian studio enclave. Instead of artists toting stretched canvases or stopping to chat on the steps of art supply stores, Chelsea offered taxi drivers, auto repair shops and gas stations. Oversized trucks

regularly protruded from storage facility loading docks, forcing pedestrians into poorly maintained and puddle-potted Belgian block streets. When Ivan Karp had regaled the author with the "noble structures" of SoHo's cast-iron architecture and wrinkled his nose at the prospect of moving, he was speaking for many who saw no charm in Chelsea. Even the committed gallery pioneers mourned the loss of SoHo's vibrancy, and more than one major dealer sheepishly admitted that there was nowhere to go if you needed to pick up a birthday gift or were craving a cappuccino.

In Chelsea it became the lot of the junior-most gallerista or the lowly intern to find lunch. Despite the addition of the eight new food and drink options now available, only five of them were on Tenth Avenue, the other three farther east on Ninth or Eighth, and several kept only evening hours. For the weary exhibition goer zigzagging back and forth along the wide gallery blocks, there was nowhere to stop and get coffee or rest sore feet and tired eyes. Only the grimly determined who set the day aside, sensibly shod and with a maximum-efficiency itinerary firmly in hand, would go there.

Furthermore, West Chelsea was not zoned for residential development and without the subway connections that had made both the East Village and SoHo accessible, an influx of additional restaurants was not likely. The same was true for retail. Without competition from food or fashion, no landlord would be able to wring out higher rents with threats of a better offer. No condominium developer would bother to claim the still soulless area. And besides, this time around, the dealers had been smart and bought their buildings, surely making rising rents and expiring leases a thing of the past. The art world would now be able to hold its ground and keep its integrity intact because—finally—no one else would want their space in Chelsea.

In many ways, the reasoning looked sound and as a result, the galleries continued to migrate. Directly after the turn of the new century, several more of the dealers who had started their programs in 1990s SoHo moved their operations to Chelsea. All had already achieved noteworthy standing with both collectors and critics before they relocated, but at their new addresses and with more spacious premises Marianne Boesky, Sean Kelly and David Zwirner grew to blue-chip international

status while also pushing the Chelsea art world map yet farther north and adding density and gravitas to its southern edge.

Since her parents were collectors, Marianne Boesky had grown up around art and had wanted to work in a gallery even as a child.[1] She studied art history at Duke and was hired as an intern by Sotheby's where she quickly got the impression that, back then at least, the auction houses might hire "nice girls," but were unlikely to give real women career paths to positions of influence. As the economy took its late-'80s nosedive, Boesky chose law school over the art world.

Her interest in contemporary art continued, however, and she stayed abreast of the New York exhibition circuit and what was new. By 1996 she felt that the economy was sufficiently strong and her chances good enough to make her move. Having recently met the painter Lisa Yuskavage, whose bodacious female figure studies excited her, Boesky first opened in a (brief) partnership with Patrick Callery. She was, of course, aware of the beginnings of Chelsea but felt that SoHo still had what she termed the "eyeballs" necessary for a new gallery to take hold. They took space at the lower (and scrappier) end of Greene Street.

Ten months into the partnership Boesky found herself at aesthetic odds with Callery's hesitation over the new talent that she was spotting—surreal scene painters like Laura Owens and the new Japanese super-flat and anime work by artists Takashi Murakami and Yoshito Nara. She was ready to go it alone, and while still in SoHo she added her own pick of idiosyncratic artists to the roster. Polly Apfelbaum spread out her early scatter pieces, multicolored, velvety disc shapes showered across the rough-hewn wooden floor like so many fallen leaves. Kate Shepherd's stringently constructed drawings maintained an austere, about-to-be architectonic discipline on the Boesky walls, in taut opposition to Apfelbaum's underfoot abandon.

By the opening of the 2000 season in September, Boesky had moved to Chelsea, initially taking a ten-year lease on a second-floor space at 535 West Twenty-Second Street. But the monthly outlay of rent bothered her, and the prospect of owning seemed to make more sense economically. She kept on looking, ultimately bought an empty lot to the east of the MGM cluster at 506 West Twenty-Fourth Street and decided to build from the ground up. Her architect was the increasingly sought-after

Deborah Berke and the pristinely designed exhibition spaces at the ground-floor level would be topped by a home where Boesky could live, right over the shop and directly alongside the abandoned tracks of an old overhead railway.

From her new quarters Boesky continued to attract groundbreaking talent. In December 2001 she debuted Rachel Feinstein's elaborately rendered neo-rococo sculptures, extravagantly wrought in wood and plaster, embellished with gold leaf or enamel. The following year the painter Barnaby Furnas similarly cannibalized an art historical moment with his third-millennium take on history painting. Here, scenes of utmost violence were somehow scrambled, torqued and distended into picture planes that bore uneasy likenesses to screen savers or video games. Liz Craft sculpted the macabre and neo-gothic, all skeletal bodies and degenerated plant life, and Alex Ross painted garishly rendered mutant blobs, at once malevolent and strangely lovable. In Sarah Sze's work, frantically multiplying installations of banal hardware store paraphernalia—Q-tips, ping-pong balls, paper cups, drinking straws—scuttled off the rungs of wooden ladders to overrun walls, wrap around corners and festoon the ceiling's surface.

Sean Kelly moved to Chelsea in April 2001.[2] In the early 1990s when he had been a co-tenant in the Bakery Building at 130 Prince Street with Luhring Augustine and Andrea Rosen, Kelly was not yet a principal in his own business but the New York director of L.A. Louver, a well-respected gallery with its home base in Venice, California. Born in Ireland and artist-trained in Wales, Kelly had already had some curatorial experience in England before moving to the United States in the late 1980s. By 1991 he had both knocked around the East Village scene enough and stayed sufficiently on top of blue-chip Fifty-Seventh Street to develop a sophisticated eye for quality as well as a renegade appetite for the new. He left L.A. Louver to test his own convictions and from 1991 to 1995 dealt privately out of his apartment in SoHo.

When he opened his first gallery at 43 Mercer Street in 1995, Kelly was also in the decidedly non-glam section of SoHo and, as much from aesthetic preference as from economic necessity, he was perfectly happy to keep it that way. His space was so understated that he didn't even have the gallery's name on the tall glass doors, and the windows were

frosted to obscure what was going on inside. Without announcements or ads for his first opening, he relied solely on the connections he had built and the reputation he now had as a talented but risk-taking scout of powerful conceptual work. Rigorous in his demands on the artists he showed and stubbornly faithful to his vision for the gallery, Kelly once told the author that he would rather go down in flames having gotten it right than compromise on the art in his program.[3] He also admitted that on opening night he was terrified that no one would actually show up.

When it came time to move to Chelsea five years later, *Artnet* magazine was already referring to Kelly as a "SoHo big foot," but again he choose to avoid the crush, believing that those who were serious about the artists he represented would find him and, ideally, the mere sightseer would not. Kelly targeted the edges and limited his search to the periphery—from Thirteenth Street to Fifteenth Street or above West Twenty-Seventh Street.

The notion of deliberately locating far from the madding crowd ran, of course, directly counter to the art world tendency to cluster around a destination gallery. While capitalizing on Leo Castelli's siren-like draw or keeping close by Pierogi on Williamsburg's North Ninth Street was a persuasive argument to many of the foot-traffic sensitive, there have always been exceptions to this rule. The mass migratory art world herd has always had its rogue elephants.

The edging away from the center that was pioneered in SoHo by Paula Cooper in 1968 and in Chelsea by Matthew Marks in 1994 had been redefined and updated only recently by both Gavin Brown's Enterprise and Michele Maccarone. Brown, as we have seen, felt that even West Fifteenth Street—almost ten blocks away from the heat being generated around Chelsea's Twenty-Fourth Street—was still too close for comfort, and he moved in 2003 to 620 Greenwich Street in the West Village. In 2007 Maccarone, who had been a director at Luhring Augustine, moved her own gallery to a location a stone's throw from Brown at 630 Greenwich. She had started out even farther off the reservation in a broken-down space on Canal Street on the borders of Chinatown.

The highly respected Allan Stone Gallery operated for decades uptown on East Ninetieth Street. In 2002 Jeanne Greenberg Rohatyn also chose to open her edgy Salon 94 program in this decidedly un-edgy part

of town, a neighborhood largely dominated by New York's elite private schools. In 2005 Jack Tilton successfully bypassed white box Chelsea by moving his Greene Street operation to an elegant townhouse in the East Seventies; his cutting-edge program didn't miss a beat. Kelly Taxter and Pascal Spengemann left their apparently well-positioned location on Twenty-Second Street in 2008 for a move way across town to Frank Stella's old studio on East Twelfth Street. In 2006 José Freire swam against the tide by moving his gallery back to SoHo, and Guild and Greyshkul similarly bucked the Chelsea trend. In all of these cases the directors clearly held to the old adage: build it and they will come.

Although Kelly did succumb to the lure of the Chelsea hub, the notion of protecting the purity of his program by distancing it from the fray was key to his search. He eventually took 7,000 square feet on West Twenty-Ninth Street and was at that point the only gallery on the block. He opened the new space in the spring of 2001 with James Casabere's enigmatic photographic interiors, trickily convincing tabletop models that were lit, shot and enlarged to disarmingly persuasive effect. The opening exhibition presented renditions of Kelly's gallery space partially submerged under fictitious floodwaters; it took the viewer several minutes to identify what they were actually looking at and just why they were in some way "off."

Always drawn to work that demanded as much of the brain as it did of the eye, it was Kelly who brought the Yugoslavian Marina Abramović to initially unready American audiences. Rigorous in her ascetic practice to the point of self-torture, it was at Sean Kelly that this radical endurance artist presented *The House with the Ocean View*. Living on a raised platform in the open gallery space for a total of twelve days, Abramović neither spoke, ate nor slept for the duration of the piece. Needless to say, in the early days of his representing her and before institutions like MoMA canonized this ephemeral and discomforting work with a major retrospective, Kelly had considerable trouble selling it.

As brutalizing as Abramović could be, Wolfgang Laib, another Kelly passion, was ethereal and pantheistic, presenting work of near ecstatic spirituality. A rigorously gridded installation of small piles of pollen, patiently harvested over many years and spread out across the gallery floor, required visitors to skirt the edges of the room in order not to disturb its

quasi-religious presence. A virginal white-on-white milk spill into an al-
most imperceptibly hollowed marble slab and a small temple-like struc-
ture pungently built of beeswax blocks were other Laib creations. Kelly
felt the magic and shared it in his gallery, quieting the outdoor clamor of
New York City to a reverential hush.

As Kelly staked out the northernmost edge of the Chelsea arts dis-
trict on Twenty-Ninth Street, the southern reaches down on West Nine-
teenth were bulking up. In 2002 David Zwirner moved the ten-year
gallery operation that he built at 43 Greene Street to a space directly op-
posite the now Chelsea-based Kitchen. By 2006 Zwirner had expanded
his initial 5,000 square feet to a total of 30,000, effectively dominating
the greater part of the block between Tenth and Eleventh Avenues and
creating three discrete, although interconnecting, gallery spaces. The
major domus therefore in terms of sheer realty footprint, by mid-decade
Zwirner had also risen to near godly status in terms of the breadth and
depth of his programs—both contemporary and historical, American
and European.

The son of a veteran Cologne dealer, Zwirner junior had been ex-
posed as early as the 1960s to the likes of Andy Warhol and Ed Ruscha
as his father presented these American renegades to his sophisticated
German clientele. The son proved equally adept at importing a Euro-
pean sensibility back into the United States, and both the Belgian Luc
Tuymans and the German Neo Rauch debuted with the Zwirner Gallery.
Neither of these painters worked in a style that could be easily equated
with anything currently on the US market. Tuymans dealt in an ethereal
combination of history painting and mass media imagery, and while the
work was often figurative, its lightly brushed weightlessness regularly
left intentions uncertain and narratives unresolved. Rauch's canvases
were equally otherworldly, but the Leipzig-based painter delivered in a
high-toned, almost garish palette and fused comic book naïveté with a
darker surrealism that regularly tended toward violence. Zwirner would
later bring on other artists who dealt in the indeterminate and the hy-
bridized, showing the paintings of Marlene Dumas, Marcel Dzama and
Jockum Nordstrom, the dreamscape video work of Diana Thater, and
the uncanny sculptural constructs created by both Katy Schimert and
Yutake Sone.

A strong presence in the secondary market made Zwirner (and his uptown partner Iwan Wirth) the brokers of choice for a timely $2 million trade in a work by Martin Kippenberger just as MoMA's much-heralded retrospective made the deceased German bad boy the talk of the town.[4] Zwirner also came to enjoy a reputation for presenting spectacularly good historical exhibitions. A museum-quality show of early Gerhard Richter, an ambitious survey of Dan Flavin fluorescents and a nervy re-staging of Ed Kienholz's sprawling installation *Roxy's* (a full-scale rec-reation of a 1940s bordello, replete with sculpted whores) all received critical attention. Zwirner also came to be perceived as the go-to site for the often-tricky management of a number of internationally renowned artists' estates including those of Dan Flavin, Gordon Matta-Clark, Alice Neel, Fred Sandback and Jason Rhoades.

An admired all-rounder, Zwirner was invariably included in the up-per echelons of the *Wall Street Journal*'s art world "Power 100" and in 2008 was ranked number one in *Flash Art*'s "Artists' Choice: Top 100 Galleries." Accused from time to time of poaching midcareer talent from other galleries, Marianne Boesky's Lisa Yuskavage, Gavin Brown's Chris Ofili and Jack Tilton's Francis Alÿs all left their original dealers to join Zwirner's increasingly happening stable.[5] He also proved as capable of making megastars of the already up-and-coming as he was of nurturing undiscovered talent. Marianne Boesky had worked with Yuskavage for ten years, raising her prices from around $120,000 in 2002 to double that amount two years later. In 2005 Yuskavage left her for Zwirner anyway.[6]

DEATH STAR LANDINGS

To whatever extent David Zwirner might rankle his colleagues in Chel-sea by actively poaching/tacitly accepting defecting talent, no one in the art world rustled cattle quite like Larry Gagosian. Described by Dorothy Spears in her *New York Times* article "The First Gallerists Club" as "the leading Lothario in the courtship wars," over time Gagosian suc-cessfully scalped Mary Boone (of David Salle and Philip Taaffe), Ileana Sonnabend (John Baldessari), Metro Pictures (Mike Kelley), Andrea Rosen (John Currin), Marianne Boesky (Takashi Murakami), Friedrich

Petzel (Richard Phillips) and Fifty-Seventh Street's revered grande dame Marian Goodman (Anselm Kiefer). He even snookered Zwirner himself by luring away the sculptor Franz West.

Larry Gagosian began his art-dealing days in Los Angeles in 1977 by picking up $2 kitsch posters, slotting them into cheap aluminum frames and re-hawking them around UCLA for $15 apiece.[7] By the early 1980s, however, he had set up a bricks and mortar gallery and was visited by the *New Yorker* critic Peter Schjeldahl. "The space breathes the cold excitement of money," wrote Schjeldahl presciently. "The air in the office is like vaporized stainless steel."[8] Gagosian blithely told the mortified visitor that if he didn't make it dealing art, his next stop would be real estate. He did make it in art and, as it turned out, without having to relinquish his yen for the property markets.[9]

Gagosian's first venture in New York in 1979 was to buy in SoHo and, partnering with the well-connected Annina Nosei, he mounted shows from his loft on West Broadway. Moving his business base to New York in 1985, he briefly operated out of a site on West Twenty-Third Street in Chelsea. In 1988 he chose the tony Upper East Side's 980 Madison Avenue, home to fellow purveyors of luxury goods Sotheby Parke Bernet, and refitted the interior with what many would later come to recognize as an ominously corporate finish.

From here on Gagosian acquired a primo reputation as an aggressive operator in the secondary sales market and with it the tag "Go-Go." It was he who procured Jasper Johns's *False Start* for S. I. Newhouse in 1988 at a price of $17 million, the most ever paid for a work by a living artist. Twenty years later he had not lost his mojo when he beat out the next best bidder again with the $23.5 million purchase of Jeff Koons's *Hanging Heart*. In 2010 he topped even that with his winning paddle in the air at Christie's as one of Matisse's bronze reliefs hammered down at $48.8 million.

Other clients included the media mogul Peter Brant, Wall Street's Steve Cohen and Leon Black, public relations guru Charles Saatchi, real estate billionaire Eli Broad and the Hollywood celebs David Geffen, Douglas Cramer and Steve Martin. Despite their own none-too-shabby business acumen, several of these titans of industry could not actually remember ever having agreed to become Gagosian clients. With an

intuitive eye for quality and a scarily retentive visual memory, Gago-
sian would routinely approach collectors about a painting they had no
intention of parting with. Discreetly but aggressively he would market
it around a carefully chosen network of prospective buyers and, after
multiple turndowns by the initially outraged owner, he would succeed
in prying it off their walls anyway, closing the deal with the proverbial
offer they couldn't refuse.

Most professional dealers take pains to place their artists' work in
prestigious museum collections with a view to securing their place in art
history. At a minimum they seek out private collectors who will one day
donate the work to a public institution. Gagosian, on the other hand,
once shamelessly told a horrified fellow dealer that he didn't like to sell
works to museums because then he couldn't get them back for resale.
He has never been invited into the Art Dealers Association of America
and when probed by a *New York Times* reporter in 2009, then president
Roland Augustine declined to say why.[10] "I thought about sponsoring
him a while ago," David Zwirner once admitted. "But everyone would
assume I was nuts."[11]

In 1991 Gagosian opened an austerely finished white box at the
top of Wooster Street that, according to several dealers, opened every-
one's eyes to the possibilities of Chelsea's cavernous garage buildings. In
among the ravaged wooden floors, tin ceilings and exposed plumbing
of the SoHo cast-iron spaces, the Gagosian showroom suddenly looked
so *cool*. And to have the nerve to do it just as the bottom fell out of the
market (all markets) was hubris beyond imagining.

Even the savvy culture critic Grace Glueck (who had by now been
seeing them come and seeing them go for some two decades) was pen-
ning a Gagosian-centric article. In a June 1991 piece entitled "One Art
Dealer Who's Still a High Roller" she was noting that, "in the gossipy,
highly competitive art world, stories about Mr. Gagosian's driven behav-
ior and sometimes corrosive relations with other dealers and clients pro-
liferate, as do questions about his backing and what he owes to whom."

Throughout the '90s and on into the new millennium, the brash
dealmaker would be shadowed by rumors of overleveraging, irregular
financing structures, questionable tax returns and near bankruptcy.
Much like Mary Boone before him, however, he appeared completely

unperturbed by the scuttlebutt and, if he bothered to respond at all, would put it down to jealousy on the part of those less smart and less daring. As if to flaunt his growing reputation as a mere supplier of art products to the rich and tasteless, in 1996 he opened a third distribution outlet in Hollywood's Beverly Hills. "The Gagosian Gallery's impeccable three-ring circus," Roberta Smith would later sniff, "the art world's answer to Niketown."[12]

Gagosian moved to Chelsea in 2001, slightly ahead of Zwirner, reportedly paying $5.7 million for 22,000 square feet at the westernmost end of what was left of Twenty-Fourth Street.[13] This corner property issued onto the north-south–running Eleventh Avenue and so had more developable air rights than his midblock neighbors. Should Gagosian ever want to expand upward or even sell, his situation was peachy. In 2001 this air rights potential was not necessarily at the forefront of anyone one else's mind as development opportunities in Chelsea were hampered by zoning restrictions. This was largely considered to the good by other galleries, as it would keep the property speculators at bay. One cannot help but wonder, however, whether Gagosian had a clairvoyant's instinct for even this opportunity. Either way, a gargantuan space was prepared. Virtually every frontage of the gallery had raisable windows, allowing access to forklifts, hoists, even a small crane if necessary. It regularly seemed as though Gagosian was in the real estate biz after all.

He followed this land grab with a gallery in London's Piccadilly in 2000 and a second London space in 2004. In 2006 he added to his Chelsea holdings with the 522 West Twenty-First Street site and expanded his overseas empire with outposts in Rome (2007), Paris, Athens and Geneva (2010) and Hong Kong (2011); as he pointed out to a *Wall Street Journal* reporter—one in every time zone. On January 12, 2011, he gleefully reveled in his Napoleonic expansionism when he rubbed the art world's nose in eleven simultaneous opening nights, all of Damien Hirst's critic-enraging *Spot Paintings*. The *Journal* put "Gagosian's Global Empire" at seventy-seven artists and $1 billion in yearly sales.[14]

And yet despite contempt for his flashy personal life, shameless social pretensions and ruthless business practices, the art world was routinely forced to acknowledge the sheer brilliance of what this irrepressible hustler routinely pulled off. In addition to picking up the

lucrative management of several important artists' estates, he mounted hugely ambitious (and largely well-reviewed) historical shows of canonical greats like Brancusi, de Kooning, Twombly, Chamberlain, Lichtenstein and Stella. The 2009 exhibition *Picasso: Mosqueteros* (curated by Picasso's principal biographer, the scholar John Richardson) resulted in museum-like lines around the block.

Earlier that year, when doing the exhibition circuit in a February blizzard, this author ran into two curators from the Museum of Modern Art. "See the Piero Manzoni at Gagosian and go home," I was told. "Nothing else will come close for the rest of the day." The advice was delivered with the usual exasperated mixture of awe, irritation and envy that surrounded all things Gagosian. In 2012 he sent shock waves through the art world again when even MoMA's recently retired éminence grise John Elderfield was lured to the dark side and signed on as a specialist with the gallery.

The ultimate imprimatur on the new Chelsea neighborhood was probably the arrival of Pace and Marlborough, two other megadealers who, while their pedigrees were longer and their reputations far finer than Gagosian's, were similarly more purveyors of established quality than they were developers of fresh talent. By the early 2000s both of these powerhouses were recognizing that the magnetic pull of Chelsea was not to be resisted; while they descended on the neighborhood fully formed and apparently without plans to reinvent themselves, their arrival was a milestone in the increasingly not-so-new neighborhood's timeline

Pace Gallery had started life in Boston's established gallery district on Newbury Street in 1960. It was launched by the young Arnold Glimcher whose wife, Milly, was an art historian. Pace was the first name of Glimcher's father, a cattle rancher from Minnesota, but as Malcolm Goldstein has suggested, it also "carried the suggestion of pulsation and movement."[15] Despite the dynamic-sounding name on his letterhead, however, and as Goldstein rightly observed, Glimcher never made any pretense of being interested in the discovery of diamonds in the rough. "He was after known talent, the tried and true, and the expensive . . . which meant raiding the rosters of other galleries."[16] While "raiding" might seem a little strong in today's altogether more ruthless game, Pace

did seduce John Chamberlain, Dan Flavin, Donald Judd, Claes Olden-
burg and Richard Serra away from Castelli and Robert Mangold and
Joel Shapiro from Paula Cooper; Glimcher even picked off Schnabel and
(briefly) Brice Marden from Mary Boone.

In addition to luring away celebrated artists with (made-good-
on) promises of beautifully staged shows, erudite essays in sumptu-
ous catalogues and tasteful marketing to blue-chip clients, Pace's other
approach to building their stable was to identify quality artists who
might momentarily have dropped off the art world radar. Regularly
demonstrating that he had both the connoisseurship and the business
acumen to resuscitate careers, Glimcher restored important twentieth-
century artists like the sculptor Louise Nevelson to their rightful place
in the art world canon, not to mention placing the work in investment-
grade collections.

Glimcher moved the Boston business to a small space at 9 West
Fifty-Seventh Street in 1963 and into its present quarters east of Fifth
Avenue in 1974. Over the next decade Pace expanded to seven floors
of art-dealing prowess—not only in modern art but also with specialist
departments in master drawings, vintage photography, primitive art and
limited-edition prints. Pace Prints was born and raised under the nurtur-
ing hand of Glimcher's old Boston buddy Dick Solomon and, as much as
Pace Gallery was associated with blue-chip artists and moneyed clients,
its Editions arm put the Pace name on quality multiples at affordable
prices. It was in Pace's always state-of-the-art printmaking facilities that
younger artists broke more adventurous ground. Skateboard decorator
Ryan McGinness put new spin on street art, Inka Essenhigh developed
her fantastical elasticized body forms and Wangechi Mutu mined her
African heritage, all to spectacular effect.

A beautifully appointed second gallery at 142 Greene Street (where
Castelli had been) was eventually opened in 1990. Although this was
now late-in-the-day SoHo, the move further opened up the notion of
Pace Gallery as a prestige, if not particularly daring, exhibitor of con-
temporary work. At the same time, very good historical exhibitions
of twentieth-century greats like Picasso, Miró, Kandinsky, de Koon-
ing, Rothko, Calder and Rauschenberg continued to be must-sees on
the Fifty-Seventh Street circuit. When Pace took a large lot on West

Twenty-Fifth Street in 2002, therefore, its benediction of the neighborhood was not unlike the arrival of Castelli or Emmerich in SoHo back in 1972. The old-line class was moving in.

Marlborough Gallery opened the same year as Pace, in 1963, and also ascended to the brahmin strata of the gallery elite. Initially on Fifty-Seventh Street at Madison Avenue, they moved in 1971 to huge quarters near Sixth Avenue, essentially anchoring the westernmost edge of the midtown power axis. The gallery's reputation had been tarnished in the late '70s by a highly suspect handling of the Mark Rothko estate—Irving Sandler referred to it as "the most notorious court case in the annals of the American art world"—that had resulted in the gallery's expulsion from the Art Dealers Association.[17] They rallied, however, and continued through the '80s and '90s to represent a cadre of big international names, both living and dead.

Marlborough (technically) moved to Chelsea early in the migratory period, opening a second gallery on West Nineteenth Street in 1997. This 10,000-square-foot space was, however, situated between Seventh and Eighth Avenues, a good way east of the caucus around Tenth. Although off the increasingly well-foot-trafficked path, the choice had much going for it given the gallery's roster of artists. The Fifth-Seventh Street premises were enormous and included a magnificent outdoor sculpture deck, but they were on the second and third floors, making elevator access the principal way in and out. Traffic on that busy commercial office and shopping strip made truck parking and the offloading of big works difficult, and Marlborough showed some big work indeed.

The gallery was always a powerhouse for sculpture, and Tom Otterness's and Fernando Botero's gargantuan figures, Chakaia Booker's towering rubber tire constructs and Magdalena Abakanowicz's twenty-strong armies of headless and backless forms all needed room to move. Even Red Groom's raucously painted scenes of New York street life and Dale Chihuly's magnificently complex but surely fragile glass creations demanded space to let their exuberance sizzle. West Nineteenth Street provided ground-floor stability, direct access off the street and industrial-sized doors that could be flung open to let Marlborough's hefty art objects sail on through. Weight as well as height could also be accommodated, and when just two sculptural works by Louise Bourgeois

weighed in at 3,500 pounds or an Anthony Caro topped 34,000 pounds, size most definitely mattered.

By season's opening in September 2005 Jerry Saltz had raised Roberta Smith's 2003 guestimate of galleries in Chelsea from her 230 to his 300.[18] By 2006 *chelseaartgalleries.com* was proposing 318 and in October 2007 Saltz hiked even that number up to 360.[19] When asked for their own best guess, most of the dealers themselves were putting the number at somewhere around 400. And it was not just a question of quantity. Most of the SoHo originals who mattered had by now migrated (Cooper, Cuningham, Sonnabend, Nosei, Gladstone, Metro Pictures, Westwater, Boone and Edward Thorp), the next generation of game changers (Marks, Spellman, Luhring Augustine, Rosen, Kelly and Zwirner) were there, bigger and better, and even the 800-pound gorillas Gagosian, Pace and Marlborough had, as we have seen, succumbed to Chelsea's irresistible pull.

Other savvy veterans like Charles Cowles, Nicole Klagsbrun, Frederieke Taylor, Paul Kasmin and Stephen Haller were now in Chelsea as were Rachel Lehmann and David Maupin and the ever-peripatetic, one-name-only Hudson of Feature Gallery. Most of the stronger East Village originals (PPOW, Postmasters, Tony Shafrazi, Massimo Audiello, Leslie Tonkonow and Jack Shainman) plus the more commercially ambitious Williamsburg contingent (Bellwether, Roebling Hall, Schroeder Romero, Edward Winkleman, Priska Juschka and Black and White) had also moved over.

Well-respected midtowners who had been running steady-state programs along Fifty-Seventh Street had also started to shake loose (Galerie Lelong, Robert Miller, James Cohan, George Adams, Mary Ryan), and even some of the small, cooperative galleries like Bowery Gallery, Blue Mountain, Amos Eno and the all-female A. I. R. had spaces in Chelsea. Editions dealers Susan Inglett, Peter Blum, Alexander and Bonin, and United Limited Art Edition's Larissa Goldston had expanded their programs beyond print to become all-media galleries and photography dealers Julie Saul, Bruce Silverstein, Yancey Richardson and Yossi Milo had also relocated.

It was not until the fall of 2007 that Marlborough moved fully into the thick of this Chelsea pack, but when they did, it was with the usual

statement-making aplomb that had always been their way. Buying not leasing, the gallery reportedly plunked down $9 million dollars for the first two floors of the Chelsea Arts Tower, a new development on West Twenty-Fifth Street.[20] Interestingly, the construction was done on property sold by the ever-shrewd soothsayer of Chelsea's darker days—Mr. Jack Fuchs.[21] Jack Guttman, the developer behind the Chelsea Arts Tower project, told the *New York Sun* reporter Kate Taylor that Marlborough got a great deal. He qualified his enthusiasm, however, by adding, "If the art market crashes, they won't do well, but I think their real estate decision was great."[22] So the proverbial "great real estate deal" had now come to the once risky, still isolated and, for many, still cheerless Chelsea. How could that possibly have happened given all of its natural topographic deterrents to mainstream discovery and commercial development?

HIGH LINERS AND STARCHITECHTS

It was August 1999 when the young style writer Joshua David first met the Internet consultant Robert Hammond at a public hearing at the Penn South housing complex on West Twenty-Sixth Street. Both men were there to speak with the activists working to prevent the destruction of the abandoned trestled railway that snaked its way through Chelsea from Gansevoort Street in the Meatpacking District up to the midtown rail yards at West Thirty-Fourth Street. For reasons that both found hard to articulate, they felt that the looming overhead train tracks, retired from active service since the 1980s, should not be torn down. On discovering that no action group actually existed, they inadvertently stumbled into launching one themselves; it would eventually be called Friends of the High Line.

The history of trains running at street level up and down the traffic- and pedestrian-crowded avenues of West Chelsea dated back to the late 1840s. The number of fatalities arising out of this lethal mix had led to Tenth Avenue being referred to as Death Avenue and by 1908 demonstrations were held against the train traffic on Eleventh and Twelfth Avenues too. The appointment of the "West Side Cowboy," a red-flag- or lantern-waving horseman who preceded the locomotives as they ran

along the unfenced tracks did little to reduce the death toll. In 1927 the city and the railroad reached a preliminary agreement for the exchange of real estate and easements to allow for the removal of the street-level tracks. The railroad proposed replacing them with an elevated line.

Construction began on the overhead tracks in 1931, and from 1934 until 1980 trains ferried goods between the West Thirty-Fourth Street train yards and St. John's Park Terminal down on Clarkson Street. The tracks passed right through certain buildings and goods were off-loaded for on-site manufacturing (flour, butter, eggs and sugar for the Nabisco Bakery) or short-term warehousing and regional distribution. By 1960, however, newly built interstate highway networks caused a shift to road haulage and the New York Central Railroad Company sold off its Clarkson Street terminal and tore down the southern section of the elevated track below Bank Street. By 1976 the flagging rail route had been inherited by the newly formed Conrail, which immediately set about divesting itself of the unprofitable burden. In 1980 the last train ran down the trestle—hauling ten boxcars of frozen turkeys.

Between 1980 and 1999 the fate of the tracks was batted around between the succeeding rail corporations who found themselves responsible for their maintenance, the landowners whose property they ran over, and one relatively lone defender named Peter Obletz. In 1984, with recourse to a rather arcane congressional instrument called the National Trails System Act, Obletz succeeded in purchasing the recently nicknamed High Line for the grand price of $10. The sale was later annulled in a back and forth of reversals by a variety of interstate and city agencies, but Obletz had in fact found the way to solve the riddle of what to do with this liability-laden structure, too dilapidated to be used and yet not sufficiently far gone to fall down of its own accord.

Under the National Trails System Act, out-of-use railway lines could be "rail banked" or put on ice in case they were needed again in the future, thereby protecting them from demolition. In the meantime, one way in which such tracks could legitimately be used was as pedestrian walks or bike trails. Clearly, this trail use provision was more commonly applied to rural track meandering through prettier pastures than Manhattan's down-at-the-heels West Side, but nevertheless, the provision still held. It was from this kernel that Josh David and Robert Hammond's

mission gradually evolved—to turn Chelsea's stretch of abandoned overhead track into a publicly accessible, albeit densely urban, trail.

The roughly twenty property owners who held the land thirty feet beneath the track were the biggest opponents of its preservation. As the art galleries continued to move in, civilizing the once sketchy neighborhood, developers writhed under the restraints of not being able to tear down the cheaply purchased buildings that sat beneath the tracks and build them out and, more importantly, up. In 1991 the Chelsea Property Owners, as the group named itself, had already succeeded in getting a second section of the original High Line south of Gansevoort Street torn down. By the late 1990s they had their position backed by outgoing Mayor Rudi Giuliani, who saw the elevated tracks as an eyesore and a liability. Although he was about to reach the end of his term, the mayor still had enough time left in office to authorize the demolition of what remained of the High Line.

Giuliani had already made himself hugely unpopular with the art world in 1999 with his disastrous handling of *Sensation,* a traveling exhibition which had originated at the Royal Academy of Art in London. His Catholic sensibilities were offended by a good deal of the art in the show, but he was particularly outraged by Nigerian-born Chris Ofili's portrait *The Holy Virgin Mary* (1996), which included elephant dung in its component materials. When Arnold Lehman, the director of the hosting Brooklyn Museum, refused to close the show of what Giuliani called "sick stuff," the mayor threatened to shut down the entire museum by withholding $7 million of city funding. The interlude was a total fiasco, with Giuliani ultimately having to back down by court order, but not before he had incited a mass outcry from artists, actors, writers and the rest of the cultivated world. The mayor of New York City had succeeded in getting himself branded as a philistine bullyboy and one who might shoot from the hip again at any moment.

After the Twin Towers fell on the morning of September 11, 2001, however, it was hard for anyone in New York City—art world or otherwise—to criticize the mayor. In the immediate aftermath of the attacks, Giuliani held together and consoled, regrouped and redirected the paralyzed city. Nothing he said or did between that Tuesday morning and the end of his term in November seemed reproachable.

Amid the avalanche of mixed emotions suffered by every New Yorker in the ensuing days and weeks, Josh David and Robert Hammond remember their tortured reactions swinging between accepting that now the High Line park would never be finished, and the equally passionate conviction that finishing it was more important than ever. They decided to appeal to the neighborhood's art world.

David had once moonlighted as what he called "a cater-waiter" at a Guggenheim Museum event, where he was assigned to Paula Cooper's table. He called her up, and both she and Matthew Marks got on board. David had also heard Richard Meier speak at the Municipal Arts Society, and a call to him got the world-renowned architect excited as well. Rome Prize winner and Pace Gallery artist Joel Sternfeld, who had recently made beautiful photographic studies of ancient aqueducts in Italy, agreed to help and offered to shoot what he saw as the haunting beauty of the High Line's desolation. Between April 2000 and July 2001 Sternfeld dedicated a full four seasons to capturing the all-weather flora and fauna, the rust and the rails. The stunning works were later auctioned at a fundraiser at the Lucas Schoormans Gallery in Gloria Naftali's West Twenty-Sixth Street building.

Jeanne-Claude and Christo, who were busy uptown in Central Park with preparations for their own New York City spectacular *The Gates* also contributed, and The Kitchen stepped in to make its West Nineteenth Street quarters available for an awareness-raising meeting. Dia curator Lynne Cooke registered support, as did director Anne Pasternak on behalf of the public art program Creative Time. Mary Boone hosted a benefit, and graphic designer Paula Sher created an eye-catching logo for the rapidly growing activist entity. The Preservation League of New York added the High Line to its "Seven to Save" list of endangered structures, and influential arts organizations like the American Institute of Architects, the Architectural League and the Alliance for the Arts all became Friends of the High Line.

In May 2005 Michael Govan, the director of the Dia Foundation, the seed out of which the whole art in West Chelsea initiative had grown, announced that it would build a new 35,000-square-foot exhibition space at the foot of the High Line on Gansevoort Street. Dia's original four-floor warehouse building on West Twenty-Second Street had closed in

2004, its steep, tight stairwells and small elevator having always been problematic. The announcement of Govan's move in 2006 to the Los Angeles County Museum of Art caused that plan to stall, but barely a month after the news of Dia's withdrawal, the uptown Whitney Museum stepped into the slot. Having so far failed to bring either a 1985 Michael Graves expansion proposal or a 2003 Rem Koolhaas plan to fruition uptown, the Whitney now added to the downtown buzz with a design from Renzo Piano. The proposed $680 million, six-story, 195,000-square-foot West Thirteenth Street building was forecast to open in 2015.

Even the uptown Museum of Modern Art was seduced by the High Line's charm. In 2004 a call to Terrence Riley, the chief curator of MoMA's Architecture and Design Department, opened the way for an exhibition featuring models and digital renderings of what the future park would look like. The winning architects (landscape by Field Operations and master plan by Diller, Scofidio + Renfro) were inspired, the museum enthused, by "the High Line's melancholic, unruly beauty, in which nature has reclaimed a once vital piece of urban infrastructure."[23] The exhibition was so popular that its run was extended from three months to six

Everyone, it now seemed, was a Friend of the High Line, including New York's newly elected, hugely wealthy and seriously philanthropic mayor, Michael Bloomberg. With both Bloomberg and Christine Quinn (the new speaker of the City Council and second only in power to the mayor) on the High Line's increasingly formidable line-up, the obstacles to saving it, whether political, financial or community based, could now be eliminated, one group at a time.

The Chelsea Property Owners were assuaged by a nifty formula for turning their frustrated development ambitions into salable assets. A price was put on the air rights blocked by the thirty-foot high track above their buildings, and arrangements were made to sell those rights to other property owners in the neighborhood. Purchasers of these rights could then exercise them to build taller buildings elsewhere. The "elsewhere" in this particular case was often up and down the corridors of Tenth or Eleventh Avenues where Mayor Bloomberg's West Chelsea rezoning initiative was lifting height restrictions on buildings between West Sixteenth and West Thirtieth Streets.

If any of the art galleries that had originally bushwhacked the then-undesirable neighborhood were worried by the property developer's newly loosened restrictions, Amanda Burden, the director of the New York City Planning Department, was protecting their interests by lobbying for height restrictions in the middle of the area's blocks and for the retention of the M1–5 manufacturing only designation. The gallery lots would therefore be less vulnerable to the speculator tactics that had bedeviled the East Village.

The height controls also helped quiet local residents who feared that Chelsea's open skies and low-rise character would be marred by view-blocking and shadow-casting skyscrapers. Those demanding more affordable housing in the area were promised it, just as the residents of Williamsburg had been, since the construction of market rate residential property in the newly rezoned neighborhood would help subsidize the development of more reasonably priced homes. Preservationists sensitive to Chelsea's important architecture were encouraged by the prospect of a possible historic district designation for Chelsea that would regulate development between West Twenty-Fifth and West Twenty-Seventh Streets.

A feasibility study prepared by the Friends of the High Line responded to the budget-based objectors who questioned the need for city funds. Other projects underway at the time included the still-live 2012 Olympics bid, the renovation of the Javits Convention Center and the extension of the Number 7 subway line. Did New York really need another park? This group was assured that the increase in property values that the park would stimulate would translate into increased tax revenues for the city; the park would cost $65 million to build, but it would generate $140 million in revenues over the next twenty years.

By mid-decade, with virtually all of the opposition comfortably squared away, the freshly rezoned field looked wide open for play, and developers and investors in real estate went quickly to work figuring out how to use their newfound freedoms. In July 2006 the industry rag *The Real Deal* predicted the construction of as many as 5,500 mostly luxury housing units in the Chelsea area. Stuart Siegel, a managing director at the brokerage firm Grubb & Ellis was ominously quoted as saying, "Everything is a (residential) development site, and there is not a gallery that can compete with a developer." Five years ago a gallery owner looking

to buy space might be able to spend $1.2 million for a 5,000-square-foot site. Now the site and air rights would carry a $6.5 million or $7 million price tag.[24]

The Chelsea Arts Tower on West Twenty-Fifth Street that had reputedly cost Marlborough over $9 million was finished by 2007. Unfortunately, while it was briefly anticipated as a possible harbinger of bold new architecture in the neighborhood, the American Institute of Architects quickly dismissed it as "a slick totem pole to the 21st-century arts scene, corporate and drab."[25] Annabelle Selldorf's 200 Eleventh Avenue at West Twenty-Fourth Street was completed in 2009; the AIA labeled that a "luxury behemoth . . . another step in the trend toward housing that mimics luxury hotels." One of its many must-have attributes included a drive-in elevator that raised the resident's luxury car directly up to a private parking space outside their sky-high apartment.

Neil Denari's HL23 (2010) was similarly for the elite only. Curving itself provocatively over the High Line at Twenty-Third Street, its promotional materials promised "cinematic views and unrivaled intimacy with the High Line for the residents."[26] All eleven of them, since the building consisted of nine full-floor apartments, one duplex penthouse and a two-floor maisonette. This handful of new Chelsea locals were also to enjoy the thrill of entering through a lobby on West Twenty-Third Street—"in the shadow of the High Line's muscular beams."[27] Nary a bat, hooker or crack addict in sight.

Four blocks farther south on West Nineteenth Street, the Pritzker Architecture Prize–winning Frenchman Jean Nouvel put up his 100 Eleventh Avenue, a residence that its press literature described as "conceived . . . to achieve the highest level of discretion and design excellence to complement art and furniture." Nouvel was already hip to the lucrative fusion of money, art and trophy architecture, having recently met the demand for downtown chic with a megamillion-dollar glass extravaganza on SoHo's Mercer Street. Also on Nineteenth Street, the Japanese architect Shigeru Ban created the Metal Shutter Houses (2010), which, as the name suggested, were clad head to toe in a gussied-up version of the roll-down gates that had fronted the taxi garages of yore.

Even the "commercial" development in the neighborhood was upmarket. Media mogul Barry Diller commissioned the megastar Frank

Gehry to design a dramatic headquarters for his IAC/InterActiveCorp. By 2007 that project was finished and the billowy facade and fritted glass of the galleon-like building looked as if it had sailed straight up the Hudson River and docked itself in the middle of West Nineteenth Street.

Polshek Partnership's Standard Hotel (2009) then staked the neighborhood's southern edge on Gansevoort Street. It received accolades from *New York Times* architecture critic Nicolai Ouroussoff for its industrial grittiness, its daring embrace of its downtown setting and its "delicious tension."[28] "From the garden café," he wrote excitedly, "people can look up at the High Line's gorgeous underbelly." It quickly became a hot spot for everything from Sunday brunch with the in-laws to rooftop drinking for the underaged. Tourists en route to the High Line could even ogle the flesh of its exhibitionist guests having sex in its large-scale windows. There was now, it seemed, something for positively everyone in once-deserted Chelsea.

By 2007 requests for proposals on the development of Hudson Yards just to the north of the High Line had attracted Brookfield Properties, Extel Development, Related Companies, Tishman Speyer and Durst-Vornado Realty—the 800-pound gorillas of property development. With 12 million square feet ready and waiting, the outlook for the New York real estate market had never looked stronger. And, as always, the art market was booming right along in lockstep. What could be bad?

13

AFTER THE FALL

2007 to 2010

"Recessions are hard on people but they are not hard on art. The forties, the seventies and the nineties, when money was scarce, were great periods when the art world retracted but it was also reborn."

—Jerry Saltz, "Frieze After the Freeze,"
New York Magazine, 2008

*T*hat summer of 2007, at about the time the mega-developers were bellying up to the bar for a full-blown binge on commercial real estate, the first rumblings were heard of homeowner loans in the residential markets suddenly going bad. In the preceding years of (ostensible) plenty, ordinary people of modest income had been seduced into believing they could afford properties that were in fact beyond their means. Many were now defaulting on their monthly mortgage payments.

In the second fiscal quarter of 2008 the Wall Street firm Lehman Brothers, heavily burdened with these so-called subprime instruments, announced a $2.8 billion loss, and the market watched in horror as the value of its stock plummeted by more than 72 percent. Throughout the spring several other investment houses had already come unraveled under the weight of a comparable subprime dependency and news hit the wires on September 14 that Lehman would go into liquidation. A recession that had in fact begun in late 2007 was just about to turn into the steepest downturn since the Great Depression.

The Friends of the High Line were holding a fundraiser the night of Lehman's collapse, and organizers looked on anxiously as wives sat beside empty chairs nervously thumbing their BlackBerries to husbands who had been summoned back to their Wall Street offices. The next day the Dow dropped 500 points, and the fundraisers thought long and hard about how they were to continue their capital-raising campaign with so many previously generous donors withdrawing support.

Barry Diller and Diane von Furstenberg stepped in, however, with a $10 million donation, and at a private dinner for 200 prospective supporters in the spring of 2009, socialite Lisa Falcone, in a dramatic microphone-grabbing gesture, announced that she and her husband, Philip, would match it with another $10 million. The ribbon was cut on the first section of the High Line elevated park on June 8, 2009, and over the next two years 3 million people—ten times as many as initially envisioned—tramped through once-desolate West Chelsea.

MONEY MATTERS

Despite the nightmare on Wall Street and the hand wringing among Friends of the High Line on the evening of Lehman's collapse, there were nether regions of the international art world that were slow to get the Crash of '08 memo. The very next day in London, the no-longer-so "Young British Artist" Damien Hirst brazenly bypassed both his local gallery White Cube and New York dealer Larry Gagosian and took 223 works of art directly to auction at Sotheby's. Already shaken by fears of what was coming in terms of an overall business downturn, the New York gallery network was also beginning to question whether the paradigm might be shifting completely. Between purchases over the Internet, prize pickings at the art fairs and the rush to buy publicly and sensationally at a powerhouse international auction, a bricks and mortar gallery with a multiyear program and a long-term commitment to artists might just be a thing of the past.

The Hirst stash fetched $220.7 million—stuffed sharks, rotting animal carcasses, dead butterflies, spin paintings, studio assistant–generated dots, diamond-encrusted skulls and all. The *Guardian*'s Maev Kennedy wryly observed that Hirst "has made more money in two days than all

the artists in the National Gallery earned in a life time."[1] But any notion that the Masters of the Contemporary Art Universe might simply be beyond the wrath of the marketplace gods was momentary hubris; as the economy folded in on itself through the autumn of 2008, dominoes toppled all along the art world system.

By November, when the regular fall sales came around, the auction houses were seriously worried about the contents of their glossy catalogues. As always, the sale lineups had been put together months earlier, and it was now too late to change the terms of consignment. Overloaded with sellers looking to capitalize on the inflated market, there was too much supply. To make matters worse, in competing for the best of what was to go on the block, several houses made imprudent minimum guarantees to sellers in the interest of luring the goods their way and not letting them fall under the hammer of a competitor.

Unfortunately, by the time the actual sales dates came around, not only Wall Street buyers but also many of the Russian oligarchs and wealthy Middle Eastern collectors who had driven prices up earlier had fled the New York market. Europeans who had enjoyed the advantages of art shopping when the euro was strong against the dollar also held back.

By the time its fall contemporary sales were over, Sotheby's was reporting a loss of $28.2 million in guarantees, and Tobias Meyer, their contemporary specialist, acknowledged that prices had dropped back to 2006 levels—to 2004 in some cases.[2] By January 2009 Sotheby's stock had fallen from $61 a share in 2007 to just $8, and the company was laying off scores of employees worldwide. More than one hundred staff were let go at Christie's as the organization began consolidating departments. The spring 2009 sales were no better with Sotheby's down 87 percent on the previous year, and Christie's down 72 percent.[3]

Needless to say, the Wall Street implosion not only impacted the commercially based auction houses but also knocked on into other arts institutions. As soon after the crash as October 20, 2008, Carol Vogel was headlining in the *New York Times* "Museums Fear Lean Days Ahead." Lehman Brothers, along with many of Wall Street's other big names, were crucial sponsors of the museum community, and many of its big bonus makers also sat on boards—and wrote the required donor checks—for a whole range of arts organizations. The Museum of

Modern Art immediately implemented a hiring freeze and imposed a 10 percent cut in its operating budget. The Brooklyn Museum followed, increasing its suggested admission fee from $8 to $10 and also instituted a hiring freeze; there too the staff was asked to cut expenses by 10 to 20 percent. For smaller, not-for-profit entities, not only private giving but also funding from government grants dwindled as Mayor Bloomberg told the Department of Cultural Affairs to reduce its spending by 2.5 percent for fiscal year 2008 and by 5 percent more in 2009.

By January 2009 the US unemployment rate was at 7.8 percent, its highest in sixteen years, with 11.1 million people out of work. In December 2008 alone, the nation lost 524,000 jobs.[4] That month, at the peak of the holiday season, *New York Magazine* started to run a worry-inducing little graphic called "The Recession Index." It used comparative indicators—ranging from sales of cars, Broadway theater tickets and cashmere sweaters to the number of college-educated New Yorkers who were on unemployment and anti-anxiety medications—to show its readers just how much worse off they were than a year ago.

While it took some time for the art world's own press to start addressing the crisis head-on, the impact of the market drop was quickly visible among the glossies. As the ever-droll Jerry Saltz remarked in the boom times of 2007, "Art magazines, once left on coffee tables, are fat enough to *be* coffee tables."[5] By February 2009, however, *Artforum*, which had weighed in at 500 pages in May 2007, was down to a slenderized 200. Advertisers, principally galleries, had slashed their budgets. Since costs could be further controlled by keeping shows up a week or so longer, there were fewer openings to announce anyway. Publisher Knight Landesman acknowledged a 40 percent drop in business.[6]

In the dailies, the usually measured critic Holland Cotter was nearly hysterical as he wailed that "sales are vaporizing, careers are leaking air, Chelsea rents are due."[7] Three long and slow months later, just as the art world sank into its perennial sleepy summer ennui, Dorothy Spears underlined the business malaise with an article entitled "This Summer Some Galleries Are Sweating." More than two dozen had closed, including veterans like Charles Cowles. After thirty years of selling art—since the 420 West Broadway days—Cowles was ready to retire. But as Spears pointed out, the economic slide left little room for hesitation.

Others saw the road ahead as survivable but just too hard to hack. The three artists who ran Guild and Greyshkul closed the gallery and returned to their studios, and the energetic but very young partners at Rivington Arms went their separate ways. Respected professionals like Feature Gallery's Hudson and the experienced partners at The Proposition shut up shop while they regrouped and figured out their next move.

Particularly hard hit during these tough times were several of the Williamsburg migrants who had hoped to up their game in Manhattan. Just like the East Village start-ups who graduated to SoHo at the end of the 1980s only to be hit by the recession of the early 1990s, this crash of '08 had its look-alike casualties. In 2008 Roebling Hall mysteriously disappeared without trace, closing its doors virtually overnight, leaving both artists and collectors stranded. Director Joel Beck became a prime target of an especially vicious little website called "How's My Dealing?" where disgruntled artists and ex-employees vented with anonymous posts and added gallery names to an art world "Deathwatch" list.[8]

The art world weigh-in on the demise of Becky Smith's Bellwether Gallery was not unlike that surrounding Mary Boone in her 1980s times of distress. Boone, of course, survived and flourished, but the snipes and gloating to which she was subjected during her tougher periods were now leveled at Smith. Ruthless ambition, traitorous disregard for early loyalties and a cavalier arrogance were all felt to be a part of the comeuppance. Smith's belief in her artists and her determination to promote their visibility and advance their careers were never in question, and even her loudest critics begrudgingly conceded that she had put up some of the most visually exciting and rule-changing shows of the era. Nevertheless, rumored to be way too dependent on a small cadre of collectors who had now stepped away, she was forced to close in June 2009.[9]

In late 2008 the partners at 31 GRAND who in July 2007 had bypassed Chelsea for the surely more affordable Lower East Side closed their apparently popular Ludlow Street gallery. Priska Juschka stayed open for a couple more years but might well have been in trouble all along. In 2003 her partner had been served a federal indictment charging him with laundering drug money by selling an Edgar Degas to an undercover agent. She was later hit by lawsuits from artists who claimed not to have been paid, and her business was dissolved in April 2011.[10]

In 2006 Black and White Gallery had taken space in the Tunnel on West Twenty-Seventh Street along with fellow Williamsburg transplants Schroeder Romero, Winkleman Gallery and Foxy Production. Covered access to the galleries on either side of the vaulted tunnel in this magnificent nineteenth-century industrial building should have made it a magnetic hub for more art world tenants. But as the down market hit, the colonization failed to happen and a dwindling number of collectors cared to pick their way across the unforgiving cobblestones to seek out a lone gallery or two.

While Winkleman and Foxy Production stayed put in Chelsea and weathered the storm, Black and White's Okshteyn closed her Manhattan space in 2010 and retreated back to Williamsburg. She regrouped, consolidated and adjusted her program in the original Driggs Avenue location that she had prudently never given up. In 2012 Schroeder Romero also surrendered their Chelsea real estate, went back to Brooklyn and took the e-commerce route to distribute more collector affordable limited edition prints and multiples.

EVERYTHING OLD . . .

Barely in under the wire before the financial crisis came down on the art world's head, a new museum opened on the Bowery at Prince Street. The building was new, but the New Museum of Contemporary Art had been in existence for some thirty years. The first New York museum to be dedicated solely to the exhibition of contemporary work, the institution was born immediately after its creator, Marcia Tucker, was fired from the Whitney.

Always a hell-raiser curatorially (Tucker entitled her memoir *A Short Life of Trouble: Forty Years in the New York Art World*), she had ruffled feathers many times before mounting a 1977 exhibition of Richard Tuttle's like-nothing-before sculptures. "Pieces made with florist wire, a nail, and a pencil line," Tucker explained, "completed by the wire's shadow. Tin, plywood, string." Believing itself ridiculed, the Whitney's board was having none of such worthless junk, and the show was Tucker's swan song. Or, as she wickedly quipped on her way out the door, "maybe duck honk is more like it."[11]

Tucker found a first home for the new museum she was defiantly determined to launch at 105 Hudson Street alongside Artists Space and Printed Matter; she put down her entire $1,200 severance pay to rent an office for a year. The New School for Social Research on lower Fifth Avenue made room for her next, and in 1983 the renegade operation moved to the Astor Building at 583 Broadway. There it continued to mount exactly the kind of off-the-reservation exhibitions that Tucker believed in and that the Whitney (of the late 1970s, at any rate) would have hated. In 1998, as her health began to fail, Tucker stepped down and ceded the reins to Lisa Phillips—ironically, seduced away from Tucker's former nemesis, the Whitney Museum of American Art.

Over the course of the next four years, the New Museum searched for the right site for its fourth, but first permanent, home. It settled on a small footprint parking lot on the Bowery at the east end of Prince Street. "We chose our location carefully," Phillips told the *New York Sun*'s Valerie Gladstone in June 2007. "We wanted to be convenient to transportation and in touch with all of the adjacent communities. It's always been a social activist neighborhood and one friendly to artists." In this, she was absolutely right.

In 1958 Mark Rothko had leased space at 222 Bowery to work on his series of murals for the Four Seasons restaurant, and sculptor John Chamberlain also took space there. William Burroughs, the bad-boy writer and some-time painter had a loft in the building in the 1970s and named it the Bunker. Allen Ginsberg, Keith Haring, Jean-Michel Basquiat and Blondie would drop by and get stoned.[12] In other buildings up and down the Bowery, artists including Kenneth Noland, Roy Lichtenstein, Dan Flavin, Robert Ryman, Eva Hesse, Robert Smithson, Cy Twombly, Vito Acconci and Brice Marden occupied studios or live/work spaces, both legal and illegal.

In addition to artists' studios, the Lower East Side was also home to a variety of exhibition spaces that found the multi-ethnic working-class neighborhood empathetic to their socially and politically outspoken programming. The Abrons Art Center had been delivering to the Lower East Side since 1975 as an integral part of the neighborhood's Henry Street Settlement. Originally a provider of basic medical and social services, it also made culture and learning accessible to the neighborhood

poor with one of the first arts facilities in the nation designed for a predominantly low-income population. Still going strong into the new millennium, the Abrons continued to fill its two gallery spaces with five to six contemporary shows a season, and its artist-in-residence program hosted such luminaries as the Iranian-born photographer and filmmaker Shirin Neshat.

ABC No Rio got its truculent start in 1980 when it was born out of the ruckus surrounding the left-leaning collective Colab's baiting of the Department of Housing with that year's *Real Estate Show*. It took its name from an abandoned sign found in the building that had originally announced "Abogando Con Notario." Several of its letters had fallen off and they named themselves with what was left. Also a nonprofit entity with a sociopolitical agenda, ABC No Rio continued in its mission to fuse artistic impulse and political activism and still mounts troublemaking exhibitions in its previously extralegal and always turbulently occupied premises at 156 Rivington Street. Its patrons, according to the organization's website, include "nomads, squatters, fringe dwellers, and those among society's disenfranchised who find at ABC No Rio a place to be heard and valued."

Equally committed in its mission was Participant Inc., operating since 2001.[13] Founder Lia Gangitano started out in the art world in Boston where, as an English major, she chose by chance a part-time job at the Institute of Contemporary Art over a position in her campus library. She stayed with the ICA for ten years and it was there—under the influence of game-changers like curator Elisabeth Sussman and scholar David Joselit—that she got her education. The ICA was a non-collecting institution, had a very strong film and video program and the 1990s were a heady moment for art in the service of activism. From these roots Gangitano developed a commitment to art beyond the object, faith in the power of purely time-based and ephemeral work, and a nervy engagement with projects that would not be easily received elsewhere.

In 1997 connections to Pat Hearn and Colin de Land brought her to New York, where she took a position with the Thread Waxing Space at 476 Broadway. At this comparably groundbreaking entity where independent curators organized exhibitions, performances, readings, musical events, film screenings, lectures, and discussion panels, Gangitano

deepened her connections to the cross disciplinary and the genre busting. When Thread Waxing closed in 2001, she felt compelled to keep the rebel flag flying.

Participant was five years at 95 Rivington Street, close by ABC No Rio and similarly struggling on not-for-profit funding. A rent hike–induced move in 2007 took Gangitano farther east to Houston Street between Norfolk and Suffolk Streets. There she continued her iconoclastic program showing challenging new film by Momenta Art's Laura Parnes as well as the media-blending creations of Charles Atlas and Antony and the Johnsons long before far fancier galleries and museums picked them up. She also had the confidence to present the gender-bending work of Vaginal Davis and Robert Boyd and stage a bloodletting performance by the endurance artist Ron Athey well before Chelsea would touch such controversial stuff.

Speaking of her partiality for the neighborhood in a conversation with the author in 2012, Gangitano acknowledged the Lower East Side's long history with small locally patronized arts, theater and music venues. At the same time, however, she was unsentimental about the realities of affordable space. The Houston Street premises had once been some kind of sex club and then the site of one of the biggest drug busts in the neighborhood's shady history. The property was so shot to pieces when Gangitano first saw it that she likened it to a Martin Scorsese film set. No one else wanted it, and it came with a fifteen-year lease. When pressed on her reputation as a visionary and a pioneer, she modestly dismissed both. Since she herself had learned to live cheaply in a tenement on Ludlow and Houston, the benefits of already knowing an affordable plumber, an electrician or a willing insurance broker were as important to the survival of her valiant little not-for-profit as were her canny eye and liberal mind.

Cuchifritos Gallery and Project Space was also born out of the pragmatics of life lived on a small budget. A 2001 outgrowth of the Artists Alliance Inc., a group formed in 1999 by artists with studios in the former PS 160 on Suffolk Street, Cuchifritos sought to foster deeper connections between local artists and the broader public. They capitalized on the neighborhood's history of labor and commerce and found modest but functional housing in a tiny space in the historic Essex Street Market.

Excellent little shows can still be seen in among the neatly stacked cans of ethnic foodstuffs, the smell of roasting coffee and the chatter of daily shoppers.

Following on the heels of these early settlers but still preceding the New Museum were a number of fresh arrivals to the neighborhood who began setting up shop from 2002 on. Almost all were commercial galleries, but the radical or emerging art they showed meant that, in the early days at least, sales were few. In 2002 Canada opened far south on Chrystie Street in the predominantly Chinese, as opposed to Jewish, section of the Lower East Side. Starting out as a kind of gallery cooperative rather than a commercial dealership, co-founder Phil Grauer and a group of working artist friends created something more in the spirit of Williamsburg than Chelsea. Showing only work that interested them from around their studio network, they called themselves Canada as a spoof on the unfettered, open-spaced freedom that their first location—a windowless basement on lower Broadway—totally lacked.

Canada had relocated to Chrystie Street when they were displaced from Lower Manhattan after September 11. With a small FEMA grant the artists did the build-out of the former sweatshop in their off hours relying on their pooled construction skills. Despite its far-flung location, the gallery quickly evolved into a vital stop on the downtown itinerary, showing Joe Bradley's scrawled, beaten and weathered canvases, Carrie Moyer's glitter-infused riffs on early feminist painting and Canada co-founder Sarah Braman's used furniture pieces. All of these artists went on to be well reviewed and actively acquired by collectors and museums.

Reena Spaulings Fine Art first opened in a former dress shop on Grand and Essex in 2003 and from the street was indistinguishable from the stores and restaurants to either side of it. The gallery later relocated to an even funkier location in a broken-down loft on East Broadway where Canal Street runs itself out at the eastern end; it gave a whole new meaning to the notion of destination gallery. It was a trek to find the gallery in the first place, and the directors were a maddeningly mysterious and member-morphing collective. Artist/writer John Kelsey and artist/performer Emily Sundblad were generally the most regular and reliable keepers of the gate. Reena Spaulings herself was never there because, like Ivan Karp's O.K. Harris, she was an entirely fictitious entity.

Nevertheless, she made art, recorded music and was the subject of a novel written by the equally elusive collective known as the Bernadette Corporation. For British artist Merlin Carpenter, the gallery created a persuasive facsimile of the café in London's Tate Gallery. This show followed an earlier body of Carpenter's work that involved defacing the gallery's walls with the exhortations "Die Collector Scum" and "Relax It's Only A Crap Reena Spaulings Show." As *Flash Arts*'s Erica Papemik wrote, "Reena Spaulings is polymorphously perverse; . . . a collective, a dealer, a plucky protagonist, and a frame of mind."[14]

Other advocates of non–object-based, genre-flexible and market-wary art making found an empathetic environment on the Lower East Side, and May 2005 saw the launch of Orchard. A twelve-member consortium of artists, filmmakers, critics, art historians and curators, Orchard so believed in the evolving nature of its mission that it set itself an expiration date three years out and duly disbanded in 2008. In between times, the for-profit, limited-liability partnership was funded by its artist investors and their monthly contributions covered costs. Like the Tenth Street cooperatives of the 1950s, they split the proceeds of any sales.

Operating their exhibition and event program out of 47 Orchard Street between Hester and Canal Streets, R. H. Quaytman, Moyra Davey, Andrea Fraser and the other Orchard operatives exemplified the same kind of resistance to commodity, rejection of market valuation and belief in time-based projects that was so crucial at Participant. Eschewing any notion of the Lower East Side as a site for only the young and emerging, they also had a strong commitment to a transgenerational array of artists and movements.

The transgenerational was also at the core of three other independent-minded programs that got underway just before the New Museum opened—at Miguel Abreu, James Fuentes Gallery and Sean Horton's Sunday LES. Miguel Abreu opened his eponymous gallery at 36 Orchard Street in March 2006 with a fusion of film, text and painting.[15] Weightily titled *Empedocles/Hölderlin, Cézanne/Gasquet, Straub/Huillet, Dominique Païni & Blake Rayne,* the exhibition set the standard for the deeply ideas-based program that Abreu would develop. A French-born philosophy undergraduate with an MFA in film and video from CalArts, Abreu came later than most of his neighbors to launching his

own program. He had been one of the founding members of the Thread Waxing Space, where he worked with Lia Gangitano.

The proximity of Participant, Reena Spaulings and Orchard was enormously important to Abreu in settling on the Lower East Side. He felt a far greater affinity to the type of crossmedia, multigenre work that they were presenting than to anything that was going up in Chelsea. Crisscrossing art forms from film to painting to performance to poetry readings, and setting up exhibitions and events that juxtaposed the ancients with the contemporary, Abreu showed the image- and text-based explorations of Orchard's R. H. Quaytman (born 1961), the bizarre bodily contortions of the surrealist Hans Bellmer (born 1902), the cameraless photogram-cum-sculptural constructs of Liz Deschenes (born 1966), and the fictional but critique-heavy films of Redmond Entwistle (born 1977).

James Fuentes was a generation younger than Abreu but shared his interest in experimental film and had studied filmmaking and anthropology at Bard College.[16] Fuentes was the son of Ecuadorean immigrants and had grown up on the Lower East Side on Madison Street at the East River. As a child he saw Keith Haring's chalk drawings on subway platforms, and when his family moved to the South Bronx, he started to notice what the Fashion Moda artists were doing up there. In his early twenties he hung out in SoHo, and Colin de Land took a liking to him—more a kid knocking around the gallery than an actual employee.

Once out of college Fuentes worked in a junior role for Creative Time on their important Art in the Anchorage projects under the arches of the Brooklyn Bridge. He was on the hunt for an apartment when a co-worker mentioned a two-floor storefront on Broome just off Varick Street. When Fuentes discovered that this had been Gavin Brown's original West Village site, he took it as a sign—and snapped it up for $900 a month.

From 1998 to 2001, while working as a security guard at the Metropolitan Museum of Art, he used the Broome Street space for impromptu exhibitions of work he was spotting in and around the studios. Several of the artists he showed in this first venture would go on to be recognized by bigger and more important galleries. Cheyney Thompson's painted *Chronochrome* grids were picked up by Andrew Kreps, Stephen

G. Rhodes's garage sale pile-ups were shown at Metro Pictures and Amy Granat's photograms at Nicole Klagsbrun.

Taking well-intentioned advice from an artist who had shown with him, Fuentes acknowledged that his committed but administratively erratic program might be a bit too wobbly to survive. In 2001 he set out to professionalize and learn from some pros. In late 2006, after a period with both Lombard Fried and Jeffrey Deitch, Fuentes found the perfect space for the second iteration of the James Fuentes Gallery. Aptly situated on St. James Place, it was at the very southern edge of his native Lower East Side and a stone's throw from where he was born. He re-opened in January 2007.

Sales came quickly and critical attention was immediate. Within months, Charles Saatchi bought eight works by the sculptor Agathe Snow, including a concoction called *Decaf Mochachino* made of such non-high art materials as paper, sand, soil, stone, wood plastic, glass, steel, coffee, acrylic and gold. Although the crash of 2008 hit Fuentes as hard as it did most of his colleagues, he continued to grow the reputation of his program and in 2012 moved to a bigger, more accessible space on Delancey Street, where he is widely acknowledged as one of the important voices in this next generation.

As Fuentes added to the small group of individualists to the south of the neighborhood, another young dealer added weight to the northern hub on Rivington Street. An out-of-towner with just a couple of years of Chelsea experience, Sean Horton took a 480-square-foot space on Eldridge Street just below Houston and called his gallery Sunday LES.[17] The name had its roots in a variety of quirky personal notions including a Southern Baptist upbringing and a yen to explore the religious in contemporary art. It was also a sly aside to the Chelsea galleries who so mercifully shut up shop on Sundays and left the field open to younger and as yet less established dealers.

Horton was studio trained with an MFA from the Boston Museum School, and an alumni connection to Pascal Spengemann of Taxter and Spengemann led him to Nick Lawrence at Chelsea's Freight and Volume. There Horton got some valuable experience in the mechanics of the gallery business to supplement his strong eye for emerging (and overlooked) talent and his growing passion to curate. He stayed on Eldridge for a

little under three years before being seduced back to Chelsea, not to a taxi garage space but to the parlor floor of the Federal townhouse that Linda Kirkland had taken out of near dereliction back in 1997. He then spent a period on projects in Berlin, but New York was calling and by now he felt sufficiently equipped to retake Manhattan. When in 2012 he heard that Canada was vacating 55 Chrystie Street to move a bit farther north, he leapt at the chance of a bigger Lower East Side space and opened again with a program strong in young painters and under-recognized older artists.

. . . IS NEW AGAIN

The seven-story, $50 million New Museum designed by the Japanese architectural team known as SANAA was the first museum to be built from the ground up south of Fourteenth Street, and its 60,000 square feet more than doubled the room the institution had to work with. Looking from the exterior like a precariously stacked pile of six white pastry boxes, with each floor not quite sitting atop the one below, the surface of each teetering level was clad in a mesh-like aluminum sheathing that caused its color to mutate in the varying light of the New York City day. Inside, in the almost square, high-ceilinged galleries, natural daylight poured down from the several glass roofs left exposed at the building's outer edges by the irregular stacking of the floors.

The last few weeks of November 2007, just ahead of its December opening, saw a tizzy of art world attention buzzing around the New Museum. All of the principal arts and culture critics went at it with abandon. Paul Goldberger at the *New Yorker* came out of the starting blocks first on November 19. He noted that, in keeping with its mission to support new art, the museum had limited its search to younger architects who had not yet built in New York. Aesthetically his review was mixed since the exterior disappointed, but he warmed to the interior spaces and acknowledged that they had a certain "frisson."

New York Magazine's Justin Davidson was next up on November 25. Younger than Goldberger by a decade and a half, he showed himself to be unabashedly seduced. "Sidle up to the museum and the hard edges soften," he drooled, "hazed by the mesh stretched over each surface like

a fish net stocking made of chain mail." The frisson was clearly happening for him too. "Sexy and defiant in this see-through armature, the museum challenges passers by to call it a freak."

Five days later Nicolai Ouroussoff got straight to the point in his piece for the *New York Times*. "The New Museum of Contemporary Art," he announced, "is the kind of building that renews faith in New York as a place where culture is lived, not just bought and sold." Born in the 1960s and of the same generation as Davidson, Ouroussoff was also attuned to the contemporaneity of the project at all levels. In an undisguised jibe at Chelsea in terms of its utilitarian gallery architecture, Ouroussoff clearly had both thumbs up. "It succeeds on a spectacular range of levels," he raved, "as a hypnotic urban object, a subtle critique of the art world and as a refreshingly unpretentious place to view art." The building, he believed, captured a moment in the city's cultural history with near-perfect pitch.

Lance Esplund published the same day from the short-lived and soon to be defunct *New York Sun*. Offering perhaps the most rigorous critique of the building architecturally, Esplund also sensed the stirrings of upheaval that the New Museum augured. Unlike the other architecture specialists, Esplund wrote broadly (and well) for his publication on art in general. And, generally, he did not like the art now being shown by the New Museum. Before he even got through the door, he was rattled by the enormous neon rainbow that adorned the upper right corner of the ethereal building's façade. "Like a trumpet blast," he complained, "Ugo Rondinone's large-scale, illuminated sculpture, *Hell, Yes* (2007), in all its rainbow-colored glory, arcs its letters across The New Museum's spare silver exterior, giving the structure the appeal of a Toys 'R' Us."

Once inside, things got worse for Esplund. The museum's opening show—*Un-Monumental: The Object in the 21st Century*—he described as "another garage-sale show . . . filled with knickknacks and odds-and-ends, tied and glued and strung together like so many found objects and bad art school collage projects." Other critics saw the same goods. "A rash of ungainly sculptures and installations, made of everything from junk to construction materials, household items, even trucks," wrote Barbara MacAdam in ARTnews.[18] Roberta Smith described "its ugly-duckling looks, rough edges, disparate parts and weird juxtapositions,"

while Jerry Saltz noted its "amorphous, disorderly, or fragmentary structure and hybridity."[19]

Disconcerting as all of these ticky-tacky mash-ups might be, not everyone agreed with Esplund that it was bad art. "It says: Get your nerve on. Take a stand," Smith suggested. "Start an argument by being focused or maybe even one-sided instead of just being confused or simply too big or too small." Of Tuttle's modest materials back in 1977, Marcia Tucker had said, "Not the stuff of greatness perhaps, but then, who's to say that the bigger something is and the more expensive and precious the materials used, the more important the work is going to be?"[20] Thirty years on, something new was again happening but it wasn't happening in Chelsea.

14

THE LOWER EAST SIDE REDUX

"The Lower East Side—roughly the area of Manhattan bounded to the north by Houston Street, to the west by the Bowery, to the south by Canal Street, and to the east by the East River—has emerged as a fecund, if not cohesive district in its own right."

—Stephen Maine, *Art in America*, 2006

As early as May 2006, a good year and a half before the New Museum officially opened its doors, that doughty explorer of art world frontiers Stephen Maine was already out and about surveying what the new construction on the Bowery might be doing to the neighborhood. What he found was, in addition to the original pioneers, a whole new wave of galleries, many of them launched by young, next-generation dealers now striking out on their own.

Most of them were not, however, *that* young and for the most part, they were far from inexperienced. Although some came with studio practitioner backgrounds, this was not the East Village of the 1980s where young art school crazies were showing each other's work just for the hell of it all. These new entrepreneurs had business heads (and often finely tuned business plans), and their pedigrees included elite college educations and apprenticeships at established (usually Chelsea) galleries.

STOREFRONTS AND START-UPS

Dennis Christie and Ken Tyburski of DCKT opened initially in a former lighting store at 195 Bowery in March 2008, and both had excellent

mentors.[1] Christie was another acolyte of Charles Cowles and started out as an intern at the legendary 420 West Broadway. When Cowles moved to West Twenty-Fourth Street in 1999, he gave Christie the opportunity to try his hand at something younger in the way of programming in a back gallery. Ken Tyburski apprenticed with Christian Haye and Jenny Liu at the Project, a well-regarded program up in Harlem. He then went on to work with dealer Paul Morris in his West Twenty-Third Street gallery and continued alongside Morris (one of the founding members of New York's Armory Show), running art fairs in Chicago.

Simon Preston also worked with Haye and Liu at the Project.[2] Preston was born in Hong Kong but was educated at the Ruskin School at Oxford and set up on his own on Broome Street. Jimi Dams was also an immigrant, arriving in 1997 from Belgium.[3] Before he opened his own Envoy Enterprises in Chelsea in 2005, Dams worked alongside Hudson of Feature Gallery fame. Hudson had by now run universally respected programs in Chicago, SoHo, Chelsea and on the Bowery. In 2007 Envoy was one of the first galleries to forsake Chelsea for the Lower East Side. Both Preston and Dams quickly garnered critical column inches and collector patronage.

Of course, this new generation also produced a fresh and formidable line-up of capable young women dealers, all of them with blue bloodlines in the art world. Lisa Cooley, a Texan like Sean Horton, had worked for both Nicole Klagsbrun and Andrea Rosen; she opened in January 2008 in what had been an underwear store at 34 Orchard Street.[4] By December 2012 she was already in a much bigger, 4,800-square-foot space at 107 Suffolk Street with a ten-year lease on her books. She was drawing decisive critical acclaim (and a collector base) with artists like Andy Coolquitt who fashioned winningly anthropomorphic sculptures out of carpet-wrapped poles topped with light bulbs or other dumpster-diver finds.

Nicelle Beauchene arrived in April, taking a tiny basement space on Eldridge Street just north of Delancey.[5] She had eight years of Chelsea training, including time at both Metro Pictures and Marianne Boesky. She expanded in 2009 to 21 Orchard but in 2012, with a different configuration in mind, gave up that space, and it became the third Lower East Side home of the DCKT partners. Beauchene moved to 327 Broome

Street, where she set up a novel arrangement alongside dealer Jack Hanley, mixing, matching and rotating their spaces from one show to the next. Right next door the other quasi-communal arrangement of the relocated Canada Gallery and a newly hip Lower East Side offshoot of Marlborough was under construction.

Rachel Uffner was just up the street from Beauchene. She also had Chelsea training—with Chris D'Amelio and Lucien Terras—and once out on her own, she indulged and redefined the yen for eclectic materials in unorthodox form that characterized their program. Pamela Lins's compactly structured planar sculptures sat atop oddly notched but pristinely painted plywood bases, creating a disconcerting but not unpleasant dynamism in the tiny gallery. Anya Kielar's life-size female forms hovered in their dyed and woven scrims, individual and self-asserting but transparent, the one visible behind the other, fusing into a group presence.

BREAKING RANK

This new generation, so accurately predicted by Jerry Saltz, also brought with it new communities and new energy. Almost from the get-go, things got done differently on the Lower East Side, in ways and by combinations of players that shook up the structures, challenged the formula and changed the rules of the art-dealing game again. A good deal of innovative thinking was done about new models, and fresh approaches were taken to many business-as-usual assumptions.

If the Reena Spaulings/Orchard crowd earned themselves the reputation of being too cool for school with their exasperatingly hard-to-pin-down ways, a very different venture, somewhat beyond the pale of the artsy neighborhood per se, set out to debunk such art world pose. In March 2003, Jen Bekman, an Internet wonk who had previously worked for New York Online and Netscape, took the $18,000 she had in her 401(k) and launched Jen Bekman Gallery at 6 Spring Street, just west of the Bowery.[6]

Struck by the fact that in her midthirties (and with a comfortable income), she owned no real art, Bekman had been intrigued that no one in New York City was actually trying to sell her any, or at least not in a

way that she found accessible. Chelsea seemed intimidating with price points starting at $10,000, if not $20,000. On the other side of the equation, she had emerging artist friends who were producing good work but seemed to have no access to the mechanics of finding a buyer. They were often included in group shows or struggled hard to mount solos of their own, but the dynamics of connecting with a check-writing purchaser rarely seemed to come together.

Carefully choosing a small ground-floor space with wide-open windows, Bekman was happy to be on the SoHo side of the Bowery. The notion of her gallery being right in the path of people shopping, lunching or hurrying to the subway was as important to her as its proximity to the New Museum. She set to work mounting shows of affordable paintings, photography, mixed media and works on paper and always offered something small enough for the pint-sized apartments her young collector clientele were likely to be renting.

In 2005 Bekman switched things up again when she launched an international photography competition called "Hey, Hot Shot." A well-qualified panel of photography experts reviewed digitally submitted works and identified ten finalists. These works were then included in a Jen Bekman Gallery group show, and an overall winner was awarded $10,000, a full-length solo exhibition and two years of representation with the gallery.

In 2007 she started 20x200, a wildly successful program through which artists submitted work digitally for limited-edition production and online sale through Bekman's e-commerce routes. Prices, dimensions of prints and the size of the edition were highly elastic, allowing the beginner collector to get started but also grow, not only in terms of budget and more space to install but also in connoisseurship.

Amy Smith-Stewart was another game changer.[7] She opened a bricks and mortar gallery space at 53 Stanton Street in April 2007, tucked in alongside the newly arrived Fruit and Flower Deli Gallery and Stephan Stoyanof's Fifty-Seventh Street migrant, Luxe. Smith-Stewart also came to the Lower East Side with a certain heft of street credibility, having worked with Alanna Heiss at PS1 and having served for a brief period as the new young radar at Mary Boone. Some of Heiss's gypsy spirit clearly took possession of Smith-Stewart, however, and she

kept her storefront for only two years. Rather than being limited by the strictures of one set space, Smith-Stewart went on to curate a series of well-regarded nomadic—or, as the phrase started to be coined, "Pop Ups"—at various guest venues around the art world.

Smith-Stewart's neighbor Fruit and Flower Deli was no such thing, but rather another one-of-a-kind innovation. The proprietor, one Rodrigo Mallea Lira (mysteriously known as The Keeper), maintained a presence at the gallery purely to communicate with the Oracle, his spouse and artist partner Ylva Ogland, whose persona was represented in the painting of a mirror housed in Smith-Stewart's gallery next door. One of their shows involved an anonymous investor/participant putting up the rent for the gallery for twelve months. "The work" in the exhibition was the twelve rent receipts from the landlord.

A similarly free spirit moved RENTAL, set up by Los Angelino Joel Mesler at 120 East Broadway in a former mah-jongg parlor. RENTAL made its premises available for just that, short-term rentals for out-of-town curators who wanted to set up in New York for a few weeks to try things out for size.

Other programs followed that also subscribed to the principle of freedom to create interesting shows from a pool of wide-ranging artists not necessarily tied to, or formally represented by the gallery. Lesley Heller had been doing her own thing her own way since the mid-1990s in SoHo and had variously set up shop on the Upper East Side near Salon 94 and on East Seventy-Seventh Street close to Castelli.[8] In February 2010 she opened Lesley Heller Workspace—not Gallery—and began staging her refreshingly eclectic, multigenerational, multigenre, and pan-global program in her fourth, beautifully finished space at 54 Orchard Street. She alternated between solo and group exhibitions and shows like *Fractured Earth, Building Beauty* and *Shoot* were typical of the stimulating thematics to be seen in this space.

Just as quirky gallery names like Fruit and Flower Deli had been a feature of the East Village scene in the 1980s, the new Lower East Side had its share of brain teasers that were nicely in keeping with the protean practices going on within. The short-lived Never Work, the longer lasting Scaramouche and the young and irreverent but quickly press-popular Ramiken Crucible all rejoiced in intriguingly unhelpful names.

Just as in the East Village, some dealers would explain the logic of their choice, others not.

Risa Needleman and Benjamin Tischer named their gallery Invisible-Exports—a term in economics denoting intangible goods—as a reflection of a program based on concepts and ideas rather than just materials.[9] Characteristic of the cerebral and routinely tough subject matter they believed in was the work of Genesis Breyer P-Orridge whose elective cosmetic surgeries on her much-altered, transgendered body were proposed as a work of art in and of itself.

In keeping with a fundamental commitment to not just marketing but discovering and nurturing new work, Needleman and Tischer also launched their Artist of the Month Club. The two partners identified twelve curators at the beginning of each year and assigned one month to each. That curator then invited an artist to create a work of art in a limited edition of fifty, and the subscriber received the piece by mail. The list of curators was announced at the beginning of each year, but subscribers didn't know the identity of the artist until the work arrived.

Candice Madey called her program On Stellar Rays; from her tiny space farther up Orchard Street, she ran a multimedia program that soon got serious traction with critics and collectors.[10] J. J. Peet's scrappy but skillfully controlled little acrylic-on-panel paintings often measured less than twelve inches but held the wall like far bigger works. Thirtysomethings recently out of MFA programs like video artist Tommy Hartung caught Madey's eye, but so did timely and newly relevant work of more mature artists like Rochelle Feinstein. *The Estate of Rochelle F.* was created as anxious commentary on the effects of economic recession on even established artists like herself; she used only supplies ready at hand in her studio, both legitimate art-making materials and scavenged and recycled everyday junk.

By 2010 the newcomers were no longer the only art world kids on the block. The grown-ups had started to join them and, just as Castelli et al. had anointed the evolving SoHo scene of the early '70s, veteran powerhouses like Sperone Westwater and Lehmann Maupin were coming on down. Angela Westwater did not finish her stunning Norman Foster ground-up construction until September 2010, but she had spotted the

potential of the neighborhood several years earlier when she bought and tore down a restaurant supply store on the Bowery.

Rachel Lehmann and David Maupin, thirty-year veterans who started out in SoHo and had been a must-make stop on the Chelsea circuit since 2002, were the New York representatives of such blue-chip artists as Tracey Emin, Mickalene Thomas and Do Ho Suh.[11] They also sensed some new potential on the Lower East Side and took over a former glass storage facility at 201 Chrystie Street. After an elegant renovation that was lovingly sensitive to the raw beauty of the old industrial space, they used this double-height gallery for projects too overwhelming to be contained in the Chelsea location. Both Jennifer Steinkamp's breathtakingly beautiful video screens and Nari Ward's muscular tower constructs were presented there to stunning effect.

The Upper East Side's Salon 94 and midtown's Greenberg Van Doren launched satellite offshoots from their established programs as directors saw the opportunity for doing something a little different in another part of town. The uptown principals wisely appointed sharp, young, foreign-born multilinguists to run their downtown locations with Fabienne Stephan at Salon 94 Freemans and Augusto Arbizo at Eleven Rivington.[12]

The buzz emanating from the Lower East Side was also being heard by young dealers beyond New York's boundaries. Laurel Gitlin was born in New York but was educated at Reed College in Oregon and had stayed out west after college to run her own Small A Projects in Portland. Well respected by a (too) small cadre of collectors there, Gitlin brought her edgy little program to the corner of Broome and Orchard Streets in September 2008. She was soon in a second, bigger venue on Norfolk at Rivington Street, now with her own name on the gallery door. Her mix of artists included Corin Hewitt, whose studio practice involved rotting food stuffs, and Jessica Jackson Hutchins, whose lumpen sculptures were piled together out of utilitarian ceramics and discarded, careworn furniture. Both artists were picked up for shows at the once Tuttle-repulsed Whitney Museum.

Kristen Dodge was a Brown graduate and, like Gitlin, another brainy addition to the neighborhood.[13] She had also sharpened her skills

and deepened her experience in the regions before setting her sights on the big leagues in New York. With several years under her belt in Boston, Dodge gutted and elegantly refinished a former sausage factory on the corner of Rivington and Chrystie. There she ran a strong multimedia program that combined thought-provoking, often iconoclastic work but also adhered to a fine-finish aesthetic—a far cry from the scrappy assemblage or improvised gallery settings that first typified the neighborhood.

As Chelsea real estate continued to boom and prices rose after the opening of the High Line, a number of other long-standing but modestly scaled operations had to move. Valerie McKenzie attended New York University's selective Institute of Fine Arts, had trained at the Met and learned the business under Holly Solomon.[14] She also spent time amid the flash of Gagosian and the decorum of the long-lived Graham Gallery on Madison Avenue. She opened her own McKenzie Fine Art in 2002 in one of the upper floors of 511 West Twenty-Fifth Street. When the Related Companies took over management of that building in the wake of the Hudson Yards land grab, she and many of the smaller galleries felt the squeeze.

Much as professionals like Betty Cuningham and Nancy Hoffman did in SoHo in the 1970s, McKenzie brought to Orchard Street a well-rounded cadre of strong mid-career painters, both abstract and representational (Don Voisine's taut vectors and Jean Lowe's dizzy interiors), and skilled object makers (Jim Dingilian's candle-smoked glass bottles and Ursula Morley Price's flanged and undulating stoneware), as well as a beyond-Bushwick regional and international group of artists used to producing at exacting levels of skill.

The sense of community that quickly took hold in this newly settled terrain was remarkable given the broad mix of players now on the scene. It was exemplified by a group-hug kind of project that was put together in the summer of 2010 by artist-curators Franklin Evans and Omar Lopez-Chahoud. Working from Richard Price's Lower East Side novel *Lush Life,* nine galleries (Collette Blanchard, Invisible-Exports, Lehman Maupin, On Stellar Rays, Scaramouche, Eleven Rivington, Y Gallery, Sue Scott and Salon 94 Freemans), each took one of the nine chapters of the novel and created an exhibition in response to it.

A four-day multiblock carnival called the Festival of Ideas for the New City took place in May 2011 and included everyone from the New Museum and its surrounding galleries to nearby educational and community organizations and local merchants. The enthusiasm for the event on the part of the galleries was not surprising, given that virtually every arrival in this new arts hub was a staunch believer in this being "a real neighborhood." Everyone was convinced that the long-standing presence of the Jewish community, the visible industriousness of the older Chinese merchant class, and the modern ambition of their well-educated offspring would protect the neighborhood's character. Unlike SoHo or Chelsea, real people actually lived, worked and went about their business here. Children went to school down the street. Fishmongers, tailors, purveyors of foodstuffs and vendors of household linens still filled the blocks between the galleries. Synagogues and other houses of worship anchored the community.

As the festival closed and the first decade of its lifeline came to an end, everything about the Lower East Side's new art world looked promising. It had attracted a healthy number and a richly varied mix of exhibition spaces without the numbers getting too high or the quality too low. Both collector traffic and critical attention were running at energetic but not frenetic levels. Price points for the art were still accessible and rents payable. The sense of community was all embracing and still free of internal rivalries or petty competition. Egos were in check and behavior among most of the players still decent. And for the first time, the neighborhood was age old and here to stay. Had the ever-itinerant art world finally found a stable home?

Epilogue

On Monday, October 29, 2012, Hurricane Sandy swept in from the Caribbean Sea and up the East Coast of the United States. A high-pressure cold front from the north forced the storm to start turning toward the major cities of Washington, Baltimore and Philadelphia. The full moon added to the deadly combination of atmospheric conditions and around 2:00 P.M. the hurricane hit New York City with its full force. Winds roared through the skyscrapers of Manhattan, rolling parked cars and toppling construction cranes. Power went out across the island, plunging buildings into darkness; elevators stalled, traffic lights failed, Internet servers crashed and water pumping to upper floors of offices and homes trickled dry. But the wind, as it turned out, was the least of it.

By the end of that day, most of the people we have followed in this history, many of their galleries or artists' studios, and much of the art they had created over the past five days or the past five decades, were under water. The tidal surge that was predicted around the coastlines of Manhattan and Brooklyn was far stronger, faster and higher than anyone had anticipated. The Chelsea galleries were inundated so quickly that dealers couldn't reach their premises in time to move already elevated works to higher floors. Electric security gates would not open and basement storage, flooded to ceiling height with Hudson River water and sewage, was too dangerous to enter.

Artists, long gentrified out of SoHo and Williamsburg, were now in the abandoned industrial buildings of Greenpoint, Red Hook and Gowanus in Brooklyn—waterfront Flood Zone A topographies every

one of them. They equally looked on in horror as their work floated on the water surging in from Brooklyn's Newtown Creek or up into the low-lying swampland around the Gowanus Canal. Red Hook, as its name implies, is just that—a hook-shaped peninsula with bodies of water on both sides. Paint supplies, brushes and stretched canvases sank, photographic and digital equipment shorted out, wood-working tools warped, even firing kilns cracked as the cold water hit their heated surfaces.

The devastation was unsparing as it rode roughshod over the whole arts community. The blocks around West Twenty-Second Street, ironically the cradle of the Chelsea art world, were the hardest hit, and even the powerhouse veterans—Paula Cooper, Matthew Marks, David Zwirner and Larry Gagosian—saw their exhibitions destroyed as large-scale sculpture was washed into broken piles and hung works were stained at the five-foot mark with scum lines. Flat files and irreplaceable archival materials were lost. Medium-sized operations like Winkleman, Foxy Production, Derek Eller, Wallspace and Jeff Bailey Gallery watched the contents of their share-the-expense storage destroyed. Smaller galleries held less costly inventory, but many lacked insurance coverage for the rebuild. Dry but powerless start-ups on the Lower East Side with no subway service worried over cash-flow dynamics that were too frail to withstand weeks of closure. Young artists had their first solo shows cancelled, possibly never to be rescheduled, and even established artists who had expansive, state-of-the-art studio set-ups in the only remaining areas legally zoned for the industrial-size work they were producing were totally wiped out.

By the end of that first day, many of the organizing principles of the New York contemporary art world that had evolved over the half century of its existence—many of them described in the opening pages of this book—were suddenly in question. The destination venue intended to protect the sanctity of the art experience had put the galleries in a location of isolated remove and topographical vulnerability. The coveted ground-floor spaces commanded by the most prestigious galleries and the once enviable basement storage facility for those with deep inventory were now costly liabilities. Proximity to Manhattan was cold comfort in a low-rent but mold-infested factory studio on Brooklyn's waterfront.

Easy access was immaterial as the MTA shut down, bridges closed and tunnels flooded.

And yet astoundingly, within a few short weeks, even days in some cases, floors were ripped up, dry wall and windows replaced, electric circuits repaired, new computers procured. Exhibitions—perhaps not the one planned but something smaller and hastily mounted—opened. Critics got out, about and back to business and the culture media reported—empathetically and constructively.

Because in fact there were still aspects of the art world's idiosyncratic coda that endured, survived the hit and came out of the crisis the stronger for it. Sense of community was at its tightest as Facebook posts for help went out and neighbors dragged sodden art works from each other's galleries. The Art Dealers Association of America set up an emergency fund, directors of artists' estates came forward with grants, and collectors wrote checks. A plethora of conservation and restoration experts provided pro bono advice and museums gave workshops on handling insurance issues. Even the big auction houses offered temporary space to displaced galleries. Once again hands reached out across the generations as younger artists and dealers helped older ones perhaps less tech savvy than themselves in accessing websites, sending digital images of damage or scanning and e-mailing insurance claims.

What changes the events of 2012 will make to the landscape of New York's art world remain to be seen. Whether art will stay on the block in Chelsea, Greenpoint or Gowanus or whether it will move elsewhere, no one yet knows. But the art will go on—creating it, showing it, collecting it, talking and writing about it—will continue, here or in the next place. Just wait and see.

Notes

CHAPTER 1: WHAT MOVES THE ART WORLD?

1. See urban sociologists Charles R. Simpson [*SoHo: The Artist in the City* (Chicago: University of Chicago Press, 1981)], James R. Hudson [*The Unanticipated City: Loft Conversions in Lower Manhattan* (Amherst: University of Massachusetts Press, 1987)], Janet Abu-Lughod [*From Urban Village to East Village: The Battle for the Lower East Side* (Cambridge, MA: Blackwell, 1994)], or Sharon Zukin [*Naked City: The Death and Life of Authentic Urban Places* (New York: Oxford University Press, 2010)].
2. Wildenstein & Company is a notable exception here with five generations of the family—Nathan, Georges, Daniel, Alec and Guy—all involved in the business.
3. Susan Emerling, "L.A. Makes a Showing at Arco," *Art in America*, February 2010, 30.

CHAPTER 2: MODERNS IN MIDTOWN

1. Quoted in Laura de Coppet and Alan Jones, *The Art Dealers: The Powers behind the Scene Tell How the Art World Really Works*, rev. ed. (New York: Cooper Square Press), 2002, 65.
2. Art of the highest quality continues to be shown on Fifty-Seventh Street in excellent galleries. Historical exhibitions, shows of older more established artists, or those working in existing genres such as representational painting, landscape or early abstraction tend, however, to predominate. Some notable exceptions, such as the always-groundbreaking Marian Goodman Gallery, did of course choose to remain there.
3. Malcolm Goldstein, *Landscape with Figures: A History of Art Dealing in the United States* (New York: Oxford University Press, 2000), 258-9.
4. Quoted in Grace Glueck, "Sidney Janis, Trend-Setting Art Dealer, Dies at 93," *New York Times*, November 24, 1989.
5. Roy Neuberger, *The Passionate Collector: Eighty Years in the World of Art* (Hoboken, NJ: Wiley, 2003), 77-78.
6. Quoted in de Coppet and Jones, *The Art Dealers*, 71.
7. John Gruen, *The Party's Over Now: Reminiscences of the Fifties—New York's Artists, Writers, Musicians and Their Friends* (New York: Viking, 1972), 234.

8. Charles R. Simpson, *SoHo: The Artist in the City* (Chicago: University of Chicago Press, 1981), 4.

9. Sharon Zukin, *Loft Living: Culture and Capital in Urban Change* (New Brunswick, NJ: Rutgers University Press, 1989), 98.

CHAPTER 3: HELL'S HUNDRED ACRES

1. Alanna Siegfried and Helene Zucker Seeman, *SoHo: A Guide* (New York: Neal-Schuman, 1979), 11–13.

2. Roselee Goldberg, "Art After Hours: Downtown Performance" in Marvin J. Taylor, ed., *The Downtown Book: The New York Art Scene, 1974–1984,* ed. Marvin J. Taylor (Princeton: Princeton University Press, 2005), 98.

3. Quoted in Mary K. Fons, "SoHo Style: A Look at Life South of Houston," *The Cooperator: The Co-op and Condo Monthly,* April 2005.

4. Sharon Zukin, *Loft Living: Culture and Capital in Urban Change* (New Brunswick, NJ: Rutgers University Press, 1989), 49–52.

5. Ibid.

6. Richard Kostelanetz, *SoHo: The Rise and Fall of an Artists' Colony* (New York: Routledge, 2003*)*, 17.

7. George Maciunas, "Information Bulletin, Fluxhouse Cooperatives," New York (1966), in Charles Simpson, *SoHo: The Artist in the City* (Chicago: University of Chicago Press, 1981), 156.

CHAPTER 4: GETTING IT TOGETHER DOWNTOWN

1. Grace Glueck, "Neighborhoods: SoHo is Artists' Last Resort," *New York Times,* May 11, 1970.

2. The Kitchen, "History and Mission," The Kitchen, accessed March 15, 2011, http://www.thekitchen.org/.

3. Robyn Brentano and Mark Savitt, eds., *112 Workshop, 112 Greene Street: History Artists and Artworks* (New York: New York University Press, 1981), viii.

4. Quoted in Claudia Gould and Valerie Smith, eds., *5000 Artists Return to Artists Space: 25 Years* (New York: Artists Space, 1998), 59.

5. Quoted in Andrew Goldstein, "Can Alanna Heiss's Vision for Her Museum Outlast Her?" *New York Magazine,* May 2, 2008.

6. Alexandra Anderson and B. J. Archer, *SoHo: The Essential Guide to Art and Life in Lower Manhattan* (New York: Simon & Schuster, 1979), 34.

7. Quoted in Laura de Coppet and Alan Jones, *The Art Dealers: The Powers behind the Scene Tell How the Art World Really Works,* rev. ed. (New York: Cooper Square Press), 2002,188

8. Paula Cooper, interview with the author, New York, February 24, 2009.

9. Grace Glueck, "Art: A Downtown Scene," *New York Times,* November 12, 1970.

10. Cooper, interview, 2009.

11. Ivan Karp, interview with the author, New York, March 11, 2008.

12. Ibid.

13. Quoted in de Coppet and Jones, *The Art Dealers,* 144.

14. Quoted in Anderson and Archer, *SoHo,* 39.

15. Grace Glueck, "4 Uptown Art Dealers Set Up in SoHo," *New York Times,* September 27, 1971.
16. Quoted in de Coppet and Jones, *The Art Dealers,* 199.
17. Betty Cuningham, interview with the author, New York, January 13, 2009.
18. Nancy Hoffman, interview with the author, New York, April 1, 2009.
19. Susan Caldwell, e-mail message to the author, January 5, 2010.
20. Angela Westwater, interview with the author, New York, June 9, 2010, and Max Protetch, interview with the author, New York, June 17, 2009.
21. Vivien Raynor and Andy Grundberg, "The Downtown Scene: A Sampler of What's New and Still Fresh South of 14th Street," *New York Times,* February 15, 1985.
22. "Sherrie Levine Talks to Howard Sinderman," *Artforum International,* April 1, 2003, 190–191.
23. Cuningham, interview, 2009.
24. Quoted in de Coppet and Jones, *The Art Dealers,* 237.

CHAPTER 5: DILUTION AND DISCONTENT

1. Thomas Hine, *The Great Funk: Falling Apart and Coming Together (On a Shag Rug) in the Seventies* (New York: Farrar, Straus and Giroux, 2007), 165.
2. James R. Hudson, *The Unanticipated City: Loft Conversions in Lower Manhattan* (Amherst: University of Massachusetts Press, 1987), 66.
3. Grace Glueck, "SoHo Is Artists' Last Resort," *New York Times,* May 11, 1970.
4. Charles R. Simpson, *SoHo: The Artist in the City* (Chicago: University of Chicago Press, 1981), 15.
5. Ibid., 25–30.
6. Grace Glueck, "Fresh Talent and New Buyers Brighten the Art World," *New York Times* October 18, 1981.
7. John Russell, "Is SoHo Going Up, Down, Nowhere?" *New York Times,* March 12, 1976.
8. Grace Glueck, "Summer Art Scene: From 42nd St. South, The SoHo Way of Life," *New York Times,* August 8, 1980.
9. Philip Jenkins, *Decade of Nightmares: The End of the Sixties and the Making of Eighties America* (New York: Oxford University Press, 2006).
10. Michael Musto, *Downtown* (New York: Vintage, 1986), 16.
11. Peter Frank and Michael McKenzie, *New, Used & Improved: Art in the 80's* (New York: Abbeville Press, 1987), 65.
12. Steven Hager, *Art after Midnight: The East Village Scene* (New York: St. Martin's Press, 1986), 51.
13. Frank and McKenzie, *New, Used & Improved,* 50.
14. Ibid., 31.
15. Jeffrey Deitch, "Report from Times Square," *Art in America,* September 1980, 59–63.
16. Phoebe Hoban, *Basquiat: A Quick Killing in Art* (New York: Penguin, 2004), 37.
17. Hager, *Art after Midnight,* 98.
18. Quoted in Roland Hagenberg, Alan Jones, Michael Kohn, Carlo McCormick and Nicolas Moufarrege, *Eastvillage 85. A Guide. A Documentary.* (New York: Pelham Press, 1985), third page of unpaginated essay.

CHAPTER 6: DECADE OF DECADENCE

1. Thomas Lawson, "The Dark Side of the Bright Light," *Artforum*, November 1982, 66.
2. Julie L. Belcove, "A New Boone: After Years of Playing Hardball, Tough as Nails Gallerist Mary Boone is Beginning to Show Her Softer Side," *W Magazine*, November 2008.
3. Quoted in Laura de Coppet and Alan Jones, *The Art Dealers: The Powers behind the Scene Tell How the Art World Really Works*, rev. ed. (New York: Cooper Square Press, 2002), 276.
4. David Rimanelli, "Time Capsules: 1980-85," *Artforum*, March 2003, 124.
5. Phoebe Hoban, *Basquiat: A Quick Killing in Art* (New York: Penguin, 2004), 181.
6. Angela Westwater, interview with the author, New York, June 9, 2010, and *Oral History Interview with Angela Westwater, 2006 July–August 1*, Archives of American Art, Smithsonian Institution.
7. Jerry Saltz, "The Mets 'Pictures' Show Captures a Moment When Borrowing Became Cool," *New York Magazine*, May 18, 2009, 66.
8. Linda Yablonsky, "Barbara Gladstone," *Wall Street Journal*, December 11, 2011.
9. de Coppet and Jones, *The Art Dealers*, 308–309.
10. Roberta Smith, "Review/Art; 3 Donald Sultan Shows: Paintings to 'Black Eggs'" *New York Times*, April 22, 1988.
11. Hoban, *Basquiat*, 79.
12. Peter Plagens, "Cents and Sensibility: Collecting the 80s," *Artforum International*, April 2003, 211.
13. Michael Brenson, "Artists Grapple with New Realities," *New York Times*, May 15, 1983.
14. Robert Hughes, *American Visions: The Epic History of Art in America* (New York: Knopf, 1997), 592–594.
15. Ibid.
16. Hoban, *Basquiat*, 194.
17. Ibid., 194.
18. Ibid., 231.
19. Belcove, "A New Boone," 2008.
20. Bob Nickas, "McDermott and McGough Talk to Bob Nickas," *Artforum International*, March 2003, 91.
21. Ibid.
22. Calvin Tomkins, "Disco," *New Yorker*, July 22, 1985.
23. Ibid.
24. Ibid.
25. Roberta Smith, "4 Young East Villagers at Sonnabend Gallery," *New York Times*, October 24, 1986.
26. Ronald Feldman, interview with the author, New York, January 30, 2009.
27. Brooke Alexander, interview with the author, New York, February 29, 2008.
28. Joni Weyl, interview with the author, New York, May 28, 2008, and Betsy Senior, interview with the author, New York, May 18, 2009.
29. Richard Armstrong, Richard Marshall and Lisa Phillips, *1989 Whitney Biennial* (New York: Whitney Museum of American Art, New York, 1989), 10–11.

CHAPTER 7: THE EAST VILLAGE SCENE

1. "Ford to City: Drop Dead," *New York Daily News,* October 30, 1974.
2. Quoted in Sandler, *A Sweeper-Up After Artists: A Memoir* (New York: Thames & Hudson, 2003), 34.
3. Ibid., 36.
4. Ibid., 273.
5. Nicholas Moufarrege, "Another Wave, Still More Savage Than the First," *Arts Magazine,* September 1982, 69.
6. Addison Parks, "One Graffito, Two Graffito," *Arts Magazine,* September 1982, 73.
7. Gracie Mansion, interview with the author, New York, March 12, 2008.
8. Howard Smith, "Canned Art," *Village Voice,* April 13, 1982, 27.
9. Carlo McCormick, "Gracie Mansion Gallery," *Artforum,* October 1999, 123.
10. Peter Nagy, interview with the author, New York, January 29, 2009.
11. Kim Levin, "The East Village," *Village Voice,* October 18, 1983.
12. Ibid.
13. Jay Gorney, "The East Village, Latest Lure of the Art World," *Washington Post,* February 12, 1984.
14. Craig Unger, "The Lower East Side: There Goes the Neighborhood," *New York Magazine,* May 28, 1984.
15. Doug Milford, interview with the author, New York, October 28, 2008.
16. Penny Pilkington and Wendy Olsoff, interview with the author, New York, February 26, 2008.
17. Ibid.
18. Mary Heilmann, "O Pioneer," *Artforum,* February 2001, 35–36.
19. Roberta Smith, "Pat Hearn, Art Dealer in New York, Dies at 45," *New York Times,* August 20, 2000, and Jack Bankowsky, "On Pat Hearn," *Artforum,* October 1999, 126.
20. Dan Cameron, "On International With Monument," *Artforum,* October 1999, 127.
21. Magdalena Sawon, interview with the author, New York, June 5, 2008.
22. Grace Glueck, "East Village Gets on the Fast Track," *New York Times,* January 13, 1985.
23. Ibid.
24. Maureen Dowd, "Youth—Art—Hype: A Different Bohemia," *New York Times Magazine,* November 17, 1985.
25. Quoted in Liza Kirwin, "Timeline," *Artforum,* October 1999, 127.
26. Roberta Smith, "Quieter Times for East Village Galleries," *New York Times,* February 6, 1987, Amy Virshup, "The Fun's Over: The East Village Scene Gets Burned By Success," *New York Magazine,* June 22, 1987 and Douglas McGill, "Art Boom Slows In the East Village," *New York Times,* July 25, 1987.

CHAPTER 8: THE STATE OF THE ART

1. Robert Hughes, "The SoHoiad: or, The Masque of Art," in *Nothing If Not Critical: Selected Essays on Art and Artists* (New York: Penguin, 1990), 405–413.

2. Michael Brenson, "Is Neo-Expressionism an Idea Whose Time Has Passed?" *New York Times,* January 5, 1986.
3. Richard Kostelanetz, *SoHo: The Rise and Fall of an Artists' Colony* (New York: Routledge, 2003), 224.
4. Lucy Lippard, "Sex and Death and Shock and Schlock," *Artforum,* October 1980, 50–55.
5. Arthur C. Danto, *The State of the Art* (New York: Prentice Hall, 1987), 30–31.
6. Michael Kohn, "The Apocalypse of the East Village," in Roland Hagenberg, Alan Jones, Michael Kohn, Carlo McCormick and Nicolas Moufarrege, *Eastvillage 85: A Guide. A Documentary.* (New York: Pelham Press, 1985), first page of an unpaginated essay.
7. Quoted in Steven Hager, *Art after Midnight: The East Village Scene* (New York; St. Martin's Press, 1986), 127.
8. Gary Indiana, "Crime and Misdemeanors," *Artforum,* October 1999, 117.
9. Robert Pincus-Witten in Hagenberg, *Eastvillage 86, A Documentary.* (New York: Egret Publications, 1986), 23.
10. Susan B. Anthony, interview with the author, New York, June 3, 2009.
11. Douglas McGill, "Art Boom Slows in the East Village," *New York Times,* July 25, 1987.
12. Michael Idov, "The Stench of '89," *New York Magazine,* February 4, 2008.
13. James Servin. "SoHo Stares at Hard Times," *New York Times,* January 20, 1991.
14. Deborah Solomon, "The Art World Bust," *New York Times,* February 28, 1993.
15. Ibid.
16. Ibid.
17. Marvin J. Taylor, ed., *The Downtown Book: The New York Art Scene 1974–1984* (Princeton, NJ: Princeton University Press, 1986), 36; also Philip Jenkins, *Decade of Nightmares: The End of the Sixties and the Making of Eighties America* (New York: Oxford University Press, 2006), 205–208.
18. Michael Musto, *Downtown* (New York: Vintage, 1986), 25.
19. Phoebe Hoban, *Basquiat: A Quick Killing in Art* (New York: Penguin, 2004), 158–159.
20. Alan Moore and Josh Gosciak, eds., *A Day in the Life: Tales from the Lower East Side; An Anthology of Writings from the Lower East Side, 1940–1980* (New York: Evil Eye Books, 1990), Introduction.

CHAPTER 9: WILD TIMES

1. James Kalm, "The Brooklyn Canon: Airbrushed out of History," *The Brooklyn Rail,* June 2008; Ward Shelley, interview with the author, New York, April 17, 2008; and Shelley's *The Williamsburg Timeline Drawing,* 2001.
2. Jane Fine, interview with the author, New York, May 24, 2011.
3. Brad Gooch, "Portrait of an Artists' Colony in Brooklyn," *New York Magazine,* June 22, 1992.
4. Roberta Smith, "Brooklyn Haven for Art Heats Up," *New York Times,* November 16, 1998.

5. "Decade Show," *The New Yorker,* May 12, 2003.
6. Ebon Fisher in Fineberg, *Out of Town,* 1993, accessed March 18, 2013, http://www.nervepool.net/ebQuivering.html
7. Shelley, interview, 2008.
8. Marc Singer, e-mail message to Jane Fine, May, 2011.
9. Citysearch, "Right Bank," accessed May 26, 2011, http://newyork.city search.com/profile/7348906/brooklyn_ny/right_bank.html.
10. Larry Walczak, telephone interview with the author, April 20, 2011.
11. Adam Simon, interview with the author, New York, May 29, 2008, and Mike Ballou, interview with the author, Brooklyn, October 26, 2010.
12. Gregory Volk, "Big Brash Borough," *Art in America,* September 2004, 93.
13. Quoted in Frances Richard, "Historic Williamsburg," *Artforum,* March 2005, 80.
14. Joe Amrhein, interview with the author, Brooklyn, January 23, 2009.
15. Eric Heist and Michael Waugh, interview with the author, Brooklyn, April 28, 2008. Laura Parnes, interview with the author, New York, February 22, 2011.
16. Parnes, interview, 2011.
17. Richard Timperio, interview with the author, Brooklyn, June 2, 2008.
18. Thomas S. Mulligan, "Via YouTube, It's the Kalm Report," *Los Angeles Times,* April 23, 2008.
19. Daniel Aycock, interview with the author, Brooklyn, April 14, 2008.

CHAPTER 10: WHITHER WILLIAMSBURG?

1. Lisa Schroeder and Sara Jo Romero, interview with the author, New York, February 1, 2008.
2. Ronald Feldman Fine Arts, "Other Rooms: Four Walls, Momenta Art Pierogi 2000, Sauce." Press Release, June 9, 1995.
3. Romero, interview, 2008.
4. Lori Ortiz, "Brooklyn Pastiche: The Brooklyn Scene," *The Brooklyn Rail,* February/March, 2001.
5. He would lose it almost immediately over conflict of interest issues, having simultaneously accepted not just one, but two other jobs, running both the Volta and the Next art fairs. He apparently failed to see why his fiscal involvement with so many dealers should impair his impartiality as a critic. The *Village Voice* saw it otherwise.
6. Greg Moser, "A Scene Grows in Brooklyn," *freewilliamsburg,* September, 2001.
7. Edward Winkleman, interview with the author, New York, May 20, 2008.
8. Becky Smith, interview with the author, New York, April 17, 2008.
9. Heather Stephens, interview with the author, New York, May 20, 2008.
10. Priska Juschka, interview with the author, New York, January 27, 2009.
11. Tatyana Okshteyn, interview with the author, New York, February 5, 2008.
12. Stephen Maine, "Whither Williamsburg?," *Artnet,* accessed April 23, 2011, http://www.artnet.com/magazineus/features/maine/maine1-12-06.asp.
13. Quoted in Marcin Ramocki, *Brooklyn DIY: A Story of Williamsburg's Art Scene: 1987–2007,* 2009.
14. Stephanie Cash, "Landlords Put the Squeeze on Brooklyn Artists," *Art in America,* March 2001, 39–41.

15. Eve Sussman, interview with the author, Brooklyn, June 9, 2008 and Deborah Masters, interview with the author, Brooklyn, April 24, 2008.

16. Carol Schwarzman, "Diary of an Air Addict, or Where's the Crisis? Williamsburg Residents Continue the Battle to Stop New Power Plants from Polluting the Neighborhood," *Wburg.com home,* Spring 2001.

17. William Powhida, *Williamsburg Eulogy.* Performed at eyewash@Supreme Trading, June, 2006.

18. Roberta Smith, "Chelsea Enters Its High Baroque Period: Too Legit for Williamsburg," *New York Times,* November 28, 2004.

19. Tracy Causey-Jeffery, interview with the author, Brooklyn, March 6, 2008.

20. Drawn from the author's conversations and experiences on many visits to the gallery.

21. Alun Williams, interview with the author, Brooklyn, May 29, 2008.

22. Williamsburg Gallery Association, *RAW 2008 Guide to Williamsburg Art Spaces, 4.*

23. Don Carroll, interview with the author, Brooklyn, May 31, 2008.

24. Stephen Maine, "Dateline Brooklyn: Its Showtime in Williamsburg," accessed April 23, 2011, http://www.artnet.com/magazineus/reviews/maine/maine10-4-05.asp.

25. Ibid.

26. Daniel Baird, "Elsewhere Is Here," *The Brooklyn Rail,* October/November 2000.

CHAPTER 11: FLEEING TO CHELSEA
AT THE END OF THE CENTURY

1. Barbara Pollack, "Westward, Ho!," *ARTnews,* May 1998, 135.

2. Carol Greene, interview with the author, New York, January 27, 2009.

3. Charlie Finch, "West Side Story or Top This Insanity," *Artnet,* December 8, 1997.

4. Quoted in Sandler, *Art of the Postmodern Era: From the Late 1960s to the Early 1990s* (New York: HarperCollins, 1996), 548.

5. Ibid.

6. Robert Hughes, *American Visions: The Epic History of Art in America* (New York: Knopf, 1997), 606.

7. Robert Storr, *DISlocations* (New York: Museum of Modern Art, 1991), 19.

8. Peter Galassi, *Pleasures and Terrors of Domestic Comfort* (New York: Museum of Modern Art, 1992), 16–22.

9. Alexandra Peers, "Chelsea's Subprime Moment," *New York Magazine,* October 15, 2007.

10. Roberta Smith, "For the New Galleries of the '90s, Small (and Cheap) Is Beautiful," *New York Times,* April 22, 1994.

11. Quoted in ibid.

12. Jerry Saltz, "Has Money Ruined Art?," *New York Magazine,* October 15, 2007.

13. Lisa Spellman, interview with the author, New York, April 22, 2009.

14. Lucien Terras, interview with author, New York, June 2, 2009.

15. A partial list of media in the work.

16. Lawrence Luhring, interview with the author, New York, May 23, 2012.

17. Roland Augustine, e-mail message to the author, May 27, 2012.

18. Ibid.
19. Andrea Rosen, interview with the author, New York, October 30, 2009.
20. Laura de Coppet and Alan Jones, *The Art Dealers: The Powers behind the Scene Tell How the Art World Really Works, Revised and Expanded* (New York: Cooper Square Press, 2002), 399.

CHAPTER 12: INTO THE AUGHTS

1. Marianne Boesky, interview with the author, New York, May 19, 2009.
2. Sean Kelly, interview with the author, New York, May 4, 2009.
3. Ibid.
4. Katya Kazakina, "Zwirner Bucks Tanking Art Market, Sells $2 Million Kippenberger," *Bloomberg.com,* accessed March 3, 2009, http://www.bloomberg.com/apps/news?pid=newsarchive&refer=muse&sid=a5N6A5LrWJxM.
5. Dorothy Spears, "The First Gallerists' Club," *New York Times,* June 18, 2006.
6. Ibid.
7. Barbaralee Diamonstein, *Inside the New York Art World: Conversations with Barbaralee Diamonstein* (New York: Rizzoli, 1994), 71–75.
8. Quoted in Sarah Douglas, "Larry Gagosian: The Art of the Deal," *Intelligent Life Magazine,* Spring 2008.
9. Ibid.
10. David Segal, "Pulling Art Sales out of Thinning Air," *New York Times,* March 8, 2009.
11. Ibid.
12. Roberta Smith, "Chelsea Enters Its High Baroque Period," *New York Times,* November 28, 2004.
13. Douglas, "Larry Gagosian."
14. Kelly Crow, "The Gagosian Effect," *Wall Street Journal,* April 1, 2011.
15. Malcolm Goldstein, *Landscape with Figures: A History of Art Dealing in the United States* (New York: Oxford University Press, 2000), 301.
16. Ibid., 302.
17. Irving Sandler, *A Sweeper-Up After Artists: A Memoir* (New York: Thames & Hudson, 2003), 337; and Goldstein, *Landscape with Figures,* 274–276.
18. Jerry Saltz, "The Battle for Babylon," *Artnet,* September 20, 2005.
19. Jerry Saltz, "Has Money Ruined Art?" *New York Magazine,* October 7, 2007.
20. Kate Taylor, "Galleries Expand in Uncertain Market," *New York Sun,* August 27, 2007.
21. He of the colorful description of old-time Chelsea that introduced Chapter 11.
22. Quoted in Taylor, "Galleries Expand in Uncertain Market."
23. The Museum of Modern Art, "Exhibitions," accessed August 2, 2012, http://www.moma.org/visit/calendar/exhibitions/107 .
24. Catherine Curan, "Galleries Find Space Crunch in Chelsea," *The Real Deal,* July 2006.
25. Norval White and Elliot Willensky, *AIA Guide to New York City* (New York: Oxford University Press, 2010), 222.
26. Arcspace.com, "Neil Denari Architects HL23, accessed August 2, 2012.
27. Ibid.

28. Nicolai Ouroussoff, "Industrial Sleek (a Park Runs through It)," *New York Times,* April 8, 2009.

CHAPTER 13: AFTER THE FALL

1. Maev Kennedy, "£111m Damien Hirst Total Sets Record for One-Artist Auction," *The Guardian,* September 16, 2008.
2. Carol Vogel, "In Faltering Economy, Auction Houses Crash Back to Earth," *New York Times,* November 17, 2008.
3. Carol Vogel, "Hard Times Hit Auction Houses," *New York Times,* January 31, 2009.
4. Louis Uchitelle, "Broad Job Losses as Companies Face Sharp Downturn," *New York Times,* January 10, 2009.
5. Jerry Saltz, "Has Money Ruined Art?" *New York Magazine,* October 15, 2007.
6. Roberta Smith, "The Mood of the Market as Measured in the Galleries," *New York Times,* September 4, 2009.
7. Holland Cotter, "The Boom Is Over, Long Live the Art," *New York Times,* February 15, 2009.
8. "How's My Dealing?" http://howsmydealing.blogspot.com/2009/11/roe bling-hall.html.
9. Dorothy Spears, "This Summer Some Galleries Are Sweating," *New York Times,* June 19, 2009.
10. Corinna Kirsch, "Priska C. Juschka Court Case Reaches a Settlement," *Art Fag City,* May 30, 2012.
11. Marcia Tucker and Liza Lou ed., *A Short Life of Trouble: Forty Years in the New York Art World* (Berkeley: University of California Press, 2008), 111
12. Rachel Wolff, "Bohemian Rhapsody: Brion Gysin, William Burroughs, and the Secret Life of a Building on the Bowery," *New York Magazine,* July 12, 2010.
13. Lia Gangitano, interview with the author, New York, September 28, 2012.
14. Erica Papemik, "From the Real Estate Show to the New Museum," FlashArtonline.com, accessed December 3, 2012, http://www.flasharton-line.com/interno.php?pagina=articolo_spec&id_art_spec=3.
15. Miguel Abreu, interview with the author, New York, September 6, 2012.
16. James Fuentes, interview with the author, New York, September 26, 2012.
17. Sean Horton, interview with the author, New York, November 28, 2012.
18. Barbara A. MacAdam, "Object Overruled," *ARTnews,* December 2007.
19. Roberta Smith, "In Galleries, A Nervy Opening Volley," *New York Times,* November 30, 2007; Jerry Saltz, "Little House on the Bowery," *New York Magazine,* November 29, 2007.
20. Tucker, *A Short Life of Trouble,* 111.

CHAPTER 14: THE LOWER EAST SIDE REDUX

1. Dennis Christie and Ken Tyburski, interview with the author, New York, September 12, 2012.
2. Simon Preston, interview with the author, New York, November 28, 2012.
3. Jimi Dams, interview with the author, New York, October 2, 2012.
4. Lisa Cooley, interview with the author, New York, October 23, 2012.

5. Nicelle Beauchene, interview with the author, New York, October 25, 2012.
6. Jen Bekman, interview with the author, New York, November 13, 2012.
7. Amy Smith-Stewart, interview with the author, New York, November 16, 2012.
8. Lesley Heller, interview with the author, New York, August 8, 2012.
9. Risa Needleman and Benjamin Tischer, interview with the author, New York, September 26, 2012.
10. Candice Madey, interview with the author, New York, October 16, 2012.
11. Rachel Lehmann, interview with the author, New York, May 22, 2009.
12. Fabienne Stephan, interview with the author, New York, August 31, 2012; Augusto Arbizo, interview with the author, New York, October 10, 2012.
13. Kristen Dodge, interview with the author, New York, October 3, 2012.
14. Valerie McKenzie, interview with the author, New York, November 28, 2012.

Selected Bibliography

Abu-Lughod, Janet L. et al. *From Urban Village to East Village: The Battle for New York's Lower East Side.* Cambridge, MA: Blackwell, 1994.

Anderson, Alexandra, and B. J. Archer. *The Essential Guide to Art and Life in Lower Manhattan.* New York: Simon & Schuster, 1979.

Ault, Julie. *Alternative Art, New York, 1965–1985: A Cultural Politics Book for the Social Text Collective.* Minneapolis: University of Minnesota Press; New York: Drawing Center, 2002.

Ballon, Hilary, and Robert T. Jackson, eds. *Robert Moses and the Modern City: The Transformation of New York.* New York: W. W. Norton, 2007.

Beard, Rick, and Leslie Cohen Berlowitz, eds. *Greenwich Village: Culture and Counterculture.* New Brunswick, NJ: Rutgers University Press, 1993.

Bender, Thomas. *New York Intellect: A History of Intellectual Life in New York from 1750 to the Beginnings of Our Own Times.* New York: Knopf, 1987.

_____. *The Unfinished City: New York and The Metropolitan Idea.* New York: New York University Press, 2007.

Berger, Joseph. *The World in a City: Traveling the Globe Through the Neighborhoods of New New York.* New York: Ballantine, 2007.

Berman, Avis. *Rebels on Eighth Street: Juliana Force and the Whitney Museum of American Art.* New York: Athenaeum, 1990.

Blatzwick, Iwona. *Century City: Art and Culture in the Modern Metropolis.* London: Tate Publishing, 2001.

Brentano, Robyn, and Mark Savitt. *112 Workshop, 112 Green Street: History, Artists and Artworks.* New York: New York University Press, 1981.

Brown-Saracino, Japonica. *A Neighborhood That Never Changes: Gentrification, Social Preservation, and the Search for Authenticity.* Chicago: University of Chicago Press, 2009.

Burnham, Sophy. *The Art Crowd.* New York: David McKay, 1973.

Cameron, Daniel J., et al. *East Village USA.* New York: New Museum, 2004.

Caplow, Theodore, Louis Hicks, and Ben J. Wattenberg. *The First Measured Century: An Illustrated Guide to Trends in America, 1900–2000.* Washington, DC: AEI Press, 2001.

Celant, Germano, and Lisa Dennison, eds. *New York, New York: Fifty Years of Art, Architecture, Cinema, Performance, Photography and Video.* Milan: Skira Editore S. P. A., 2006.

Cohen-Solal, Annie. *Leo and His Circle: The Life of Leo Castelli.* New York: Knopf, 2010.

Cooke, Lynne, and Douglas Crimp, with Kristin Poor, eds. *Mixed Use, Manhattan: Photography and Related Practices, 1970s to the Present.* Cambridge, MA: MIT Press, 2010.

Currid, Elizabeth. *The Warhol Economy: How Fashion, Art and Music Drive New York City.* Princeton, NJ: Princeton University Press, 2007.

Crane, Diana. *The Transformation of the Avant-Garde: The New York Art World, 1940–1985.* Chicago: University of Chicago Press, 1987.

Danto, Arthur C. *The State of the Art.* New York: Prentice Hall Press, 1987.

David, Joshua, and Robert Hammond. *High Line: The Inside Story of New York City's Park in the Sky.* New York: Farrar, Straus, and Giroux, 2011.

de Coppet, Laura, and Alan Jones. *The Art Dealers: The Powers behind the Scene Tell How the Art World Really Works, Revised and Expanded.* New York: Cooper Square Press, 2002.

Diamonstein, Barbaralee. *Inside the New York Art World: Conversations with Barbaralee Diamonstein.* New York: Rizzoli, 1994.

Fiore, Jessamyn. *112 Greene Street: The Early Years (1970 –1974).* Santa Fe, NM: Radius Books, 2012.

Frank, Peter, and Michael McKenzie. *New, Used and Improved: Art in the 80's.* New York: Abbeville Press, 1987.

Galassi, Peter. *Pleasures and Terrors of Domestic Comfort.* New York: Museum of Modern Art, 1992.

Goldstein, Malcolm. *Landscape with Figures: A History of Art Dealing in the United States.* New York: Oxford University Press, 2000.

Gosciak, Josh, and Alan Moore. *A Day in the Life: Tales from the Lower East Side, 1940–1990.* New York: Evil Eye Books, 1990.

Gould, Claudia, and Valerie Smith. *5000 Artists Return to Artists Space: 25 Years.* New York: Artists Space, 1998.

Gruen, John. *The New Bohemia.* New York: Grosset and Dunlap, 1967.

————. *The Party's Over Now: Reminiscences of the Fifties—New York's Artists, Writers, Musicians and Their Friends.* New York: Viking, 1972.

Grunenberg, Christoph. *Gothic: Transmutations of Horror in Late Twentieth Century Art.* Cambridge, MA: MIT Press, 1997.

Haden-Guest, Anthony. *True Colors.* New York: Atlantic Monthly Press, 1996.

Hager, Steven. *Art after Midnight: The East Village Scene.* New York: St. Martin's Press, 1986.

Harris, Luther S. *Around Washington Square: An Illustrated History of Greenwich Village.* Baltimore: Johns Hopkins University Press, 2003.

Hillen, Andreas. *1973 Nervous Breakdown: Watergate, Warhol and the Birth of Post-Sixties America.* New York: Bloomsbury USA, 2007.

Hine, Thomas. *The Great Funk: Falling Apart and Coming Together (On a Shag Rug) in the Seventies.* New York: Farrar, Straus and Giroux, 2007.

Hoban, Phoebe. *Basquiat: A Quick Killing in Art.* New York: Penguin, 2004.

Hofmann, Alexandra. "An Analysis of the Evolution of the Contemporary Art Dealer: Specific to Emerging Dealers in the Lower East Side and Bushwick." MA diss., Sotheby's Institute of Art, 2012.

Hudson, James R. *The Unanticipated City: Loft Conversions in Lower Manhattan.* Amherst: University of Massachusetts Press, 1987.

Hughes, Robert. *Nothing If Not Critical: Selected Essays on Art and Artists.* New York: Penguin, 1990.

Institute of Contemporary Art. *Devil on the Stairs: Looking Back on the Eighties.* (Catalogue for exhibition curated by Robert Storr and Judith Tannenbaum.) Philadelphia: Institute of Contemporary Art, 1991.

_____. *American Visions: The Epic History of Art in America.* New York: Knopf, 1997.

Jackson, Kenneth T., ed. *The Encyclopedia of New York City.* New Haven, CT, and London: Yale University Press, 1995.

Jacobs, Jane. *The Death and Life of Great American Cities.* New York: Random House, 1961.

Jenkins, Philip. *Decade of Nightmares: The End of the Sixties and the Making of Eighties America.* New York: Oxford University Press, 2006.

Kardon, Janet. *The East Village Scene.* Philadelphia: Institute of Contemporary Art, University of Pennsylvania, 1984.

Kirwin, Liza. "It's All True: Imagining New York's East Village Art Scene of the 1980's." Ph.D. diss., University of Maryland at College Park, 1999.

Kostelanetz, Richard. *SoHo: The Rise and Fall of an Artists' Colony.* New York: Routledge, 2003.

La Farge, Annik. *On the High Line: Exploring America's Most Original Urban Park.* New York: Thames & Hudson, 2012.

Lederer, Victor, and the Brooklyn Historical Society. *Images of America: Williamsburg.* Charleston, SC: Arcadia Publishing, 2005.

Lindemann, Adam. *Collecting Contemporary.* Los Angeles: Taschen, 2006.

Marquis, Alice Goldfarb. *The Art Biz: The Covert World of Collectors, Dealers, Auction Houses, Museums and Critics.* Chicago: Contemporary Books, 1991.

_____. *The Pop Revolution: How an Unlikely Concatenation of Artists, Aficionados, Businessmen, Collectors, Critics, Curators, Dealers, and Hangers-on Radically Transformed the Art World.* Boston: Museum of Fine Arts, 2010.

Mele, Christopher. *Selling the Lower East Side: Culture, Real Estate and Resistance in New York City.* Minneapolis: University of Minnesota Press, 2000.

Mendelsohn, Joyce. *The Lower East Side Remembered & Revisited: History and Guide to a Legendary New York Neighborhood.* New York: Lower East Side Press, 2001.

Miller, Terry. *Greenwich Village and How It Got That Way.* New York: Crown, 1990.

Mollenkopf, John H. *Power, Culture and Place: Essays on New York City.* New York: Russell Sage Foundation, 1988.

Moore, Thurston, and Byron Coley. *No Wave: Post Punk. Underground. New York 1976–1980.* New York: Abrams Image, 2008.

Morrisey, Lee. *The Kitchen Turns Twenty. A Retrospective Anthology.* New York: Kitchen Center for Video, Dance, Performance, 1992.

Musto, Michael. *Downtown.* New York: Vintage, 1986.

Myers, John Bernard. *Tracking the Marvelous: A Life in the New York Art World.* New York: Random House, 1983.

Neuberger, Roy R., with Alfred and Roma Connable. *The Passionate Collector: Eighty Years in the World of Art.* Hoboken, NJ: Wiley, 2003.

New Museum of Contemporary Art. *Alternatives in Retrospect: A Historical Overview, 1969–1975.* New York: New Museum, 1981.

O'Doherty, Brian. *Inside the White Cube: The Ideology of the Gallery Space.* Berkeley: University of California Press, 1986.

————. *Studio and Cube: On the Relationship between Where Art Is Made and Where Art Is Displayed.* New York: Columbia University, 2007.

Patterson, Clayton. *Resistance: A Radical Social and Political History of the Lower East Side.* New York: Seven Stories Press, 2007.

Perl, Jed. *New Art City: Manhattan at Mid-Century.* New York: Knopf, 2005.

Pollock, Lindsay. *The Girl with the Gallery.* Cambridge, MA: Public Affairs/ Perseus Books Group, 2006.

Purnick, Joyce. *Mike Bloomberg: Money, Power, Politics.* New York: Perseus Books, 2009.

Roberts, Sam. *Only in New York: An Exploration of the World's Most Fascinating, Frustrating and Irrepressible City.* New York: St. Martin's Press, 2009.

Rosati, Lauren, and Mary Anne Staniszewski, eds. *Alternative Histories: New York Art Spaces 1960–2010.* Cambridge, MA: MIT Press, 2012.

Sakamaki, Q. *Tompkins Square Park.* Brooklyn: powerHouse Books, 2008.

Saltz, Jerry. *Seeing Out Loud: Village Voice Art Columns Fall 1998–Winter 2003.* Great Barrington, MA: The Figures, 2003.

————. *Seeing Out Louder: Art Criticism 2003–2009.* Lenox, MA: Hard Press Editions, 2009.

Sandler, Irving. *Triumph of American Painting: A History of Abstract Expressionism.* New York: Harper & Row, 1976.

————. *Art of the Postmodern Era: From the Late 1960s to the Early 1990s.* New York: Harper Collins, 1996.

————. *A Sweeper-Up After Artists: A Memoir.* New York: Thames & Hudson, 2003.

Schjeldahl, Peter. *The Hydrogen Jukebox: Selected Writings of Peter Schjeldahl 1978–1990.* Berkeley: University of California Press, 1991.

Siegel, Fred. *The Prince of the City: Giuliani, New York and the Genius of American Life.* New York: Encounter Books, 2006.

Siegel, Jeanne, ed. *Art Talk: The Early 80s.* New York: Da Capo Press, 1988.

Siegfried, Alanna, and Helen Zucker Seeman. *SoHo: A Guide.* New York: Neal-Schuman, 1979.

Simpson, Charles R. *SoHo: The Artist in the City.* Chicago: University of Chicago Press, 1981.

Sorkin, Michael. *All Over the Map: Writings on Buildings and Cities.* London and New York: Verso, 2011.

Stallabrass, Julian. *Art Incorporated: The Story of Contemporary Art.* Oxford: Oxford University Press, 2005.

Taylor, Marvin J., ed. *The Downtown Book: The New York Art Scene 1974–1984.* Princeton, NJ: Princeton University Press, 2006.

Thornton, Sarah. *Seven Days in the Art World.* New York: W.W. Norton, 2008.

Tomkins, Calvin. *Off the Wall: Robert Rauschenberg and the Art World of Our Time.* New York: Penguin, 1981.

————. *Post- to Neo-: The Art World of the Eighties.* New York: Penguin, 1988.

Tucker, Marcia, and Liza Lou, ed. *A Short Life of Trouble: Forty Years in the New York Art World.* Los Angeles: University of California Press, 2008.

Watson, Steven. *Strange Bedfellows: The First American Avant-Garde.* New York: Abbeville Press, 1991.

Wetzsteon, Ross. *Republic of Dreams: Greenwich Village: The American Bohemia, 1910 to 1960.* New York: Simon & Schuster, 2002.

White, Norval, and Elliot Willensky. *AIA Guide to New York City.* New York: Oxford University Press, 2010.

Zukin, Sharon. *Loft Living: Culture and Capital in Urban Change.* New Brunswick, NJ: Rutgers University Press, 1989.

_____. *Naked City: The Death and Life of Authentic Urban Places.* New York: Oxford University Press, 2010.

Index